TREES
AND FORESTS
WILD WONDERS OF EUROPE

"WHAT IS WILD IS
NOT USELESS AND
IRRELEVANT BECAUSE
IT IS ECONOMICALLY
UNPRODUCTIVE; IT
COMPLETES THE
MAN-MADE WORLD....
IT OPENS AN
ALTERNATIVE TO IT....
THE WILD EXPANDS
OUR CONSCIOUSNESS
AND SUPPLIES ONE
OF ITS FORGOTTEN
DIMENSIONS."

—RODOLPHE CHRISTIN

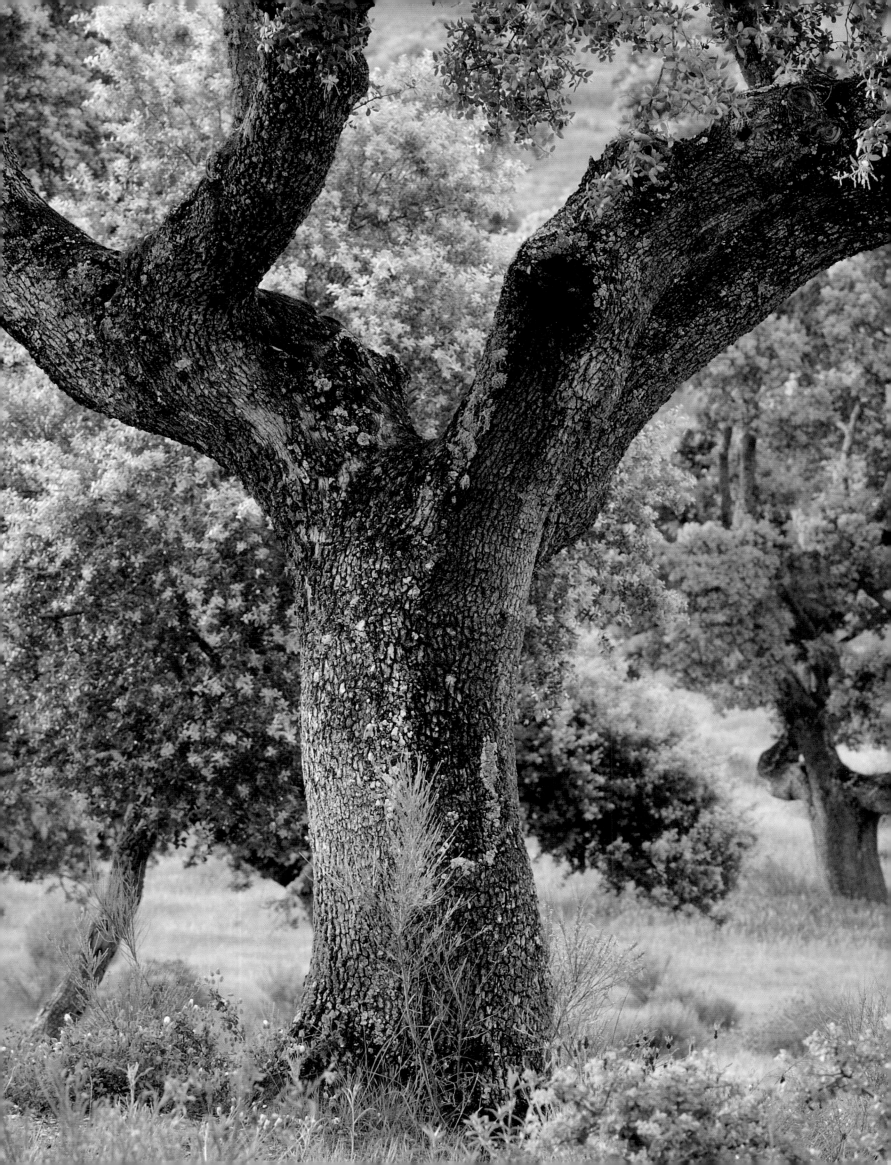

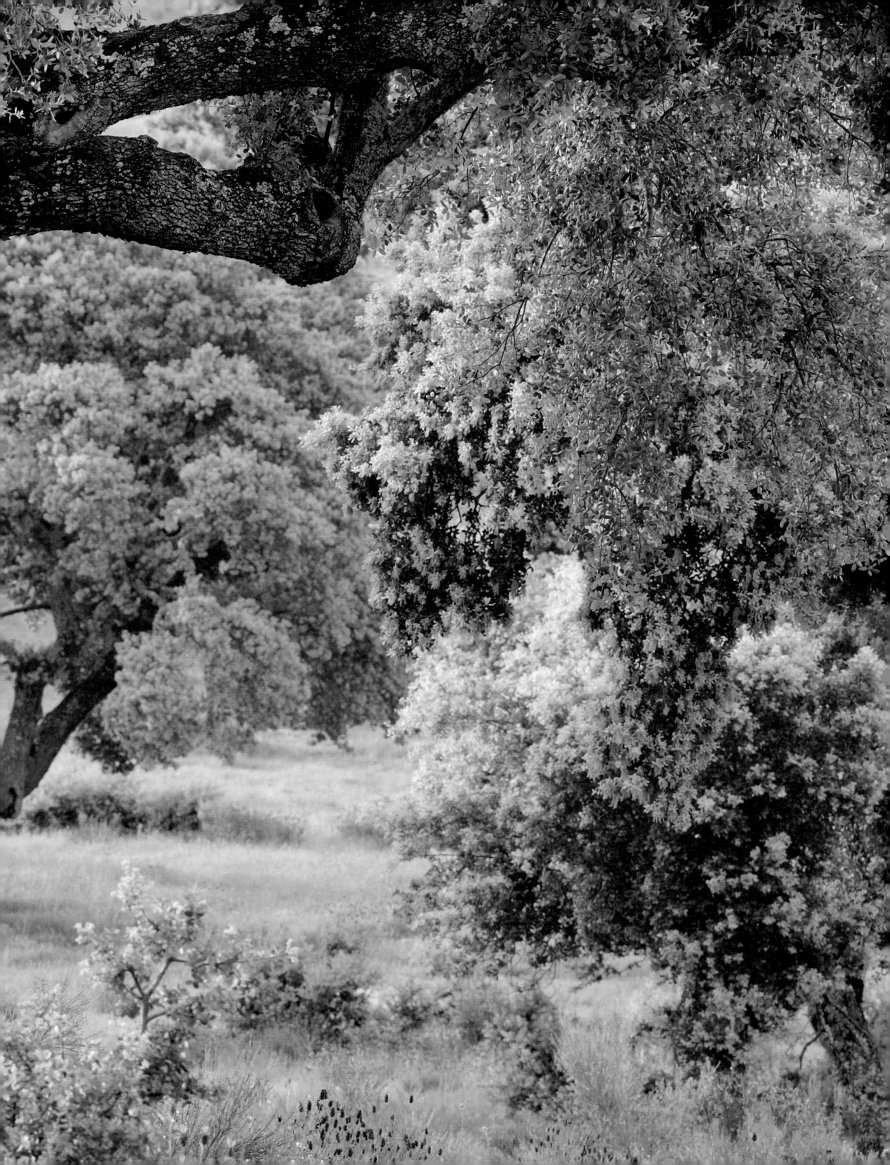

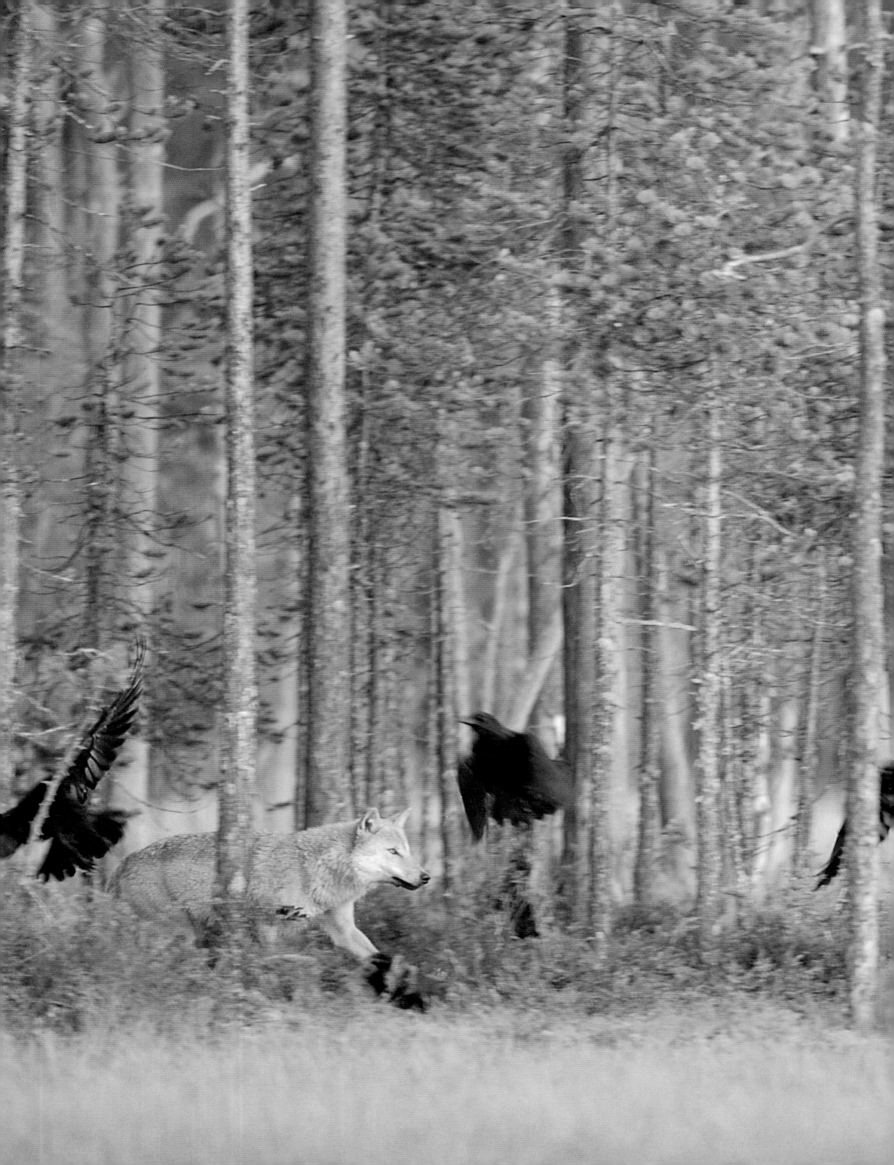

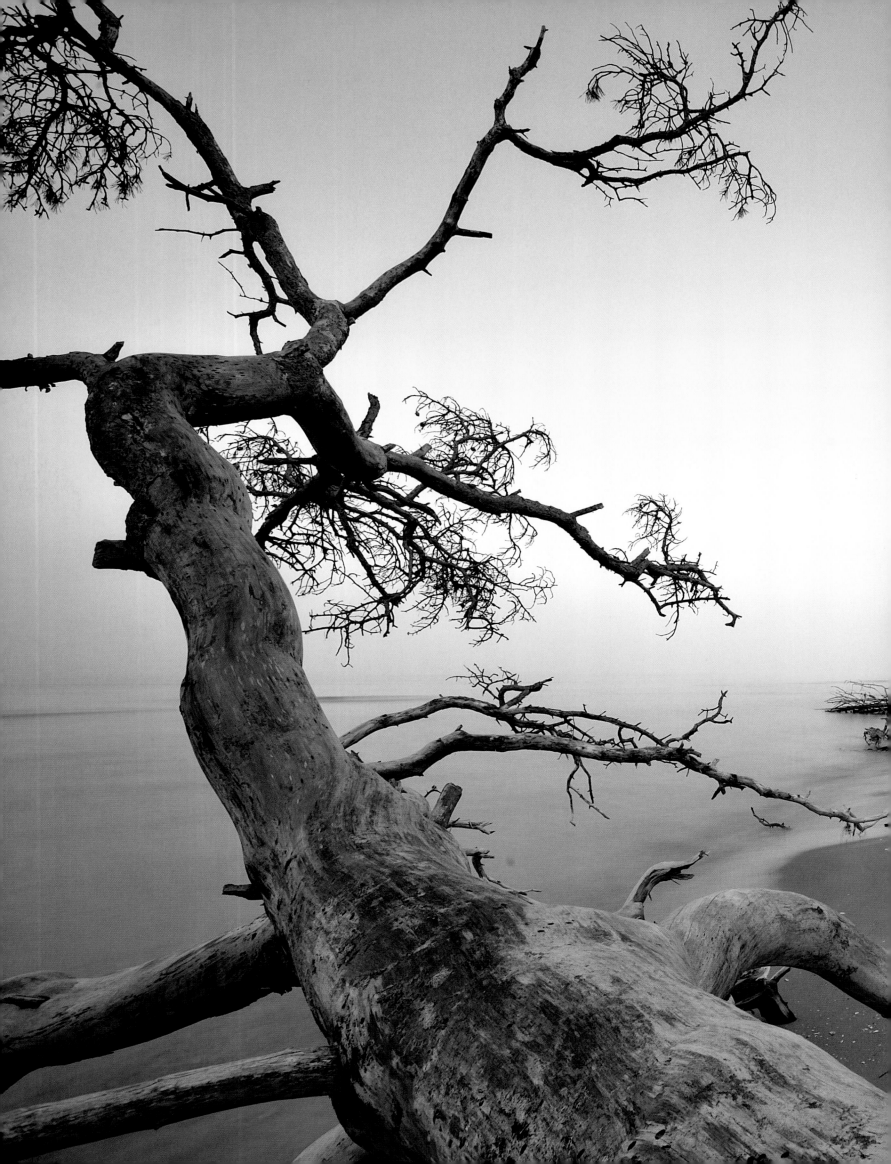

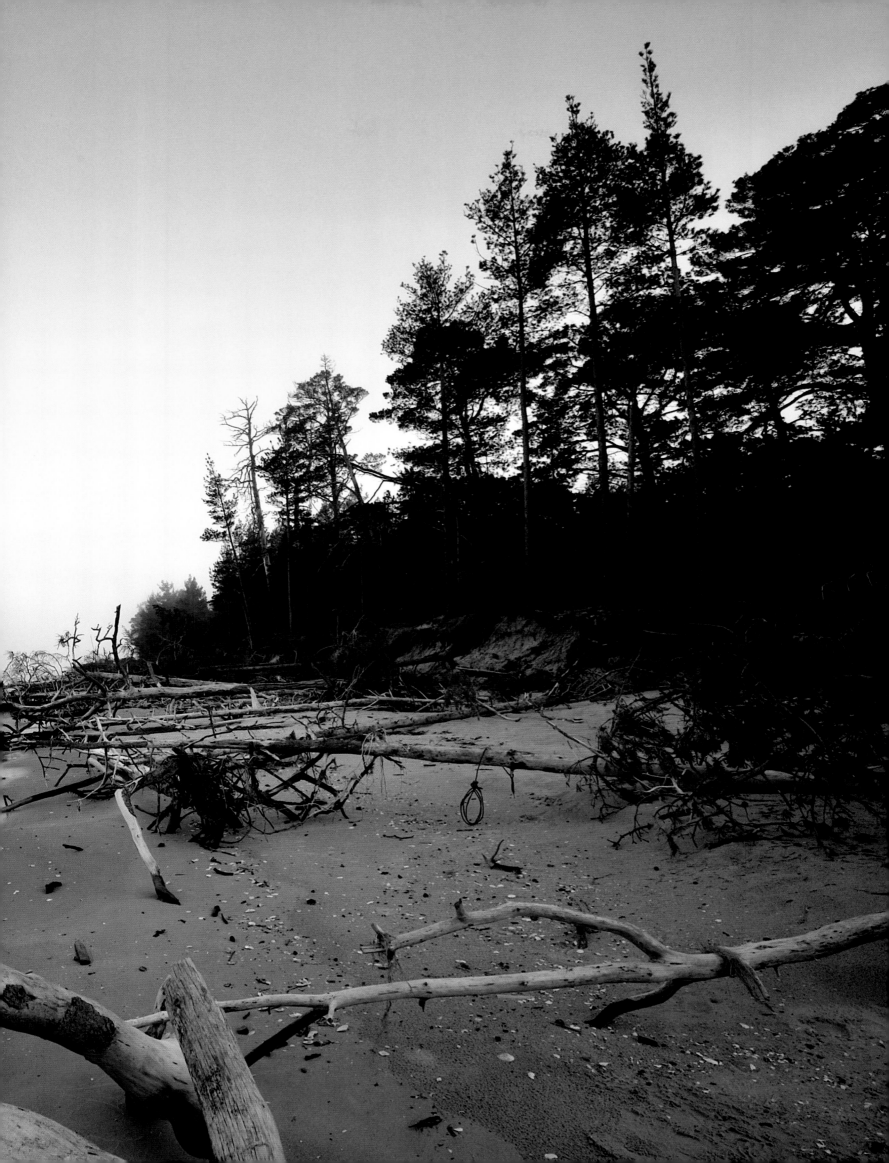

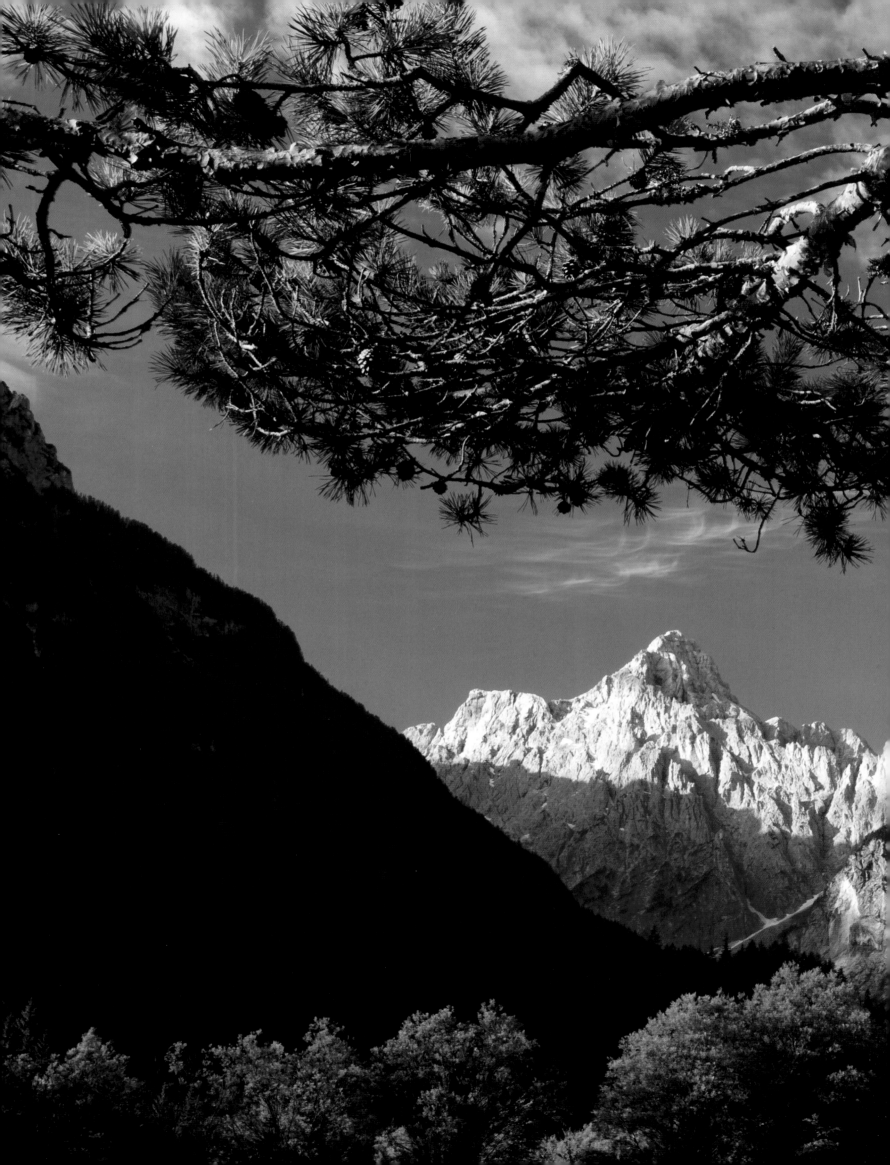

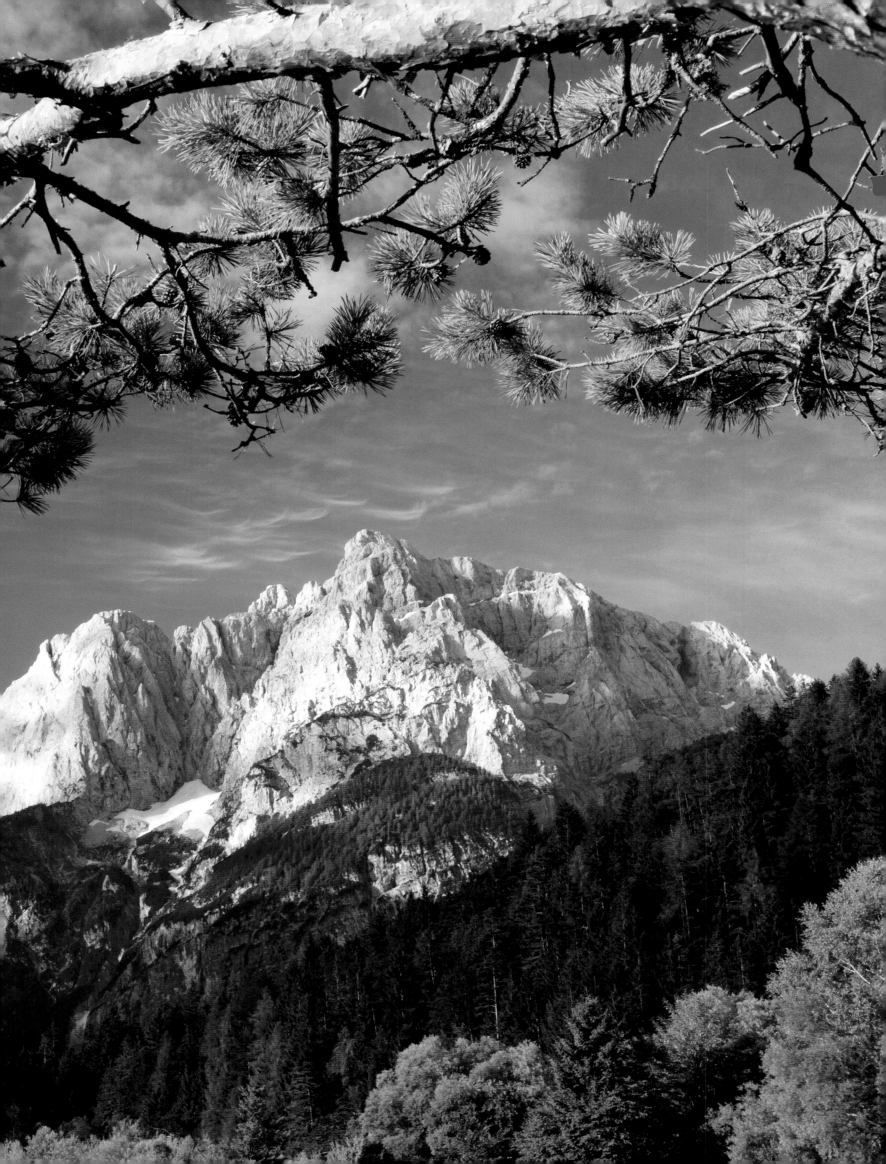

Holm oaks

Quercus ilex
SPAIN | CAMPANARIOS DE AZÁBA
NATURE RESERVE, CASTILLE AND
LEÓN, SALAMANCA REGION

The holm oak, also known as the holly oak, is one of the major species of the dry scrubland, or garrigue, of the Mediterranean region. It can live to be 500 years old.

Staffan Widstrand

Wolves and crows

Canis lupus and *Corvus corax*
FINLAND | KUHMO,
KAINUU REGION

Visitors from the world over hold their breath in astonishment and fear as they watch wolves, wolverines, crows, and eagles from the blinds set up by tourist guides in Kuhmo. Yet while some seek out these wildlife experiences, the majority of Europeans (if we are to believe their national politics) are against rehabilitating large predators in their countries.

Staffan Widstrand

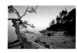

Dead trees on the beach

LATVIA | CAPE KOLKA, SLĪTERE
NATIONAL PARK

The forests growing along the Baltic Sea on the coast of Latvia often have very active edges. Wind and water are constantly redrawing their boundaries and contribute to the dispersal of seeds and the creation of new habitats for pioneering species and their accompanying insects.

Diégo Lopez

Triglav

SLOVENIA | TRIGLAV
NATIONAL PARK

At 9,396 feet (2,864 meters), Triglav ("three-headed") is the highest peak in the Julian Alps (the southeastern spur of the Alps jutting into Slovenia) and also the highest point in Slovenia. Its glacier is receding due to global climate change. The general warming trend over the past fifty years, along with the abandonment of pasturelands in the mountains, has allowed conifers such as the European larch (*Larix decidua*) and the mountain pine (*Pinus mugo*) to flourish higher on the mountain's slopes. Projections suggest that the upper limit for trees in the Alps, which is today at 6,500 to 8,200 feet (2,000 to 2,500 meters), may well rise by 1,200 to 2,300 feet (370 to 700 meters) in the next century or two.

Daniel Zupanc

Osprey

Pandion haliaetus
FINLAND | KANGASALA,
PIRKANMAA REGION

Every year, large numbers of ospreys undertake the 6,000-mile (10,000-kilometer) trip from their winter grounds in West Africa to their nesting grounds in Europe. They build their nests on cliffsides, in large trees, or even at the top of electric poles. In spring 2011, 26-year-old Lady, one of the oldest female ospreys in the world, returned to her nest in the Dunkeld Nature Reserve, thus completing her 21st trip from Gambia to Scotland! All over Europe, ospreys are reappearing in places where they haven't been seen for decades, due mostly to stricter hunting laws along the bird's migration route.

Peter Cairns

Red deer roaring in a Danish forest

Cervus elaphus
DENMARK | DYREHAVEN ROYAL
DEER PARK, KLAMPENBORG,
COPENHAGEN REGION

The extraordinary "roaring" sound of red deer in rut, the clash of their antlers in combat, and their aggressive call, somewhere between a bark and cough, as the breeding stags desperately try to keep control of the hinds in their harems, makes the rutting season of the red deer one of the greatest of all nature spectacles offered by the forests of Europe.

Florian Möllers

Cowslip

Primula veris
SWEDEN | KALLHÄLL, UPPLAND

This member of the Primula family grows on open ground and in moist, lightly canopied forests on poor and slightly calcareous soil. According to an old German legend, Saint Peter dropped his keys from heaven to Earth, where they turned into lovely yellow flowers that looked like a key ring. Cowslip was used in traditional medicine to treat whooping cough, tremors, and headaches—though they may have contributed to the latter two. It was also used in making a white wine similar to Muscadet.

Staffan Widstrand

TREES
AND FORESTS
WILD WONDERS OF EUROPE

FLORIAN MÖLLERS ANNICK SCHNITZLER STAFFAN WIDSTRAND BRIDGET WIJNBERG

ABRAMS
NEW YORK

CONTENTS

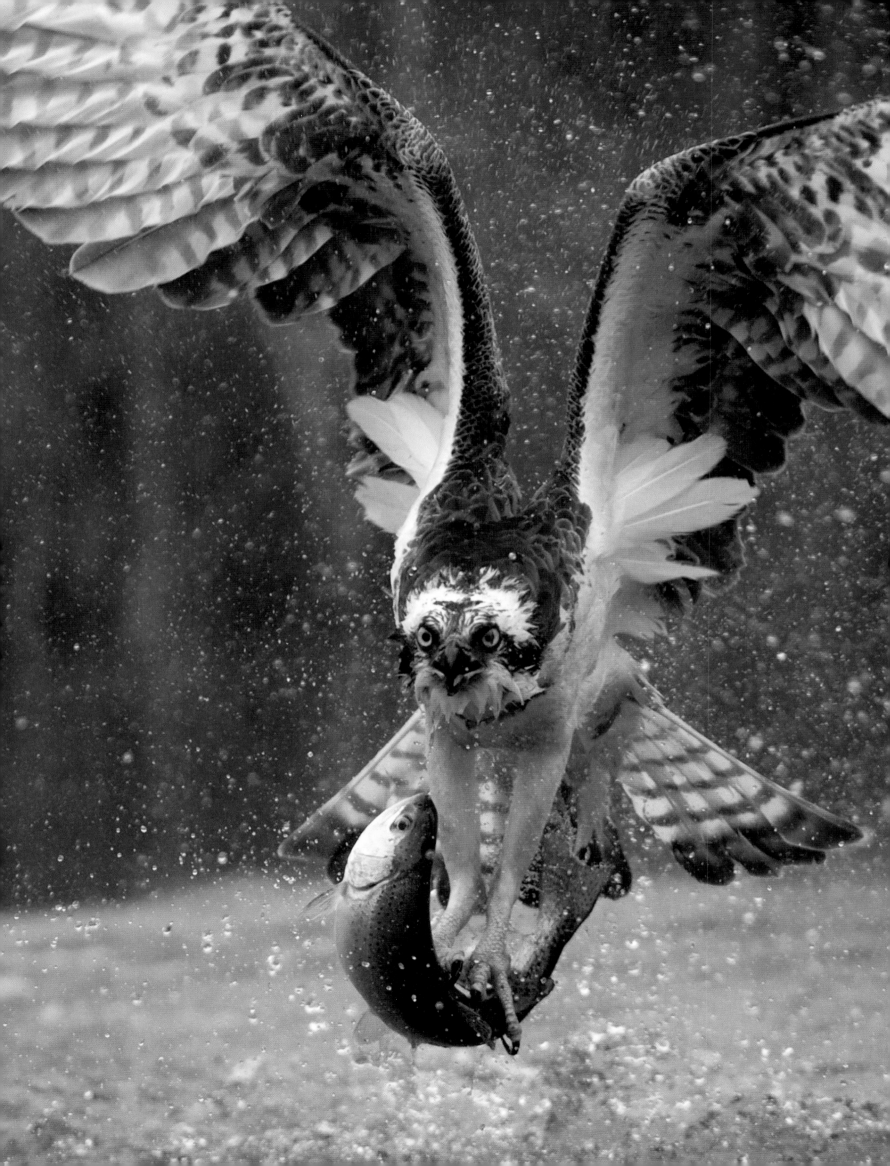

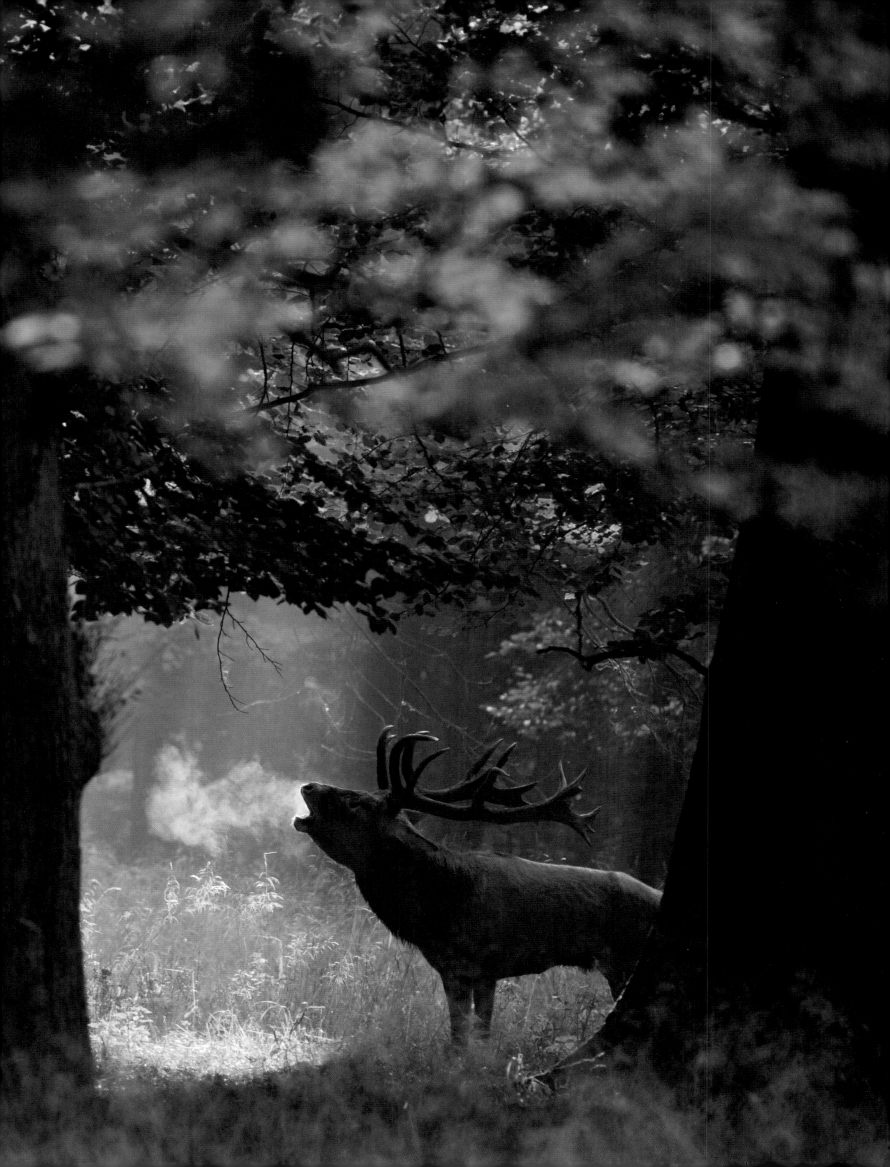

INTRODUCTION

IN A WORLD WHERE NATURE IS RECEDING, A JOURNEY THROUGH THE LAST WILD FORESTS OF EUROPE HELPS US UNDERSTAND THE EXTENT TO WHICH MAN IS still caught in nature's cycles. One must visit a forest, its huge moss- and fern-covered trunks rising like cathedrals skyward or lying heaped in the underbrush—broken, thrown down, and tangled together—to experience the extraordinary power of these living entities, among the most ancient and gigantic on Earth. Forests are living, powerful edifices to which we have long belonged and from which we still draw numerous resources, both spiritual and material. To look on one in all its many aspects, wherever a forest has been left to follow its innate laws, imparts a feeling of well being, freedom, respect, and curiosity.

Of these original forests, which have existed throughout Europe for more than six millennia, there are few remnants, as man has altered nature to his needs, turning it into urban strips, geometric fields, hedgerows, pastures, managed watercourses, and intensively harvested forests. As the present century begins, the shape of the natural world may yet change significantly, molded by contradictory impulses: an ever-increasing desire to exploit natural resources on the one hand, with its corresponding growth in pollution, and on the other, an ever-keener awareness of the need to protect the environment.

To better understand today's forests, as well as our bonds to them, we must briefly consider their history. Forests may seem unchanging, yet they have evolved continuously since the end of the last glacial period some ten thousand years ago. Once dominant over a large part of Europe, woodlands have suffered during the last three thousand years under the combined attack of fire, steel, and grazing livestock. As a result of human activities, other ecosystems have taken their place, relegating the last bastions of original forest to a few tens of thousands of square kilometers in the most inaccessible or infertile sites. The last remnants of the environment in which our distant hunter-gatherer ancestors lived, these fragments of so-called "primeval" forest, have enormous cultural and natural value. While this is now widely acknowledged, the last remaining sites have not been systematically protected. In fact, the threat of imminent exploitation hangs over them. Furthermore, Europe's forests have often not been harvested sustainably, and as a consequence, their natural diversity has suffered. If we better understood the issues at stake in conservation, we would know the forest's needs and frailties and possibly make use of forest resources more wisely. This book attempts to start a discussion about conservation, while at the same time exploring forest environments throughout Europe, celebrating the beauty of these complex ecosystems, aiming to generate ever-growing admiration. Perhaps with increased respect will come a greater will to preserve old-growth trees and the spectacular fauna of forests, which are not only crucial to our physical survival but also to our culture, having always been powerful sources of inspiration for man in philosophy, religion, and art.

—Annick Schnitzler

A PLACE FOR THE EXCHANGE AND CONSERVATION OF ORGANIC ELEMENTS AND MINERALS, WATER AND ENERGY, THE FOREST IS AN ESSENTIAL COMPONENT OF EUROPE'S BIODIVERSITY. FORESTS, IN THEIR NATURAL, HETEROGENOUS STATES, HARBOR TREES OF ALL SIZES AND AGES. THE OLDEST TREES, WHICH DOMINATE THE UPPER STRATA OF THE FOREST, PROVIDE STABILITY TO THE ENTIRE ECOSYSTEM AND OFFER HABITATS—FROM LEAVES TO ROOTS, LIVING WOOD TO DEADWOOD—FOR MANY FORMS OF LIFE: ANIMALS, MICROORGANISMS, FUNGI. THE FOREST FLOOR IS HOME TO MANY SPECIES, BUT ALSO PLAYS A VERY SPECIFIC ROLE IN THE CONSERVATION OF MINERALS AND THE RECYCLING OF ORGANIC MATTER, AND SAFEGUARDS MUCH OF THE FOREST'S WATER RESOURCES.

WHAT IS A FOREST?

FOREST LANDSCAPES IN EUROPE
ARE UNDER MANY STRESSES,
FROM FIRES, FLOODS, OR STORMS,
WHICH VERY GREATLY DEPENDING
ON LOCATION. THESE EVENTS, WHICH
OCCUR RANDOMLY, KILL OR INJURE
DOMINANT TREES, ALLOWING DIRECT
SUNLIGHT TO REACH THE GROUND.
OPENINGS IN THE CANOPY CAN ALSO BE
CAUSED BY SENESCENCE OF VERY LARGE
TREES. THESE OPENINGS (CREATED BY
DEADWOOD) STIMULATE THE GROWTH
OF PLANTS IN THE UNDERBRUSH AND
ALLOW THEM TO REPRODUCE. HERBIVORES,
POLLINATORS, AND SEED EATERS GATHER
THERE DURING THE TIME BEFORE THE
CANOPY OPENINGS ARE CLOSED BY NEW
TREES. THESE REPETITIVE EVENTS ARE THE
KEY TO WHAT IS CALLED THE FOREST CYCLE.

THE FOREST, A LIVING SYSTEM

THE TERM "FOREST" DESIGNATES A WHOLE COMPLEX SYSTEM OF LIVING ORGANISMS. STRUCTURED AROUND THEIR LARGE TREES, forests are composed of many species of plants, animals, fungi, and microorganisms. These species extend from the tree canopy to the understory to the forest floor, and into the leaf litter and rotting wood. The organisms forming this structure can be divided into two basic groups: the **AUTOTROPHS** or primary producers (mostly green plants) that produce sugars and proteins from inorganic compounds through **PHOTOSYNTHESIS**, and the **HETEROTROPHS** that consume the organic compounds and ultimately break down organic molecules into their constituent parts. Thus all the populations in the forest are connected by exchanges of matter and energy, forming complex **FOOD WEBS**.

These interactions among organisms allow the different populations to benefit from the ecosystem's resources but not exhaust them. They also provide the forest as a whole with better resistance to fire, wind, and prolonged periods of drought or freezing. However, such stressful climatic events can temporarily affect the functioning of the forest, especially if they come frequently or in rapid succession. A lengthy summer drought, for instance, can weaken the trees and cause a spike in the population of leaf-eating insects. Stress related to excessive cold or heat can have similar consequences. It is known that oak trees weakened by periods of severe winter cold are more readily attacked by wood-boring beetles and pathogenic fungi, such as *Armillaria* and bark cankers.

When plants are injured, burned, or broken, they most often survive thanks to their extraordinary capacity for regenerating from their vegetative parts (trunks and branches). Some even use climatic disturbances to aid their reproductive efforts. Aleppo pines, native to the Mediterranean, disperse their seeds by opening their cones right after a fire. Having adapted to thrive in high temperatures, the seeds land in the hot soil and can easily surpass the growth of the seeds of other species. Other organisms take advantage of periodic flooding. Willows and poplars disperse their seeds when large quantities of snow are melting, and the resulting high water in nearby rivers carries their seeds far downstream and even onto the floodplain. The scouring action of the water along riverbanks helps seedlings survive by clearing away competing vegetation. In forests, the complex webs of organisms have evolved to flourish in spite of or even because of the ebb and flow of nature's resources.

AUTOTROPHY
The capacity of plants to produce organic compounds from sugars from light, carbon dioxide, minerals, and water.

PHOTOSYNTHESIS
Process by which plants use the sun's energy to turn water and atmospheric carbon dioxide into organic matter. The process removes carbon dioxide from the atmosphere and releases oxygen. As performed by algae, phytoplankton, and the world's forests, photosynthesis produces nearly all of the organic matter and energy necessary for the functioning of the Earth's ecosystems.

HETEROTROPHS
Organisms that are unable to fix carbon directly and derive their nutrients from other organisms

FOOD WEB
A set of interrelated food chains within an ecosystem through which matter and energy are circulated

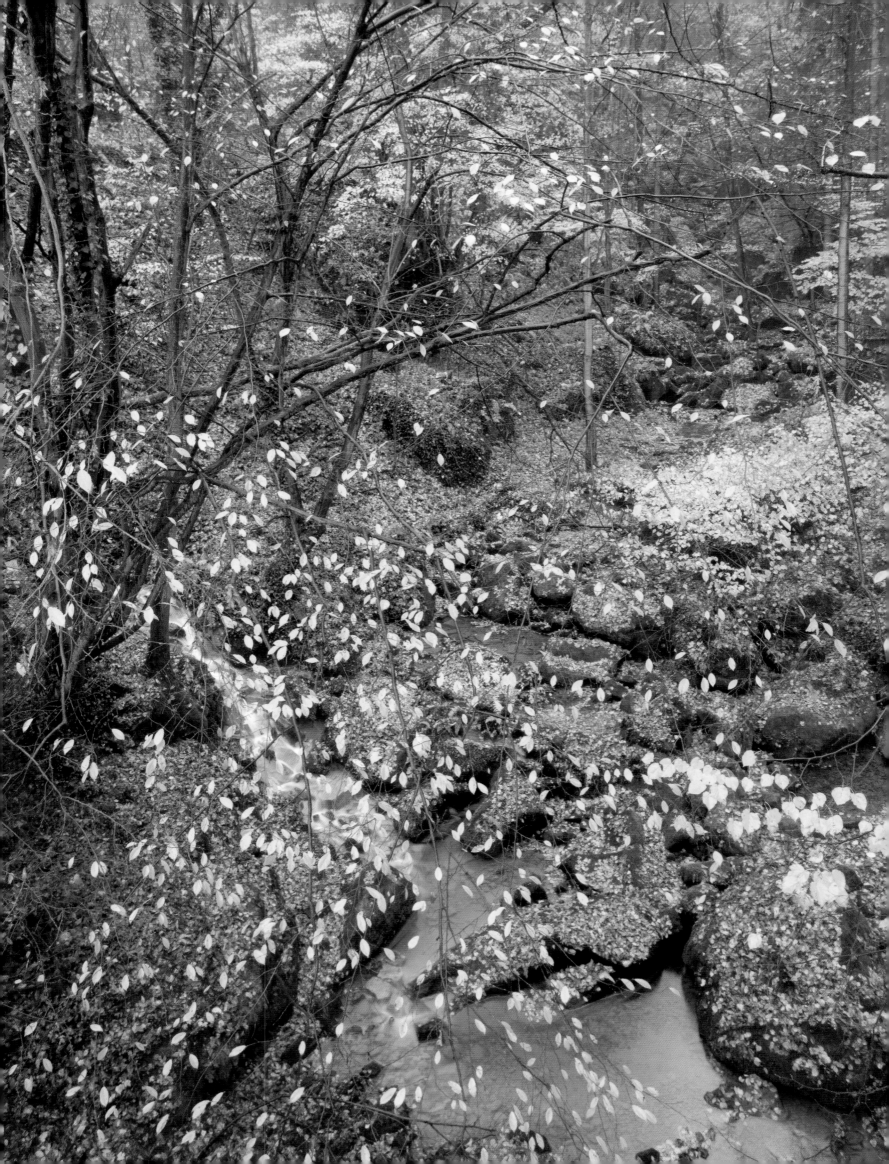

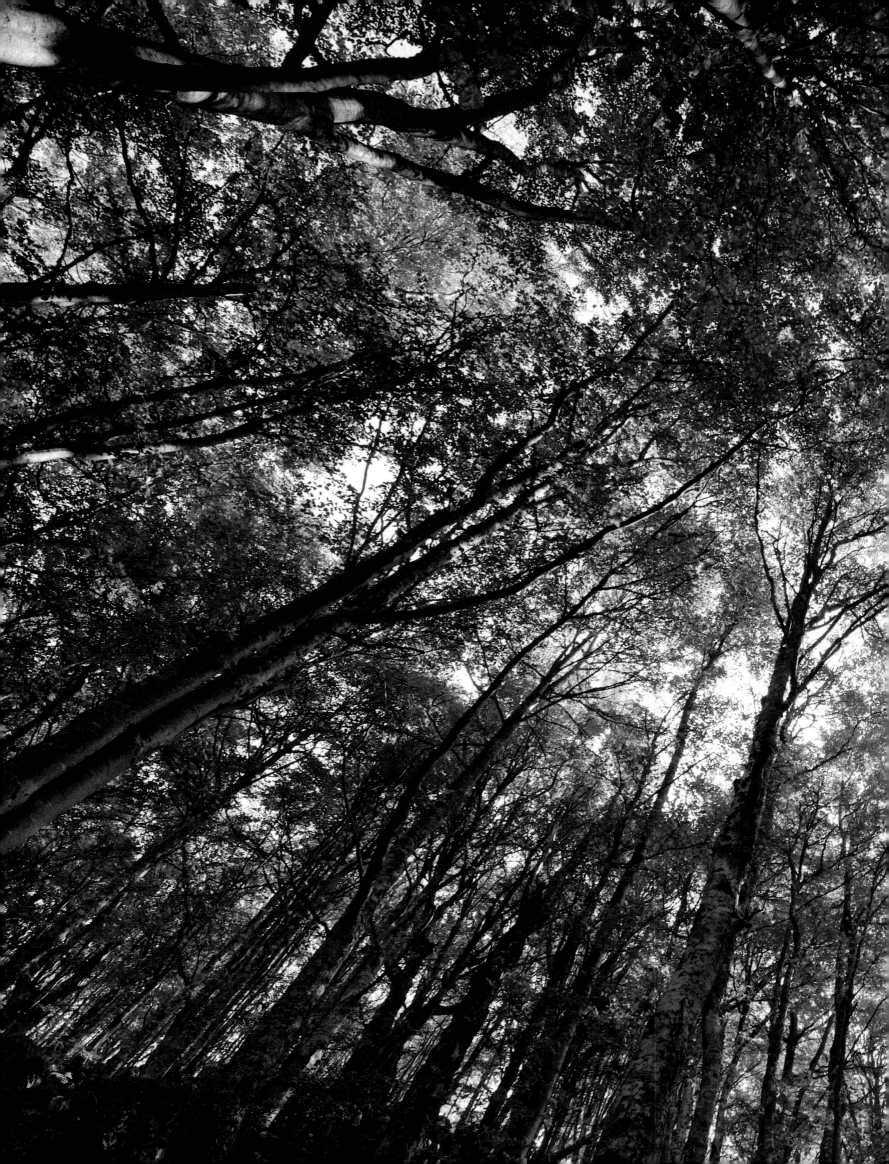

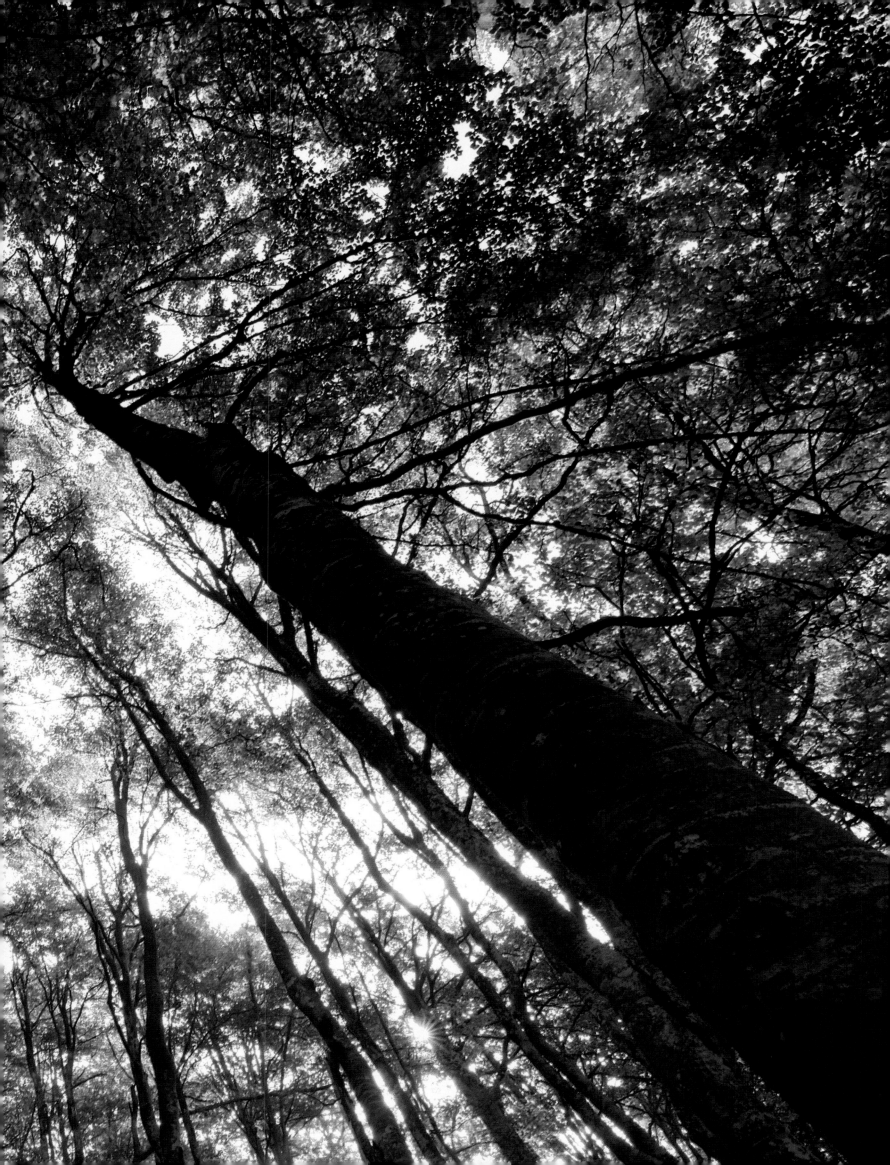

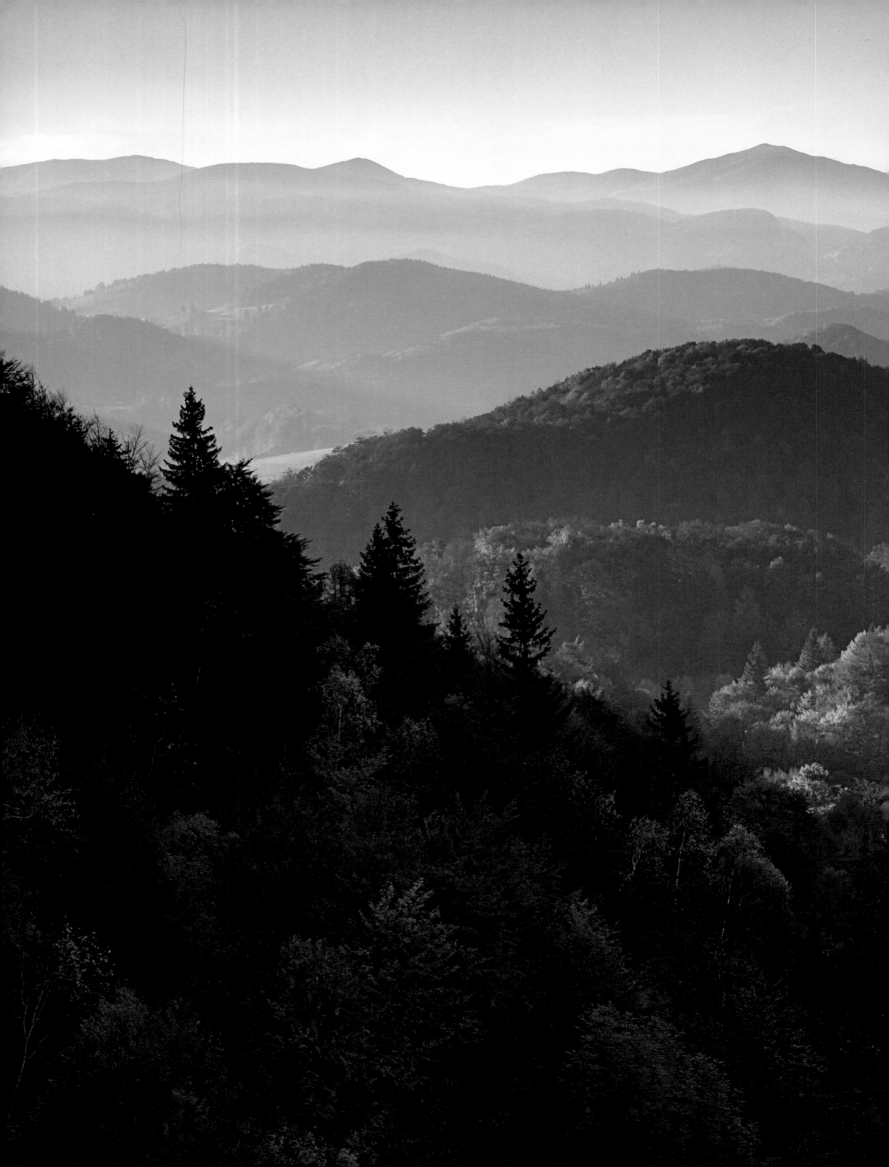

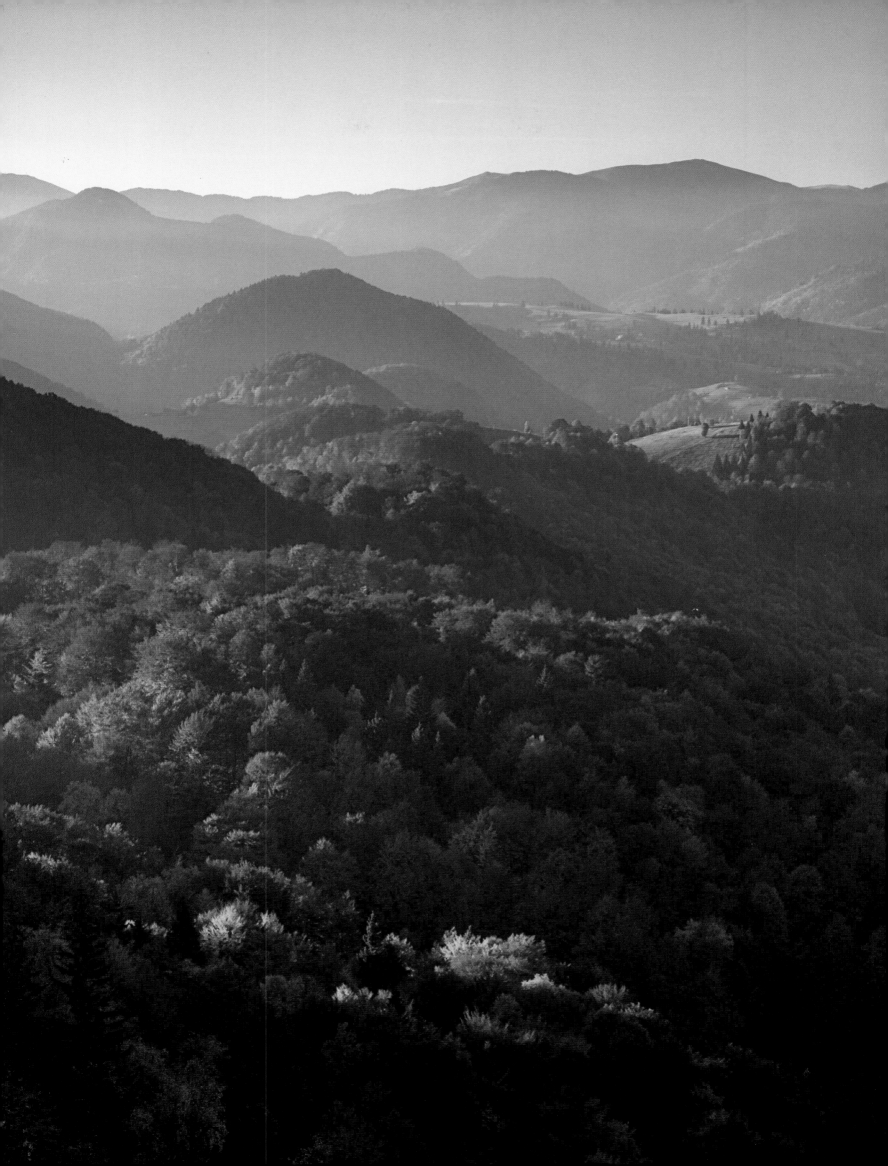

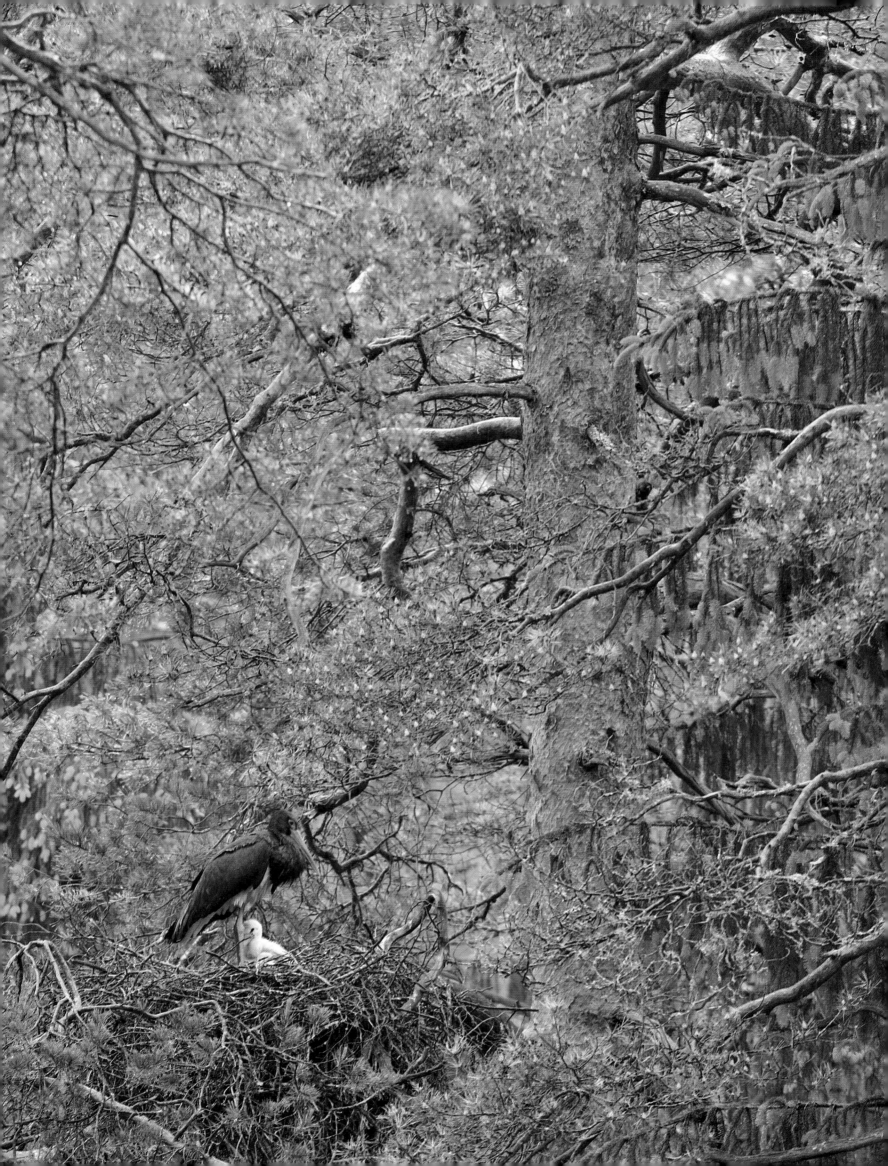

FROM CANOPY TO FOREST FLOOR

The forest is a closed universe, distinctly separate from other ecosystems. The forest canopy forms its upper limit and the ground its lower limit. Its lateral boundaries are more diffuse: The dense forest cover is interrupted by rivers, mountains, ravines, stretches of open water, and man-made ecosystems (fields, pastures, urban areas, and roads). But the forest remains closed because of its dense edges, where trees develop thick foliage along their trunks and branches, and where shrubs and vines flourish.

The canopy is formed by the crowns of the forest's large trees and, occasionally, the tops of its large vines. Joining one another, the crowns create a highly undulated surface, in places broken by gaps several yards wide, depending on the height of the dominant trees. Due to the height of the crowns and the density of the leaves, the forest's large trees absorb more than 80 percent of the red and blue light necessary for photosynthesis. Some of this light is diffused through the leaves or reflected off the vegetation, but generally not enough to trigger the germination of seeds buried in the soil or to stimulate the growth of understory species.

Forming a continuous screen, the canopy protects the plants in the understory from extremes of temperature and ultraviolet rays. The leaf screen also mitigates the movement of wind, wind-borne seeds, and aerial pollutants. An intense biochemical activity in the foliage produces insecticidal and fungicidal substances that protect the understory vegetation from leaf-eating insects and pathogenic fungi. The evolutionary strategy of trees and other long-lived plants is to produce leaves that are not very nourishing or outright toxic, rich in tannins and resins. These characteristics vary according to the time of year and the species in the canopy. Leaf-eating insects such as those of the order Lepidoptera (butterflies) are highly sensitive to variations in the chemical composition of their food. In spring, when the newly formed leaves are high in proteins and low in toxins, the canopy is home to many caterpillars. In autumn, the same leaves are older, tougher, more tannic, and lower in water and protein.

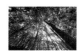

Deciduous forest in autumn

CZECH REPUBLIC | HRENSKO,
CESKE SVYCARSKO
NATIONAL PARK, BOHEMIA

Bright fall foliage and leaf drop at the start of the cold season are major characteristics of deciduous forests. Compared to temperate forests in other parts of the world, notably Asia and North America, Europe's forests are much poorer in plant species. The two main reasons are that European forests are fewer and farther apart, and the mountain ranges run east to west, forming a barrier to species migration during the cold season.

José B. Ruiz

Beech forest in autumn

Fagus sylvatica
ROMANIA | PIATRA CRAIULUI
NATIONAL PARK, SOUTHERN
CARPATHIANS, TRANSYLVANIA

The European beech develops a crown that is relatively open to the passage of direct sunlight, yet it penetrates only about 7 to 10 feet (2 to 3 meters). The understory is lit only by a mosaic of sunspots and shadow. A single adult beech produces up to 100 million cubic feet (3 billion liters) of oxygen and 8,800 lbs. (4,000 kg) of organic matter per year. It also filters 15,000 lbs. (7,000 kg) of dust out of the air and 18,000 gallons (70 cubic meters) of water. All this for free!

Cornelia Dörr

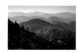

Beech forest in the Carpathians

ROMANIA | PIATRA CRAIULUI
NATIONAL PARK, SOUTHERN
CARPATHIANS, TRANSYLVANIA

Extending over more than seven countries and encompassing more than 1,200 square miles (3,100 square kilometers) of primary forests, the Carpathian Mountains contain a large part of the most ecologically significant forest habitats in Europe. The

Carpathians also host a vast, diverse population of large mammals and birds that have been pushed to the brink of extinction in most other parts of the continent. In May 2011, the ministers of all the nations in the Carpathian Convention signed an agreement to guarantee the long-term management and conservation of this treasure trove of European biodiversity.

Cornelia Dörr

Black stork in a pine forest

Ciconia nigra
LITHUANIA

The black stork (*Ciconia nigra*) is considered an indicator of the high ecological value of the forests of Central Europe. For nesting, this bird prefers mixed broadleaf forests with a high percentage of old trees. In 2009, the black stork population in Europe was estimated at 6,000 to 8,000 pairs. Previously, the species had disappeared from Belgium, Denmark, and Sweden, and populations elsewhere on the continent were in decline until the 1970s. Drastic conservation measures, from the restoration of the stork's habitat to the surveillance of its nests, have turned the tide and allowed the black stork to survive. Today, more than 560 nesting couples have been counted in Germany, and more than 1,000 in Poland and Lithuania.

Diego López

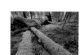

Mossy trunks of dead trees

FINLAND | SUOMUSSALMI, YLI-VUOKKI
OLD FOREST RESERVE, KAINUU

Europe's old forests contain the trunks of many dead trees. As they are slowly incorporated into the soil, a process that can take several decades, these fallen trees serve as a refuge for numerous species—mosses that like the moisture and high acidity of the trunk, fungi and insects that feed on its organic matter, and their predators.

Staffan Widstrand

Forest dung beetle

Geotrupes stercorosus
SLOVAKIA | BEECH FOREST,
OKO MORSKÉ RESERVE,
VIHORLAT MOUNTAINS

This beetle, common in forests, is attracted by the smell of decomposing organic matter (excrement, rotten mushrooms). The adults colonize these substances and then dig galleries in the ground below them where they will store a supply of decomposing matter and lay their eggs.

Konrad Wothe

Red squirrel beside a mature pine

Sciurus vulgaris
GERMANY | IN DEN KISSELN
CEMETERY, BERLIN

The whole universe of the red squirrel, a seed eater, is in trees. Its nest is located in a branch 10 to 30 feet (3 to 9 meters) off the ground, or next to the trunk. Its main predator is the European pine marten (*Martes martes*), which is capable of pursuing it from branch to branch. The red squirrel, which spends 60 to 80 percent of its waking time searching for food or eating, plays an important role in the dispersal of seeds and distribution of trees. The squirrels store excess seeds, fruits, or nuts in caches in the ground. This behavior is typical of squirrels living in mixed-wood or deciduous forests, where food is scarce in winter.

Florian Möllers

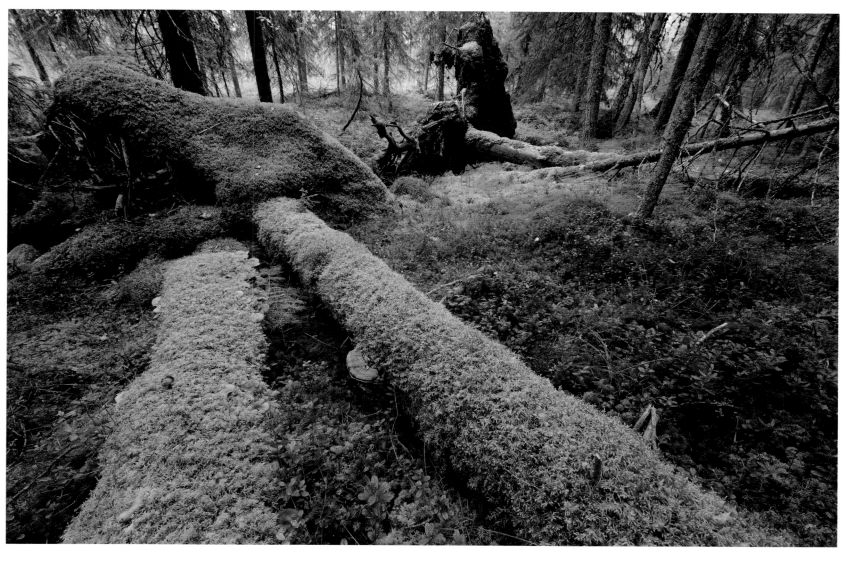
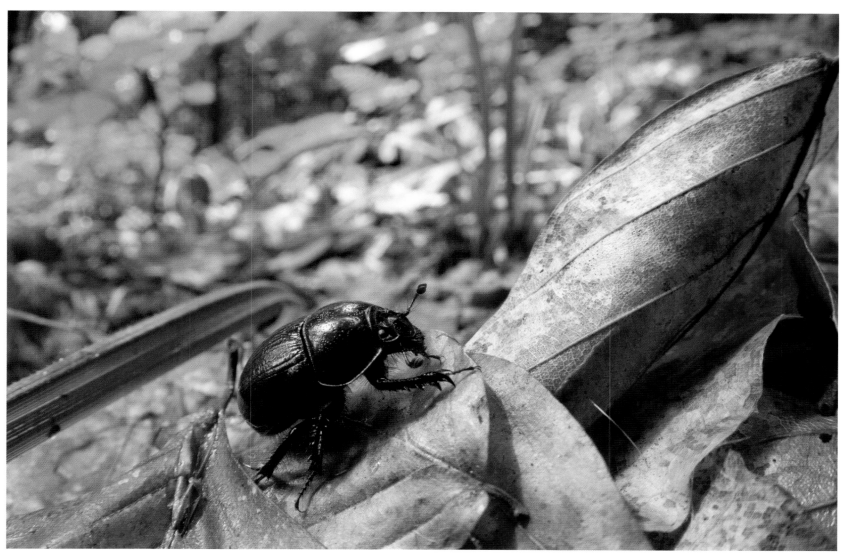

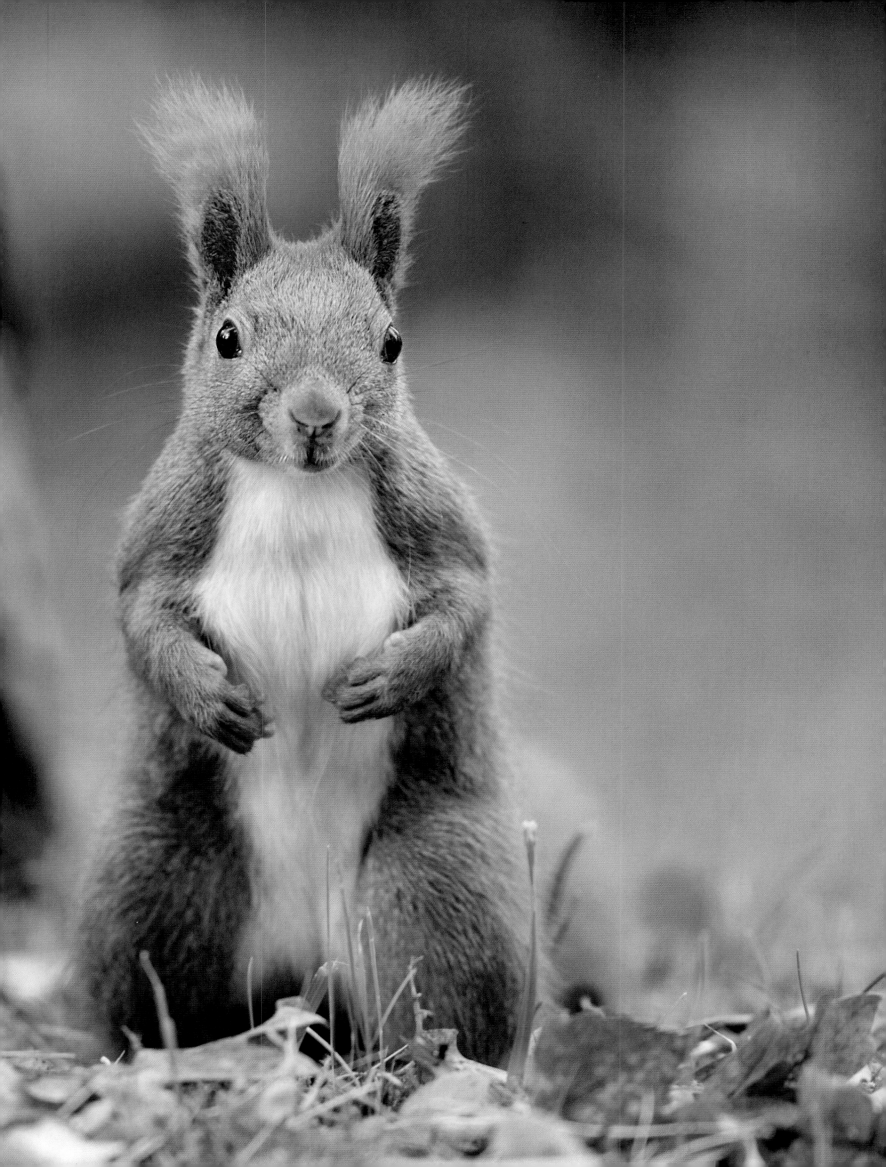

When the **DEFOLIATION** of trees by insects reaches a certain threshold, it can slow the trees' growth. For example, a beech that loses 90 percent of its leaves to the caterpillar of a particular butterfly (*Dasychira pudibunda*) for one or two years running may show a decrease in growth of 7 to 13 percent, while a spruce that loses its needles similarly to the *Lymantria monacha* moth may show a reduction in growth of 50 to 80 percent. On the other hand, the droppings of these insects are very rich in minerals. Large infestations noticeably fertilize the forest soil, stimulating the growth of seedlings and understory vegetation.

The canopy, the understory, and the forest floor also generate a large amount of water vapor thanks to the process of **EVAPO-TRANSPIRATION**. This accounts for the differences in temperature and relative humidity between open ground and forest, which can be considerable in summer.

Canopy trees live a very long time, usually several centuries. Beeches, maples, and pines can live 350 to 450 years, and oaks for 700 years. Yews and olive trees can live to 2,000 years. Some ancient trees grow to impressive size, particularly where the soil is fertile and the climate moderate. In the old-growth forest of Bialowieza in Poland, some trees (elms, ashes, oaks, poplars) reach 8 to 13 feet (2.5 to 4 meters) in diameter. The tallest trees in Europe are conifers: Certain spruces in Romania, Russia, and Poland reach a height of 180 feet (55 meters), and certain pines a height of 190 feet (58 meters).

The forest floor is at the heart of the functioning of terrestrial ecosystems, at the intersection of the mineral and the organic worlds. Its formation depends on the substrate (bedrock), local climate, vegetation, and other living organisms in the soil. It provides nutrients essential for plant growth. But many other organisms, from microorganisms (bacteria, fungi) in the soil to mammals (moles, badgers, foxes), benefit from its resources while continually changing its structure to adjust it according to their needs.

DEFOLIATION
The loss of some or all of the leaves on a tree or bush. "Defoliators" are organisms that feed on leaves.

EVAPOTRANSPIRATION
A term that describes the total amount of water transferred to the Earth's atmosphere by plant transpiration

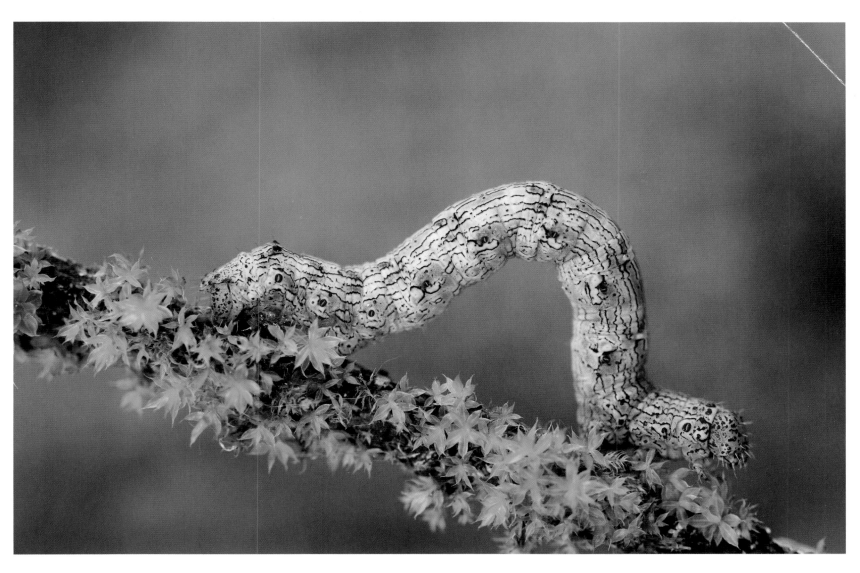

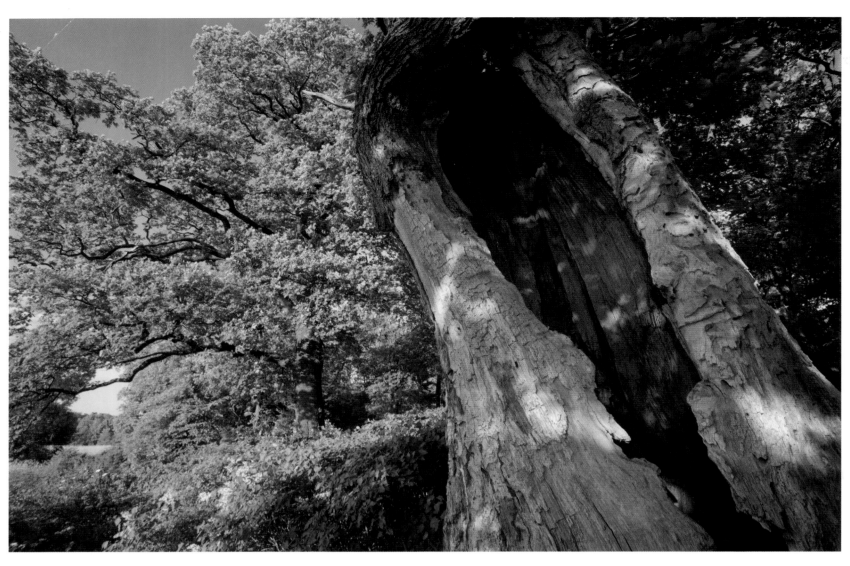
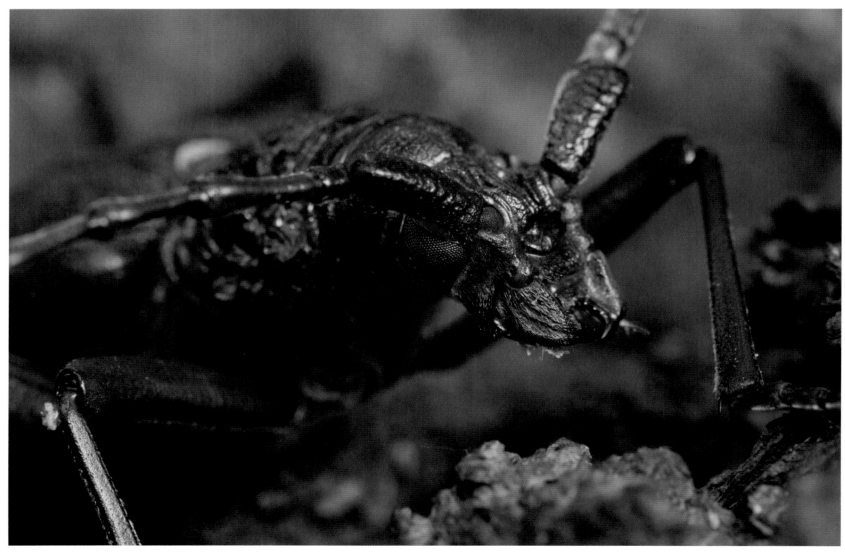

The forest floor recycles dead organic matter from leaf litter, twigs and dead roots, dead bodies, the droppings of animals, and the hyphae (or mycelium) of mushrooms. Recycling occurs through the activity of microorganisms, which aerate the soil. This perpetually transformed organic matter puts minerals and simple organic molecules at the disposal of the whole ecosystem. The ground repeats a process of synthesis (production of humus) and degradation (mineralization of organic matter). This powerful system, just 1 to 8 inches (3 to 20 centimeters) below the surface, is responsible for the fertility of the forest. In temperate regions, it produces several tons of dry matter per hectare per year.

Plants form a symbiotic relationship with certain fungi, their tiny rootlets entering into association with the fine, filamentous HYPHAE of mushrooms to form a mutually beneficial relationship known as mycorrhizae. The fungal MYCELIUM, for their part, provide increased absorptive capacity to the plant's roots, protect them from microbial

soil-borne pathogens and other toxic substances (limestone, aluminum), and supply them with water during periods of drought. In return, the plants share some of the products of photosynthesis (vitamins, growth hormones) with the fungus. The quantity of fungus in the forest's soil can be extremely extensive, sometimes occupying up to a third of the volume of the soil and forming dense interconnecting networks. A network may bring several species of fungus into association with a single species of plant. The association, however, imposes a cost on both partners, as each must give up a portion of its resources to benefit the other. This explains why plants develop mycorrhizal associations only in environments with poor soil.

Invertebrate populations in the soil form another world that is just as complex. By examining the soil in a forest closely, even without a microscope, you will discover an astonishing number of small organisms. These invertebrates consist of the microfauna (such as nematodes, copepods, water bears, and protozoans), small creatures less than a millimeter in size, which compose the largest number of soil organisms after bacteria and whose number is estimated at 405 million individuals per square meter! Their biomass, however, adds up to only 0.5 grams (.02 ounces) of dry weight per square meter.

HUMUS
Top layer of soil, created and maintained by the decomposition of organic matter. The process of decomposition is performed by animal, bacterial, and fungal agents, and its byproducts include nitrogen, phosphorous, and all the other nutrients necessary for plant growth. Humus is a soft and aerated material, dark in color, that absorbs and retains water.

HYPHAE
Long, branching filaments of a fungus that extend through the soil and gather nutrients and moisture. Collectively they are called the mycelium.

MYCELIUM
The vegetative tissue of a fungus, consisting of a network of fine filaments, or hyphae. The mycelium can break down even the most resistant organic materials (such as wood) and absorbs the carbon elements necessary for life. It also plays a role in the ecosystem, allowing mycorrhyzae or symbiotic associations between plants and fungi. These increase the ability of many plants and trees to absorb water and nutrients.

35

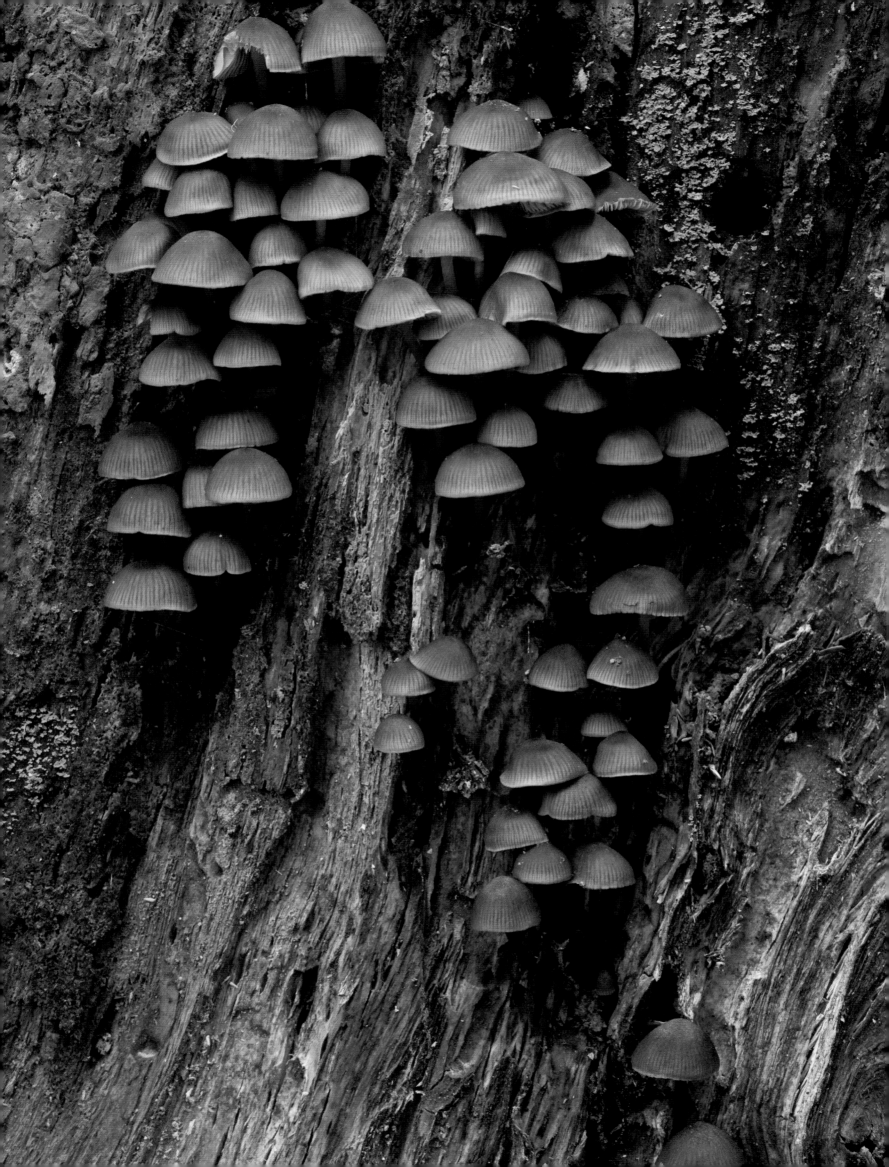

Hollow oak trunk
Quercus robur
GERMANY |
PFAUENINSEL, BERLIN

The city parks that leave their trees live to a ripe old age are rich in insects whose life cycle depends on the decaying wood, and have become rare or endangered. It is therefore desirable that the example of Berlin is followed in Europe.

Florian Möller

Great capricorn beetle
Cerambyx cerdo
GERMANY | GRUNEWALD FOREST, BERLIN

Measuring up to 3 inches (8 cm) in length, the great capricorn beetle is one of Europe's most endangered insects. Its existence is dependent on decaying wood and which thrive in the conditions provided by the deadwood of large deciduous trees, preferably old oaks. The larvae mature between the bark and the sapwood and then burrow into the sapwood. Their metamorphosis occurs very near the surface, and the adult emerges in June or July, remaining hidden during the day. Because of Europe's strong horticultural tradition, its city parks have many old trees that (like this one on Berlin's Pfaueninsel) provide havens for *Cerambyx cerdo* and several other species whose life cycles are highly dependent on rotting wood.

Florian Möllers

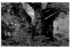

Beech tree: a natural monument
Fagus sylvatica
ROMANIA | PIATRA CRAIULUI NATIONAL PARK, SOUTHERN CARPATHIANS, TRANSYLVANIA

A relatively sparse forest allows beech trees to develop large crowns and massive trunks, particularly as the trees grow to an advanced age.

Cornelia Dörr

Mushrooms
MONTENEGRO | NEAR LAKE ZMINJE, DURMITOR NATIONAL PARK

Fungi play a crucial role in the life of the forest, performing a variety of functions. They decompose deadwood and organic matter in the litter on the forest floor, form symbiotic associations with plants, and keep other forest organisms in check through parasitism. Fungi are generally only visible when they fruit. This dead tree, riddled with mycelia from many fungi, will display the fruiting bodies of *Mycena haematopus* for only a few days. After dispersing their spores, they will disappear.

Milán Radisics

↓
A glade in the forest: light and diversity
SLOVENIA | ALONG THE LEPENJICA RIVER, LEPENA VALLEY, TRIGLAV NATIONAL PARK

Climatic disturbances and the natural aging of trees open the way to woody species normally suppressed by the absence of direct light in the understory, seedlings often related to the canopy trees. Other species (ferns, herbaceous plants) colonize the ground layer. The creviced trunks of dead and dying beeches host a particular array of mosses and lichens, which do not grow on the trunks of younger trees. Many woodpeckers inspect the aging bark and the larva-filled galleries beneath it.

Daniel Zupanc

Ferns
LATVIA | MORICSALA ISLAND STRICT NATURAL RESERVE, LAKE USMA

The ferns that carpet the floor of this Latvian forest reflect very moist understory conditions due to the influence on the climate of the nearby ocean and the closed canopy structure of this well-preserved forest.

Diego López

↑
Moth caterpillar
SLOVENIA | TRIGLAV NATIONAL PARK

The caterpillars of geometer moths (family Geometridae) are all leaf eaters. They advance by forming a loop and extending their bodies. Most of the geometrids are exceedingly well camouflaged at every stage of their lives, from larva to adult: By assuming the coloration and patterning of leaves, twigs, moss, or bark, they employ a defensive strategy known as "mimicry."

Daniel Zupanc

Hart's-tongue fern
Asplenium scolopendrium
SAN MARINO

The long fronds of this elegant fern are undivided, unlike the fronds of most other ferns. Highly prized as an ornamental for its beautiful and unusual architecture, the hart's-tongue fern prefers a moist, shady environment in forests with calcareous soil.

Florian Möllers

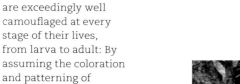

Slightly more voluminous are the mesofauna, consisting of creatures, such as annelids, enchytraeids, and micro-arthropods, measuring from 1 to 3 millimeters (.04 to .12 inches), and numbering 550,000 per square meter for a biomass of 1.5 grams (.05 ounces) of dry weight per square meter. These numbers vary widely according to the quality of the topsoil and the season of the year. The mesofauna also decline in number in dark parts of the forest and where the humus is rich in organic matter.

The macrofauna (earthworms, arachnids, myriapods, crustaceans, mollusks, insects) are creatures larger than 3 millimeters (.12 inches) in size. Their numbers on the forest floor are estimated at a few thousand per square meter, for a biomass of about 7 grams of dry weight per square meter. Earthworms can be present in numbers up to several hundred per square meter (from 73 to 360 individuals, depending on the fertility of the soil).

The diet of these invertebrates ranges widely. Some attach to roots, while others graze on microflora, prey on other invertebrates, or feed on bacteria or fungal hyphae. Eighty percent of the forest's organic waste (leaf litter, dead wood, decaying roots, animal and microbial bodies) passes through their digestive systems.

Invertebrates thus perform many functions in the forest soil: They regulate the vegetative growth of the canopy by their consumption of leaves and benefit or injure plants by their choice of foods. Their mineral-rich droppings contribute to the recirculation of minerals in the forest. Invertebrates thereby stimulate the activity of scavenging microorganisms and decomposers. These functions are in turn regulated by the invertebrates' predators and parasites.

These are real engineers: In optimal conditions, approximately 400 tons of soil per hectare per year pass through the digestive tracts of earthworms! Those who live in the organic matter of the upper soil perpetually fragment the soil on which they feed. Their droppings constantly rearrange the soil structure and soil-water dynamics and stimulate microbial activity. The cycles of matter are also affected by external contributions from rainfall, dust deposition, and the circulation of water.

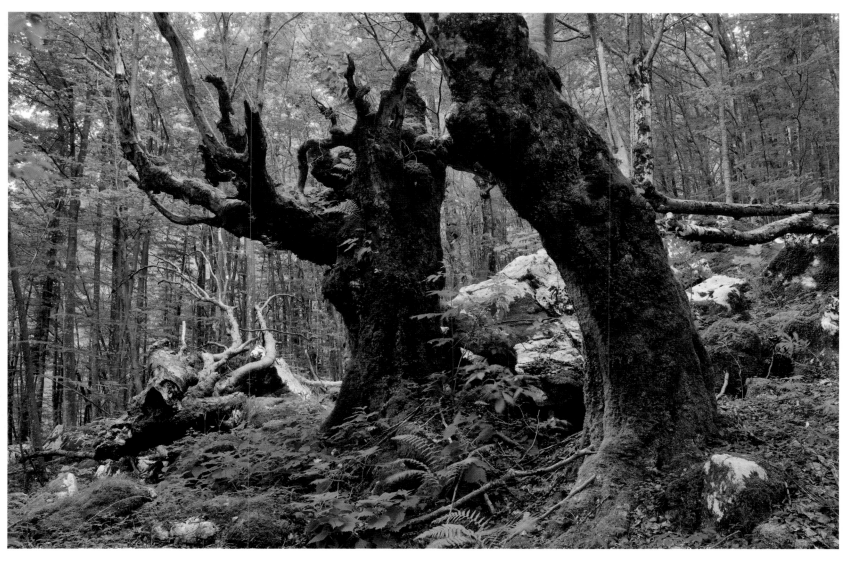

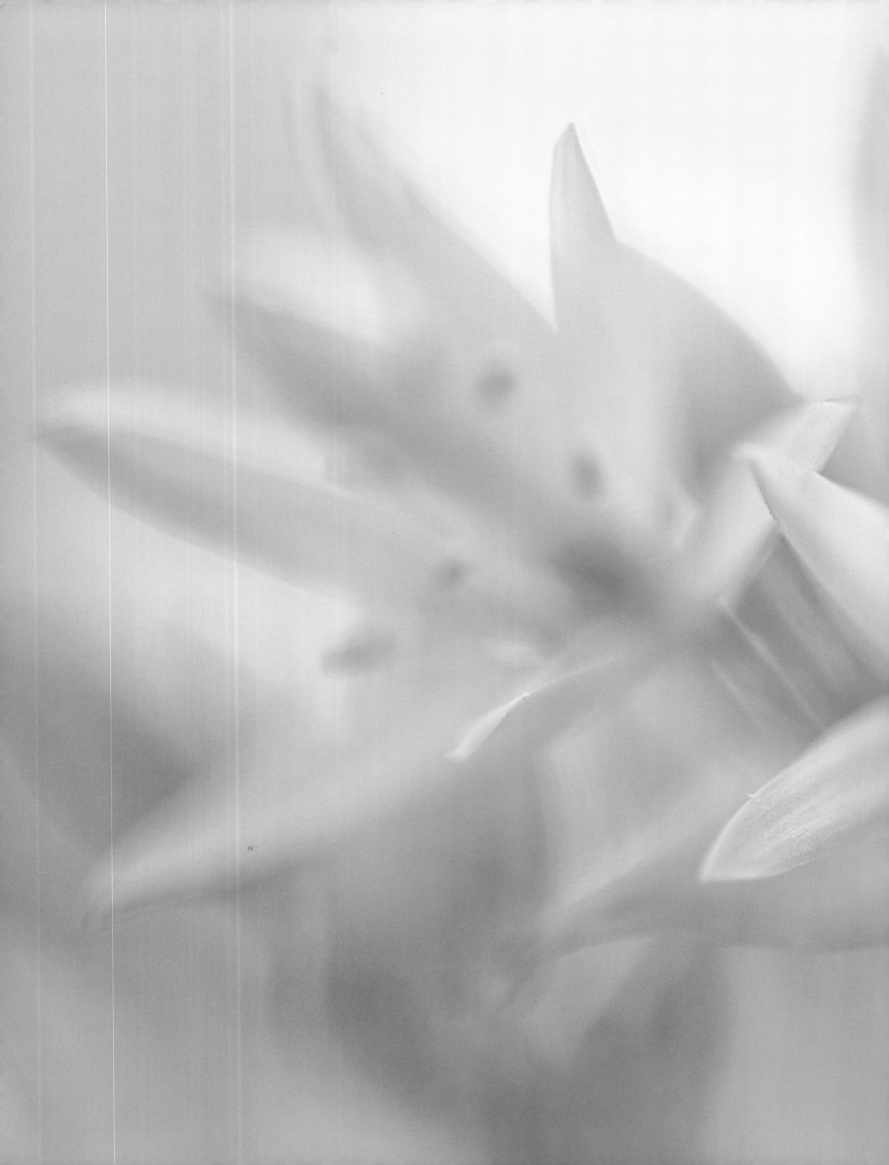

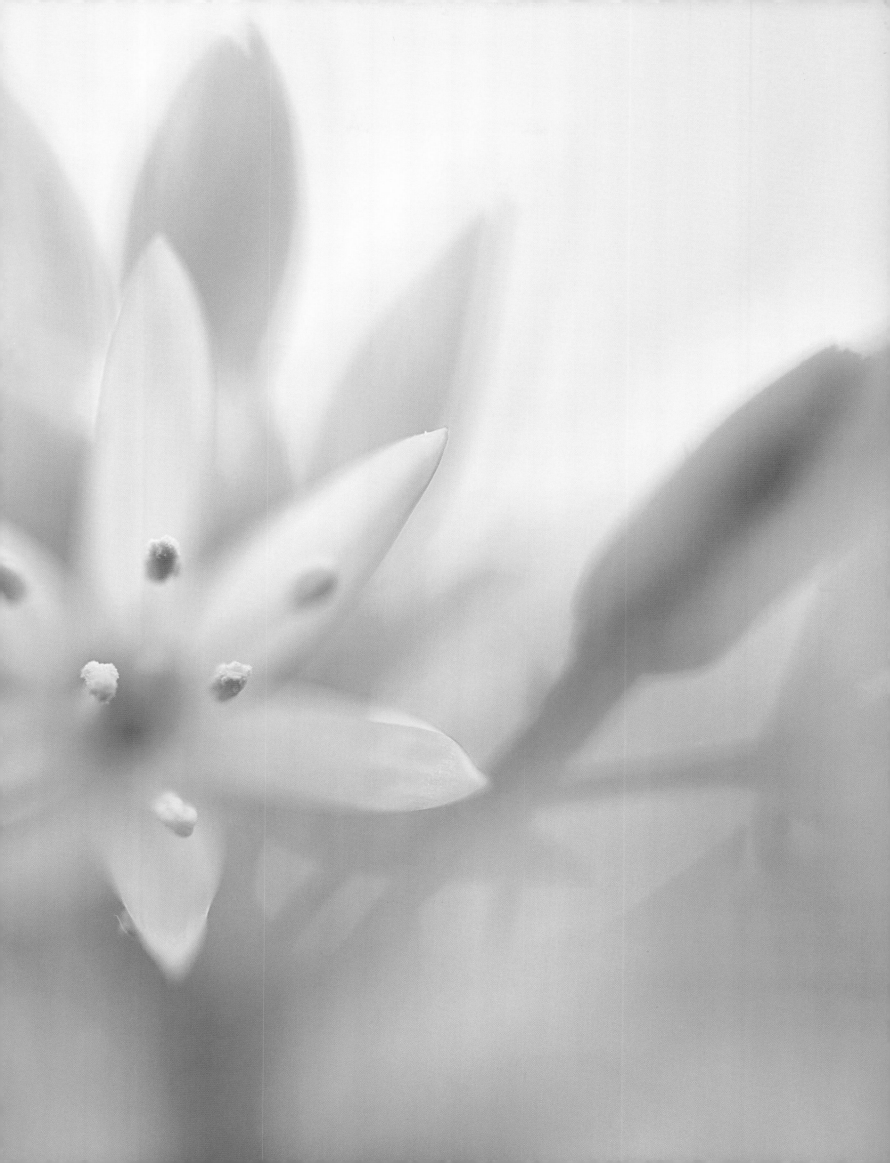

↑
Flower of a ramp blossom
Allium ursinum
BELGIUM | HALLERBOS, FLEMISH BRABANT

Biological activity in the forest starts up again in spring. In deciduous forests, herbaceous plants with bulbs or rhizomes, like this ramp, or bear's garlic, are quick to take advantage of the warmer temperatures in March and April and the strong sunlight on the forest floor before leafout. To walk in a forest strewn with ramps is a heady experience: Their aroma is overpowering, almost intoxicating. The young leaves of ramps make a wonderful salad or pesto. The plant has been used for thousands of years to treat high blood pressure and arteriosclerosis.

Maurizio Biancarelli

↓
Cortinarius with a feather
CZECH REPUBLIC | BRTNICKY HRADEK, CESKE SVYCARSKO NATIONAL PARK, BOHEMIA

The discreet beauty of this cortinarius emerging from a mat of sphagnum, here with a downy feather resting against it, often goes unnoticed.

José B. Ruiz

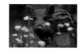

Wild boar
Sus scrofa
GERMANY | BOHMTE, LOWER SAXONY

Originally from the swamp forests of Southeast Asia, the wild boar population spread rapidly across Europe at the end of the last ice age. Powerful, prolific, and omnivorous, endowed with a keen sense of smell and an elaborate social system, the boar may well be the most successful wild mammal of our time. In Central Europe, where corn is grown on a vast scale (partly to supply a mounting network of biofuel plants), the wild boar population has increased by several hundred percent since the 1980s.

Florian Möllers

Deadwood across a mountain stream
SLOVAKIA, KOPROVA VALLEY, TICHÁ, WESTERN TATRAS

Deadwood is a basic element in the life of a river, yet it is lacking in most watercourses in Europe. It provides shade, shelter, and food to aquatic invertebrates and fish. In natural forests, deadwood can occupy considerable portions of the streambed, sometimes creating swamps or diverting the water into new channels.

Bruno D'Amicis

Brown bear climbing the broken trunk of an evergreen
Ursus arctos
POLAND | BIESZCZADY NATIONAL PARK, CARPATHIANS

Bears often climb the trunks of dead trees looking for bees' nests, which they raid for honey. They also forage on decayed wood looking for carpenter ants. This powerful animal has been hunted mercilessly since the dawn of man. In Poland, the bear was eliminated from the western and central parts of the country by the end of the eighteenth century. Today, there are 55 to 70 bears in Bieszczady National Park, and about 400 total in all of Poland.

Grzegorz Lesniewski

White-backed woodpecker
Dendrocopos leucotos
POLAND | TARNAWA, BIESZCZADY, CARPATHIANS

The white-backed woodpecker almost invariably chooses to nest in forests composed mainly of deciduous trees (oak, alder, and hornbeam, among others), selecting trees that are either starting to die or standing snags. This preference for old trees explains why the species is very rare in Europe's managed forests: In Poland, 8.4 percent of nesting couples have been counted per 40 square miles (100 square km) of natural forest, as compared to 3 percent in managed forests. Because of its ecological requirements, the white-backed woodpecker is considered emblematic of Europe's primary forests.

Grzegorz Lesniewski

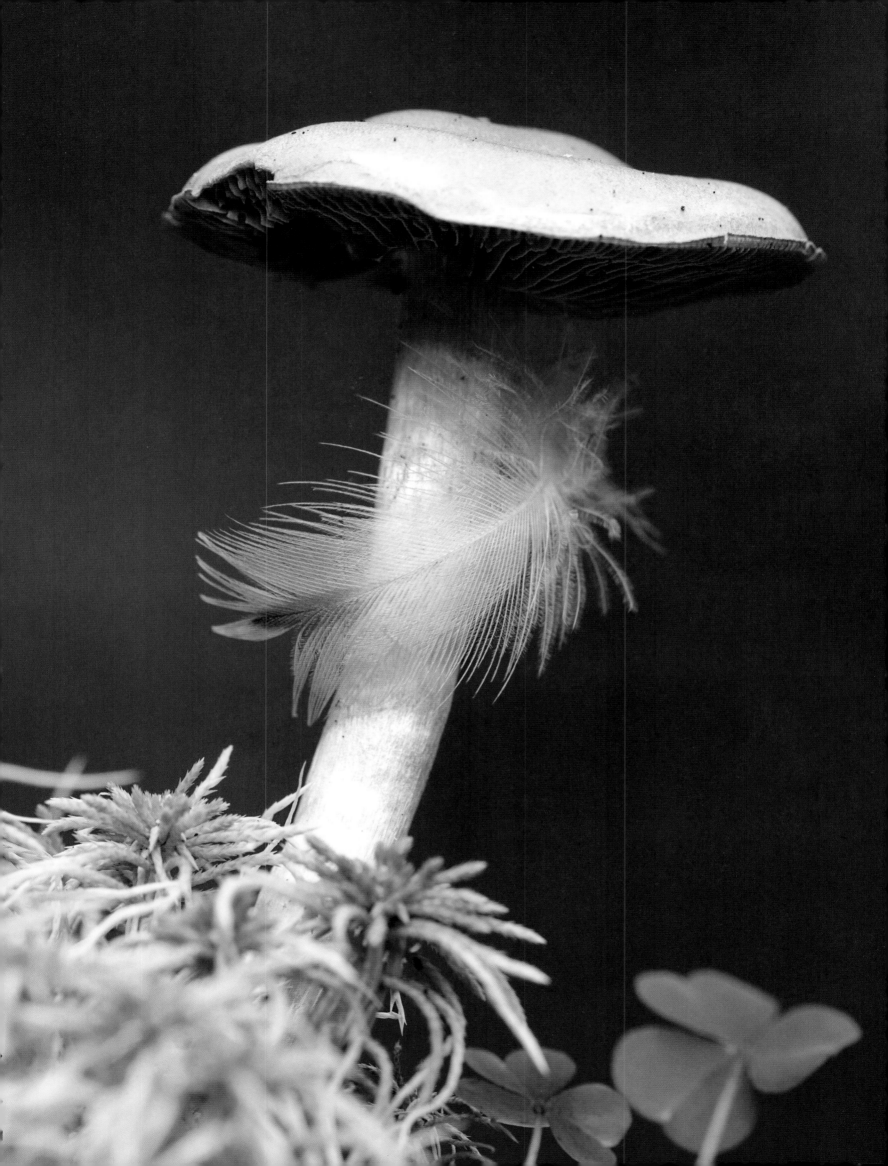

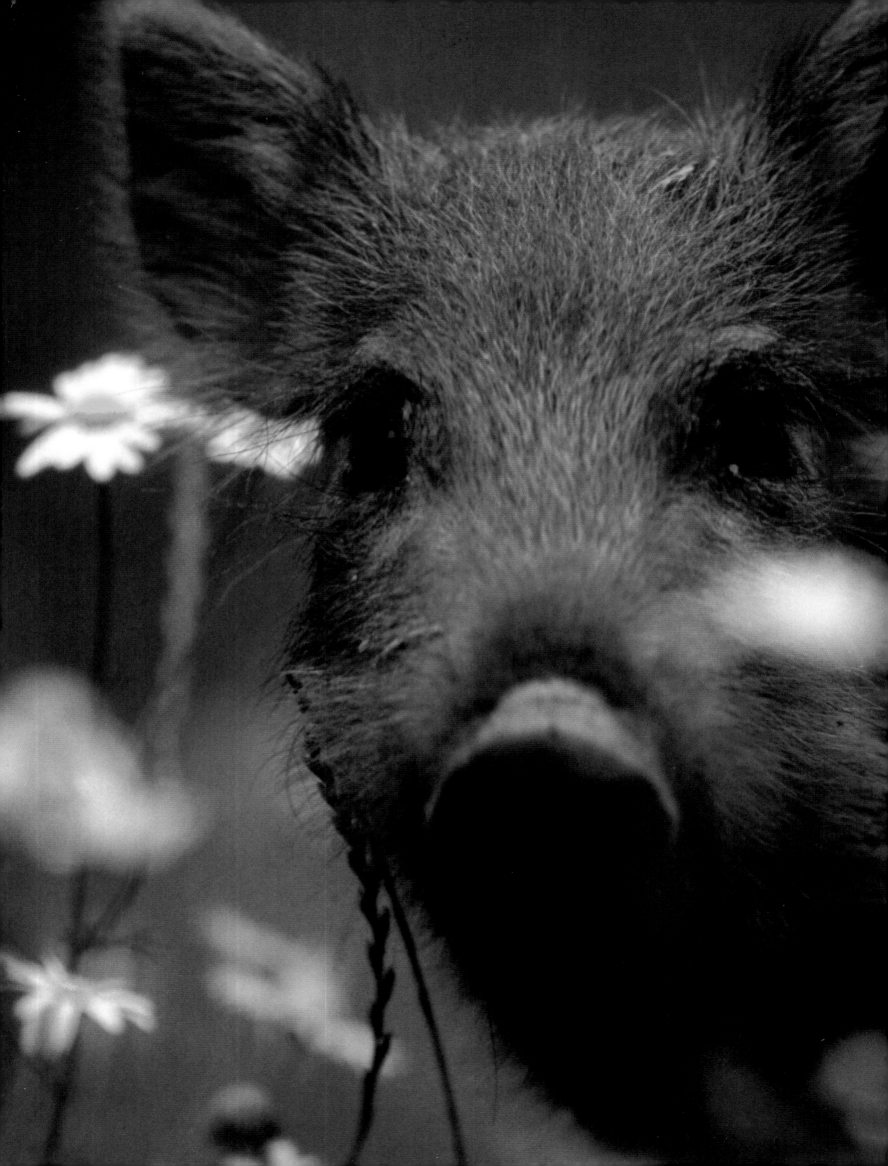

LIFE CYCLES IN THE FOREST

A REPEATING BUT HIGHLY RANDOM EVENT FUELS THE LIFE CYCLE OF FORESTS: THE SUDDEN APPEARANCE OF A GAP OR OPENING IN THE CANOPY. THE opening might be caused by one or more trees falling after a storm (windthrow), or by the slow death of a tree due to old age (senescence), in which case the tree gradually loses its foliage and its branches. When the gap occurs, the local microclimate is altered and a new, youthful phase in the cycle begins. Direct sunlight reaches the ground with its full complement of red and blue rays, stimulating the store of seeds buried in the soil and promoting the growth of the understory's seedlings, herbaceous plants, vines, and shrubs, allowing them to reproduce. Among the plants that only reproduce in forest gaps are hawthorn (*Crataegus monogyna*), euonymus or spindle-tree (*Euonymus europaeus*), and blackberry (*Rubus fructiosus*) in temperate forests, and bilberry (*Vaccinium myrtillus*) in boreal forests (for a discussion of the difference between temperate and boreal forests see pages 120–156). Their flowers and fruit attract large numbers of plant feeders from among the mammals, birds, and insects. The pollinating and browsing insects come buzzing into the opening, which also attract small rodents, ants, and seed-eating birds. In their wake come predators—birds of prey as well as mammals.

The openings made by the fall of canopy trees do not last long, particularly where the soil is rich and the climate hot. In a few years, the shady conditions reappear, and the former climate is reestablished; the opening has closed. The trees that have colonized the opening in the canopy will grow old and collapse a few centuries later, and the cycle will begin again. The cycle passes through four stages, common to all life on Earth: youth (appearance of the opening), adolescence (trees take over the clearing), maturity (canopy trees reach full growth), and finally, after a slow **SENESCENCE**, the collapse of the tree and the reappearance of the gap.

DEAD WOOD: A FOREST TREASURE

Natural forests, meaning those which are not harvested for timber, accumulate a great quantity of dead wood, between 25 and 100 cubic yards per acre (50 and 200 cubic meters per hectare), most of it from the fall of canopy trees, but also from smaller trees that died in the struggle with their rivals for a place in the canopy. This dead wood represents a large reservoir of organic matter, whose constituent elements will only be restored to the ecosystem gradually, particularly if the climate is cold or dry, the soil acidic, or the tree species chemically resistant to decay. Dead wood also accumulates and retains water as it decomposes. The dead wood of stumps and roots promotes the penetration of water deep into the soil, and the network of dead roots provides a prime path for the development of living roots, which benefit directly from the stored water.

SENESCENCE
Biological process of aging in an organism, resulting in death

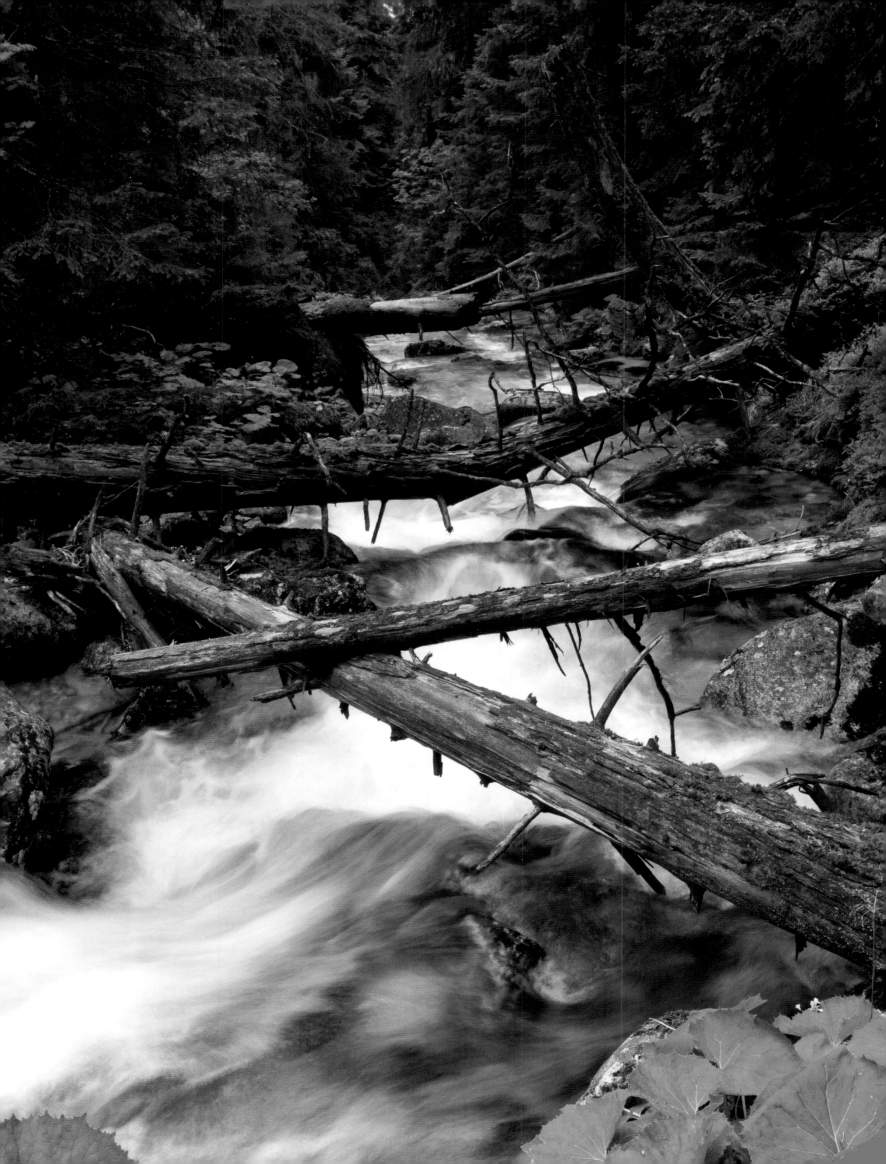

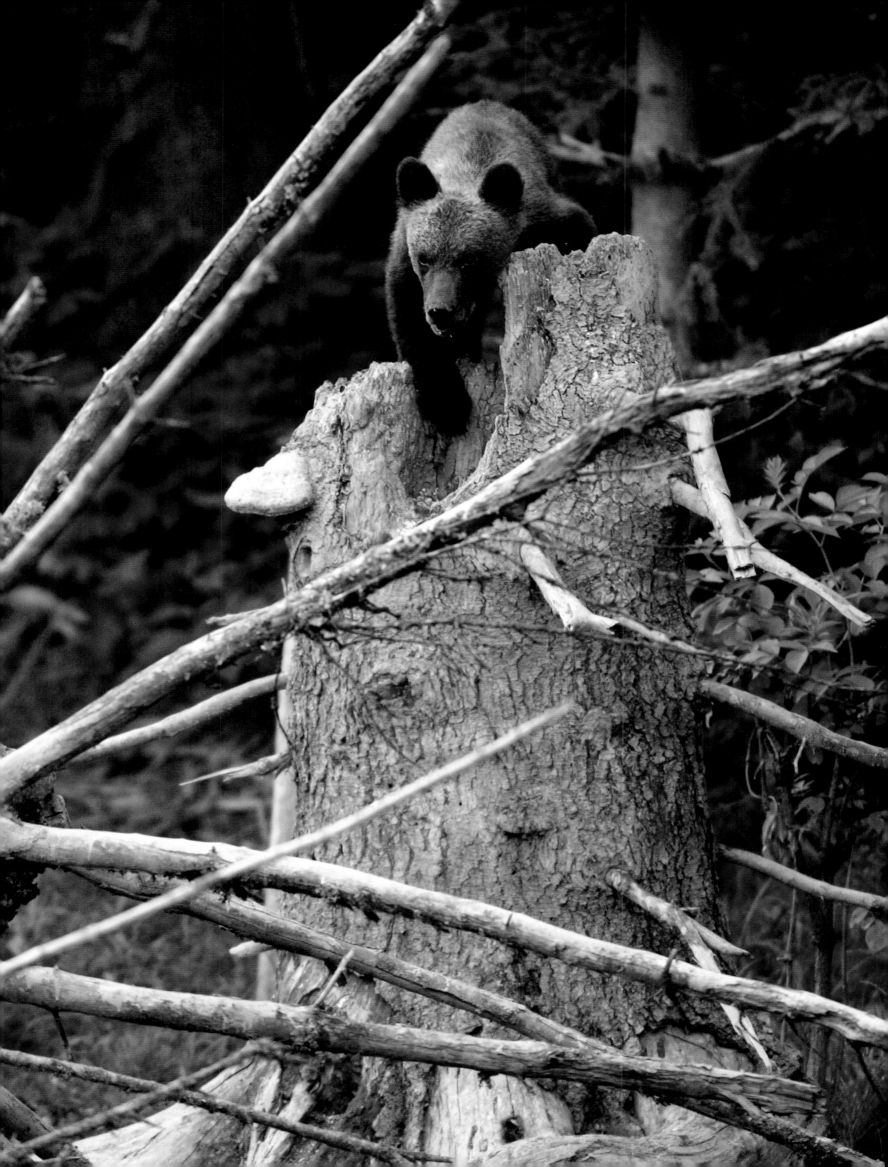

Aging trees and dead wood create a wide diversity of habitats, which are exploited by different species of a biodiverse forest: plant EPIPHYTES (mosses, ferns), cavity-dwelling creatures, and animals that feed on old or dead wood. The array of organisms that exploit decaying wood has been intensively studied in Europe, both in old-growth forests and in forests that have sprung up after sylvicultural practices were abandoned. A startling assortment of life-forms congregate around dead wood. Many highly specialized organisms join in decomposing it, using it as a food source, a shelter, or a place to reproduce. Among the species specialized to exploit decaying wood are fungi, SLIME MOLDS, invertebrates, and vertebrates, but the most important are the fungi and the invertebrates. Thus 394 species of fungi associated with decaying wood, so-called SAPROXYLIC fungi, have been found in the forest of Fontainebleau near Paris, France, which is rich in decaying wood. Fungal mycelia invade nearly 30 percent of tree trunks, digesting the solid cell walls of CELLULOSE and lignin that are the major constituents of wood. Certain wood-inhabiting mushrooms such as the oyster mushroom (*Pleurotus ostreatus*) complement their diet by trapping nematodes that live in decaying wood. To do this, they have developed special snare-shaped hyphae that capture and digest the nematodes. Other fungi hunt the nematodes with paralyzing toxins. Slime molds use decaying wood by feeding on the mycelial debris, fungal fruits, and bacteria that they find there. Of the 44 known species of slime molds, 38 can be found in the decaying wood of the forest of Bialowieza. There are also protozoans that feed on wood or on the wood-decay substances left in the waste of insects and fungi.

Insects and invertebrates also play an important role in wood decay. The saproxylic insects fall into three major orders: the Coleoptera or beetles, such as the great capricorn beetle (*Cerambyx cerdo*); Diptera or two-winged flies; and the Hymenoptera, which include the black and red ants. Thirteen hundred species of beetles are estimated to feed on or otherwise exploit rotten wood in Europe. Some of these insects only attack wood that is free of fungal infection, while others actually depend on the prior activity of wood-inhabiting fungi. Some live in cavities in the trunks and branches of large hardwood trees. The cavities provide an unusually stable habitat for these organisms, which show little tolerance for long journeys or migrations.

The saproxylic invertebrates all have very exacting requirements for habitat, which allows many species to be present simultaneously without interference. It is also true that the diets of the larvae and the adults are different: The adults are plant-eating, but the larvae feed on rotting wood, which they ingest thanks to a symbiotic relationship with bacteria, fungi, and protozoans capable of digesting the wood directly. Certain beetle larvae, the great capricorn beetle for instance, have symbiotic organisms of this kind in their gut that produce wood-decaying enzymes.

EPIPHYTE
A plant that uses other plants for support and generally has aerial roots. Epiphytes are not parasites, as they do not obtain nutrients from their host. Epiphytes absorb moisture from the air and obtain minerals in part from the humus that accumulates at the base of branches and in part from the gasses and particulates absorbed with rainwater and dew.

SLIME MOLDS
Formerly classified as fungi, these organisms are now grouped with the protists. Slime molds feed on bacteria and fungi and are found in moist environments on decaying plant material.

SAPROXYLIC
Describes an organism whose life cycle depends wholly or partly dead wood.

CELLULOSE
A polysaccharide consisting of a linear chain of linked D-glucose molecules (between 200 and 14,000). It is the main constituent of plants, providing the structure of their cell walls.

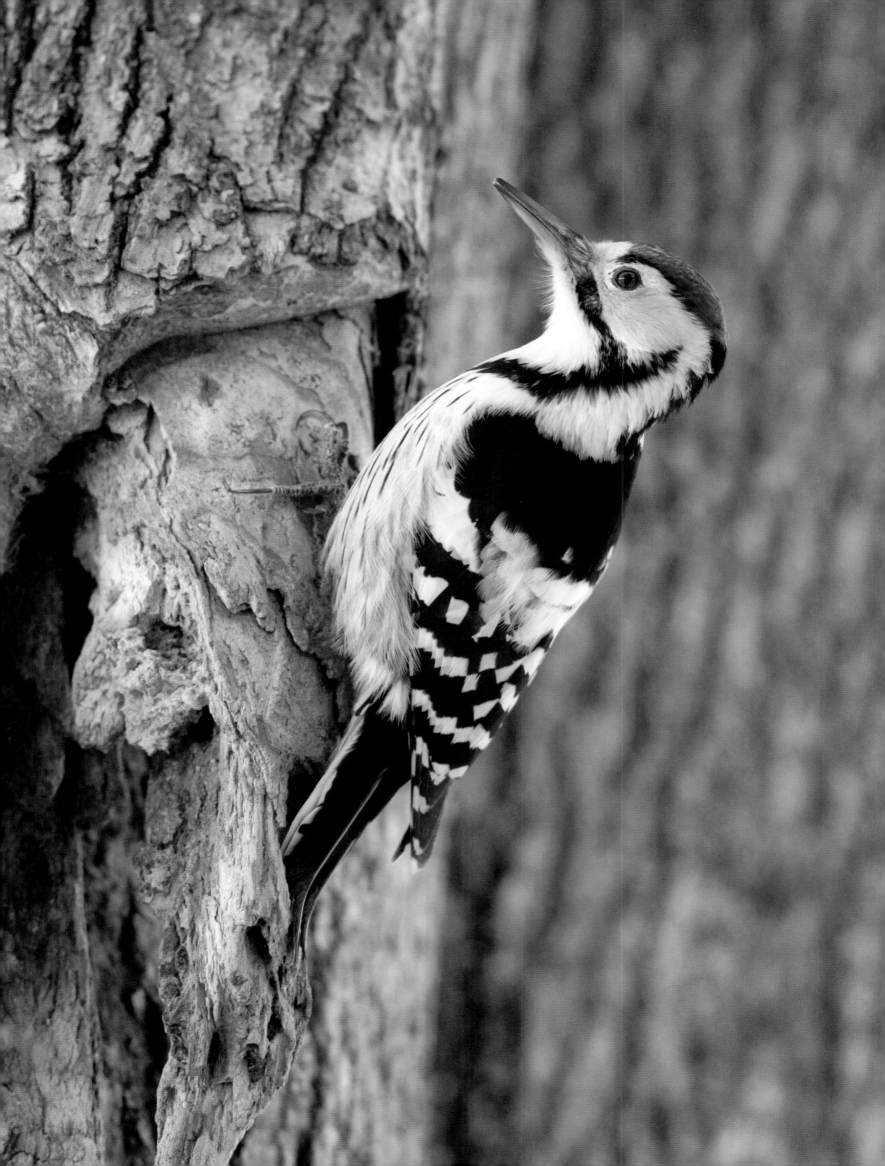

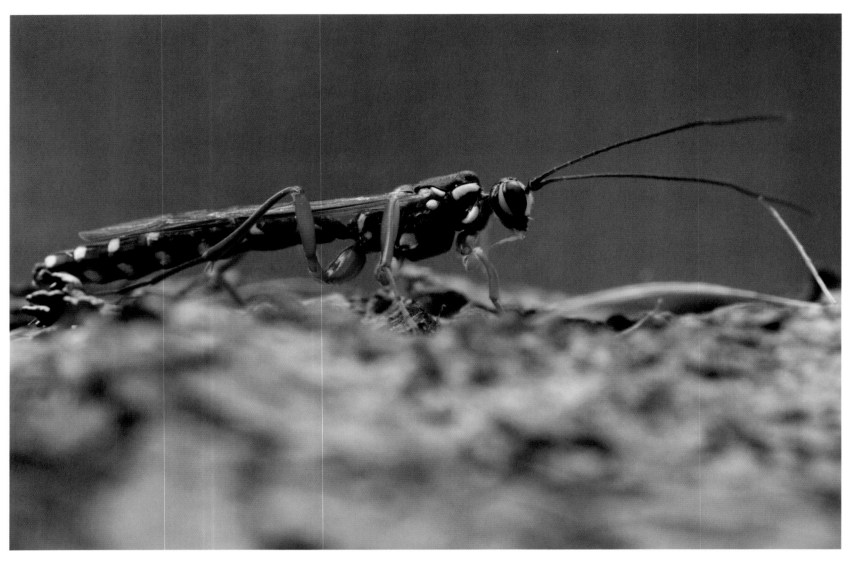

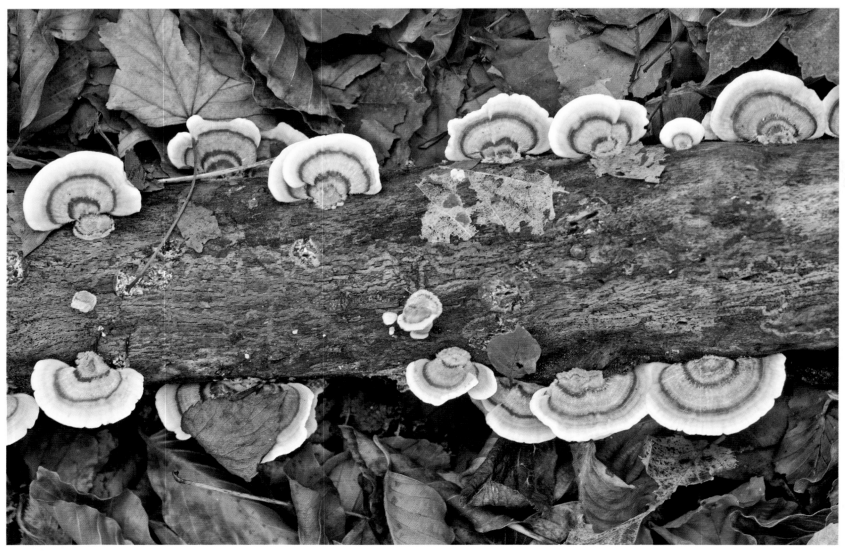

Many other species take advantage of natural cavities, including birds, mammals, reptiles, and amphibians. In the old-growth forest of Bialowieza, 44 species of birds are classified as cavicolous, or cavity-seeking. So numerous are the natural cavities in that forest—unlike in managed forests—that not all of them are occupied, or they are occupied for several years and then abandoned for several more. Not all cavities are alike. Woodpeckers move to a new nest cavity every year, seeking out nesting cavities in decaying rather than living wood, probably because the microclimate is better there. Certain species of woodpeckers also depend entirely on large decaying trunks for food, among them the white-backed woodpecker (*Dendrocopos leucotos*) and the three-toed woodpecker (*Picoides tridactylus*). Not surprisingly, woodpeckers are rarer in managed forests, where dead wood is scarce, while their population rises as forests are left unmanaged and the number of large and aging trees increases. These two woodpecker species, which are particularly dependent on large, mature forests with many dead trunks, are therefore threatened with extinction all over Europe.

Cavities are also used by other birds that, unlike the woodpecker, are unable to excavate cavities themselves: the jackdaw (*Corvus monedula*), the stock dove (*Columba oenas*), the flycatchers (genus *Muscicapa*), the old-world tits (genus *Parus*), many nocturnal raptors, the Eurasian nuthatch (*Sitta europea*), and the short-toed tree-creeper (*Certhia brachydactyla*).

Mammals use cavities as well, including all 11 species of bats identified in Bialowieza. One is the common noctule (*Nyctalus noctula*), which roosts inside tree trunks in closely packed groups of several hundred individuals. The greater noctule (*Nyctalus lasiopterus*), the lesser noctule (*Nyctalus leisleri*), and the barbastelle (*Barbastella barbastellus*) all rest in cavities during the summer and throughout the winter. Some rodents nest in rotting stumps, among them the bank vole (*Myodes glareolus*), whose range extends throughout Europe. Larger mammals use decaying wood in a variety of ways, either for the food it harbors or the shelter it provides: Bear and bison seek out the honey or fungi it may contain, boar and members of the rodent family feed on its invertebrates, and some of the Mustelids (weasel family) mate there.

The water retained in rotting wood attracts amphibians, which find both shelter and food in this water. The fire salamander (*Salamandra salamandra*) requires dead and rotting trunks to survive, and it is thought that the population of all species of ground-dwelling salamanders depends on the quantity of dead wood in a forest. Reptiles find decaying wood useful in regulating their temperature. It provides them a common winter shelter as well as a source of invertebrates.

When a tree finally collapses after several decades of decay, it will slowly become incorporated into the forest floor. But the imprint of the vanished tree will long remain in the ground, in the form of raw humus.

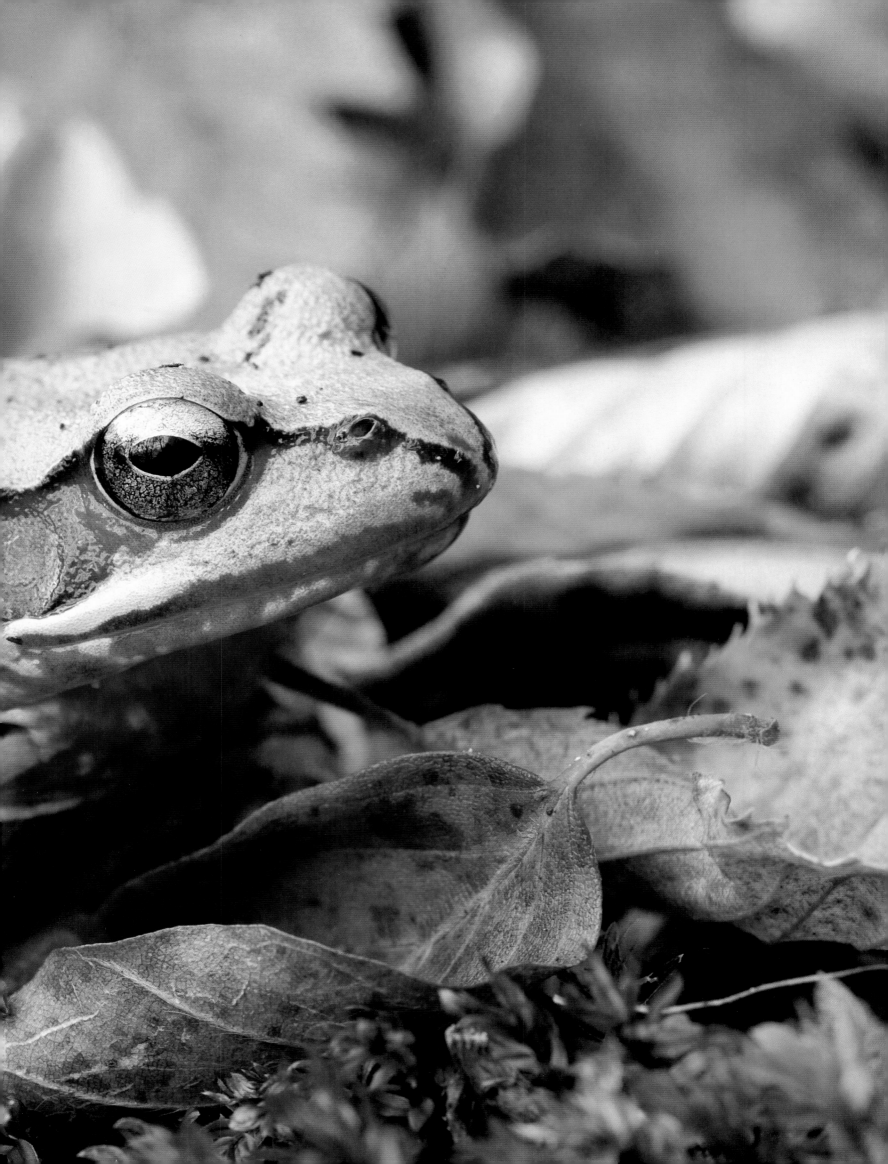

Agile frog among dead leaves

Rana dalmatina
CROATIA, CORKOVA UVALA
VIRGIN FOREST, PLITVICE LAKES
NATIONAL PARK

This frog species is widely represented on the floor of Europe's moist, broadleaf forests from northern Spain to Sweden and in central Europe, but not Russia. The agile frog lays its eggs in vernal pools or small boggy depressions. It spends the winter on the ground, well protected under a layer of leaves or soil.

Maurizio Biancarelli

✦ Hawfinch

Coccothraustes coccothraustes
Elusive during the greater part of the year, the hawfinch may well claim the prize for having the strongest beak of all the European passerines: five cutting edges on the upper mandible, highly adaptable counterparts on the lower mandible, and an extraordinary muscle power that allows it to break prune or cherry pits in a few short seconds. The hawfinch can even handle olive pits, which take 154 pounds (70 kg) of pressure to crush.

Markus Varesvuo

Understory of a beech-fir forest

Abies nordmanniana and *Fagus orientalis*
RUSSIA | TEBERDINSKY
BIOSPHERE RESERVE, ARKHYZ,
KARACHAEVO-CHERKESSIA

Broken trunks, deadfalls, standing snags, and fallen branches accumulate in the understory of this natural forest in the mountains of Western Caucasus. They provide a multitude of microhabitats for organisms that shelter in decaying wood, whose diversity expands as the trees in a forest vary more in size and extent of decay.

Tom Schandy

Fire salamander

Salamandra salamandra
SLOVAKIA | POLONINY
NATIONAL PARK,
WESTERN CARPATHIANS

A ground-dwelling amphibian, the fire salamander is nocturnal and therefore rarely seen. During the day, it lies hidden in moist spots under rocks or bark, inside rotting stumps, or between tree roots. The female approaches water only to deposit her eggs in vernal pools or streams too small to have fish.

Konrad Wothe

Male wood warbler on a beech tree

Phylloscopus sibilatrix
GERMANY | BERLIN

The wood warbler nests in the lower canopy of broadleaf forests, preferring stands of beech, oak, and hornbeam. On forested mountain slopes, up to an altitude of 4,000 feet (1,200 meters), the wood warbler can be found in evergreen forests, but only if beech trees are also present. Flitting through a shaft of sunlight, the bird is a brilliant yellow-green, its breast sulfur yellow, its belly white, and its eyebrow stripe a handsome yellow. The wood warbler is the most tree-dwelling of the warblers, frequenting parts of the canopy that are amply supplied with flies, mayflies, butterflies, aphids, and larvae. It winters in Africa in parklands and on the edges of rainforests.

Florian Möllers

✦ Male parasitic wasp

Dolichomitus imperator
SLOVAKIA | WESTERN TATRAS

Dolichomitus imperator is a wasp that parasitizes wood-boring insects. The female's abdomen ends in a long ovipositor with which she drills through wood to reach the larvae in their galleries and inject her eggs into their bodies. The young wasp feeds on the larva until it hatches.

Bruno D'Amicis

A chain of colorful polypore fungi

Lenzites betulina
CROATIA | CORKOVA UVALA
VIRGIN FOREST, PLITVICE LAKES
NATIONAL PARK

This member of the Polyporales order, is a fungus that requires a substratum of broadleaf species, notably various species of the genus *Populus* (poplar), in a riparian environment.

Maurizio Biancarelli

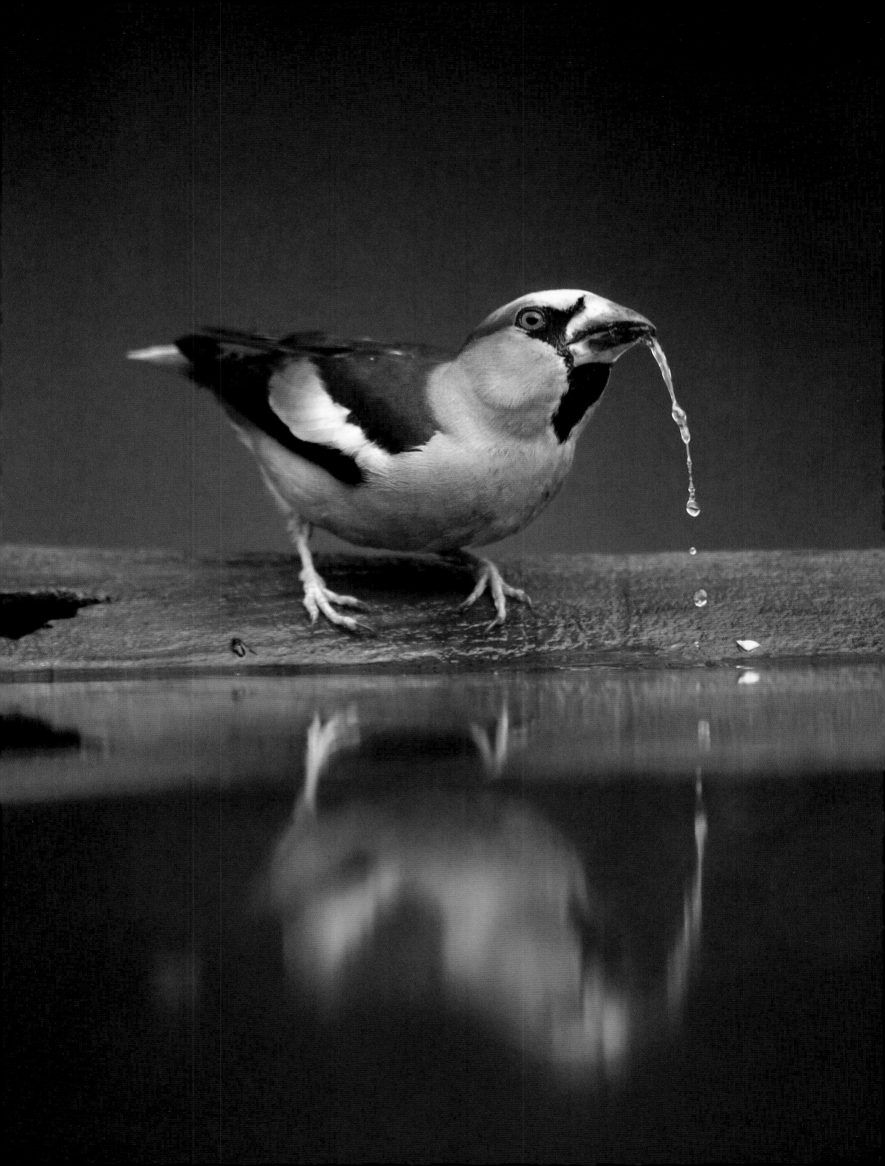

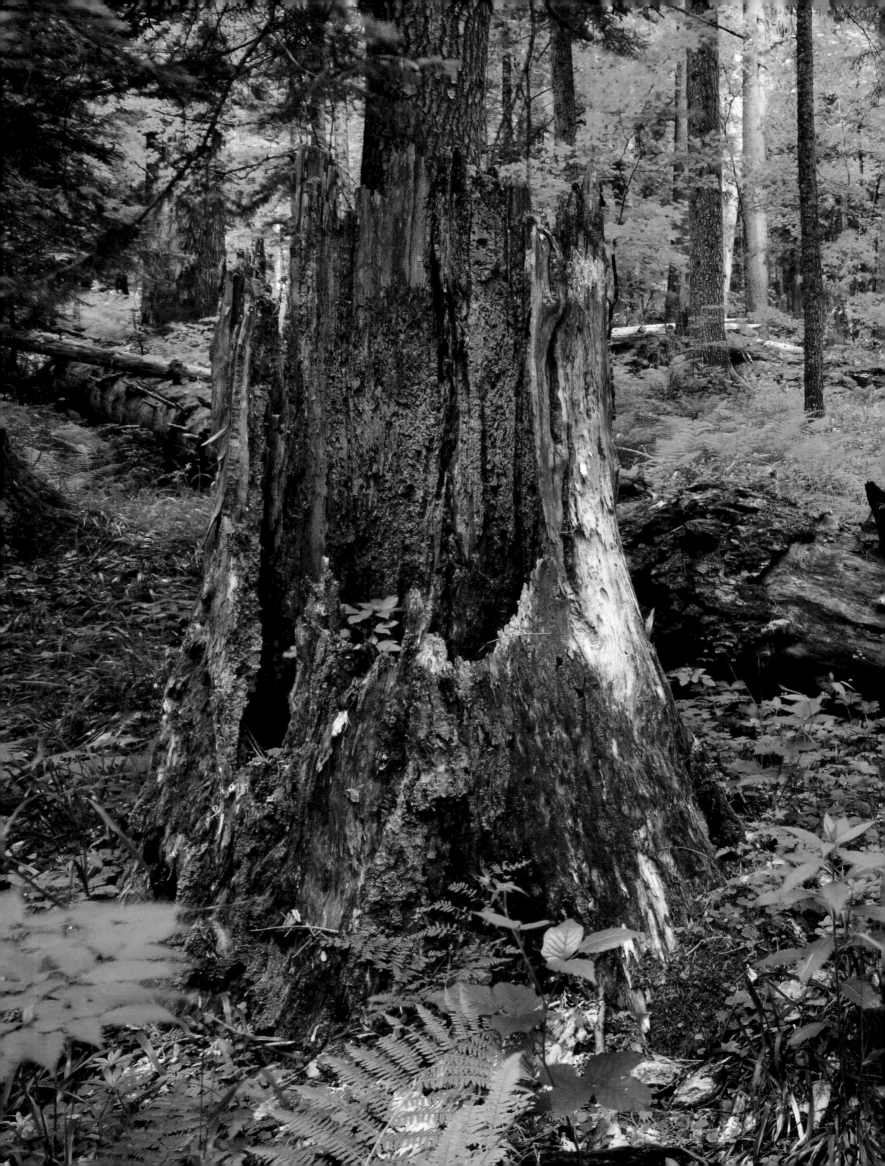

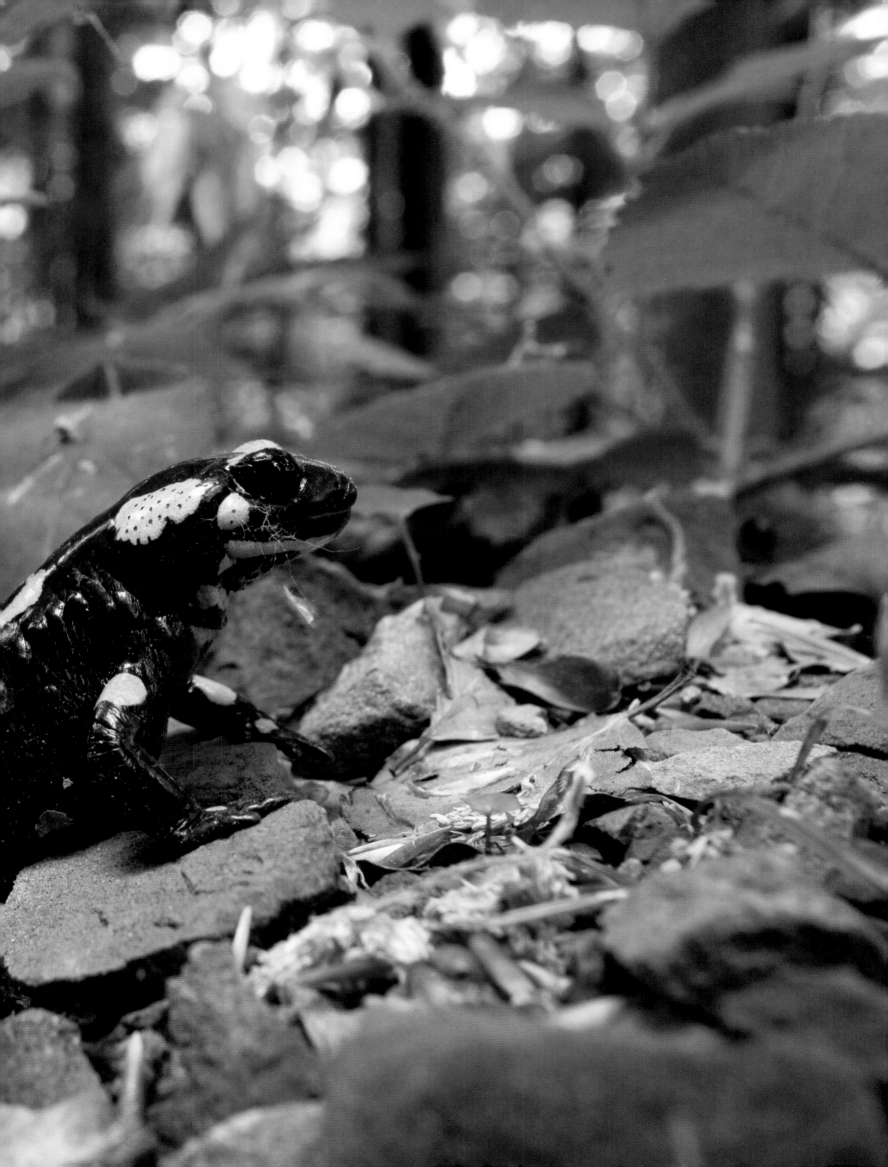

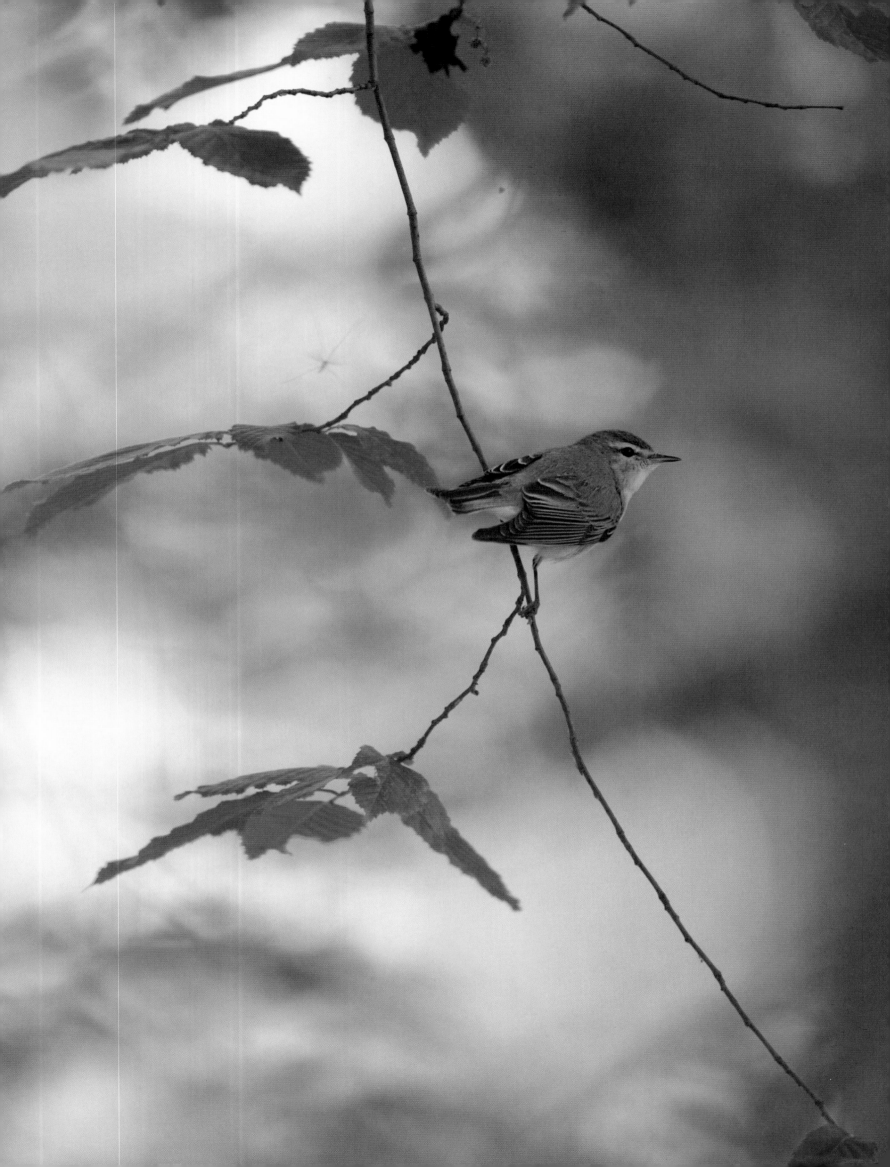

A WEALTH OF FAUNA

To look at how wood decomposes is to understand the importance of animal life in the regenerative processes of the forest and its cycles of matter generally. Insects live in the forest in great numbers and are extremely active there. They are found in the canopy, feeding on leaves and buds. They also tap into the sap of trees, eat fruits and seeds, live on bark and in dying wood. Their species composition is dependent on the characteristics of the host species. Conifer forests, for example, host fewer species of ground beetles (e.g., scarabs) than deciduous forests, and in each type of forest, the dominant insect species is different.

The distribution of insects also depends on elements in the forest microclimate. Some live in the canopy foliage, such as leaf-eating caterpillars that are attracted by the light and temperature. Others, certain diptera among them, live near the ground, where air currents are relatively weak and mating is easier. The tree-trunk microclimate is the most unusual offered by forests. Under the bark, temperatures are attenuated, which favors the larvae of some beetles (genus *Chrysobothris*) capable of withstanding high temperatures (thermophilic) and disfavors others (genus *Rhagium*). Symbiotic relationships have developed between certain families of wood-eating insects, like bark beetles (subfamily Scolytidae) and ambrosia beetles (subfamily Platypodidae) on the one hand, and fungi on the other. The insect larvae excavate galleries deep into the wood, but they would be unable to attack it unless it was already penetrated by the mycelia of ambrosia fungi. The fungus in turn enters the wood through spores that live and grow in a specialized organ of the beetle, the mycangium.

Species of true forest birds, which nest and feed exclusively within the forest, are also very abundant in Europe. At least 70 species are known, with another 10 or so that nest in the forest but feed on open land outside it. An additional 30 species are identified as tree-dwelling, meaning that they build their nests in isolated trees or trees at the forest edge and feed beyond the forest, one instance being the gray heron (*Ardea cinerea*). Typical forest birds include the common blackbird (*Turdus merula*), which is now much more common in urban areas than in forests, the thrushes (*Turdus viscivorus, T. philomelos, T. iliacus . . .*), the woodpeckers (genera *Dryocopus, Dendrocopus*), the tits (genus *Parus*), the Eurasian nuthatch (*Sitta europaea*), and the tree-creepers (genus *Certhia*). They are all very skillful at dodging obstacles, which they accomplish at the cost of speed, their wings being wide and relatively short.

Some birds prefer coniferous forests, among them the crested tit (*Parus cristatus*), blue tit (*Parus caeruleus*), marsh tit (*Parus palustris*), goldcrest (*Regulus regulus*), and Eurasian siskin (*Carduelis spinus*). Conifer forests supply them with seeds in winter as well as insects on the underside of branches, which remain free of snow.

Other species are more abundant in largely deciduous forests. These include the Eurasian wren (*Troglodytes troglodytes*) and the European robin (*Erithacus rubecula*). Hardwood forests

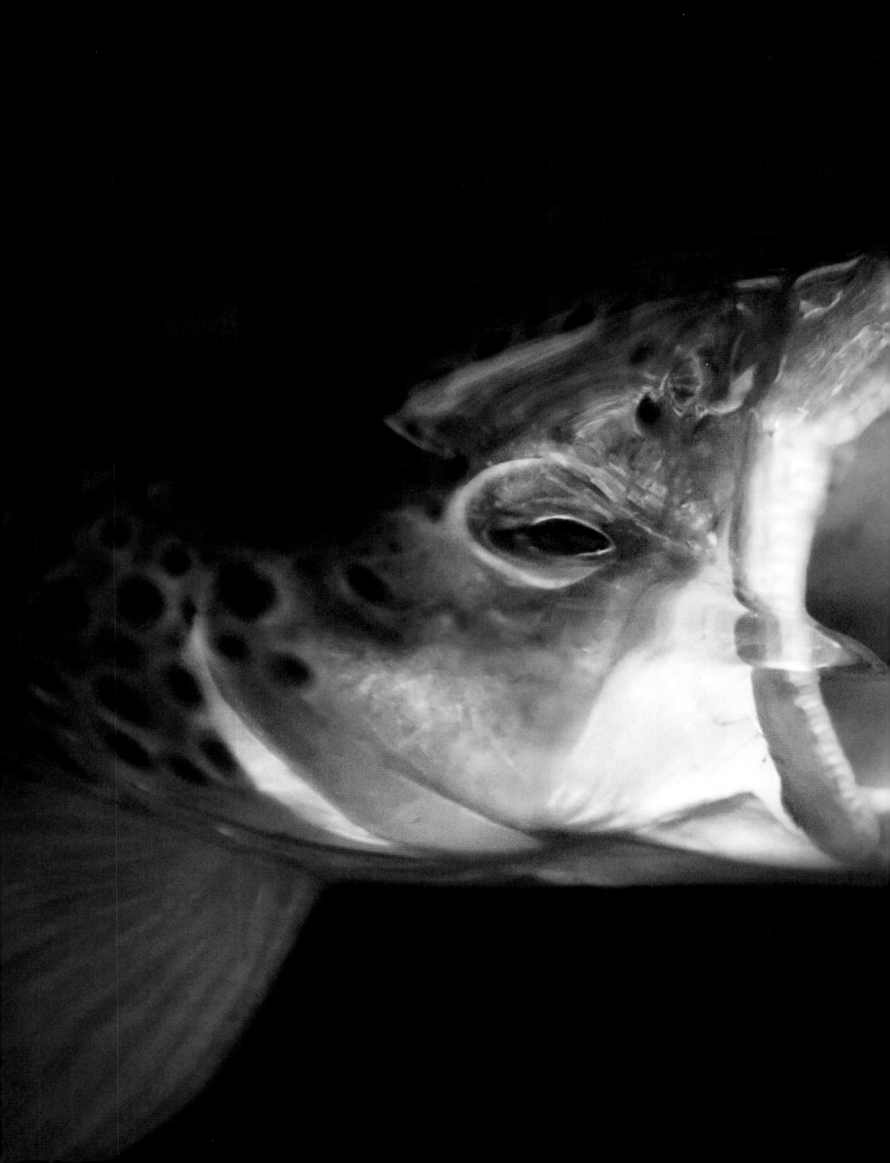

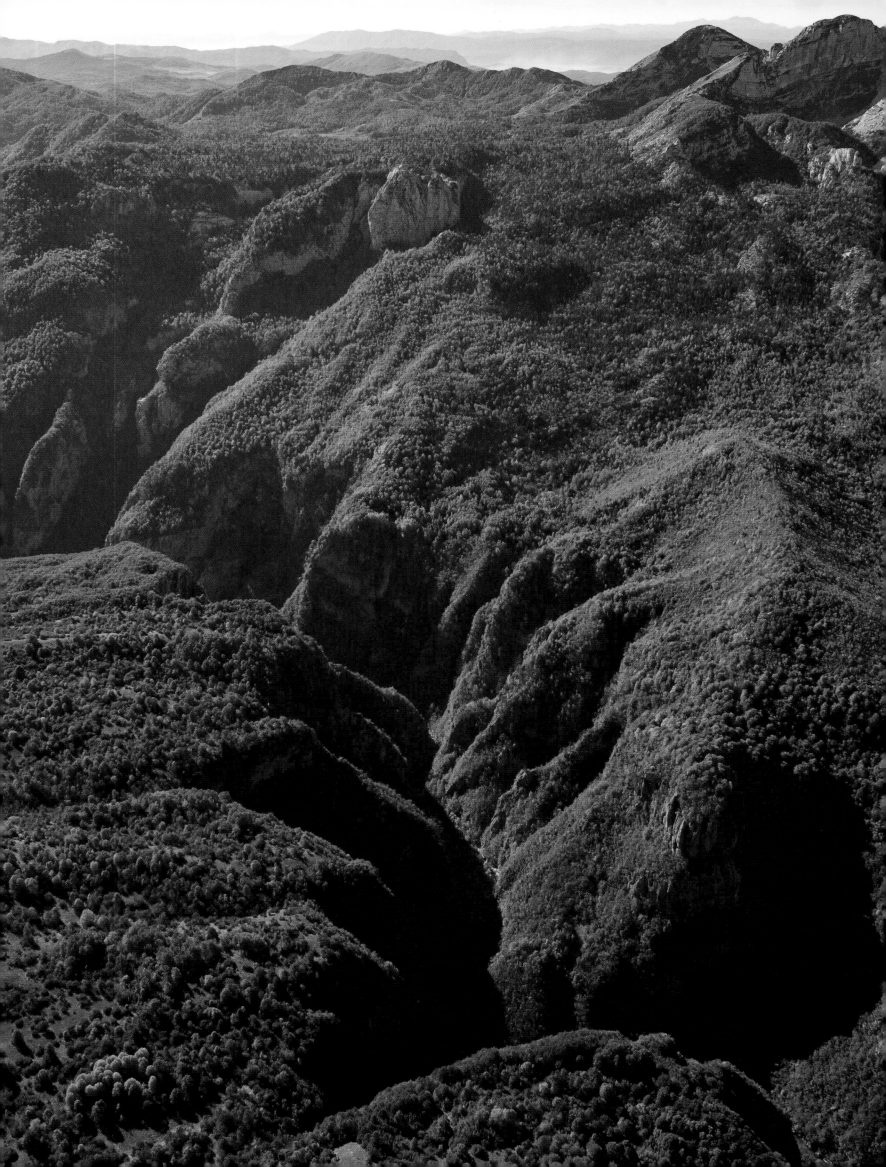

are in fact richer in insects than softwood forests and their understories are denser and thus generally contain more birds. Among the bird species that share an important place in hardwood stands (groups of forest trees that can be considered to be a homogeneous unit, having trees of a sufficiently uniform species composition, age, and condition) are the chaffinch (*Fingilla coelebs*), the willow warbler (*Phylloscopus trochilus*), and the robin.

Birds distribute themselves in distinct strata between the forest floor and the canopy according to their needs. Fruit-eating birds, for instance, spend little time in the canopy since the forest trees of Europe produce no pulpous fruits. More likely to be found in the highest reaches are the wood pigeon (*Columba palumbus*), several of the family Corvidae, and the large raptors, which are canopy nesters.

European forests are rich in mammals, which occupy every branch of the food chain from plant eaters to predators to scavengers. At night, bats (order Chiroptera) fill the daytime role of insect-eating birds and can be found at every stratum of the forest from the ground to the treetops. The noctule bats (genus *Nyctalus*), for instance, feed on insects all through the canopy, sometimes flying low into the understory. The lump-nosed bats (genus *Plecotus*) and Bechstein's bat (*Myotis bechsteinii*) flutter among the leaves but also forage on the ground for small invertebrates. The type of forest dramatically affects what species of bat inhabits the area; for instance, some bats of the *Myotis* genus live only in mature forests. However, in most cases, the diversity of bat species is greatest in forests where dead wood is most abundant (standing snags and fallen logs), where the stratification of the forest is complex, and where the woody species are numerous. The presence of water increases bat populations, as humid areas produce more flying insects. Bats are most common in forests in the spring, just as they emerge from hibernation, and in the fall, just as they return to it.

Large herbivores also play an important part in the functioning of the forest. They influence plant distribution and regulation by removing bark and grazing on leaves and buds, exercising their preference for some and their disinterest in others. The wild boar plows up the forest floor in search of edible roots and rhizomes, preparing the ground for the germination of acorns. Among the family Cervidae, Eurasian elk, reindeer, and European red deer feed on bark, as well as sprouts and young trees. Roe deer prefer seedlings and tender shoots. Bison feed (as did once the aurochs, an ancestor of domestic cattle, now extinct) on herbaceous plants that are for the most part indigestible to other herbivores, including the tarpan (now extinct) and other species of wild horses.

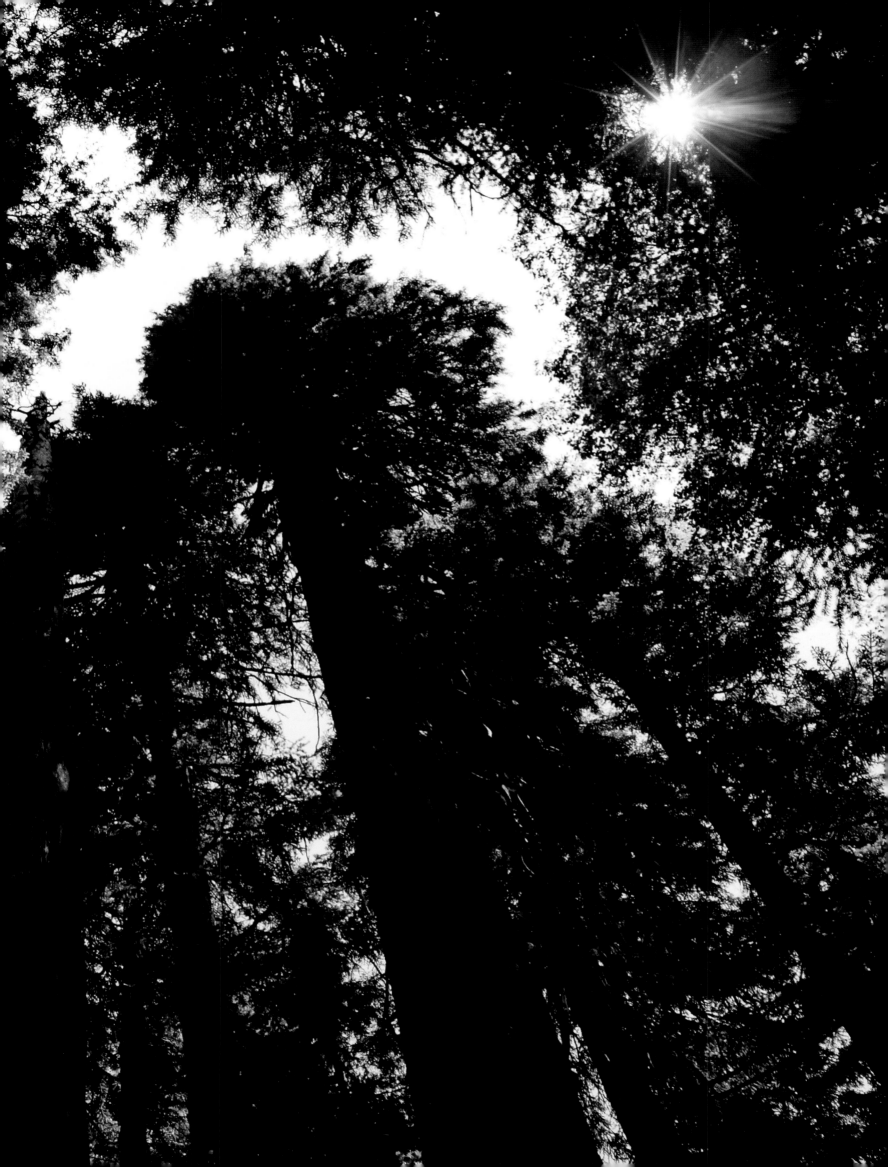

↟
Brown trout feeding
Salmo trutta
SWEDEN | DALA RIVER, GÖTENE, VÄSTRA GÖTALAND

The brown trout swims up tiny forest streams in winter, where it spawns on pebbly bottoms or on the shallow edges of the stream. Once hatched, the fry take shelter in the roots of alders, beeches, or other trees growing on the stream's banks. The species thrives only in ecosystems where the water is pure and well oxygenated with a sufficient supply of its main prey: adult and larval mayflies, stoneflies, and caddisflies.

Martin Falkland

Tara River Canyon
MONTENEGRO | NEVIDIO CANYON, KOMARNICA, DURMITOR NATIONAL PARK

The Nevidio Canyon, worn by the Tara River, is 50 miles (80 kilometers) long and 4,250 feet deep (1,300 meters) at its deepest point, the second-largest canyon in the world after the Colorado's Grand Canyon. Long inaccessible, the canyon lies within the 150 square miles (390 square kilometers) that encompass Durmitor National Park, created in 1952 and registered as a UNESCO World Heritage Site in 1980. The park includes the Durmitor massif, the Tara River canyons, the Susica and Draga rivers, and the upper part of the Komarnica Canyon plateau. Its forests are remarkably well preserved, notably its forests of black pine (*Pinus nigra* subsp. *nigra*). The Balkan lynx, among other large predators, survives there.

Milán Radisics

Forest of Nordmann fir
Abies nordmanniana
RUSSIA | TEBERDINSKY BIOSPHERE RESERVE, ARKHYZ, KARACHAEVO-CHERKESSIA

A few forests of large Nordmann fir trees, some more than 160 feet (50 meters) tall, survive in the Teberdinsky Biosphere Reserve, mixed with Oriental beech. The foliage of the largest trees captures most of the sunlight, while the few scattered patches of light that reach the ground nourish all the life in the understory.

Tom Schandy

↓
Siberian jay
Perisoreus infaustus
FINLAND | OULANKA NATIONAL PARK, KUUSAMO, NORTHERN OSTROBOTHNIA

This shy corvid is typical of mature boreal forests of spruce, pine, and birch, from the Scandinavian peninsula to Russia. An omnivore, it feeds at every height in the forest from the ground to the highest branches, eating small mammals (voles), adult willow tits, and other small songbirds. It supplements its diet with carrion, lizards and invertebrates, the berries of juniper and bilberry, and spruce seeds. The jay stores provisions by coating bits of food with saliva and sticking them randomly on trees.

Sven Začek

Gray wolf
Canis lupus
POLAND | BIESZCZADY NATIONAL PARK, CARPATHIANS

The range of the gray wolf was once vast, extending over the entire northern hemisphere, but it has been reduced considerably owing to the severe persecution of the wolf. Healthy populations nonetheless survive in various parts of Europe in natural reserves where the wolf is protected. Whenever regulations protecting the animal extend beyond the reserve, the wolf can quickly expand its range. In the Carpathian Mountains of Poland, the wolf is found in every type of forest, including alpine habitats. Official counts put the number of wolves in the Carpathians at 550, though scientific estimates, based on average densities, place the number closer to 250.

Stefano Unterthiner

Bialowieza Forest in winter
POLAND | BIALOWIEZA NATIONAL PARK

This forest, located on the eastern border of Poland near Belarus, is one of the largest well-preserved plains forests in the country. It hosts an extensive array of tree species: European hornbeam (*Carpinus betulus*), pedunculate oak (*Quercus robur*), littleleaf linden (*Tilia cordata*), various elms (*Ulmus*), Norway maple (*Acer platanoides*), and a spruce (*Picea excelsa*)—26 species in all. The Bialowieza Forest is ecologically fascinating. It represents a unique example of the forests that once covered all of central Europe before the wholesale clearing, fragmentation, and logging of historical times. Yet Poland's forests, right to the edge of the Bialowieza Reserve, are being logged heavily, affecting natural processes in the park.

Stefano Unterthiner

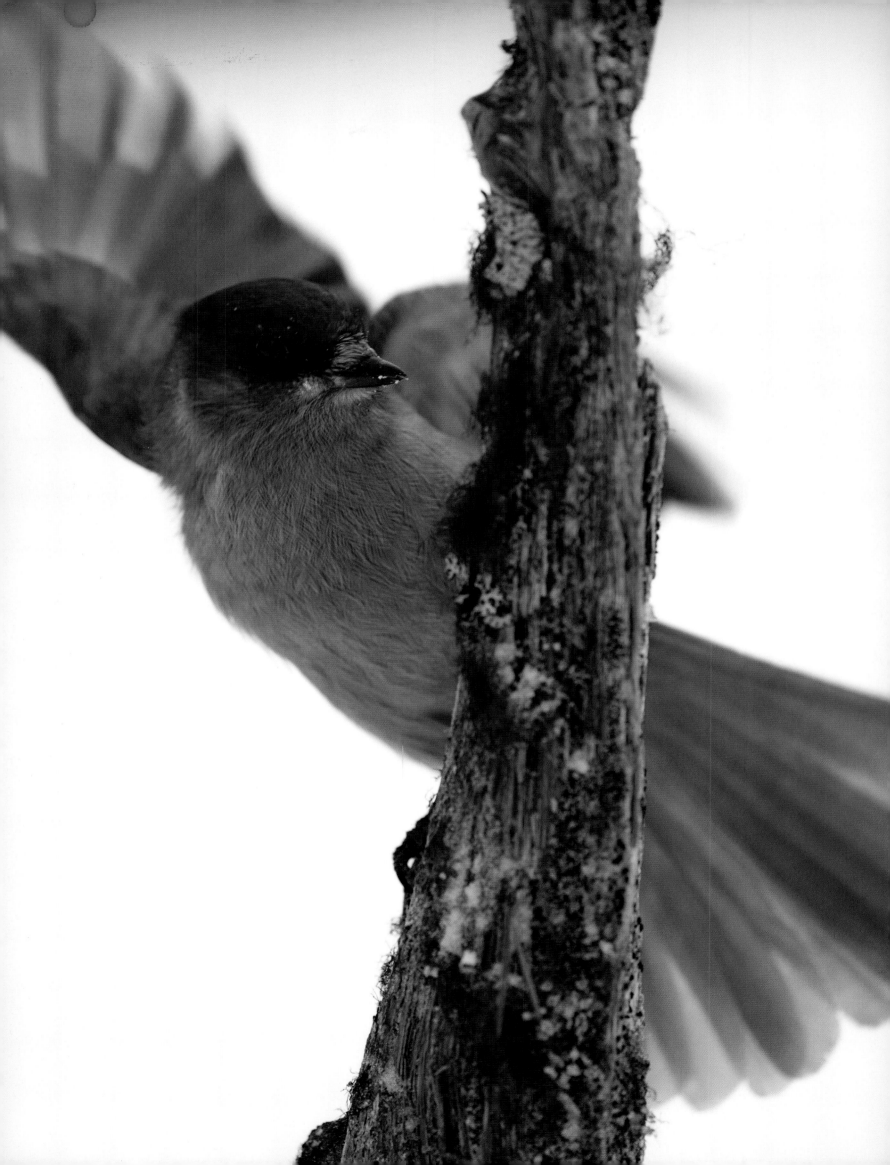

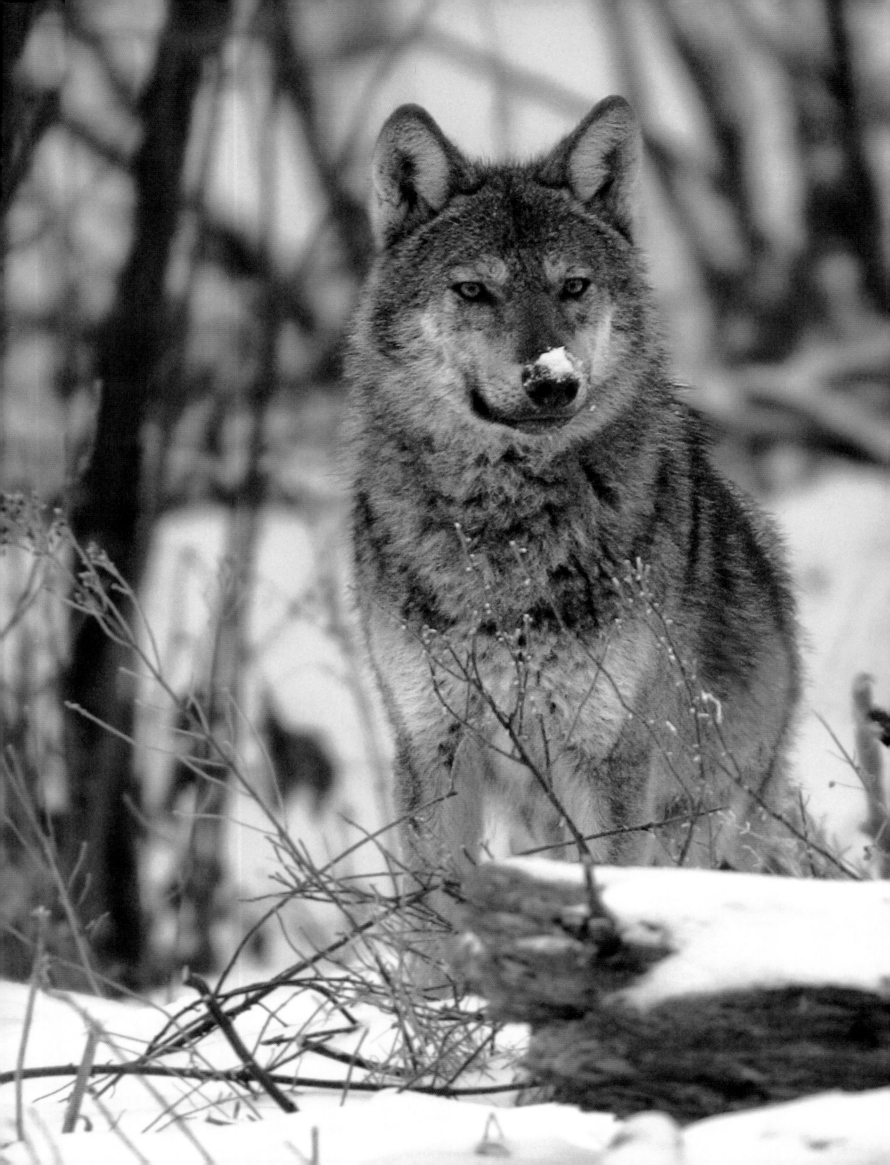

THE ORIGINAL FORESTS

DURING THE LAST GLACIAL PERIOD, APPROXIMATELY FROM 100,000 TO 10,000 YEARS AGO, EUROPE EXPERIENCED EXTREME CLIMATIC CONDITIONS, MORE severe than anywhere else in the Northern Hemisphere. During the very cold and very dry Würm glaciation, at the end of the **PLEISTOCENE**, populations of forest species were confined to small areas immediately beside inland seas, notably the Black Sea and the Mediterranean, and to a few rare mountainous sites. Numerous species became extinct.

In the postglacial era, the forest steppe that periodically covered Europe during previous interglacials (between 135,000 and 115,000 BP) did not reestablish itself. The large herbivores (mammoths, woolly rhinoceroses) and some of the large carnivores (cave bears and lions) that lived in Europe during the glacial period had already disappeared, probably wiped out by human hunters as man emerged in the early Holocene. Other species such as the European bison, tarpans, and aurochs gradually dwindled, also negatively influenced by humans.

Many areas left bare by ice were swiftly recolonized by successive waves of trees, which spread from their zones of refuge along the Mediterranean and in Asia Minor. The birches and pines returned first, followed by the oaks and other hardwoods (elm, linden, maple, and then beech) as well as by the conifers (pine, spruce). The composition of the forests evolved in concert with the rhythms of species migration and the oscillations of the climate, unfurling an ever-denser covering over Europe. The warm, moist period known as the Atlantic period (7,500 to 5,000 BP) allowed forests to reach their maximum extension, though their true dimensions are still largely unknown. The two most plausible scenarios provide competing hypotheses. In one version, the forest in central Europe formed a continuous canopy with few open spaces other than on the banks of large rivers, at the edges of continental glaciers, deltas, marshes, in a few arid spots, and on the ocean shore. In another version, herds of ungulates, including wild horses, aurochs, red deer, Eurasian elk, and roe deer, kept the countryside open, forming a mosaic of forests, savannas, and grasslands.

PLEISTOCENE
Geologic epoch that includes most of the recent glaciations, up to the Younger Dryas cold spell that ended around 11,000 BP. The Pleistocene is divided into the Early Pleistocene (1.8 million to 780,000 BP), the Middle Pleistocene (780,000 to 130,000 BP), and the Late Pleistocene (130,000 to 11,000 BP). The Pleistocene and Holocene epochs belong to the Quaternary period.

BP
Dates given in this form (before present) have generally been obtained by using absolute dating methods, e.g., carbon-14 dating

HOLOCENE
Period of generally temperate climate that followed the Pleistocene and the last ice age. The Holocene began about 10,000 BP and is characterized in Europe by the constant expansion of forestlands. It is divided into five main climatic periods.

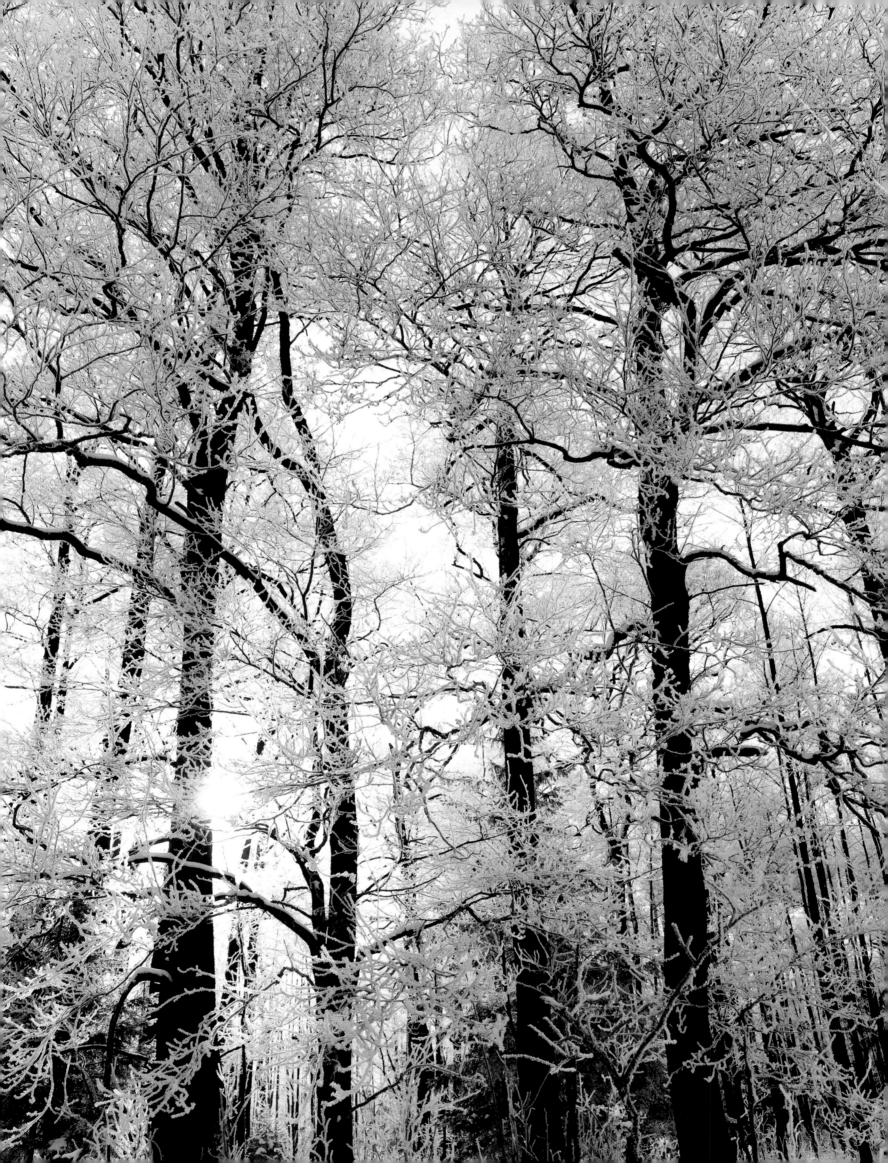

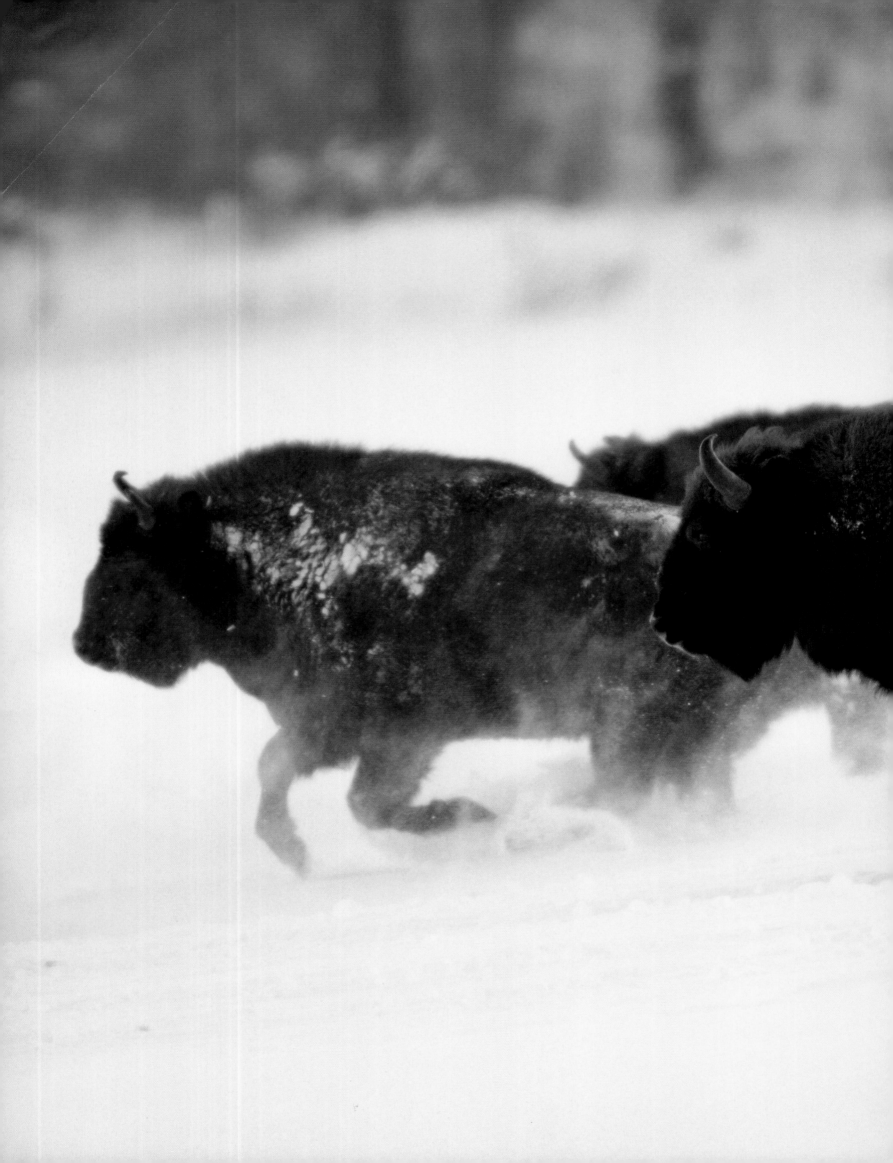

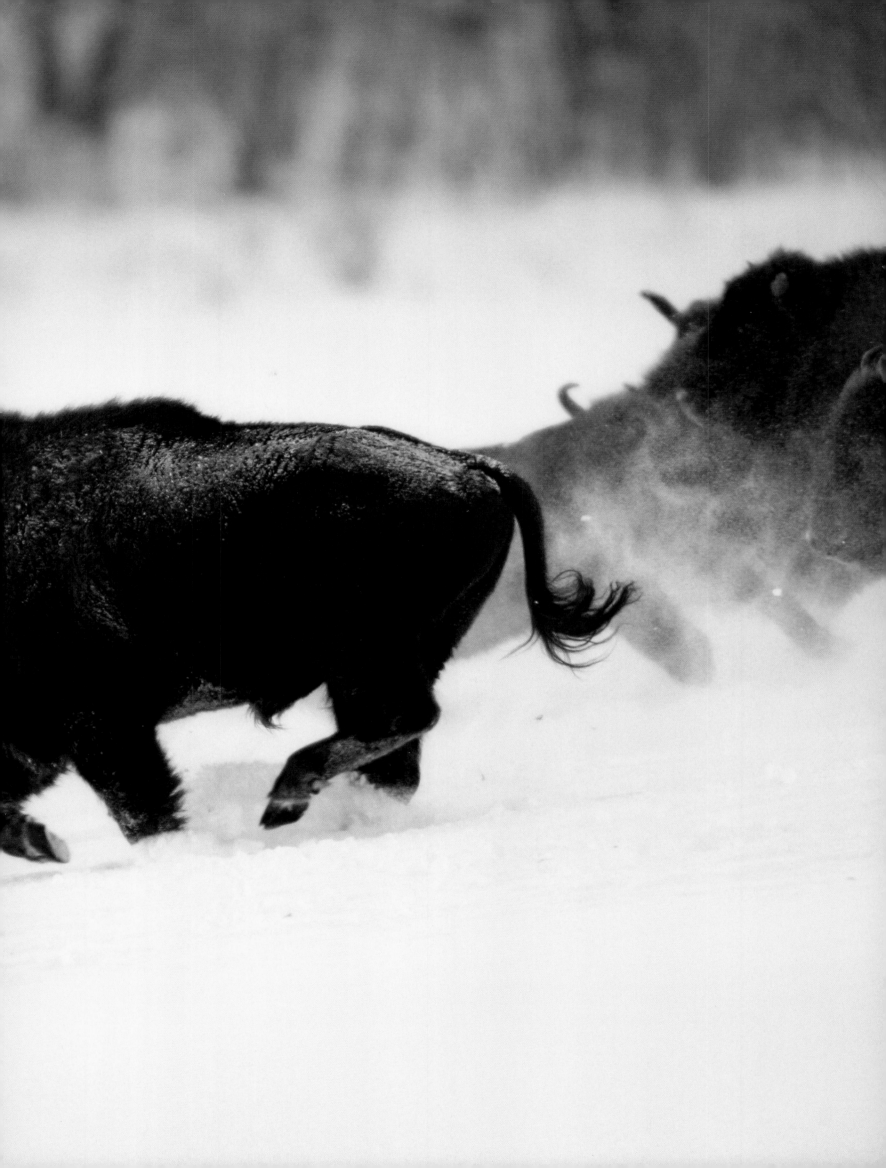

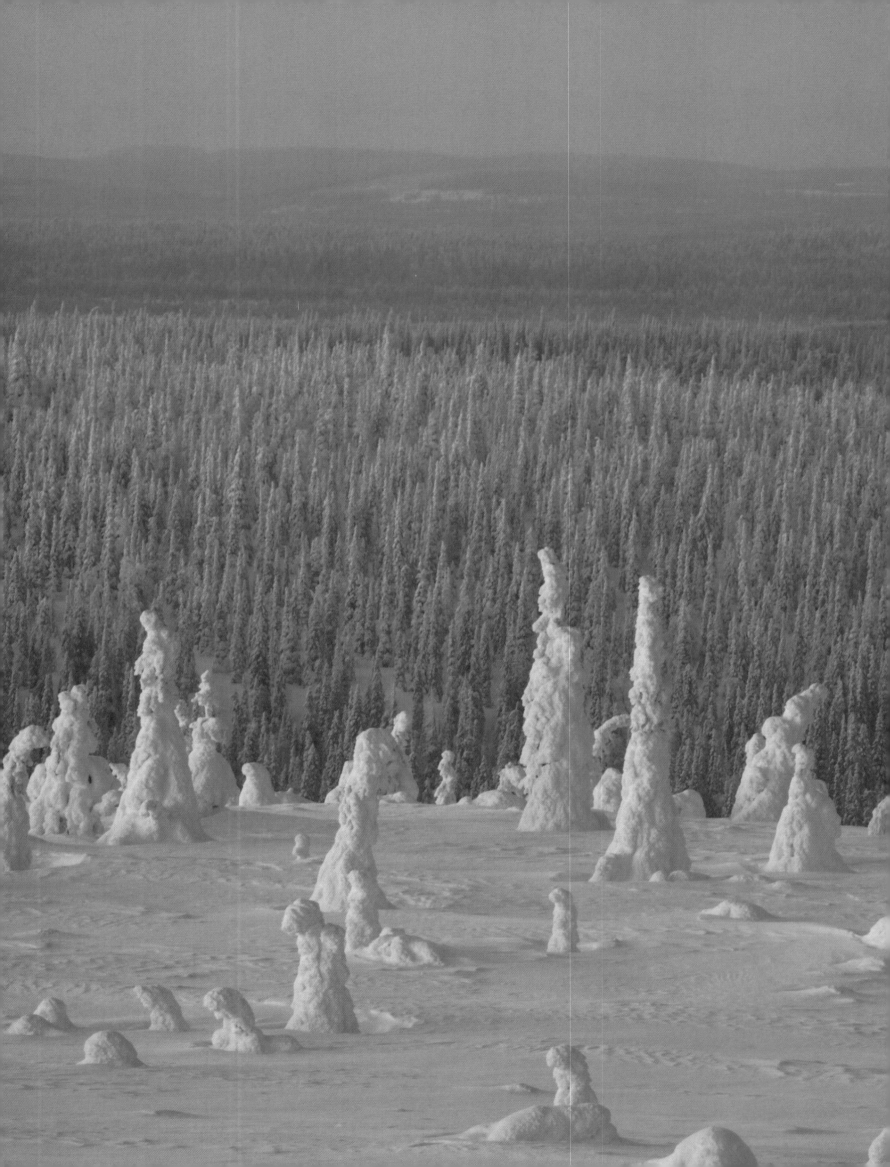

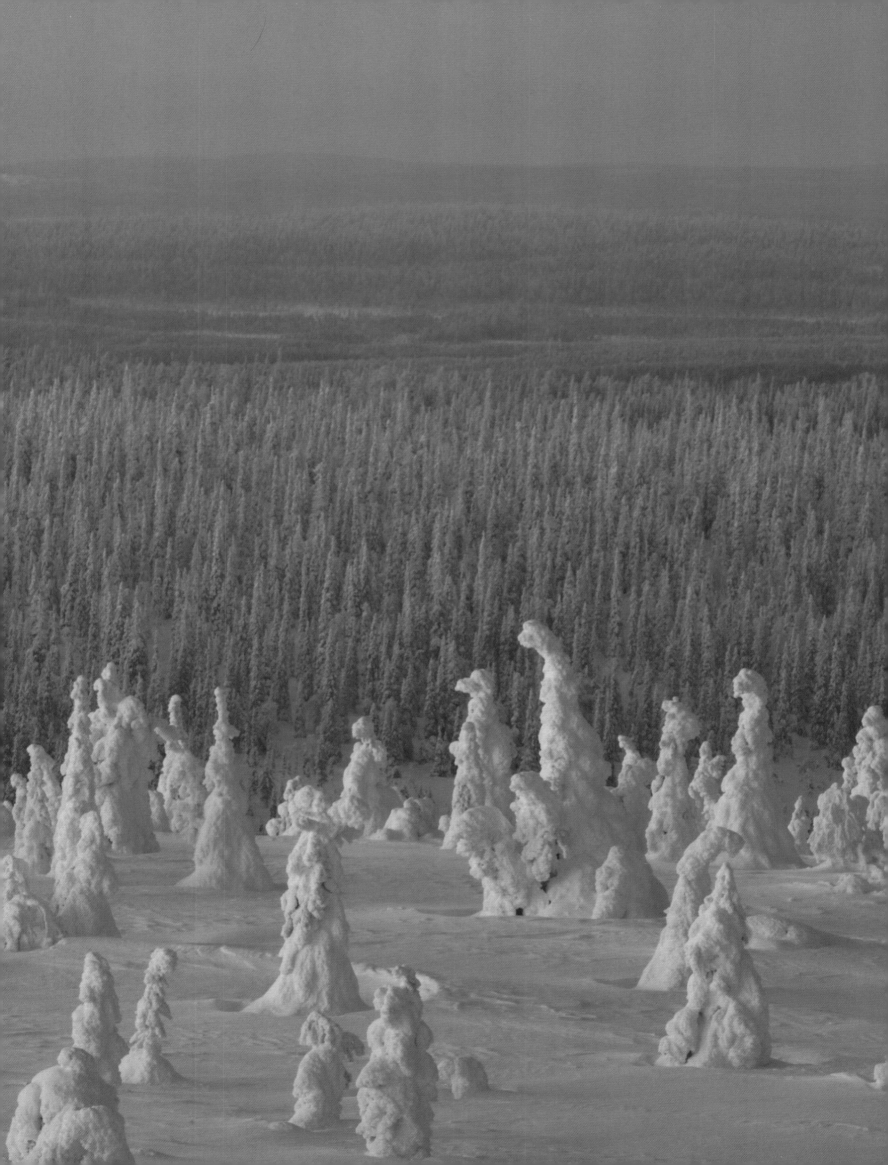

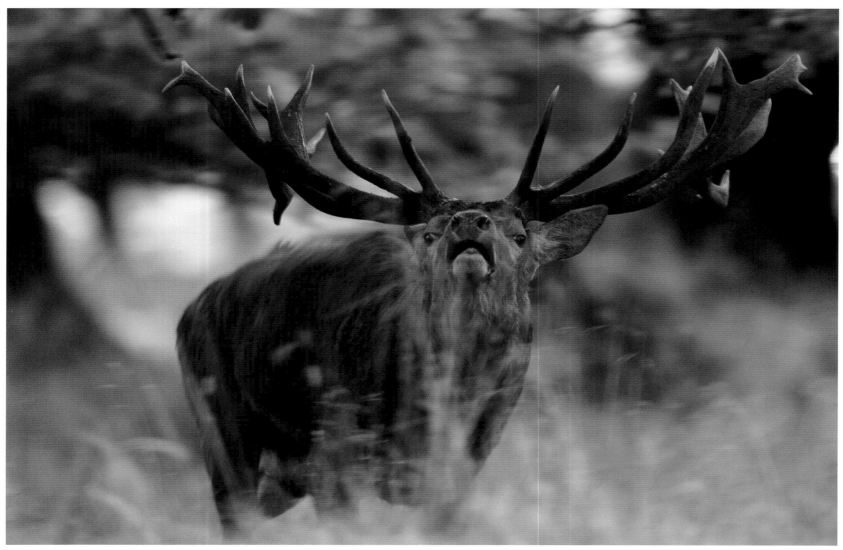

While some recent publications demonstrate that these large herbivores (sometimes called "bulldozer" herbivores) could not affect this type of permanent damage, it should be noted that in Europe today, forest regeneration is closely linked to the resident population of red deer: too many, and they profoundly affect the capacity of forest renewal. Elk have an identical impact on boreal forests.

Because human activity has driven most of Europe's large predators (lynx, bear, and wolf) to extinction, it is difficult to measure the role they played in determining the number, distribution, and feeding behavior of their prey, the large herbivores. Recent studies conducted in the United States (Yellowstone Park) and Germany (Metalliferous Mountains) indicate that in areas where large carnivores (wolf, for example) are allowed to thrive, herbivores modify their grazing behavior and movement patterns: The forest grows back in territory that they have abandoned, along the trails used by predators, and in the vicinity of their dens.

The two hypotheses of a continuous canopy and an open-forest parkland are not necessarily incompatible. Most scientists agree today on the variety of causes behind the diverse nature of European forests—isolated trees scattered in the midst of prairies, open savannas, or dense forests. Unfortunately, there is no longer a place on the European continent where we can go to form an idea of the size and structure of the original forest habitat, or the distribution and diversity of its species, in 10,000 BC.

The assumptions of a continuous canopy or parkland are not necessarily contradictory. All researchers recognize that the importance of large herbivores in forest dynamics has been largely underestimated because of difficulties in assessing the effects of herbivore populations and their dynamics, since they were either exterminated or have been greatly diminished by humans for millennia. One can easily imagine that fires, storms, heavy snowfall, or massive attacks of leaf-eating insects were able to destroy trees and allow light to reach the forest floor. These large, natural openings in the canopy could be maintained, for a time, by large herbivores, which also facilitated the maintenance of species in need of light. But these processes are now part of the past. The main player in the overwhelming majority of European forests today is man.

↑
European bisons
Bison bonasus
POLAND | BIESZCZADY NATIONAL
PARK, CARPATHIANS

Eliminated over most of
its range during historical
times, the European
bison was reduced in the
nineteenth century to a
small population on the
border between Poland
and Russia. Thanks to a
successful program to
rebuild its population from
zoo specimens, a number of
bison have been introduced
into the forests of central
and eastern Europe. Today,
there are some 2,400
bison living in the wilds in
Poland, Russia, Belarus, and
Ukraine. Reintroduced into
several parts of its original
range, the bison has been
assigned an important
role in the preservation
of prairie-forest parkland,
a goal of the Rewilding
Europe initiative.

Grzegorz Lesniewski

The taiga in winter
FINLAND | RIISITUNTURI NATIONAL
PARK, LAPLAND

In the blue light of winter, the
taiga bends under the weight of
the snow, which accumulates to
a considerable depth in northern
zones, covering the ground and
the vegetation all through the
winter season. Spruce trees,
the major species in the taiga,
are perfectly adapted to local
conditions. They are compact
in structure and grow laterally,
the better to support the weight
of the snow and the abrasive
effect of the wind. As soon as
the snow melts, spruce trees
begin to photosynthesize,
taking full advantage of the
very short growing season in
these latitudes.

Sven Začek

Large expanse of mixed forest and open land
ROMANIA | NEAR SIRNEA,
SOUTHERN CARPATHIANS

The primary forest was, to
a large extent, cut down
to make way for a mixed
landscape of forest and open
land, intended for a traditional
mix of farming, herding,
and forest activities. Such
landscapes are rare in western
Europe, but still remarkably
common in central and
eastern Europe.

Cornelia Dörr

Red deer
Cervus elaphus
DENMARK | KLAMPENBORG,
DYREHAVEN PARK

For centuries, the red deer
(*Cervus elaphus*) was thought
to be an obligate forest
species. Yet it is now clear
that in many parts of its
present range, red deer
are capable of spending
much of the year outside
of woodlands entirely,
in reedbeds, swamps,
and parklands. Hunting
has reduced red deer
populations to a fraction
of their historical levels
throughout Europe. Despite
this, the red deer is still
considered the primary

enemy of modern forestry,
as its browsing can cause
considerable damage
to seedlings and stifle
natural regeneration.
Some scientists believe
that large numbers of deer
prevented Europe's cleared
lands from reverting to
dense forests.

Florian Möllers

↓
White helleborine
Cephalantera damasonium
ITALY | GARGANO, APULIA

Unlike most species
of European orchids,
which grow in
extremely exposed
and relatively dry
places, the white
helleborine favors
beech forests
on chalky soils
with minimal
ground cover. This
helleborine needs at
least eight years to
germinate and two or
three more to flower.

Claudia Müller

Mixed temperate forest
CZECH REPUBLIC |
KRINICE, BOHEMIA

In the background of
this landscape of mixed
temperate forest lies the
Krinice floodplain.

José B. Ruiz

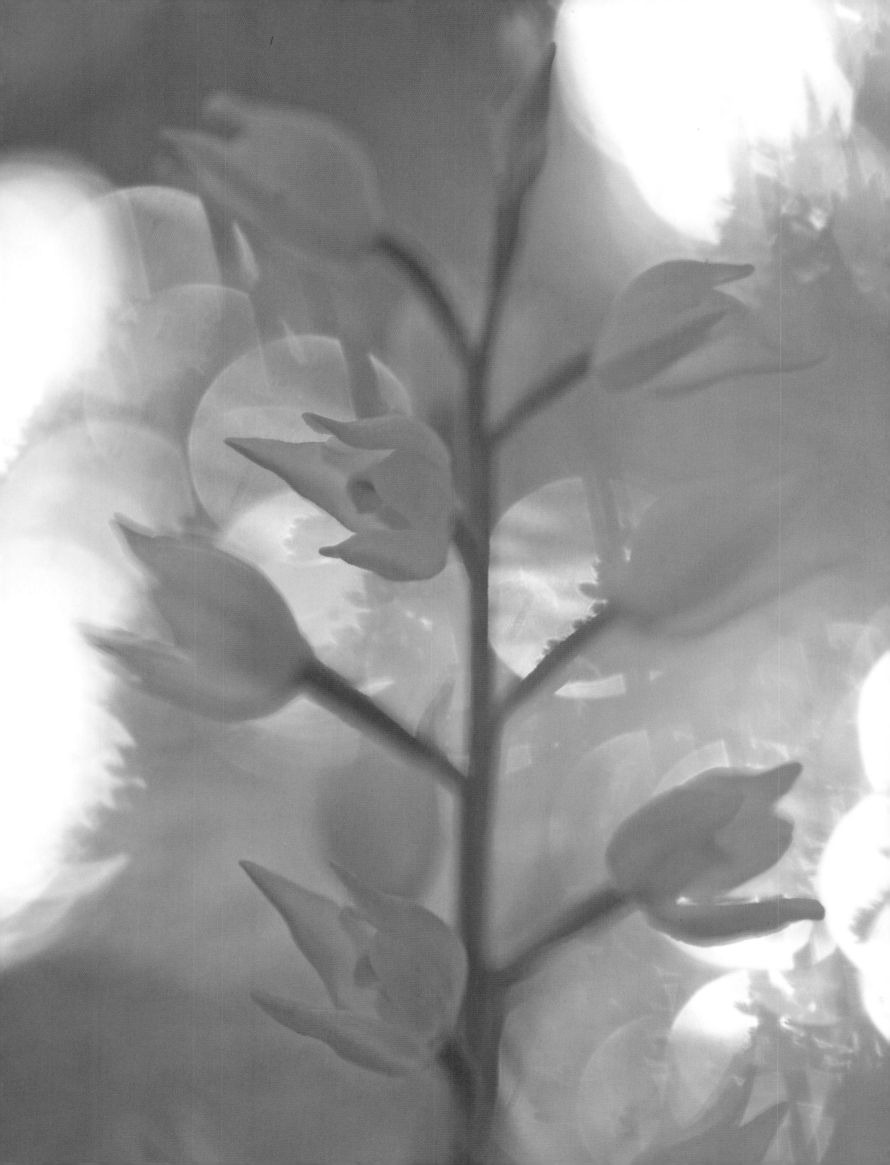

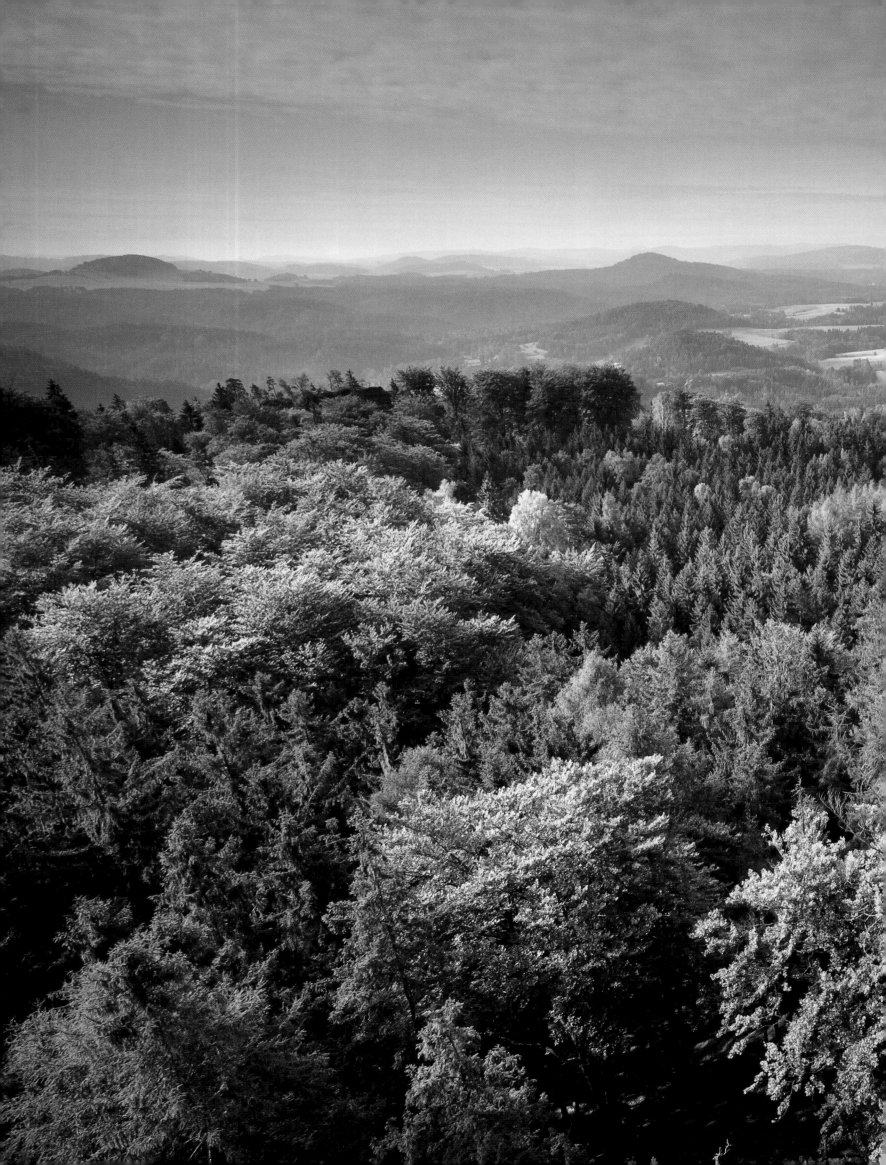

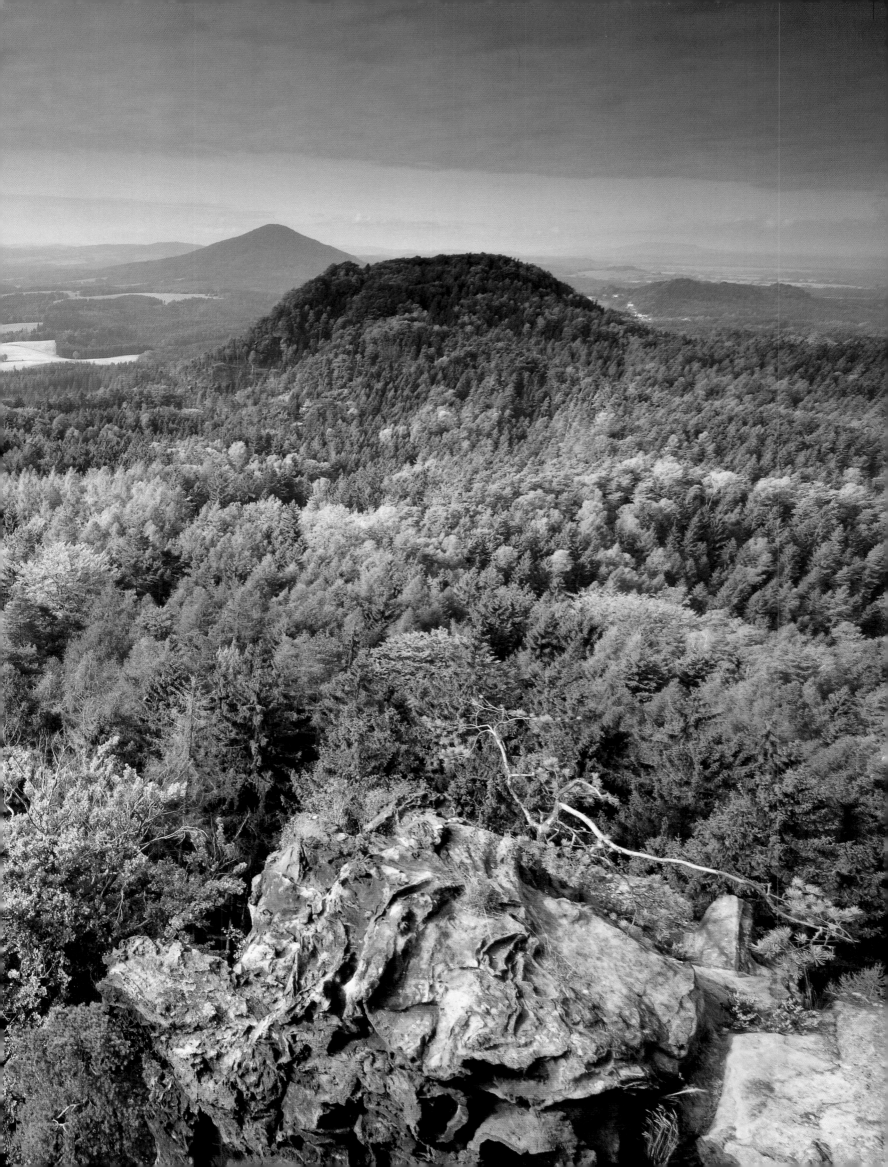

EUROPE COVERS A VAST AREA THAT ENCOMPASSES THE ATLANTIC ISLANDS FROM MACARONESIA (AZORES, MADEIRA, AND THE CANARY ISLANDS) TO ICELAND, EUROPEAN RUSSIA (WEST OF THE URAL MOUNTAINS AND THE URAL RIVER), THE CAUCASUS, WESTERN TURKEY, AND THE ISLANDS OF THE MEDITERRANEAN. THE GREAT VARIETY OF CLIMATES, TERRAINS, AND SOILS WITHIN THIS RANGE ACCOUNTS FOR THE COMPLEXITY OF THE FOREST FLORA, WHICH IS ROUGHLY DIVISIBLE BY LATITUDE INTO THREE GREAT BIOGEOGRAPHICAL AREAS: THE BOREAL REGION, THE TEMPERATE REGION, AND THE MEDITERRANEAN REGION. WE SHOULD ALSO NOTE THE EFFECT OF THE CONTINENTAL LANDMASS ON THE CLIMATE, WHICH INCREASES FROM WEST TO EAST. LARGE LANDMASSES SEPARATED FROM THE MITIGATING EFFECTS OF LARGE BODIES OF WATER, SUCH AS MUCH OF RUSSIA, ARE SAID TO HAVE A CONTINENTAL CLIMATE, CHARACTERIZED BY HOT SUMMERS, COLD WINTERS, AND LIMITED RAINFALL. FURTHERMORE, FORESTS OF A VERY DISTINCTIVE KIND HAVE DEVELOPED AROUND THE INLAND SEAS (BLACK SEA) AND CERTAIN VOLCANIC ISLANDS (SICILY, THE CANARY ISLANDS, AND MADEIRA).

ONE EUROPE, MANY FORESTS

FORESTS ARE ALWAYS DEFINED BY THEIR VEGETATION, AND IN
PARTICULAR BY THEIR DOMINANT TREES. WE SPEAK OF "BEECH
FORESTS" OR "OAK FORESTS," "OAK-HORNBEAM WOODS," "SPRUCE
FORESTS," AND "PINE WOODS," FOR EXAMPLE. THEIR CONSTITUENT
PLANTS—MUCH MORE THAN THEIR ANIMALS—ARE LINKED TO THE
PRECISE NATURE OF THE CLIMATE, THE TOPOGRAPHY, AND THE SOIL,
FOR THE SIMPLE REASON THAT PLANTS CANNOT MOVE. CONSEQUENTLY,
PLANTS MUST DEVELOP GREATER SPECIALIZATION TOWARD CLIMATIC
STRESSES AND ECOLOGICAL CONDITIONS THAN ANIMALS, WHICH
ARE MOBILE. IN DEFINING THE DIFFERENT FORESTS OF EUROPE,
WE WILL THEREFORE BE GUIDED LESS BY THE ANIMALS THAT
LIVE THERE THAN BY THE PLANTS GROWING IN THEM. BESIDES,
THE DISTRIBUTION RANGES OF PLANTS STRADDLE THE MAJOR
CLIMATIC REGIONS AND HABITATS OF EUROPE, WHEREAS THE
RANGE OF ANIMALS IS MORE A FUNCTION OF THEIR EVOLUTIONARY
HISTORY AND, IN MANY CASES, THE INTERVENTION OF MAN.

THE RIPARIAN AND SWAMP FORESTS

RIPARIAN FORESTS GROW IN THE FLOODPLAINS OF RIVERS AND ARE SUBJECT TO REGULAR FLOODS, WHILE SWAMP FORESTS OCCUPY THE WETTEST AND MOST peat-filled portions of lowlands, though they are flooded only when rivers reach unusually high water. The differences between forests in boreal and temperate areas will be discussed in the following pages, but riparian forests are relatively extensive in both the boreal and temperate zones of central Europe, notably in the Danube Basin. Very handsome riparian forests also survive along other river systems, in Germany, Poland, Ukraine, Belarus, the Baltic nations, and Russia. Swamp forests, whose dominant tree is the black alder, are found in the great plains of central Europe, as in the Warta Valley in Poland.

From northern Europe to the Mediterranean, and from the Atlantic coastline to the inner reaches of Russia, riparian forests provide a striking landscape, stretching out in long corridors from mountain vales to the broad valleys of the plain, and sometimes even into the river deltas. Their physical characteristics are fundamentally different from other types of forests that exist outside the riverine world. Upstream from the valleys, rivers form multiple branches and islands, changing their beds often, on a scale of decades. Farther downstream, the watercourses make large meanders that are more stable and that change their path more slowly, on a scale of

centuries. Riparian forests colonize the banks of the rivers, the terraces set back from the rivers, and the islands. They avoid the shore along the inside of river bends, which can be subject to prolonged submersion, and are not found in swamps or backwaters, except as they begin to fill in. Then swamp forests develop.

The riparian forests of the temperate zone are composed of deciduous trees, whose leaves drop in the autumn and grow back in the spring. They can be categorized into two main groups of trees: those with softer wood—the willows and poplars, which grow on the river banks and in areas subject to prolonged flooding—and the hardwood forest, consisting of ash, elm, oak, poplar, and large vines, with a very dense understory, growing on the uplands. In the Mediterranean zone, the composition is a little different. In the western section, white poplar (*Populus alba*) and ash (*Fraxinus* sp.) dominate the hardwood forests. Farther east, along the continental rivers and as far as the Balkans, oleander (*Nerium oleander*) and the Oriental plane (*Platanus orientalis*) compose the forest along the shore. In the swamp forests, the species of trees are fewer in number and dominated by black alder (*Alnus glutinosa*).

RIPARIAN FORESTS
Plant communities that grow on the edges of streams or bodies of water, in the border zone between water and solid ground. Their constituent plants must be able to tolerate standing water for longer or shorter periods: willows, alders, ash on the edges, maples and elms on higher ground, pedunculate oaks and hornbeams on the top of the bank.

PHOTOSYNTHESIS
See p. 27

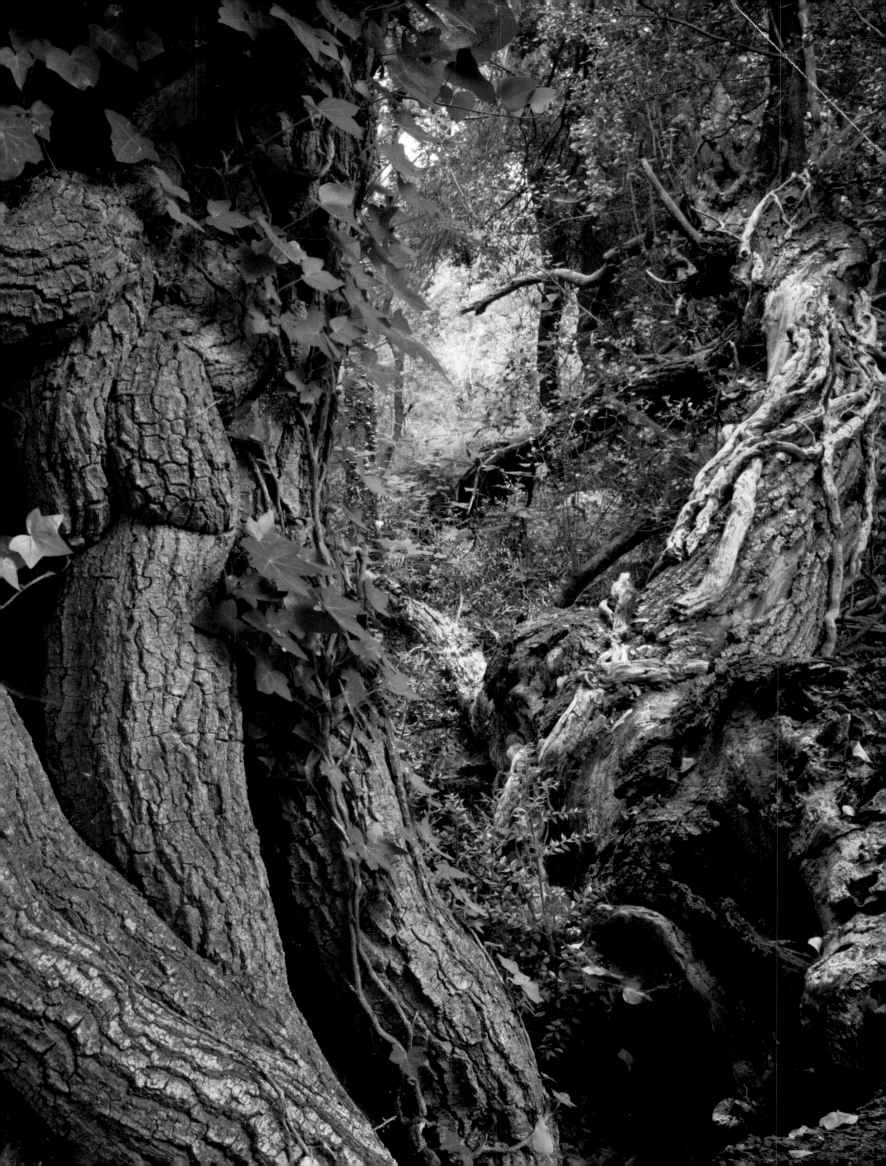

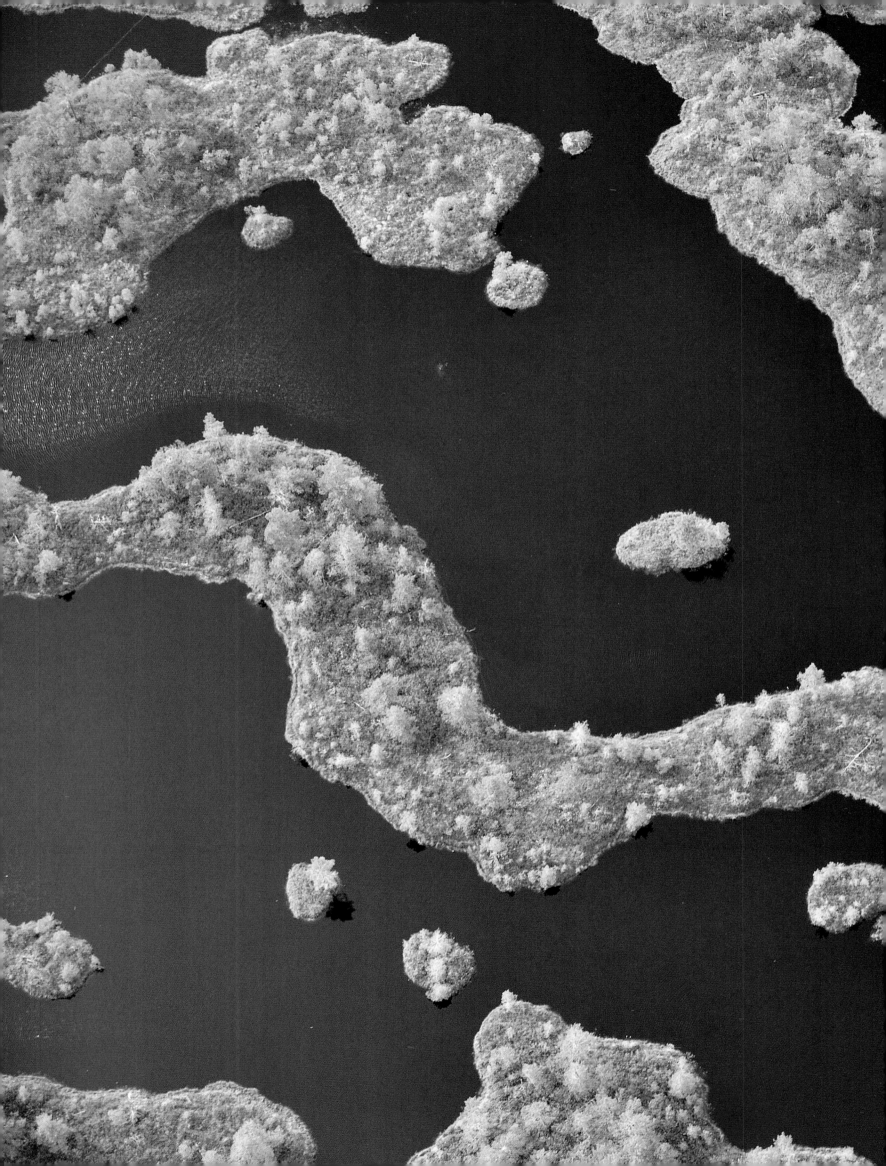

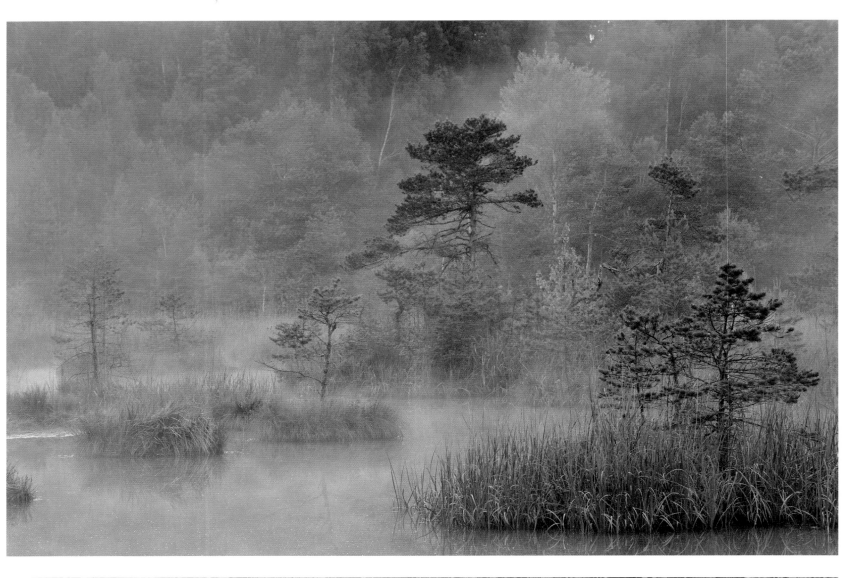

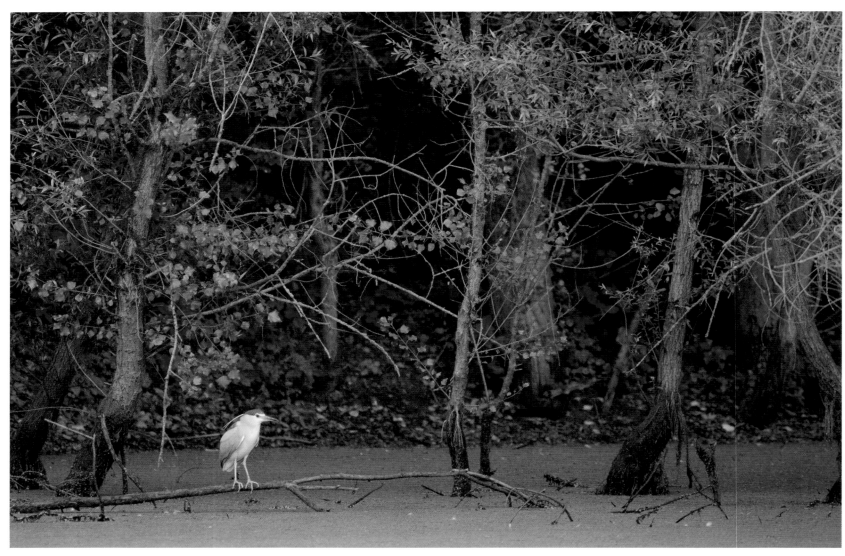

Riparian and swamp forests differ from other forest ecosystems in being reliant on the hydrological conditions in the valleys. Riparian forests in particular depend on the rhythmic phases of the river, the regular expansion and contraction of its waters, both on the surface and in underground springs. As the waters rise, a state that can last several weeks, the roots are drowned and the plants temporarily lack oxygen. Many are capable of withstanding these conditions, but some individuals may die, particularly if the flood occurs during a period of full foliage, at the beginning of the summer. The stress of flooding is better withstood by species that have adapted morphologically and physiologically, and in places where the alluvium, or sedimentary soil, is porous. If the groundwater levels fall relatively quickly, air will circulate soon after the waters recede, and the plants can then resume photosynthesis.

Inundations deposit mineral-rich silts and supply ample water during the growing season, thereby fertilizing the forest and providing transport for insect eggs, organic matter, seeds, and fruits. In concert with the belowground water, the surface water brings moisture to the atmosphere and staves off drought, which can be common during dry European summers.

Certain species such as beech, hornbeam, and conifers do not tolerate a temporary lack of oxygen, particularly when the flooding occurs in summer. They are therefore rare or absent in riparian forests, unlike other species such as oak, ash, poplar, willow, and elm. The trees in the first group are known to have dense foliage and create dark understories, unlike those in the second group, common in riparian forests. The understories in riparian forests are often filled with light, causing them to sometimes be referred to as "forests with trees of light."

Light-filled, moist, and rich in nutrients, some riparian forests display a luxuriance that is quite uncommon in Europe. This is particularly true of the forests growing along the rivers that flow from the Alps on high terraces inundated by relatively calm waters (except during large floods). Plant life flourishes there to such a degree that at every height, from the ground to the canopy, these forests are sometimes referred to as "temperate jungles." As in a true jungle, a very high proportion of the total number of plant species is woody plants (between 15 and 20 percent), and these are particularly abundant in the understory. There, not only does one find the young offspring of the canopy trees, waiting for their chance at growing to full size, but also trees that will remain understory trees throughout their life cycle, including wild pear, wild apple, wild cherry, maples, and a great diversity of shrubs.

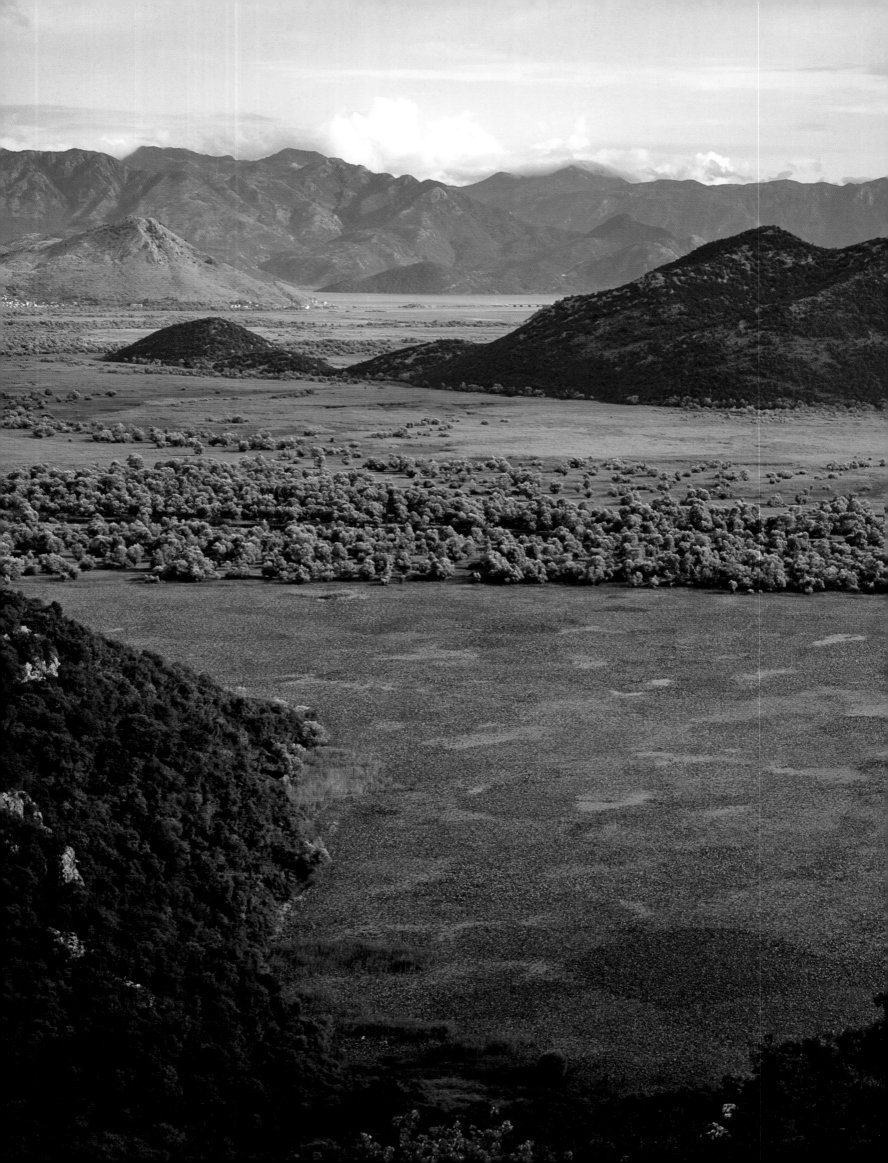

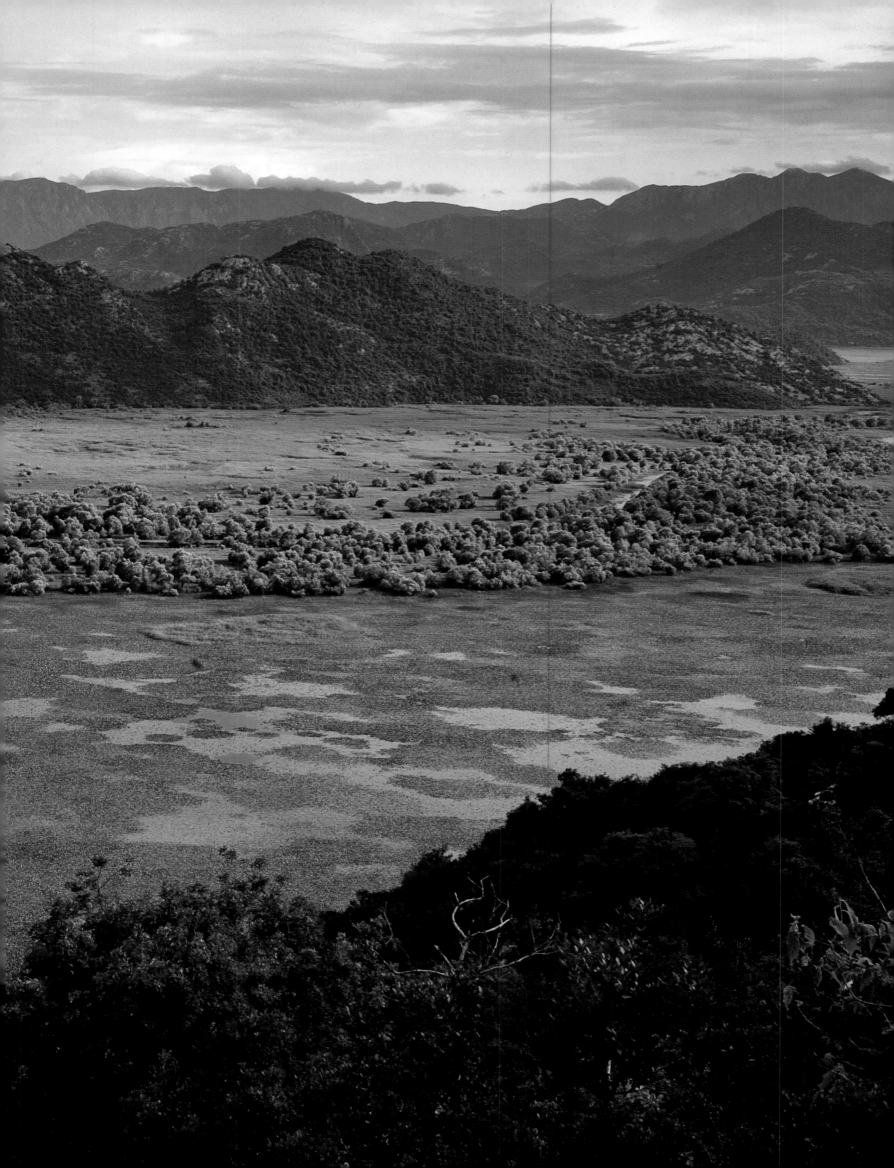

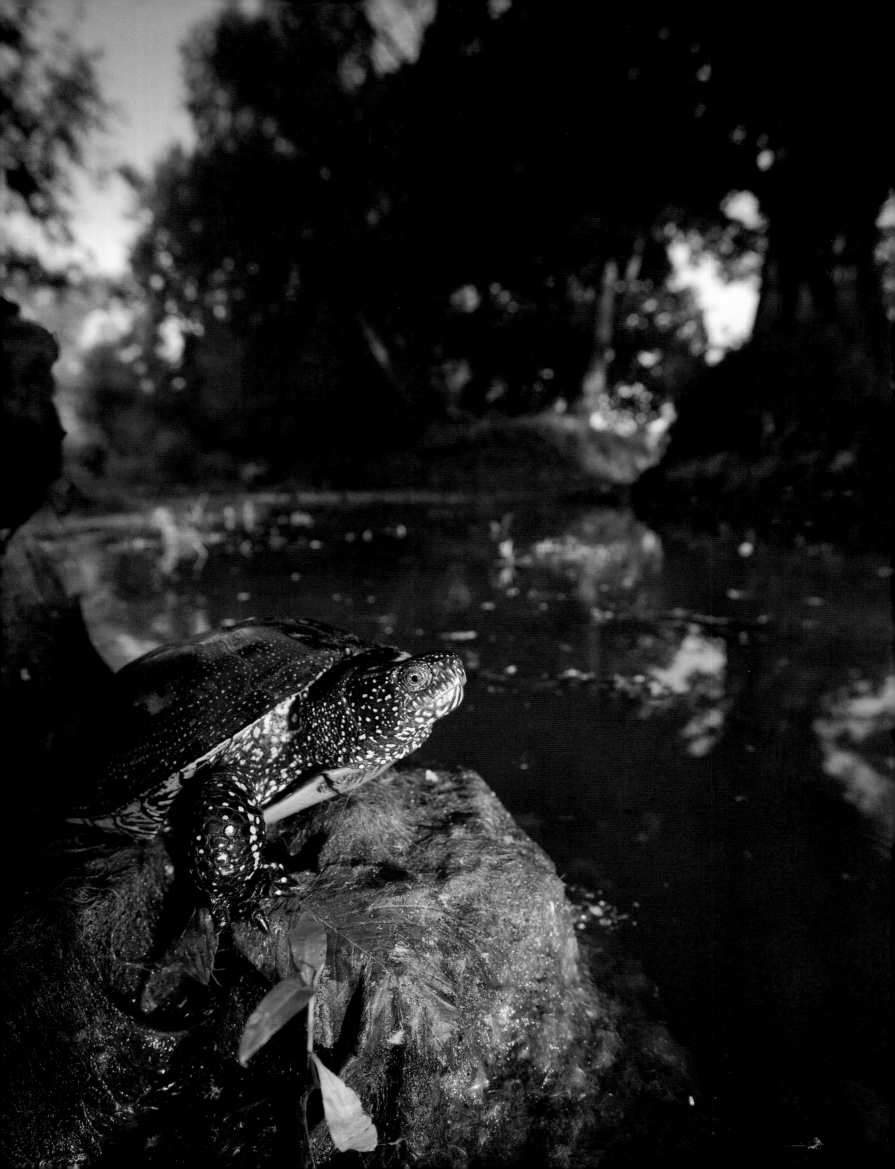

Bog

LATVIA | KEMERI NATIONAL PARK, GULF OF RIGA

Bogs comprise 24 percent of Kemeri National Park in Latvia. Only a few tree species like Downy birch (*Betula pubescens*) and Scots pine (*Pinus sylvestris*) survive on small islands with drier ground. As soon as the water level drops under a certain level for a longer period of time, more and more trees will establish themselves in this extreme environment. A single mature birch tree will then evaporate up to 450 liters of water per day, speeding up the process of the bog's transformation into a completely new habitat.

Diego López

↟
Pedunculate oak overgrown with ivy

Quercus robur and *Hedera helix*
BOSNIA AND HERZEGOVINA | HUTOVO BLATO NATURE PARK

Plants with deciduous leaves (ash, oak) and laurel-like leaves (ivy, box, holly) are sensitive to atmospheric dryness and suffer in the Mediterranean summer. In ravines, however, the impact of human activity is lessened and the soils are deeper. Ravines also maintain a constant atmospheric moisture due to their partial enclosure and proximity to underground water. Deciduous trees grow to an uncommon size in ravines, as do vines such as ivy, which is very sensitive to summer dryness.

Elio Della Ferrera

Bog

LATVIA | KEMERI NATIONAL PARK, GULF OF RIGA

Kemeri National Park, founded in 1997 on a large tract (150 square miles, or 380 square kilometers) on the shores of the Gulf of Riga, contains a wide variety of wetland habitats: swamp forests with black alders; drier pine forests interspersed with lakes, marshes, bogs, and streams. The area is internationally recognized for its wealth of nesting and migratory birds, including such rare species as the Great Snipe (*Galinago media*) and the black stork (*Ciconia nigra*).

Diego López

Black-crowned night heron

Nycticorax nycticorax
FRANCE | BANKS OF THE ALLIER RIVER, PONT-DU-CHÂTEAU, AUVERGNE

The black-crowned night heron is a stout, thick-necked, medium-sized wading bird with relatively short legs. Generally quiet, the heron nests and shelters in clusters of trees, spending the day perched with other herons in foliage near the water and becoming active mainly in the evening and at night. Most of the black-crowned night herons that nest in Europe overwinter in sub-Saharan Africa. The species requires well-preserved wetlands, neither logged nor drained, for its nesting range as well as for its migration route and wintering grounds.

Florian Möllers

Riparian habitat

MONTENEGRO | NEAR DODOSI, LAKE SKADAR NATIONAL PARK

Lying between Montenegro and Albania, Lake Skadar is the largest lake in the Balkans, measuring between 140 and 200 square miles (370 to 530 square kilometers), depending on the flow of the rivers that feed it. Its vast flood zone makes it a major site for waterfowl (ducks, geese, swans, herons, bitterns, and egrets, among others), which nest there in vast numbers. Among those that winter there is the Dalmatian pelican (*Pelecanus crispus*). The forests around the lake are oak-hornbeam or alder woods.

Milán Radisics

European pond turtle

Emys orbicularis
SERBIA | GORNJE PODUNAVLJE SPECIAL NATURE RESERVE, UPPER DANUBE

The European pond turtle is one of the only aquatic turtles in Europe, a carnivorous species that feeds on mollusks, aquatic insects, dead fish, and amphibians. For almost six months from October to March, it winters underwater in quiet areas that are rich in vegetation and deadwood, and that provide it with stable temperatures. The European pond turtle has been in decline since the nineteenth century in large parts of its range, due to human predation for food and to destruction of habitat (straightening of rivers, draining of wetlands, loss of hedgerows). Today, it is an endangered rarity in most of its former range. Efforts to preserve and reintroduce the pond turtle are in progress.

Ruben Smit

↓
European white water lily

Nymphaea alba
SWEDEN | BOHUSLÄN

Water lilies grow in the quiet waters of a river's sidestream. The roots are attached to the river bottom and send up a long stem to the water's surface, tethering the plant's wide leaves and its flowers, which are a blinding white.

Magnus Lundgren

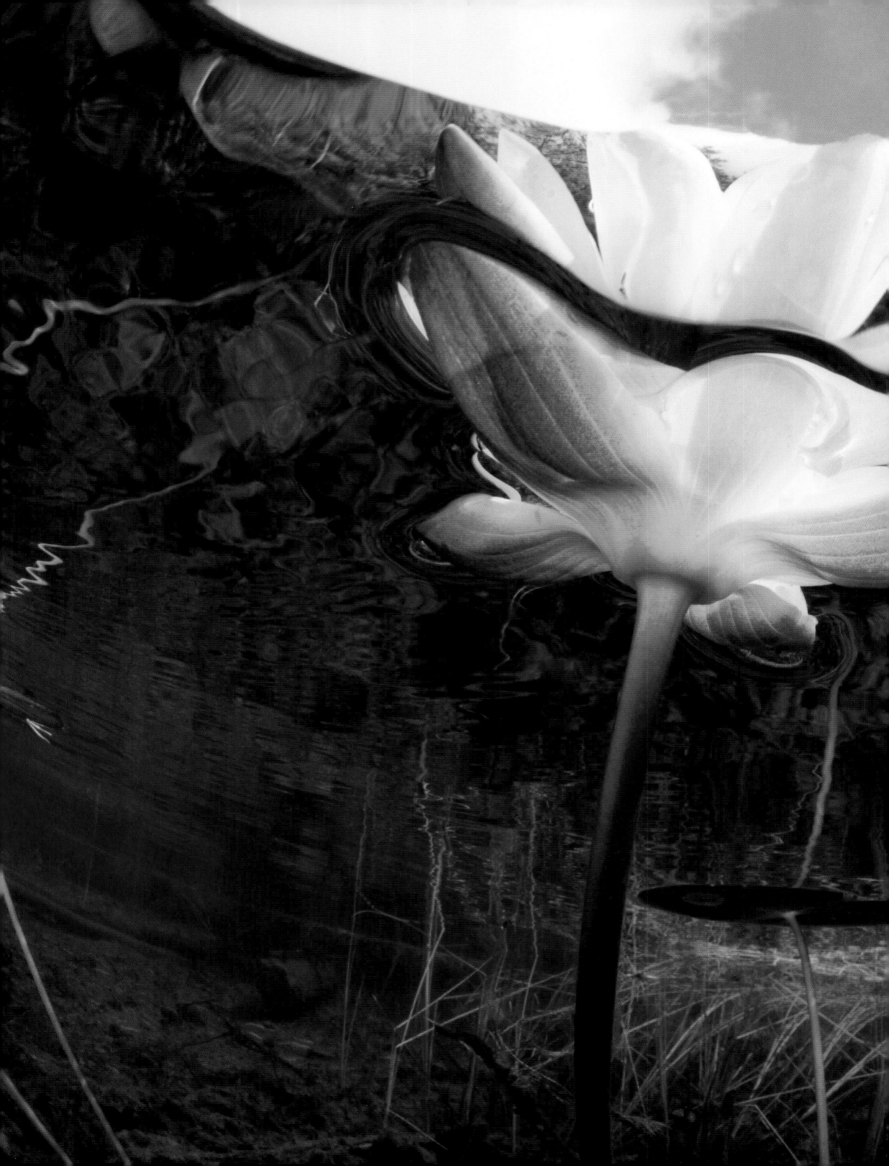

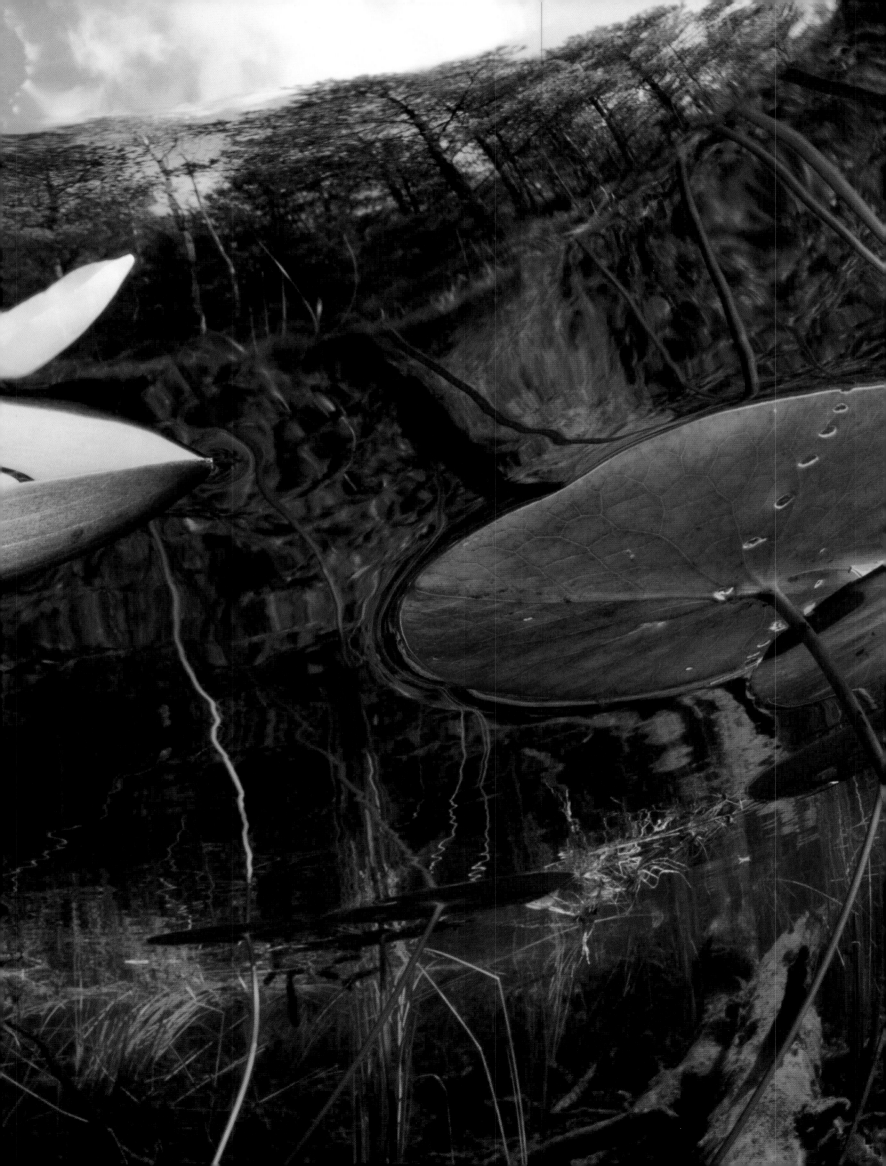

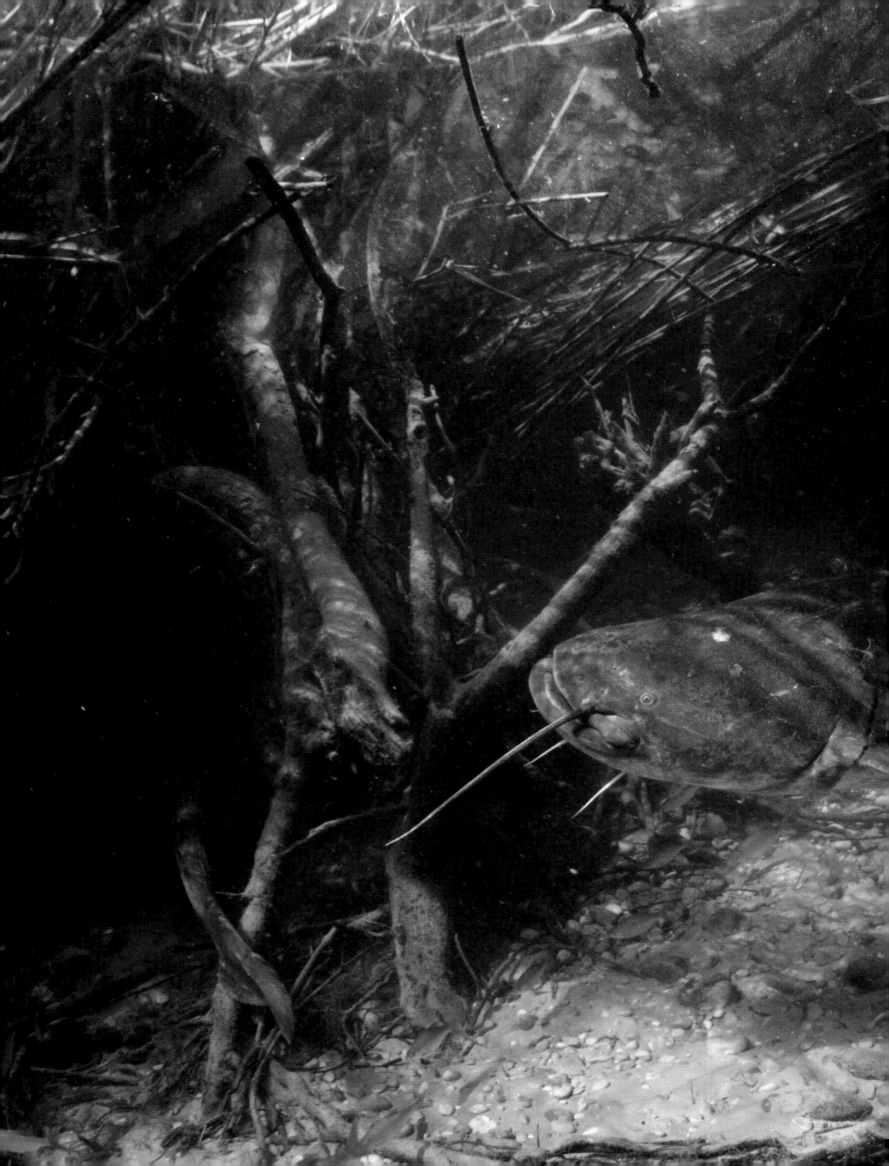

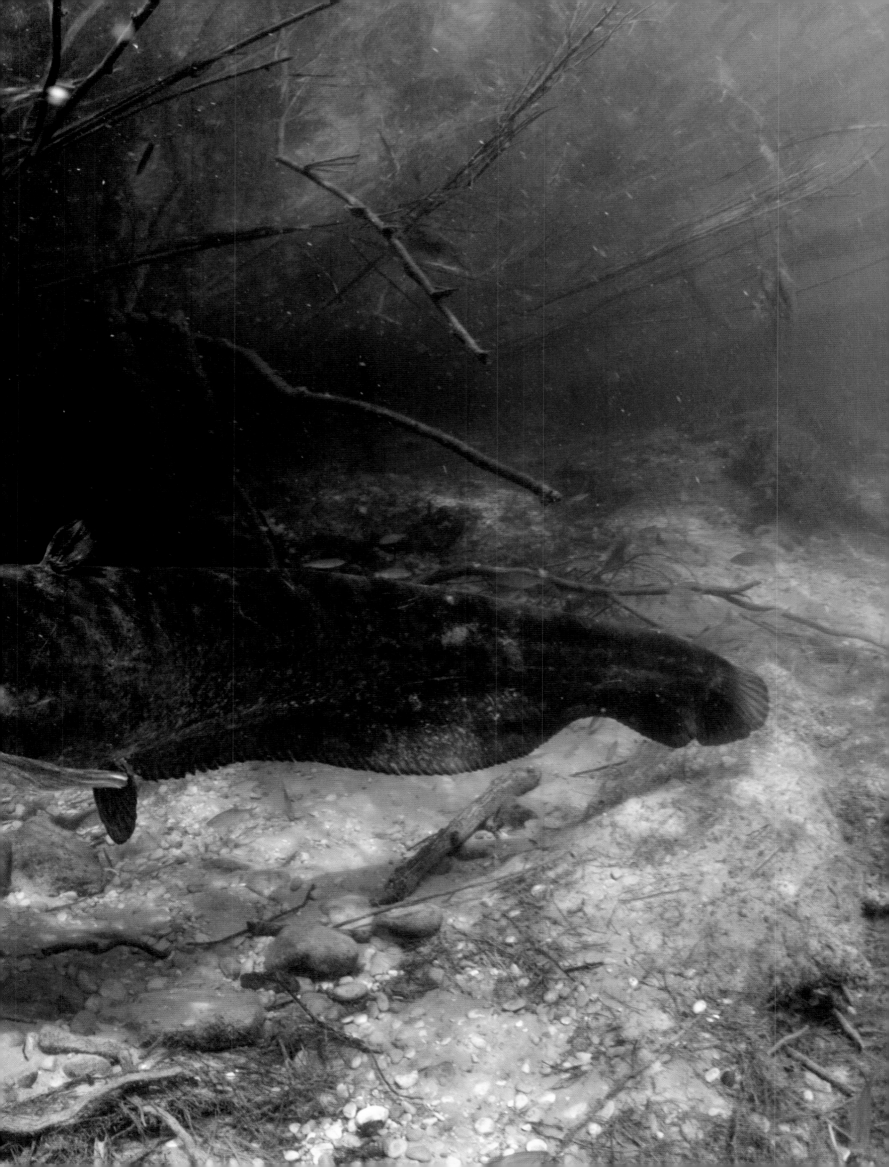

The richness in species and the numerous representations within each species testify to the abundance of resources in these forests, which reduce competition between individuals. In the more stable floodplains of the lower river, the plants in the riparian forests reach unusual sizes very quickly. A white or black poplar may grow to 115 or 130 feet (35 or 40 meters) in less than 100 years; a wild apple may grow to 65 feet (20 meters) in 50 years; and some shrubs that often have only one trunk such as hawthorn may grow to 50 feet (15 meters). In glades opened by a recent deadfall and along the light-filled river edge, woody vines cover every surface with a dense drapery, much as one would expect in a tropical rainforest.

The forests of the temperate jungle are very efficient agents for soaking up floodwaters.

Watercourses play an important role in the productivity and species abundance of riparian forests, but the forests also contribute to the biodiversity of watercourses. They supply them, for instance, with deadwood falling from riverbank trees into the water. The wood, sometimes in large pieces, moves down the streambed in fits and starts. If the resulting accumulations were not regularly removed by human agency, large obstructions would form that are capable of changing a river's course and transforming parts of the floodplain into swamps. Those swamps would then be colonized by species adapted to a waterlogged environment. Nothing remains stable on a river's floodplain; during major floods, everything can change.

By remaining practically intact for centuries, driftwood offers a choice spot for innumerable generations of small aquatic filter feeders to attach their eggs, which can hatch there in safety, ultimately providing an important food source for their predators. When driftwood reaches the sea, it is caught by ocean currents and eventually returned to lie on beaches in drift piles that can reach several meters in height, as, for instance, on the shores of the Baltic Sea or in the Rhone Delta. Driftwood accumulations protect the coastline from erosion and feed numerous life-forms that decompose the wood.

PUBESCENT
Describes the appearance of a plant covered with fine down. This characteristic plays a part in classifying certain flowering plants.

EVERGREEN
See p. 156.

LAURIFOLIATE
See p. 156.

ENDEMIC; ENDEMISM
The native presence of an organism in a given geographic area

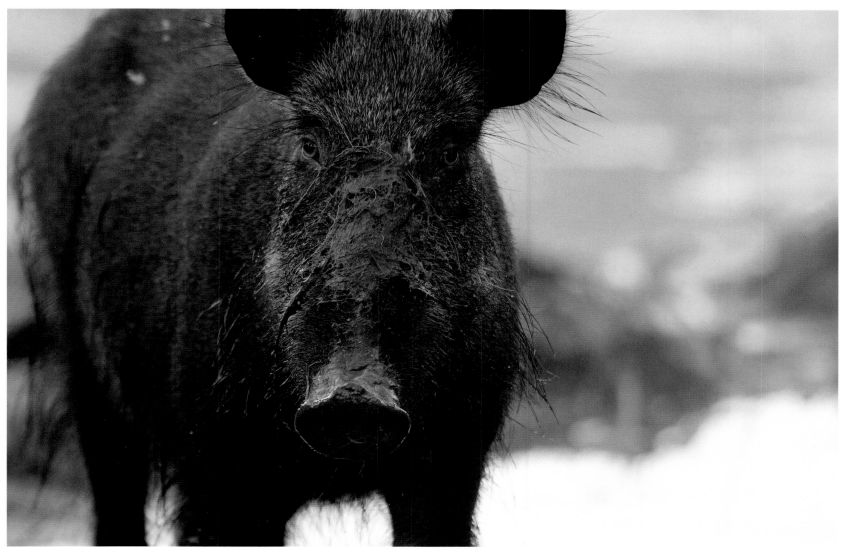

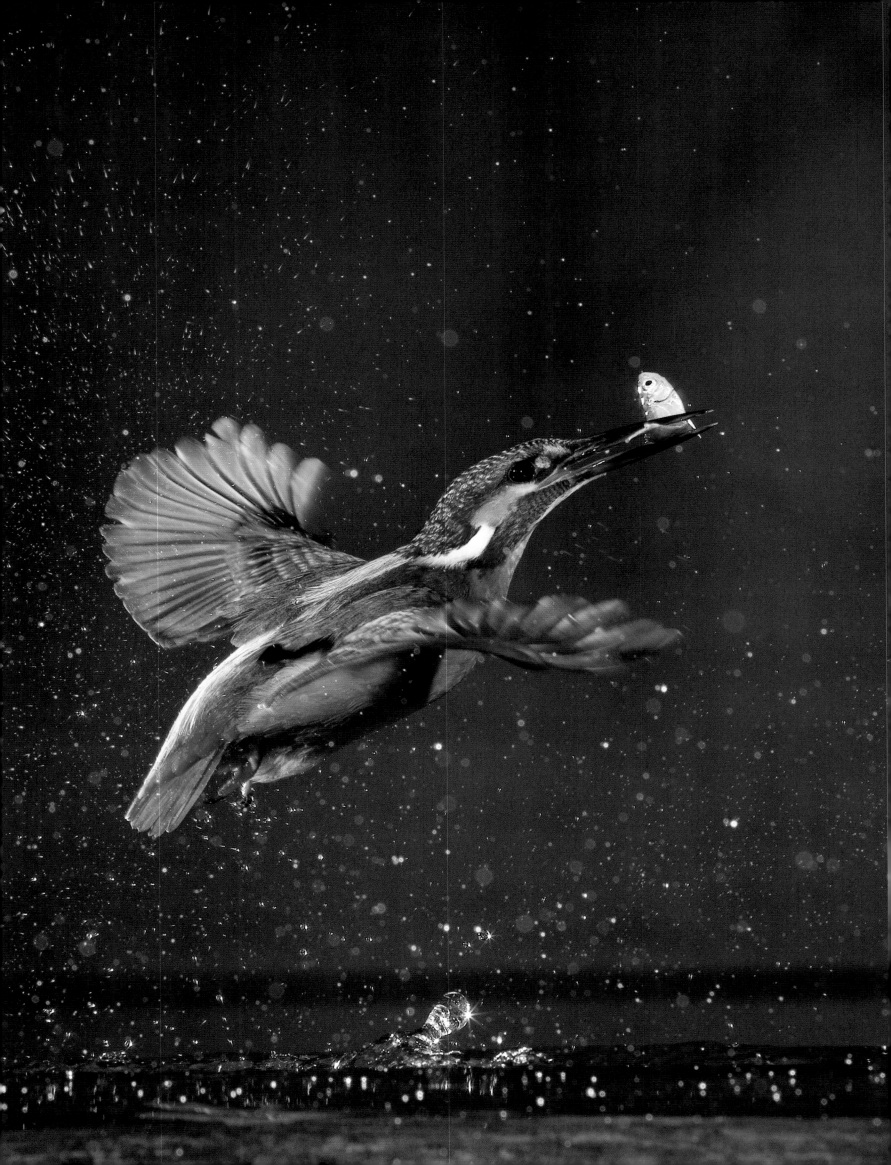

Animals have developed many adaptations to the riparian environment. Ground-dwelling invertebrate species, which are the most endangered by floods, adapt by climbing the nearest tree or becoming airborne. The species of the family **CARABIDAE**, or ground beetles, common to riparian forests are better fliers than those living in upland forests. Other species live in bark crevices rather than on the ground or else adapt by living submerged.

The riparian environment also offers birds a great variety of habitats. Birds live on the banks of watercourses, on their sand and gravel bars; in their forests; reed marshes, and swamps; as well as in their many edge environments. Sixty-two percent of the bird species found in European forests nest in riparian zones or travel through them regularly.

The riparian forests known as temperate jungles can be particularly attractive to certain bird species due to their strong primary production and their stratified architecture. Nesting birds are more common there than in the upland forests of Europe, as more habitat is available and coexistence is easier. The luxuriance of the understory in particular benefits species that live in bushes and low trees, such as the great tit (*Parus major*) and the song thrush (*Turdus philomelos*). The strongly diverse canopy allows the spotted flycatcher (*Muscicapa striata*), the hawfinch (*Coccothraustes coccothraustes*), and the golden oriole (*Oriolus oriolus*) to live there in high densities.

In addition, in temperate jungles, one may also find species that are specific to conifer forests, such as the black woodpecker (*Dryocopus martius*) and the common firecrest (*Regulus ignicapillus*), and to cool mountainous zones, such as the Eurasian treecreeper (*Certhia familiaris*). The frequency of these transient species in riparian forests may be due to the abundance of common ivy (*Hedera helix*), which surrounds many large trunks with a thick mantle of green leaves throughout the year. This large vine's ample fruit production feeds numerous passing birds: dozens of fieldfares (*Turdus pilaris*) and redwings (*Turdus illiatus*) are seen every winter. Ivy also supplies berries to early nesters like the common wood pigeon (*Columba palumbus*) and the common blackbird (*Turdus merula*), among others. The great spotted woodpecker (*Dendrocopos major*) feeds on the ivy's sap, just as it feeds on the sap of trees.

Some bird species nest on point bars, the sand and gravel accretions on the inside of river bends that are uncovered during periods of low water. Among them are the little ringed plover (*Charadrius dubius*) and the common tern (*Sterna hirundo*).

CARABIDS
Large carnivorous beetles;
see p. 65.

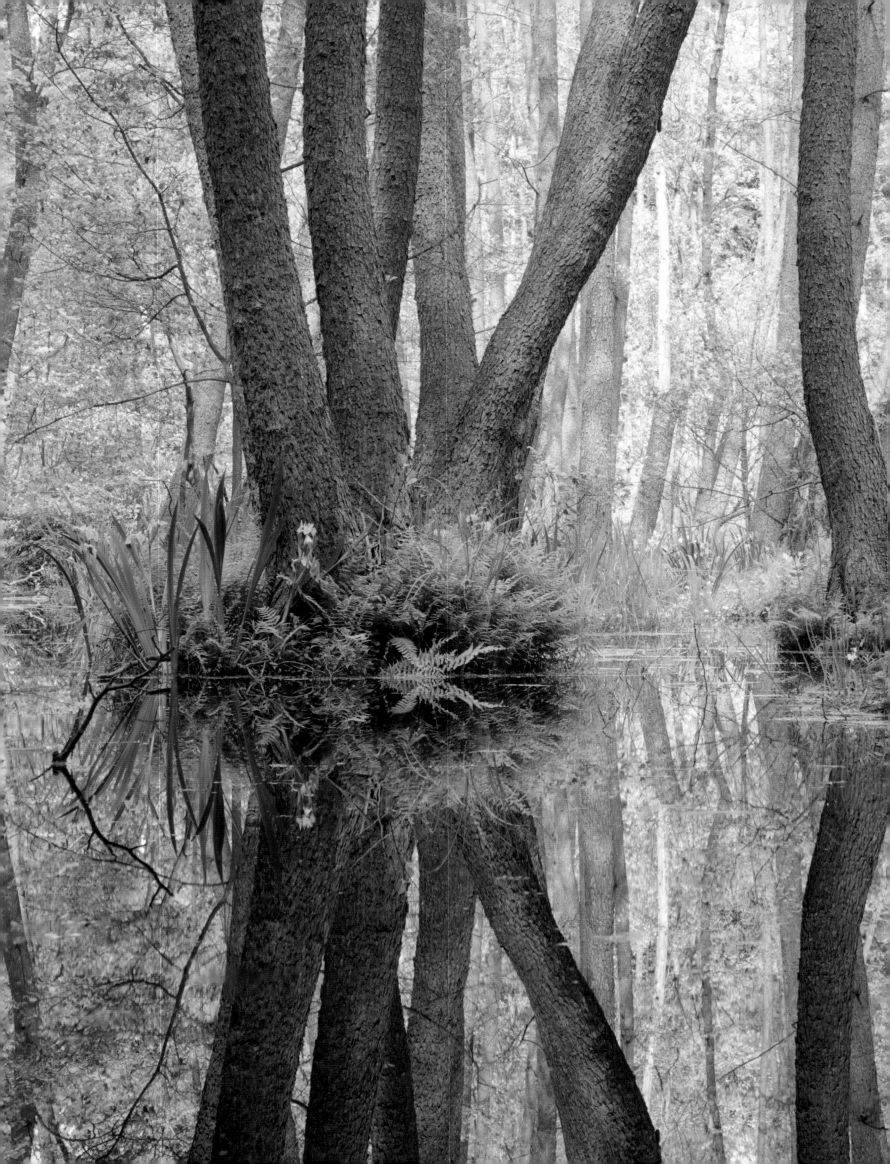

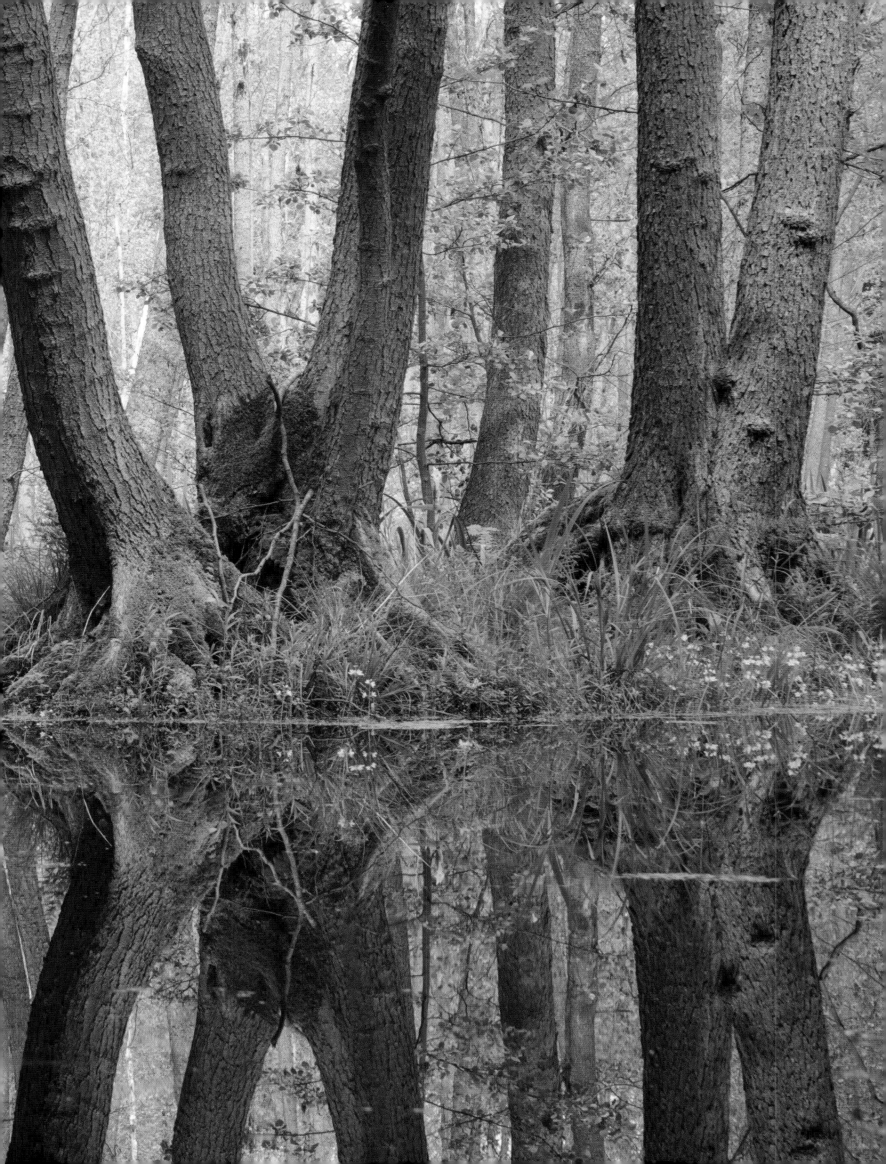

↟
Wels catfish during spawning season
Silurus glanis
SPAIN | EBRO RIVER

Growing up to 10 feet (3 meters) and more than 330 lbs (150 kg), the giant catfish (*Silurus glanis*) is the biggest freshwater predator in large European river systems like the Po, the Ebro, the Rhine, and the Elbe, and in shallow warm lakes. Hiding during the day in dead or hollow trees, or in roots of trees, catfish hunt at night using their excellent hearing, the sensory abilities of their six barbels, special electroreceptive organs, and their head sensory canal system that allows them to track the wakes (a trail of hydrodynamic and chemical signatures left by a swimming fish) of their prey up to ten seconds old over distances of more than fifty times the length of the prey.

Michel Roggo

Valley of the Danube at dawn
SERBIA | GORNJE PODUNAVLJE SPECIAL RESERVE, UPPER DANUBE

The Gornje Podunavlje conservation area is in the floodplain of the Danube River in Serbia. Fine specimens of pedunculate oak are still to be found in its forests, in association with ash and poplar trees. The trees in the reserve reach record sizes after only 100 years of growth, thanks to the unfailing supply of water and nutrients during the growth cycle. However, increased illegal logging and clear-cutting pose a major threat to this forest ecosystem, which is still missing proper protection.

Ruben Smit

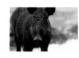

Wild boar
Sus scrofa
SERBIA | GORNJE PODUNAVLJE SPECIAL RESERVE, UPPER DANUBE

Wild boar are excellent swimmers and easily cross streams. They also take advantage of low-water periods to feed on aquatic marsh plants and use the riparian habitat to wallow in mud-holes, especially on hot summer days, as they do not possess sweating glands. As the mud on their bodies dries and flakes off, the parasites attached to their fur fall to the ground.

Ruben Smit

Common kingfisher
Alcedo atthis
HUNGARY | NEAR BALATONFUZFO, LAKE BALATON

Fishing is the kingfisher's distinguishing behavior. The bird locates the fish by sight, preferably from directly above, then swoops down and penetrates deep into the water to find its prey. Kingfishers have a particular fondness for minnow, burbot, gudgeon, bleak, and other cyprinids, but they will also prey on crustaceans, insects, and small frogs. The quick, darting flight of the kingfisher leaves little time to admire its elegant blue and orange plumage, but the bird signals its presence by uttering short, sharp cries in midflight. Entirely diurnal, it flies practically at the surface of the water, rarely rising more than 3 feet above it. The kingfisher nests in a burrow excavated in the cutbank of a river, 3 to 12 feet (1 to 4 meters) above the water. The species suffers when rivers are straightened or confined to artificial channels, as their nesting habitat is impoverished and the river's fish-carrying capacity is reduced.

László Novák

Alders
Alnus
GERMANY | GROBER UND KLEINER ROHRPFUHL NATURE RESERVE, BERLIN

This alder swamp forest is not located in such a "wild" place as the Sava floodplains, but in Germany's capital city, Berlin. Set aside as a nature reserve as early as 1933, the area was part of the death strip around the city in Socialist times, but has since become a Natura 2000 area. Decent water levels are mandatory and the responsibility of the local forester, not only to keep the forest ecosystem intact, but also in order to protect the nests of the two pairs of Common cranes that live on the reserve from predators like foxes and wild boar.

Florian Möllers

Marsh frog
Pelophylax ridibundus
MACEDONIA | MACRO PRESPA LAKE, PRESPA TRANSBOUNDARY PARK

Highly aquatic, the marsh frog remains in proximity to bodies of water, ponds— even rice fields, gravel pits, and eutrophic pools—all year. It can live on the edges of large rivers despite the presence of fish. The marsh frog lays its eggs later than other European frogs, generally in May and June but sometimes as late as July, adjusting its egg laying to the local flood season. The amphibian overwinters in the water, in crevices along the shoreline.

David Maitland

Male golden oriole
Oriolus oriolus
BULGARIA | NIKOPOL, PERSINA NATURE PARK

The golden oriole is relatively common in Europe's temperate and Mediterranean forests. It is hard to mistake for any other bird because of the male's bright yellow plumage (the female's plumage is duller) and its tuneful, trilling song, which ends with a distinctive grating sound. The oriole lives in the higher layers of the broadleaf forest, where it feeds on beetles, the caterpillar of the European oak leafroller, inchworms gathered from the underside of leaves, aphids, bumblebees, spiders, and also fruit.

Dietmar Nill

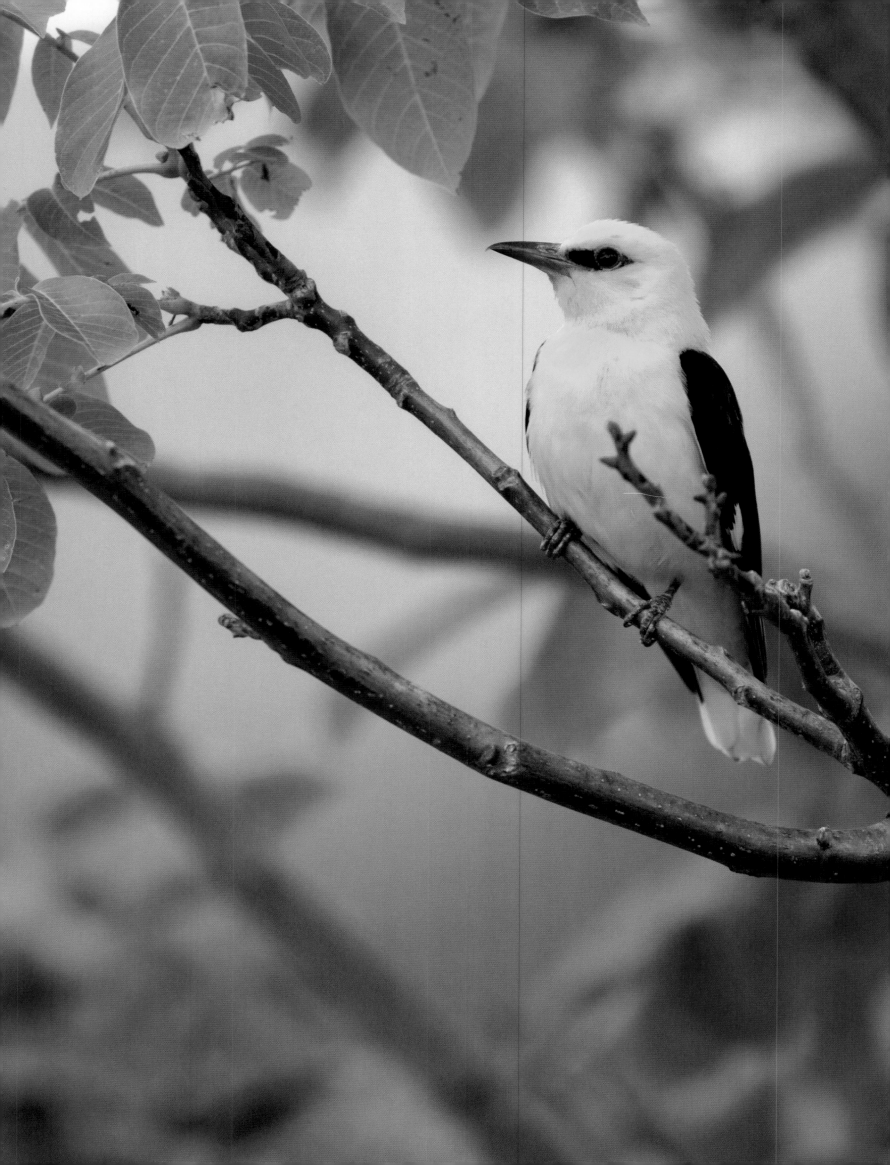

Others nest in the steep cutbanks on the outside of a bend in a stream, such as the sand martin (*Riparia riparia*) and the common kingfisher (*Alcedo atthis*).

The great river valleys and their deltas are important stopping points in the migration of many birds, who follow the three major migratory routes in Europe: on the coastlines of the Baltic Sea and the North Sea, in central Europe, and in the Balkans. The river deltas in particular, with their innumerable rivulets, lakes, fresh or salt marshes, dunes, and riverine forests, are excellent refuges for birdlife. Counting resident and migrating species together, between 250 and 300 species of birds have been observed in the deltas of the Danube River in Romania, the Rhone in France, and the Nestos River in Greece.

No discussion of the riparian environment can fail to mention beavers, in this case the Eurasian beaver (*Castor fiber*), and the European otter (*Lutra lutra*), two mammals specific to stream banks. The beaver, an engineer skilled at felling trees, is most at home along slow-moving watercourses with wooded, unconsolidated banks, where it can feed on herbaceous plants and on the leaves and inner bark of softwood trees, and where it can burrow dens into the bank above mean water level or, if it chooses, use willow sticks to construct a lodge. It was the popular belief at one time that the beaver's lodge-construction, tree-felling, and dam-building activities were responsible for the flooding of whole forests and the destruction of valuable economic resources. In fact, as we now know, the beavers' activity is a key element in the ecological cycle of riparian forests. Nonetheless, the beaver was hunted mercilessly for its valuable fur, leading to its near elimination. By the end of the nineteenth century, only a few Eurasian beavers were left, most of them in Russia. Programs to reintroduce them into many parts of Europe have, however, been successful.

The weasel family is well represented in the riparian forest: the otter, of course, but also the stoat (*Mustela erminea*), the European polecat (*Mustela putorius*), and several species introduced from America including the American mink (*Mustela vison*) and the muskrat (*Ondatra zibethicus*).

Amphibians abound in the riparian environment, living in temporary pools left in the wake of floods. These typically include the yellow-bellied toad (*Bombina variegata*). The agile frog (*Rana dalmatina*) and the smooth newt (*Lissotriton vulgaris*) live in permanent ponds. Other amphibians, such as the European common frog (*Rana temporaria*), live on the moist floor of the riparian forest.

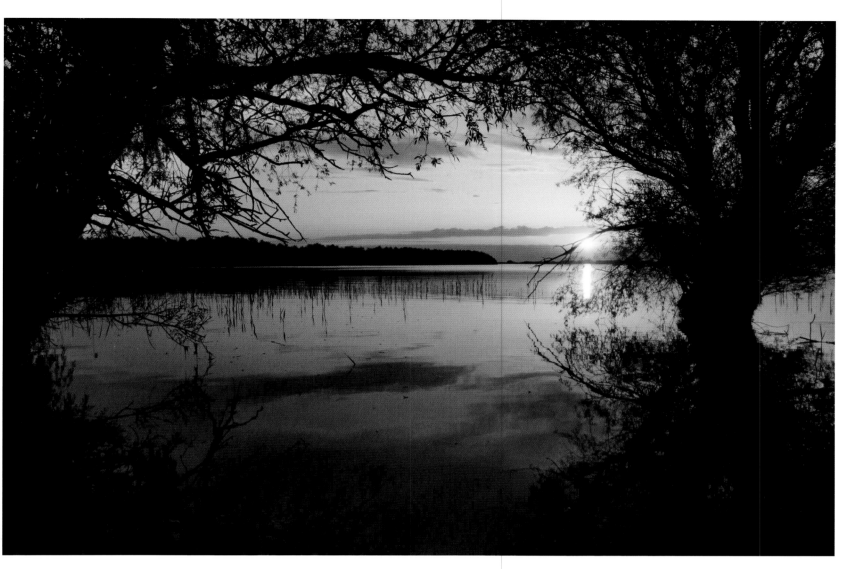

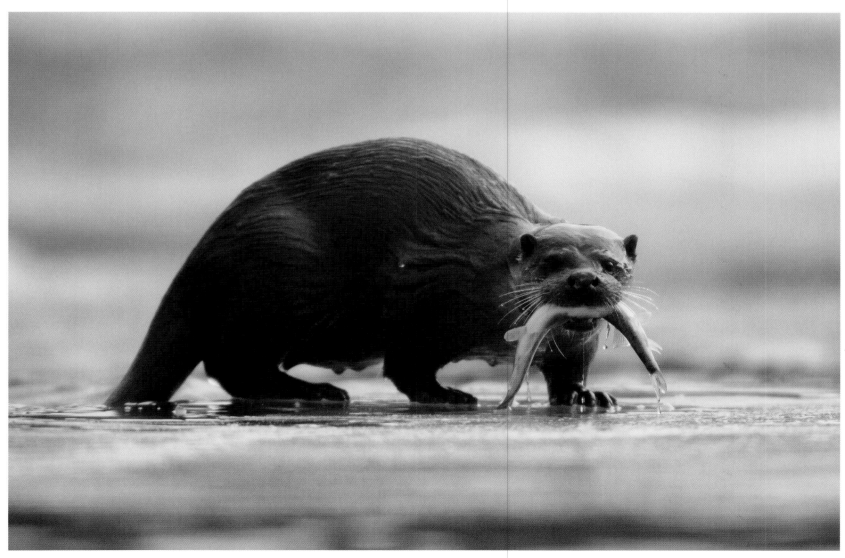

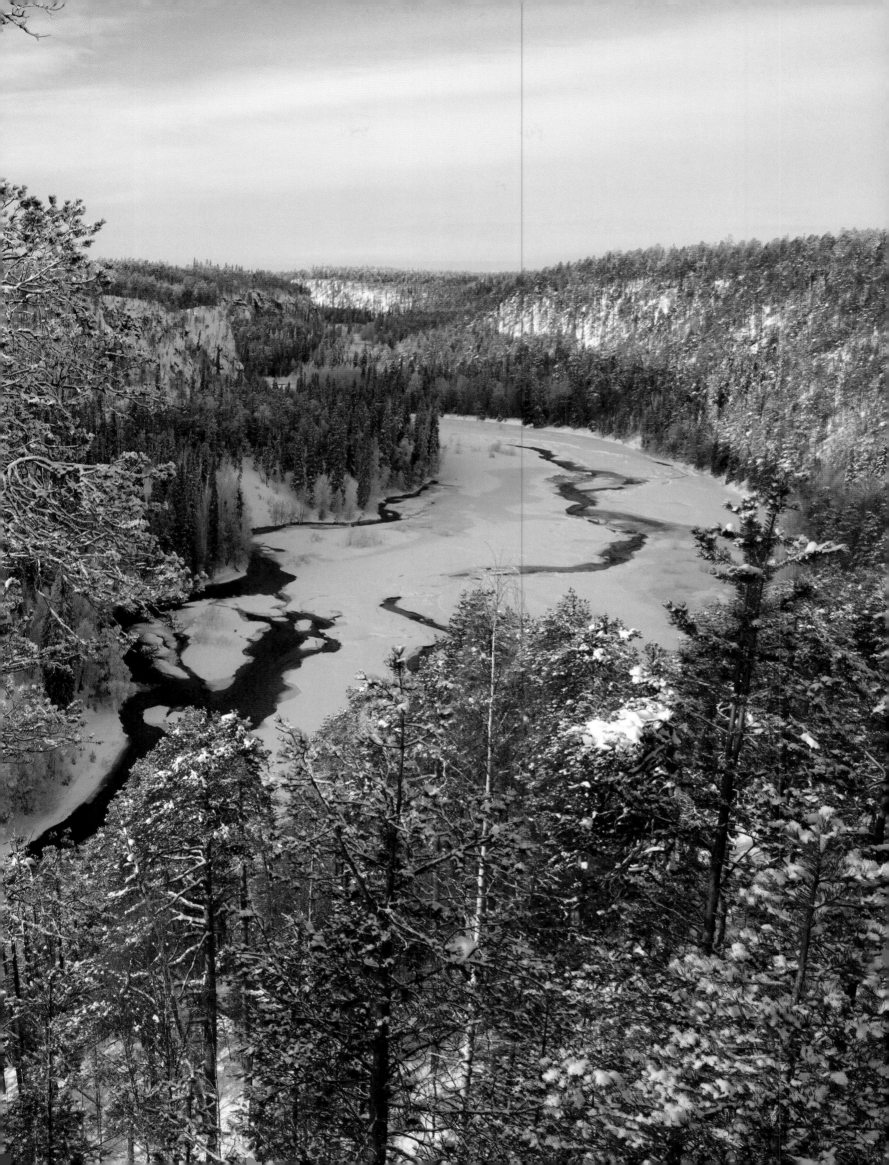

THE BOREAL FOREST

EUROPE'S NORTHERN REACHES, ROUGHLY BETWEEN 56 DEGREES AND 66 DEGREES NORTH LATITUDE, ARE OCCUPIED BY TWO MAJOR BIOMES: the TUNDRA, which extends above the Arctic Circle, and the coniferous boreal forest, or TAIGA, immediately to the south. In the tundra region, the subsoil is PERMAFROST or permanently frozen soil. The lack of trees in the tundra is also partly due to extremely cold winter temperatures, low annual rates of precipitation, poor soils, and intense browsing by reindeer, Eurasian elk, lemmings, and grouse. At the point where the permafrost ends, the boreal forest starts. The ecology of the boreal forest changes gradually from west to east as the climatic effects of the continental mass increase. Moving from Iceland to the eastern parts of European Russia, thermal contrasts become greater, the brightness level is higher, and precipitation declines. The forests are therefore more productive in the east.

Low temperature levels in the boreal region limit the amount of evaporation occurring there. The natural environment, saturated with meltwater in summer, is dotted with lakes and peat bogs. In the forest, the very cold winters and short growing seasons favor the establishment of coniferous trees—spruce, pine, and fir—that have developed useful adaptations. The conical form of these trees causes the snow to slide off, preventing breakage to their branches from the snow's weight. Their needles, whose dark green color absorbs the weak sunlight, have a waxy coating that protects them from freezing and slows transpiration. Only the Siberian larch loses its needles in winter. A few deciduous trees nonetheless survive in the taiga, such as birches (genus *Betula*), rowans (genus *Sorbus*), the common aspen (*Populus tremula*), black alder (*Alnus glutinosa*), and hazel (genus *Corylus*).

Climate differences between west and east explain differences in species composition between boreal forests. To the west, they are dominated by Norway spruce (*Picea abies*) and include the Scots pine (*Pinus sylvestris*). To the east, Siberian spruce (*Picea obovata*) is dominant, along with two Asiatic species in western Russia: the Siberian larch (*Larix sibirica*) and the Siberian fir (*Abies sibirica*).

Boreal forests also host a greater number of moss and lichen species than temperate forests (excepting temperate rain forests). Moss and lichen grow abundantly on the tree trunks and branches. They are epiphytes, meaning they do not parasitize the trees they grow on. Epiphytes are uncommon in Europe. They generally thrive in continuously humid climates. However, the quantity of moss and lichen also rises in proportion to the age of the trees, as they thrive in the deep

BIOME
A set of ecosystems that make up a unified geographic and climatic entity. To consider ecological conditions at the biome level is to consider them on a fairly large scale.

TUNDRA
Open plant community of the Arctic characterized by mosses, lichens, a few grasses, and birch trees occurring in areas of scarce rainfall and low temperatures (average temperatures during the warmest month are below 50 degrees Fahrenheit, or 10 degrees Centigrade, and the frost-free period lasts only two or three months per year).

TAIGA
A synonym for "boreal forest," the taiga is found at latitudes just below the tundra.

PERMAFROST
Soil or subsoil that is frozen throughout the year and that covers 20 percent of the Earth's surface.

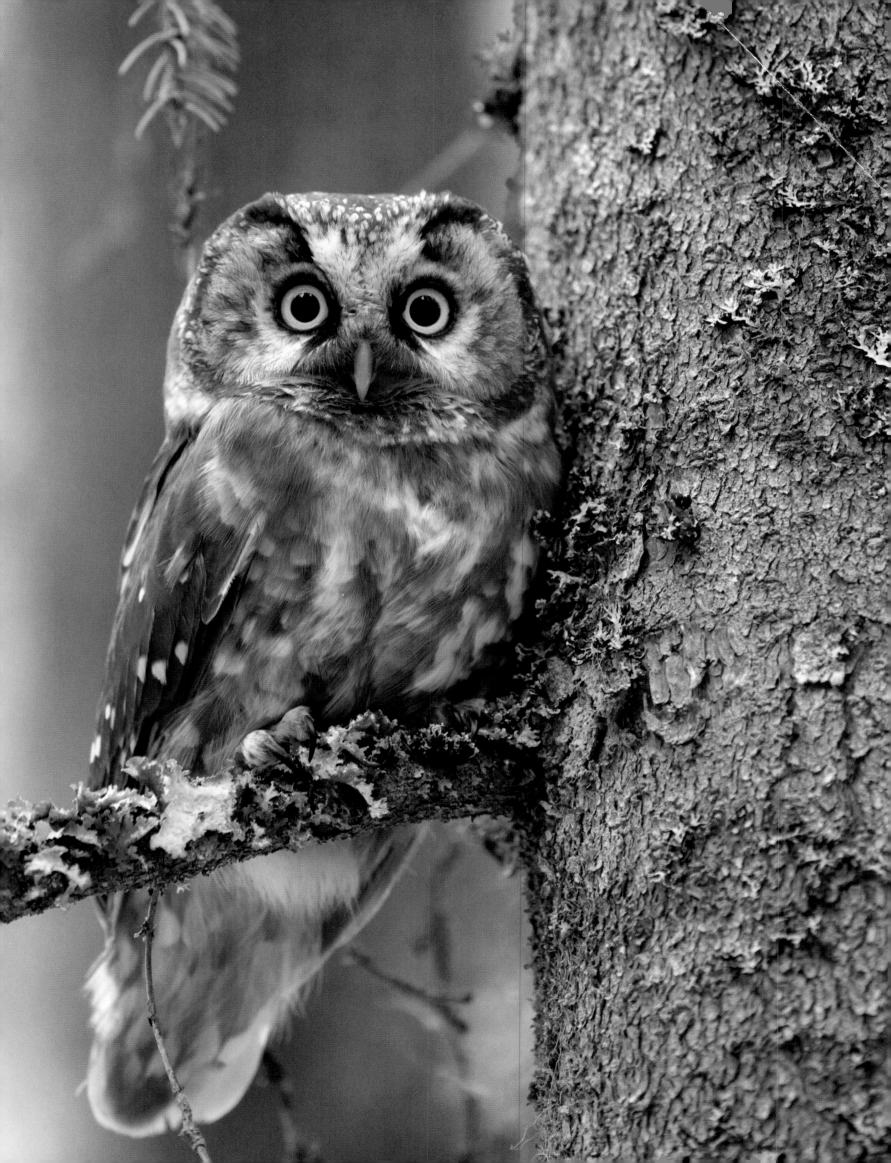

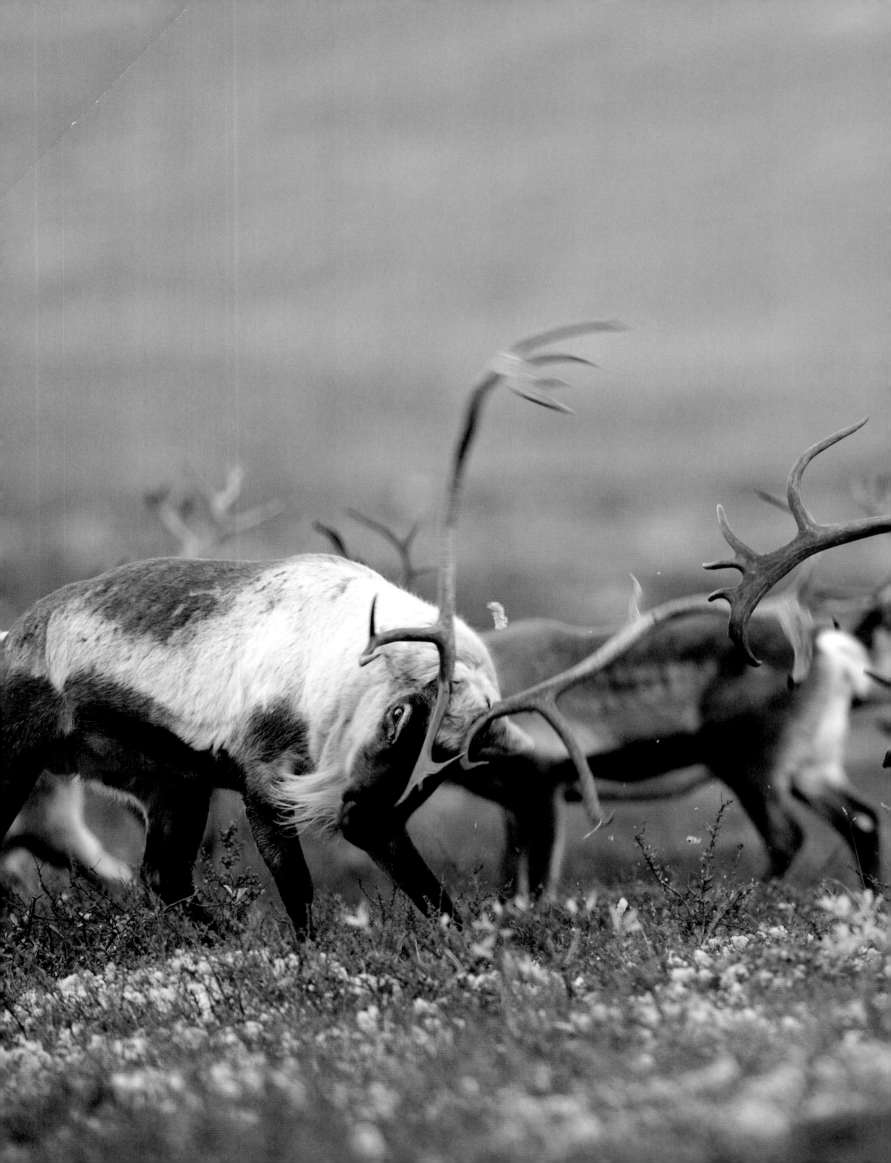

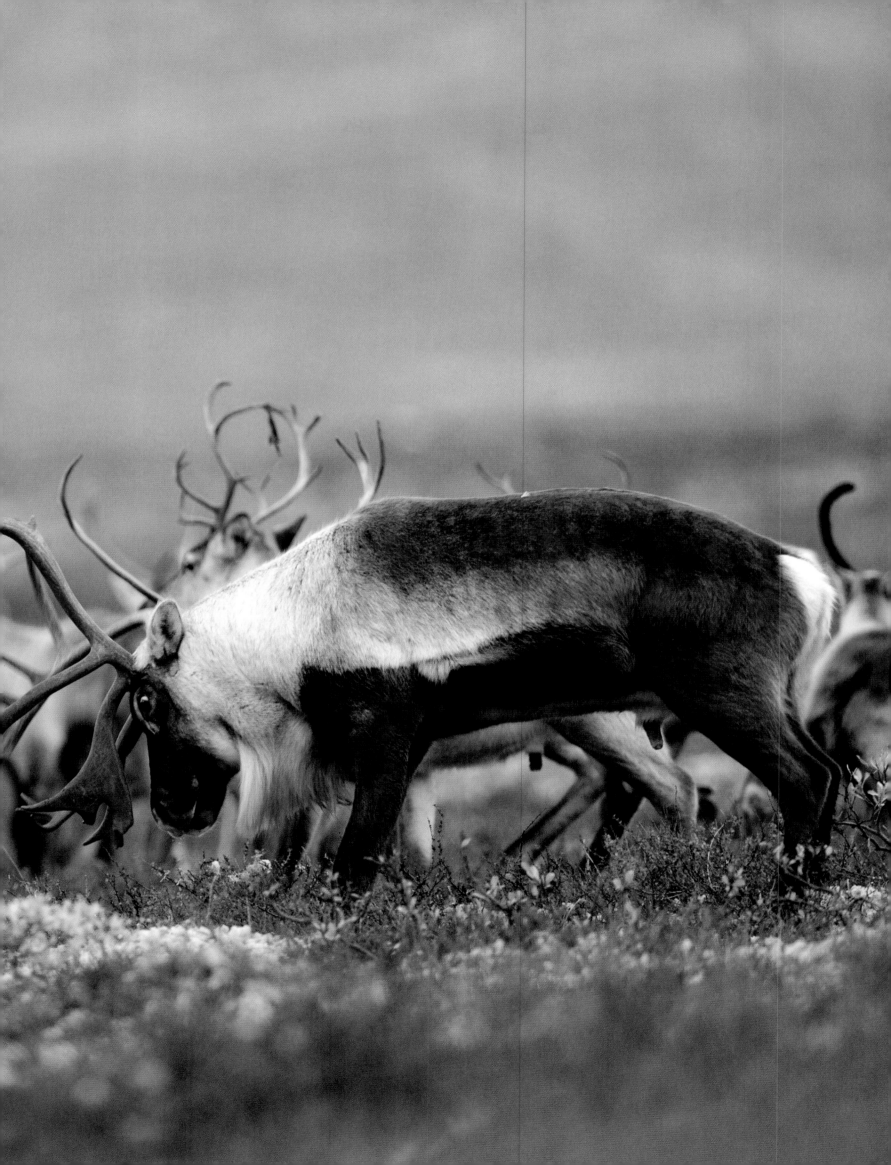

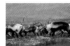

Danube Delta
ROMANIA

The delta of the Danube River and the Razim-Sinoe Lagoon, which lies south of the delta, extend over 1,700 square miles (442,000 hectares) on the edge of the Black Sea in Romania. This is the largest wetland in Europe after the Volga Delta. The Danube delta has three branches: Chilia, Sulina, and Sfantu Gheorghe, all of them interspersed with vast freshwater lakes, sandy islands, dunes, marshes lined with extensive reedbeds, and riparian forests with softwoods and hardwoods. Because of its great ecological value, this wetland is extensively protected: as a designated Ramsar site, a biosphere reserve, and a nature reserve.

Manuel Presti

European otter
Lutra lutra
POLAND | BIESZCZADY

For centuries, the otter (*Lutra lutra*) was considered a danger to fish stocks in rivers, lakes, and fish farms, and was heavily persecuted for its wonderful fur. In addition, the destruction of natural rivers and floodplain habitats, the impact of pollution quickly led to its decline all across Europe. Conservation campaigns in the 1980s and 1990s, the restoration of its equally threatened habitats, and strict hunting bans largely contributed to the slow return of the otter to many of its old haunts. Even some cities like Berlin now have growing otter populations to such an extent that some people think hunting and trapping should be permitted again to control their numbers. Otters are classified as a "near-threatened species" on the Red List of Threatened Species published by the International Union for the Conservation of Nature (UICN), as they are extinct in a portion of their natural range.

Grzegorz Lesniewski

Black grouse
Tetrao tetryx
SWEDEN | BERGSLAGEN

The black grouse likes clearings in pine-birch forests in the northern and mountain regions of the temperate zone. The great majority of the extant black grouse population lives in Finland, Scandinavia, and Russia. Gregarious during mating season, the male grouse gather at a traditional area called a lek to parade in front of the females. They spread their wings and fan their tails to display their white under-tail coverts, uttering a low, far-carrying coo that alternates with explosive "sneezes." The females then select a male with which to mate.

Erlend Haarberg

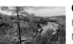

Old-growth boreal forest
FINLAND | OULANKA NATIONAL PARK, KUUSAMO, NORTHERN OSTROBOTHNIA

The Oulanka River in northern Finland displays the characteristics of an intact boreal floodplain ecosystem. Its forests are old-growth, and those along the river have a large quantity of deadwood, contributing branches and trunks to the stream. In winter, a portion of the river is iced over. The habitat draws many nesting birds (fourteen of the fifteen nesting species of northern Europe are present). Established in 1956, the national park boundaries were extended in the 1980s to border Russia, and now measure more than 100 square miles (270 square kilometers). The connection between the two countries allows the free circulation of species between them.

Sven Začek

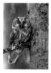

Boreal owl
Aegolius funereus
SWEDEN | BERGSLAGEN

This small owl chooses mixed old-growth forests in northern Europe's belt of mainly coniferous forests and in subalpine zones further south. The boreal owl nests in abandoned cavities made by the black woodpecker and depends so closely on this species that its population fluctuates accordingly with black woodpecker populations. It also requires an abundance of small mammals to feed on. When prey populations are scarce, many females will not lay eggs.

Peter Cairns

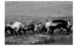

Reindeer on the tundra
Rangifer tarandus
NORWAY | FOROLLHOGNA NATIONAL PARK

Reindeer, which live on the tundra and in open portions of the taiga, migrate over great distances in summer. In the tundra biome where the reindeer lives (and is hunted) in the wild, it feeds largely on cladonia, a genus of mosslike cup lichens that cover the tundra floor. In winter, the reindeer subsists on a frugal diet of lichens and mosses, which it reaches by digging through the snow with its hooves. Shown here in rut season in October, the males fight each other for a harem of females. Norway's Forollhogna National Park holds one of the last truly wild populations of reindeer in Europe.

Vincent Munier

A stand of dwarf willow on the tundra
Salix herbacea
ICELAND, THINGEYJARSYSLUR

Harsh conditions in the Arctic make growth difficult for woody plants, and only a few extremely small willows colonize the open spaces of the tundra. One of these is the dwarf willow (*Salix herbacea*). Other herbaceous plants accompany this tiny tree, protected from the cold by their thick structures and their clonal propagation by underground runners. Flowers, always brightly colored because of the importance of ultraviolet light at these high latitudes, make only a brief appearance during the short growing season.

Daniel Bergmann

Forest of European black alder
Alnus glutinosa
LATVIA, KEMERI NATIONAL PARK, GULF OF RIGA

In this very wet swamp-forest landscape, the partially open canopy with its many large dead trees points to the excellent state of conservation of this northern European forest.

Diego López

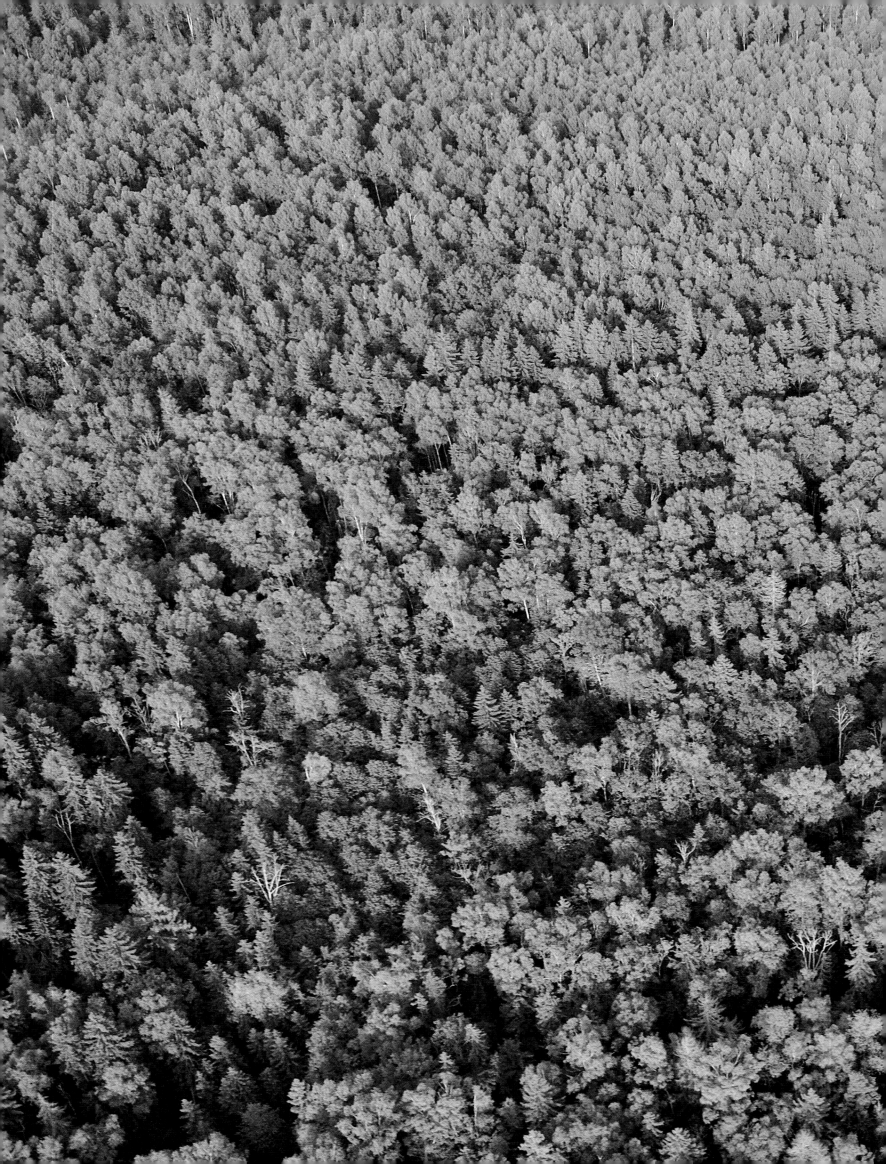

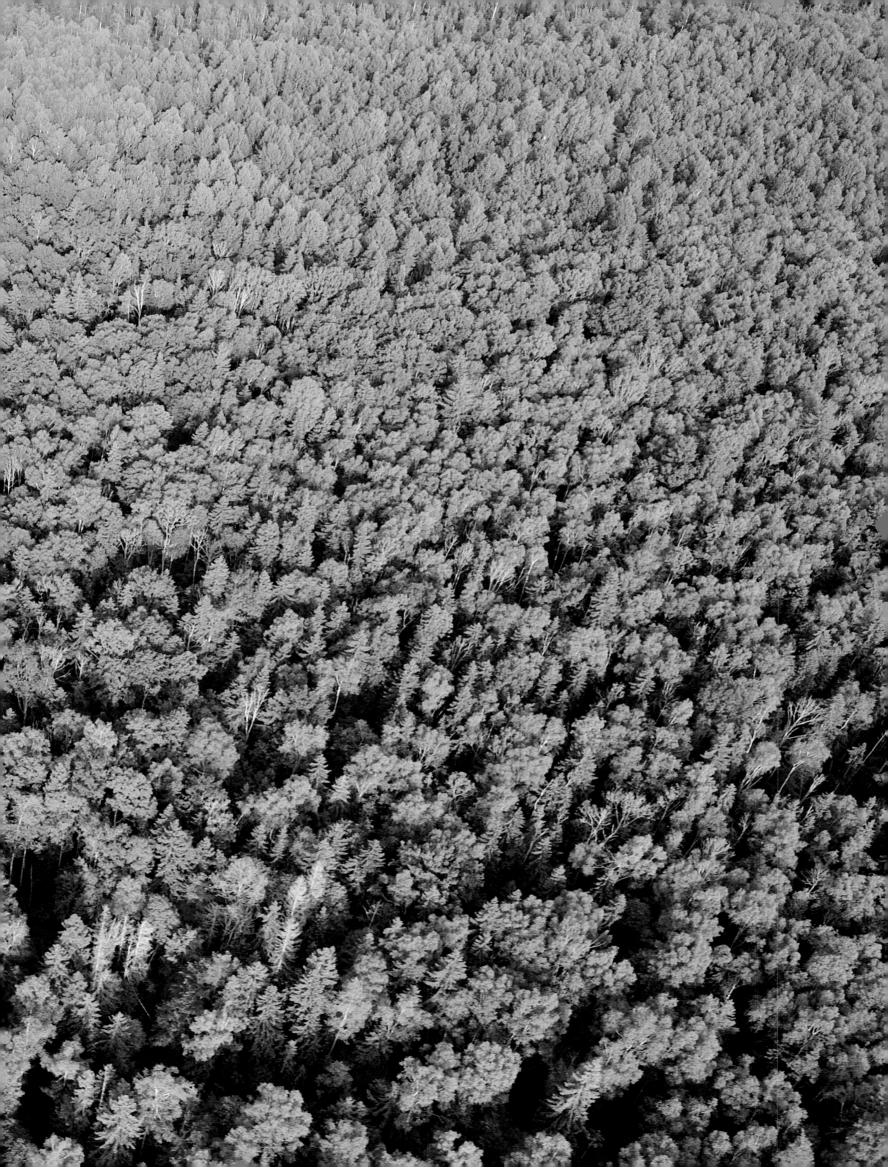

crevices of a mature tree's bark, which retains water, and boreal forests often contain very old trees.

As cold temperatures and high acidity levels inhibit bacterial activity in the soil and retard the breakdown of organic matter into its mineral components, boreal forests have an abundance of dead wood and highly humic soils, that is, soils with a deep layer of humus. Plant growth is slowed down. Trees develop slowly and remain small in stature. They can nonetheless survive to a very advanced age, sometimes several hundred years.

Because of the poor soil, symbiotic relations between plants and mushrooms become extremely important. Mycorrhizae are found in 70 to 80 percent of plants in the boreal forest.

The abundance of dead wood, the highly organic soils, and the dry summers make for conditions favorable to fire, though conditions are even more favorable in eastern Siberia, where the climate is more influenced by the continental landmass than other areas of Europe. Fires also become distinctly more frequent where men have started blazes deliberately. But whether caused by lightning or the hand of man, fire accelerates the decomposition of organic matter, and a new and diverse array of life forms quickly takes over—plants, fungi, lichens, and invertebrates— stimulated by the access of light and ashes on the burnt ground. Club

mosses (genus **LYCOPODIUM**) spring up, as well as brackens (genus *Pteridium*), willowherbs (genus **EPILOBIUM**), and deciduous trees (poplar and willow), which remain in place until the conifers take over once again. Some of the deciduous trees can survive for a very long time. In the natural forests of Scandinavia, it is not uncommon to find ancient willows, sometimes two hundred or three hundred years old, in the midst of a stand of conifers, evidence of a long-ago fire.

The ability to survive long, cold winters is crucial for animals living in the boreal zone, which face the choice of hibernation or migration. Snow confronts them with another challenge, limiting their range of movement and their access to food. Among the mammals of the boreal forest are Eurasian elk, woodland reindeer, wolf, and lynx, as well as wolverine, which is the largest of the European Mustelids. In winter, the wolverine may feed on reindeer, which it catches thanks to the deep snow that makes escape difficult. In summer, the wolverine also preys on reindeer, but only the young of the species. Sometimes called "Europe's hyena," the wolverine is above all a carrion eater, following in the wake of other large carnivores, the wolf and the lynx, to scavenge on the carcasses they have left. As for the reindeer (*Rangifer tarandus*), some

LYCOPODIA
Plants of the fern family, the *Lycopodia* are a genus of club mosses. Though able to reproduce sexually by spores, they more generally do so vegetatively by rhizomes. Their creeping stems make them susceptible to trampling underfoot, and they are becoming scarce.

EPILOBIA
The epilobia (genus *Epilobium*) are herbaceous plants of the family Onagraceae. They have large inflorescences of pink flowers, recognizable by their extended ovaries. A familiar example is fireweed (*Chamerion angustifolium*).

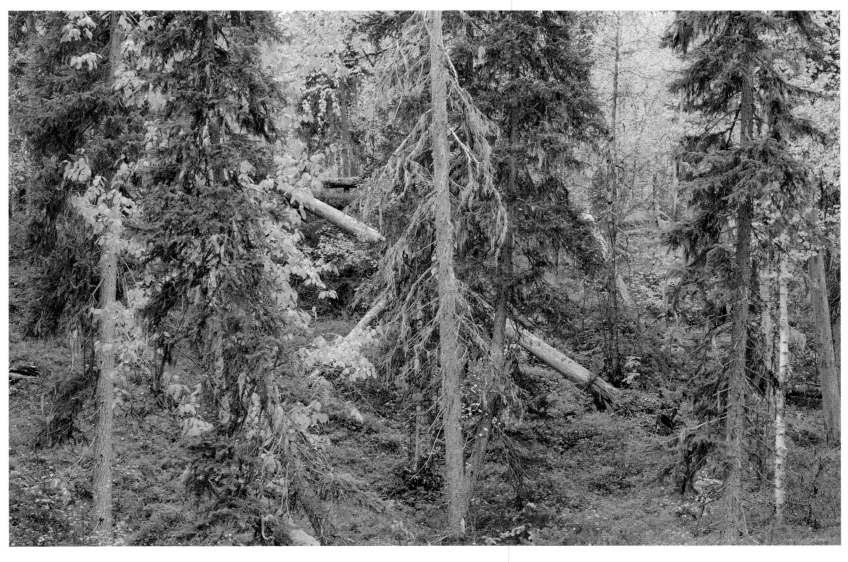

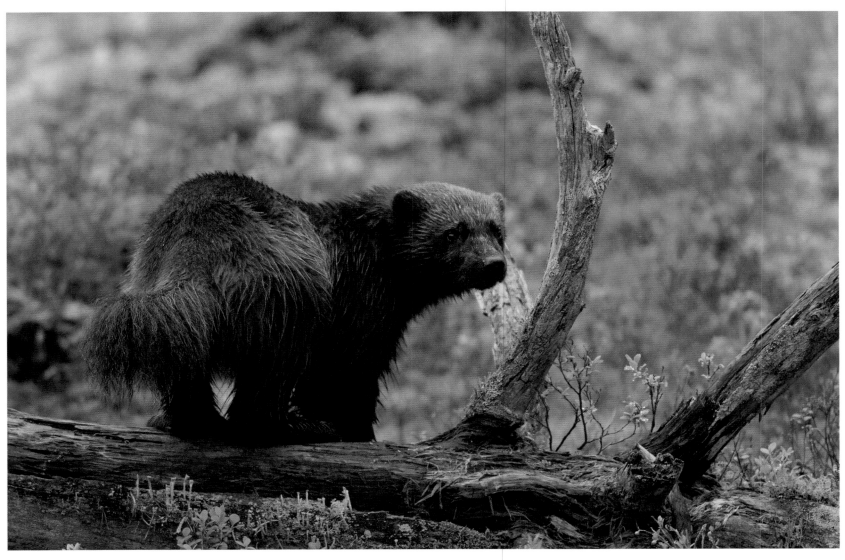

populations move onto the tundra in summer, but the woodland reindeer spends its whole life in the taiga, as does the Eurasian elk (*Alces alces*).

The large predators of Europe—bear, wolf, Eurasian lynx, and wolverine—live in the boreal forests, but their population densities vary widely. Where they face pressure from hunters and poachers, they are scarce, becoming more common where protections are in place for them and also for their prey. All in all, these four predators have made a remarkable comeback in the last twenty years, and their numbers, though small, are on the increase in most countries.

Certain birds are emblematic of the evergreen forest. The great gray owl (*Strix nebulosa*) is partial to boreal forests, using nests vacated by diurnal raptors. Other owls, such as the boreal owl (*Aegolius funereus*) and the Eurasian pygmy owl (*Glaucidium passerinum*), inhabit the conifer forests of the temperate northern and mountain zone.

Grouse are well represented in boreal forests. The western capercaillie (*Tetrao urogallus*) is dependent on conifers, whose needles it browses in winter. It also requires clearings where berry bushes can grow and a good selection of ARTHROPODS, essential for feeding its chicks. Though the species is rapidly

disappearing from the mountains of south and central Europe, largely because of loss of habitat due to massive deforestation, the western capercaillie is holding its own in the north. Other grouse species live in open spaces within the forest (clearings, peat bogs, glades created by deadfalls), such as the hazel grouse (*Tetrastes bonasia*) and the black grouse (*Lyrurus tetrix*), a magnificent bird with a spectacular mating dance. The three-toed woodpecker (*Picoides tridactylus*) is another species of these boreal forests. Feeding on sap and the larvae of wood-boring insects, it favors mature forests with an abundance of dead wood.

Boreal forests have been heavily exploited as an economic resource. Their use for intensive timber harvesting has altered them considerably, transforming rich and diversified habitats into same-age plantings of a single species. This type of intensive use leaves very little room for natural forest regrowth processes.

ARTHROPODS
Phylum that includes insects, spiders, scorpions, and centipedes, but also such fossil groups as trilobites

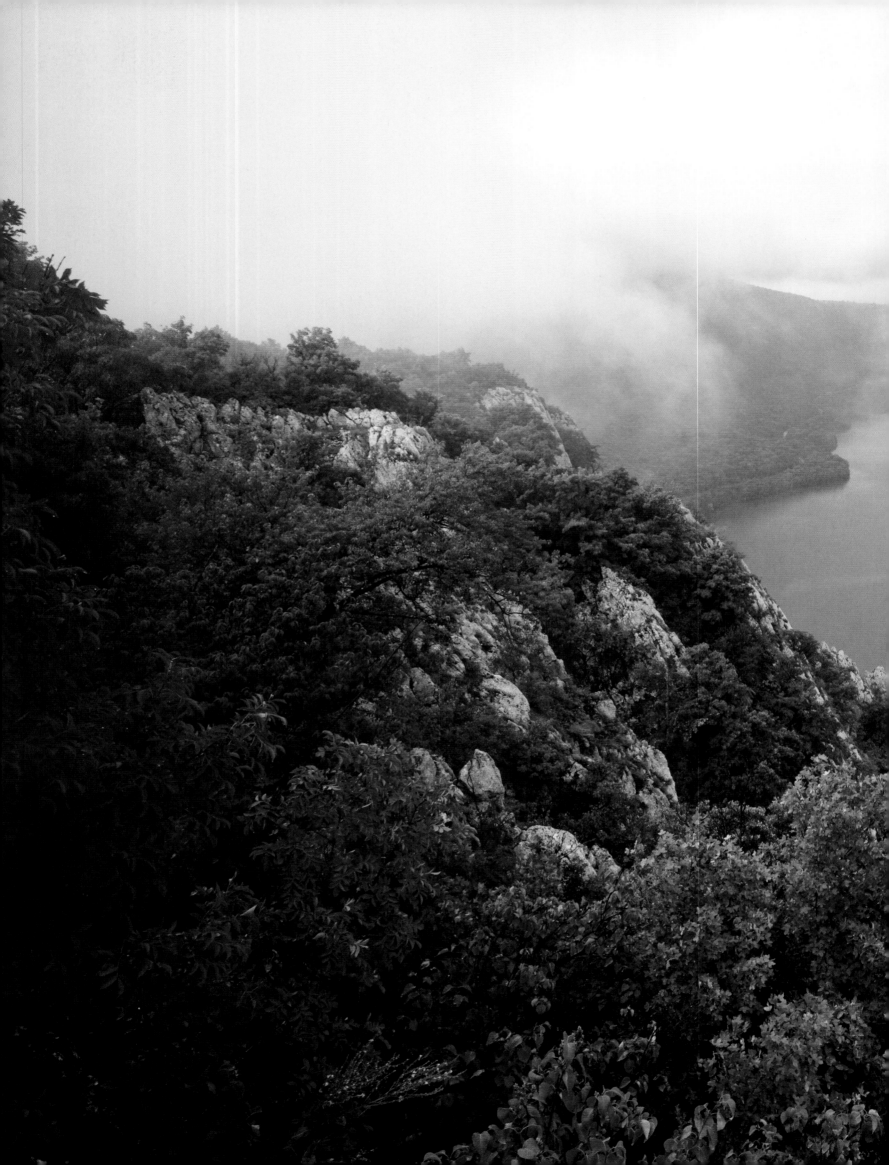

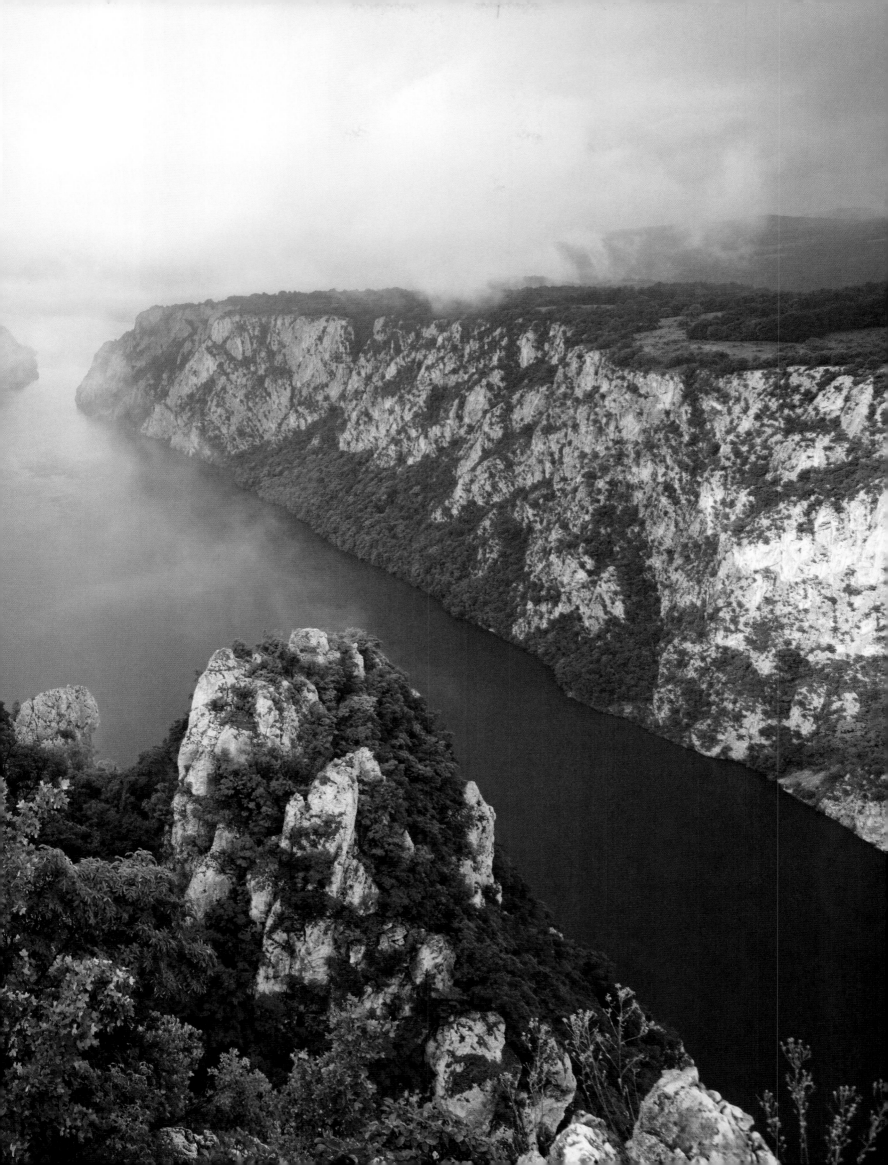

THE TEMPERATE FOREST

The temperate forests exist roughly between 44 degrees and 55 degrees north latitude. The effect of the continental landmass on climate, which shows a marked gradient from the Atlantic coast to the Urals, contributes to their diversity, as does the wide variance in topography across the region, from broad plains to high mountains. Rainfall is ample throughout the area, particularly in western Europe, ranging from 30 to 60 inches (750 to 1500 millimeters) annually. Average yearly temperatures vary from 45 to 60 degrees Fahrenheit (7 to 16 degrees Celsius), with cold winters. The soil of the forests is generally moist, deep, and fertile, especially in the western plains.

PRODUCTIVE SPRING, FLAMBOYANT AUTUMN

Unlike boreal and Mediterranean forests, temperate forests are not subject to frequent fires, but they do have to contend with the effects of wind, especially in the Atlantic region. The great majority of their plant species are deciduous, the main forest trees being beech (genus *Fagus*), ash (genus *Fraxinus*), oak (genus *Quercus*), maple (genus *Acer*), linden (genus *Tilia*), hornbeam (genus *Carpinus*), and elm (genus *Ulmus*), all of which include more than one species. In the mountains and interior of the continent where periods of freezing can be long, conifers become dominant over deciduous trees. In western Europe, fir takes over, and in eastern Europe, spruce. The northern temperate forests of Scandinavia and Russia also contain more spruce for the same reason. Toward Russia, the conifers include larch and Siberian fir, as in the boreal forests.

The temperate forests have two features that set them apart, both related to their deciduous nature: their flamboyant autumn colors and the sudden, brief blooming of their understory in early spring. The autumn colors, which range from orange to deep yellow, correspond to a physiological process, the degradation of chlorophyll, which allows the nongreen pigments of the leaf to appear. All through fall, the leaves draw off the mineral by-products of photosynthesis to stock them in their roots for the following spring. Also an indirect consequence of the leaves' dropping in the fall is the concerted spring bloom of plants with bulbs and rhizomes (garlic, squill, primrose, bluebell, corydalis, violet).

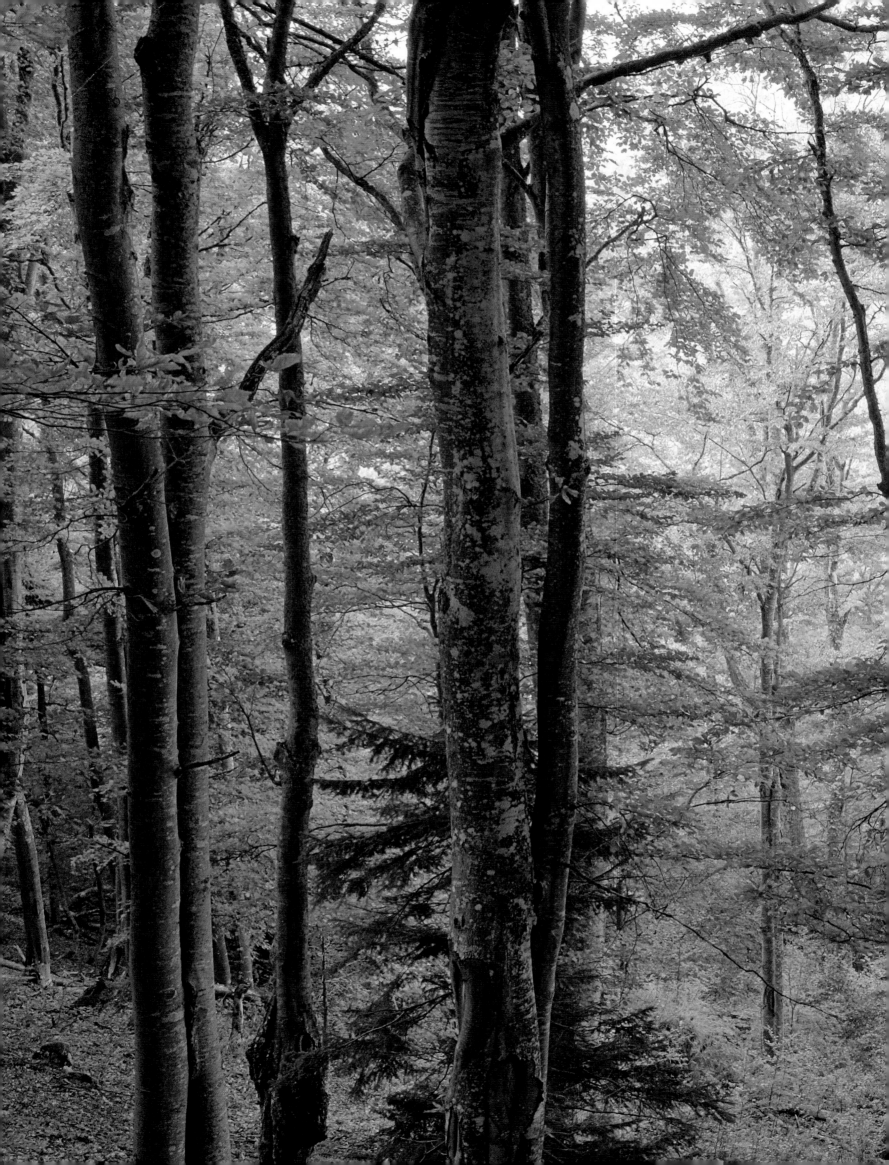

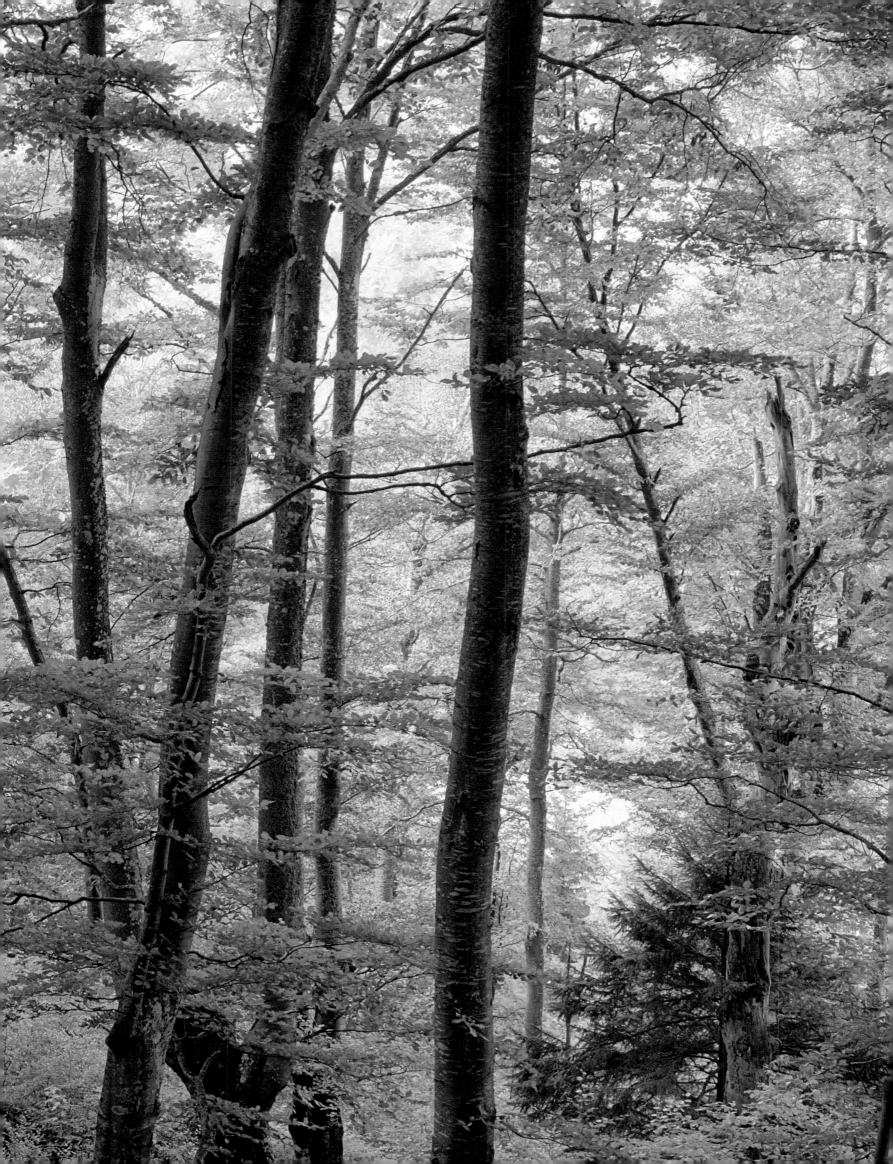

Taiga
FINLAND | OULANKA NATIONAL PARK, KUUSAMA, NORTHERN OSTROBOTHNIA

The dominant tree in the natural forests of the taiga is spruce, supplemented where there are openings in the canopy by broadleaf trees, particularly birch. The glade here resulted from the death of several conifers, perhaps due to insect attacks. The increased fall of spruce needles after one of these attacks returns mineral elements to the soil that benefit plant life in the understory.

Staffan Widstrand

Wolverine
Gulo gulo
FINLAND | KUHMO, KAINU

The wolverine eats both carrion and live prey, attacking even such large animals as domestic and wild reindeer. The wolverine has acquired a very negative image, and is depicted as the worst enemy of the Sami, reindeer herders in Lapland. At least 6,000 wolverines have been exterminated in Finland since 1850. By the time Finland finally granted this species protection, the population had fallen to between 50 and 80 animals. In 2009, the number had reached 155, compared to 300 in Norway and about 500 in Sweden.

Staffan Widstrand

Elk in a boreal forest
Alces alces
SWEDEN | SAREK NATIONAL PARK, VALLEY OF RAPADALEN

At the end of the summer, in the valley of Rapadalen, one of the largest "rallies" of European elk takes place. The velvety covering of their impressive antlers begins to molt just before mating season, which occurs in September and October. More than 100,000 European elk are slaughtered in Sweden each year, for their meat and for their antlers.

Staffan Widstrand

Willow tit
Parus montanus
FINLAND | KOROUMA, POSIO, LAPLAND

The willow tit, whose range extends all across Europe, has several subspecies. The Scandinavian subspecies (*Parus montanus borealis*) has a gray back (not brown), with a light-colored underside and very white cheek patches. Known as old man's beard or treemoss, the *Usnea* genus of lichens has been given a variety of other names reflecting the enormous range the species cover, from boreal forests in the north to laurifolate forests on the Canary Islands. Most species were listed as "critically endangered" until the mid-1990s, and acid rain and sulphuric air pollution had exterminated them from many areas of Europe. Better legislation against air pollution and the decrease in the use of pesticides and fertilizers in agriculture contributed largely to the spontaneous recolonization of its former range. Nowadays these lichens are frequently used a bio-indicators for air quality. Something that also la Mésange boréale (*Parus montanus*) benefits from.

Sven Začek

Gorges of the Danube
SERBIA | DJERDAP NATIONAL PARK

The gorges of the Iron Gate divide the Southern Carpathians from the northwest Balkan region, forming the border between Romania and Serbia. At this point, the Danube tumbles into a deep canyon, only 500 feet (150 meters) wide at its narrowest point, where it reaches a depth of 173 feet (53 meters). Large trees don't stand a chance of setting foot on the steep cliffs facing the "Iron Gate," the entrance to the gorge where the Danube breaks through the Southwestern Carpathians on its way to the Black Sea. Two-thirds of Djerdab National Park on this Serbian side of the Danube are forested. They harbor many relict species and plant communities dating back to tertiary times, which have become rarities or gone extinct in most other parts of Europe.

Ruben Smit

Bark of a birch tree
Betula alba
ITALY | POLLINO NATIONAL PARK, BASILICATA

Birch bark was used by northern farming cultures to make fasteners, baskets, pack baskets, shoes, and roofs for houses. Its wood was used in construction, and to make furniture and tools. Different parts of the birch tree are still used in Finland: Most pulp for papermaking is derived from its fibers, and its sap, which is rich in a sugar called xylitol, is used as a sweetener.

Claudia Müller

Beech forest
Fagus sylvatica
ROMANIA | PIATRA CRAIULUI NATIONAL PARK, SOUTHERN CARPATHIANS, TRANSYLVANIA

Beech is the dominant species in most forests in western and central Europe. It is found at every altitude, but in correlation with its latitude: In southwest Scandinavia, it lives on the plains and down to sea level, while in the southern part of its range in Spain, Sicily, and Calabria, it is found on mountain slopes. The center of its range is the moist zones of central Europe, and the largest beech forests are found in Romania, where the trees can reach 125 feet (38 meters) in height.

Cornelia Dörr

Forest floor in autumn
CROATIA | PLITVICE LAKES NATIONAL PARK

Fall colors (yellow, red, and brown) appear when the leaf has lost its chlorophyll, and the leaf's other pigments suddenly become visible. The leaves fall after the last products of photosynthesis have been reabsorbed toward the trunk and roots. The tree then emits substances that form a barrier to the flow of sap into the petiole (the small stem attaching the leaf to the branch). The leaf eventually dries and falls from the branch.

Maurizio Biancarelli

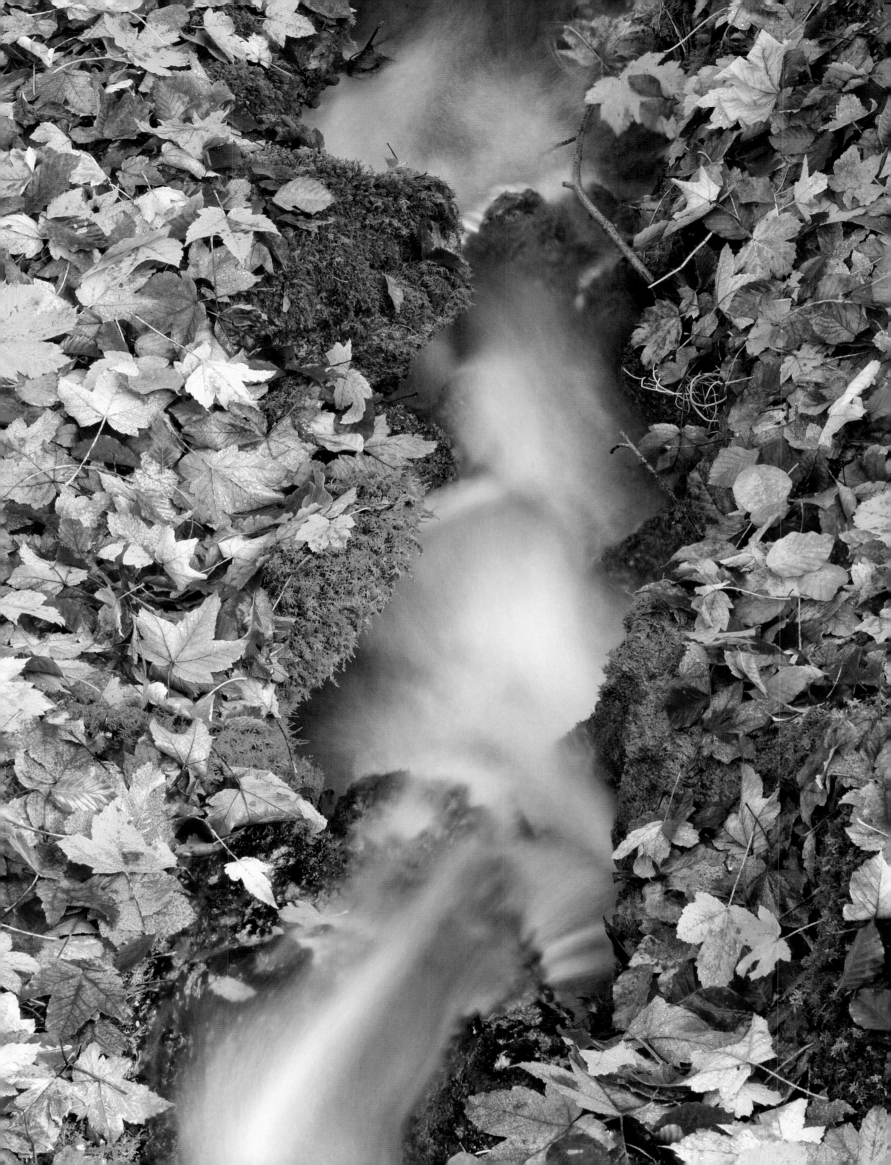

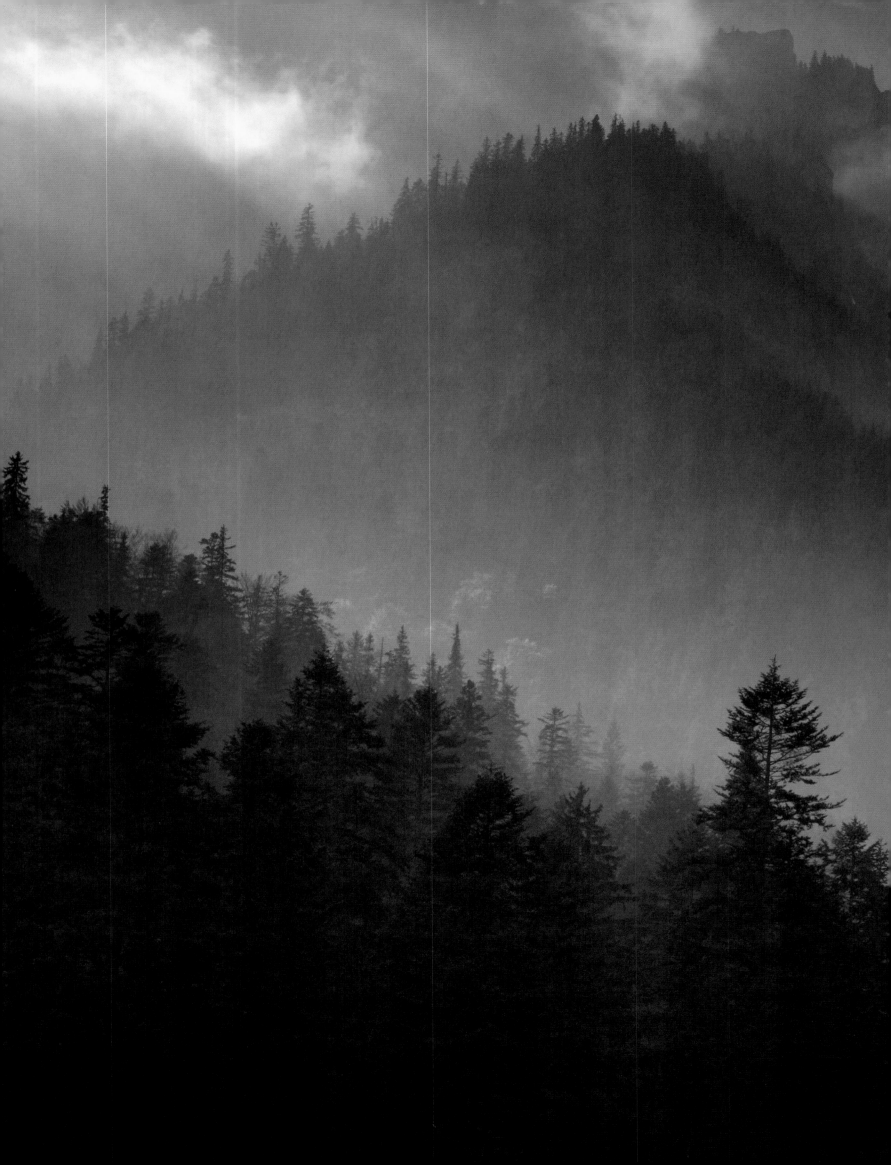

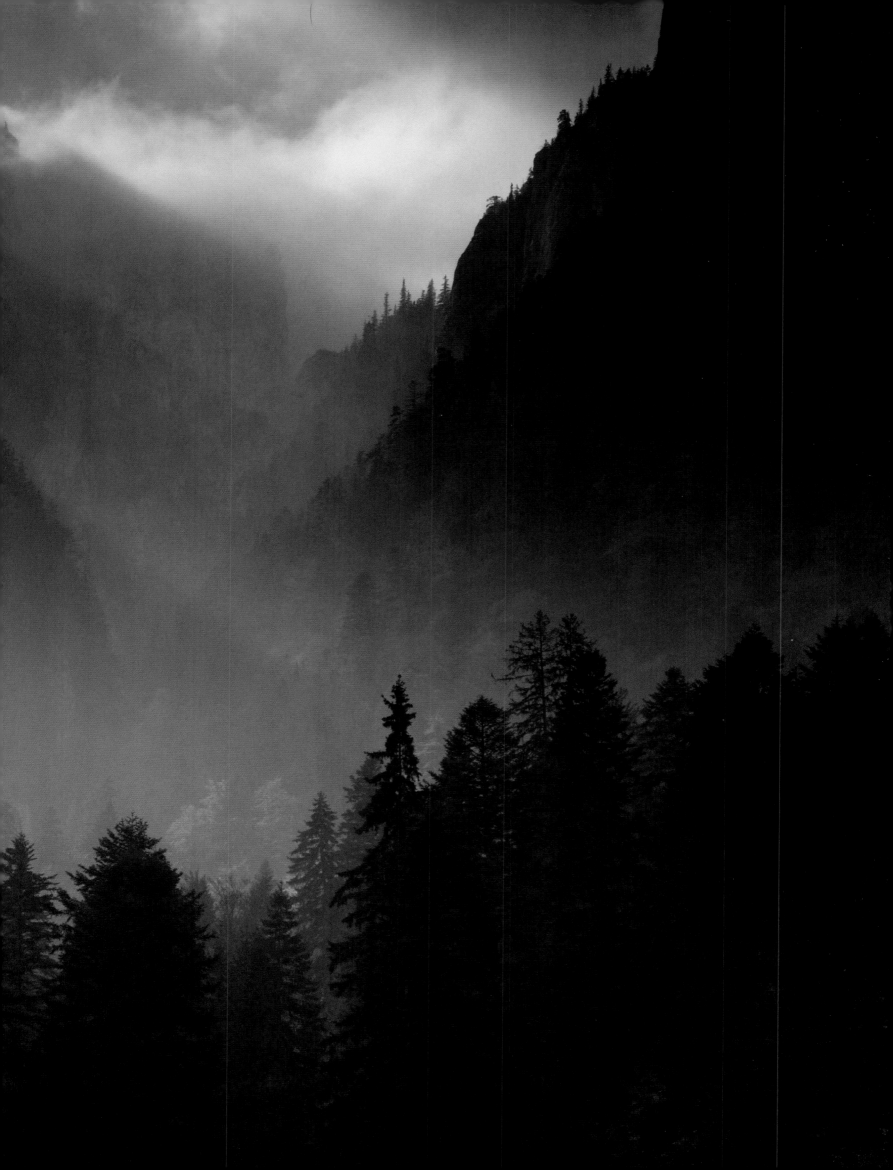

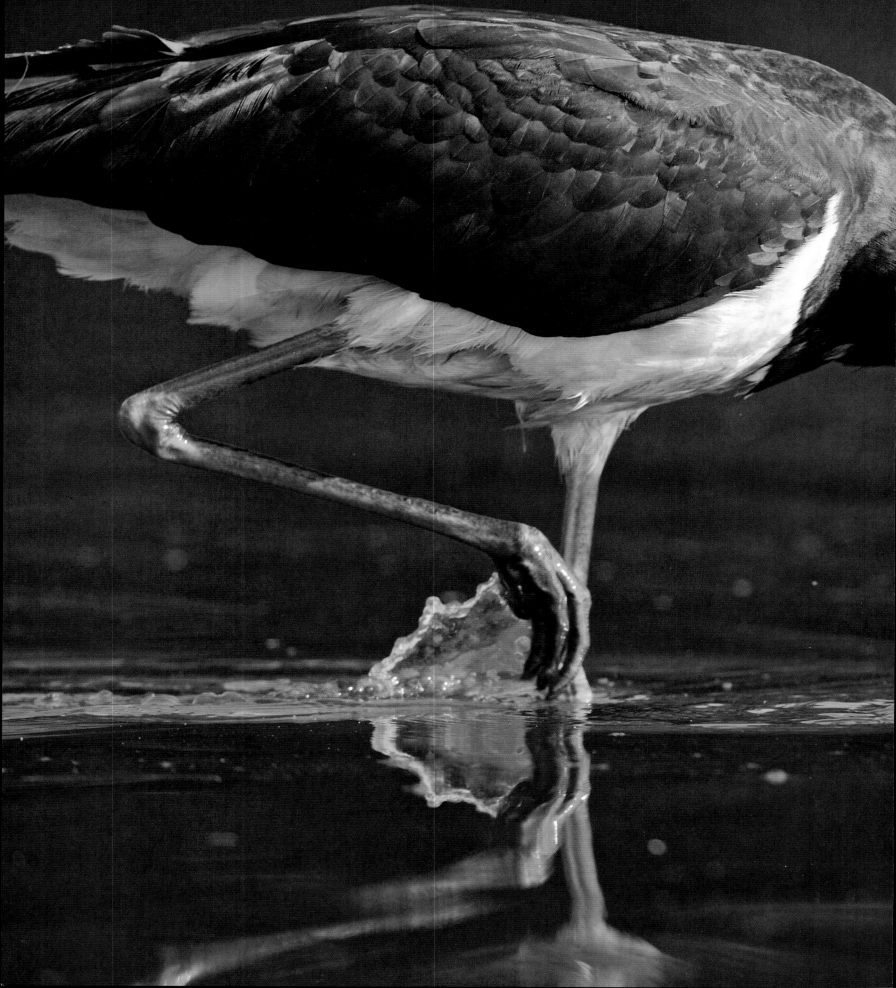

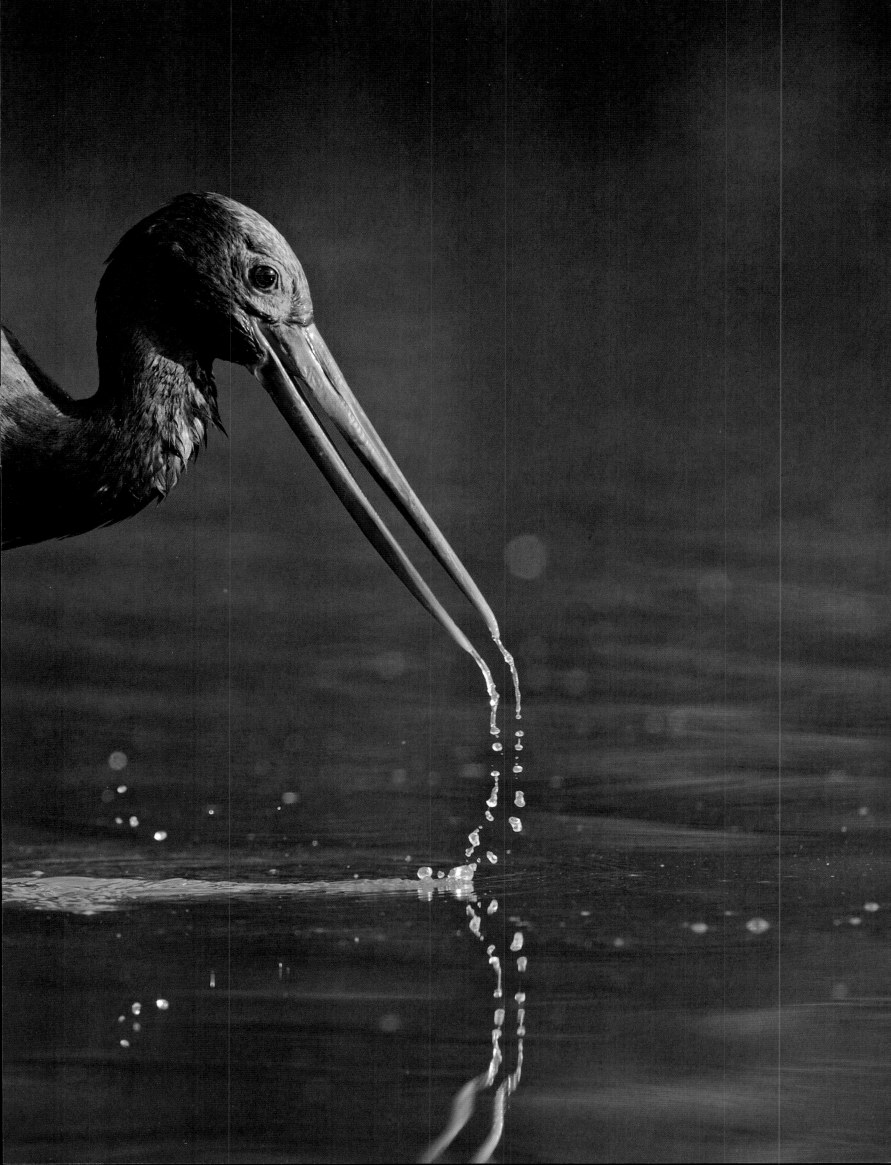

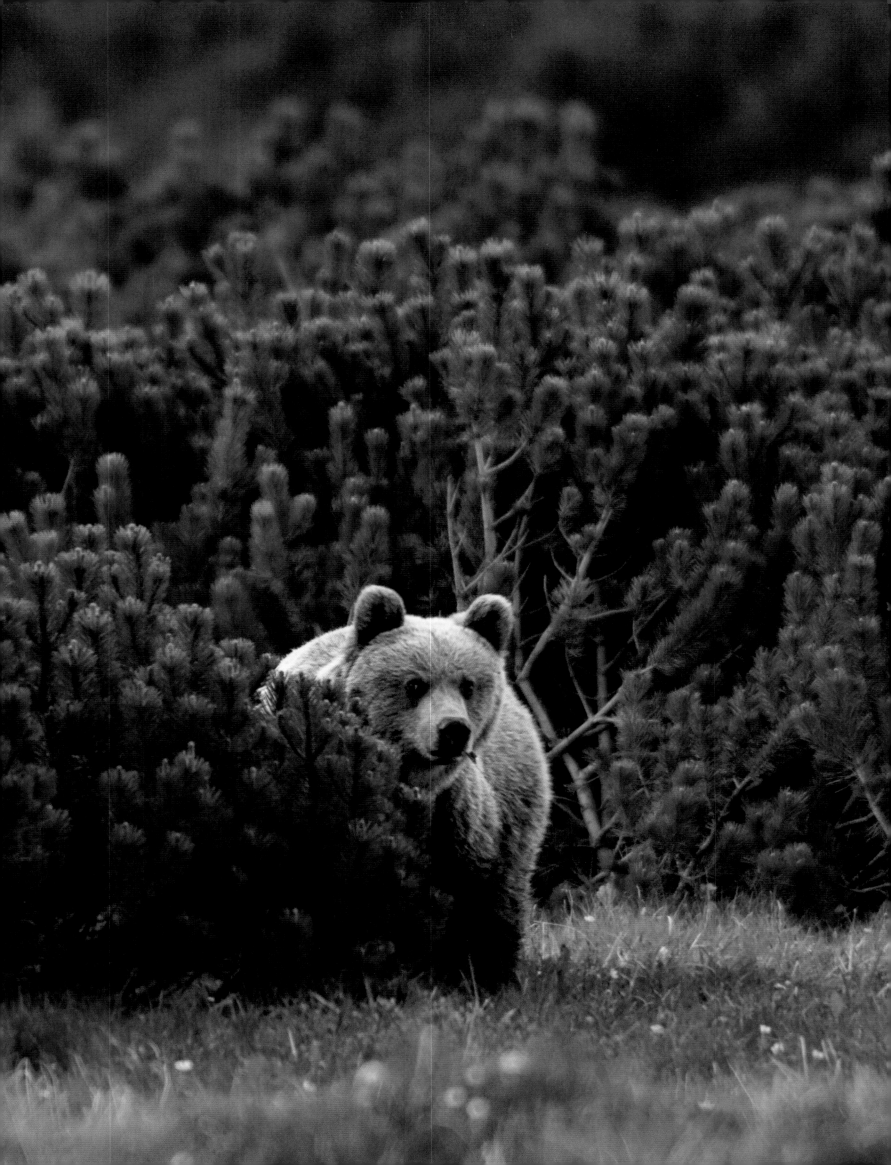

A few weeks before leaves reappear in the canopy, conditions in the understory are favorable for these light-loving plants, which enjoy the increased sunlight and warmer temperatures brought on by the passing of winter. Working fast, they move through their growth cycle in a few weeks, thanks to stored reserves in their underground parts. After those weeks, they return to their dormant state belowground until the following spring. Such rapid cycles require moist, rich soils, which are found only in riparian forests and certain forests of the plain with deep soil.

The shrubs of the understory (cornel, spindle, hawthorn, elderberry, hazel) also profit from spring conditions and blossom from February to April. The fruit ripens in the shade of the canopy trees from summer to autumn, offering sugars and proteins to the forest fauna, from martens to squirrels to many fruit-eating birds.

At the present time, practically all the temperate forests are under human management, to the point where each individual of every tree species receives or is denied authorization to grow, and the same goes for most of the species that reside in the forests.

A FEW INHABITANTS OF THE TEMPERATE FOREST

Many species of birds live in Europe's temperate forests. The black stork (*Ciconia nigra*) is particularly at home in the mature forests of Europe's temperate and Mediterranean zones. An icon because of its beauty and rarity, this wading bird has received recent protection. Its range, which had shrunk because of hunting and nest destruction, has increased and now extends from Spain to central Europe, with populations on the rise in Poland, Ukraine, and Belarus.

Mammal species inhabiting the temperate forest are also numerous. Of the large herbivores, the most common are the red deer (*Cervus elaphus*), whose rutting call (or "roar") fills the forests in autumn, the roe deer, and the wild boar. Large bovines were also once common; they included the bison (*Bison bonasus*), the now extinct aurochs (*Bos primigenius*), and the Alpine ibex (*Capra ibex*) of the mountains of temperate and Mediterranean Europe.

The large carnivores of this forest are the bear, the wolf, and the Eurasian lynx, of which there are several subspecies, including the Balkan lynx (*Lynx lynx martinoi*).

Brown bear
Ursus arctos
SLOVAKIA | TICHÁ, WESTERN TATRAS

The brown bear repopulated Europe after the last glaciation, migrating northward from two refugia: one in the west, on the Iberian Peninsula, and the other in the east, in the Carpathians. At the start of the interglacial about nine thousand years ago, the two migration routes met in central Sweden. Today, the western lineage survives in the bear populations of western Europe, between Spain and the Balkans. The eastern lineage is found in the bears of the Carpathians and the nations to the north and east, including Belarus and Russia. The bears in the northern reaches of Europe are larger and heavier, particularly in autumn, facing longer, colder winters than southern bears.

Bruno D'Amicis

↑

Piatra Craiului Mountains
ROMANIA | PIATRA CRAIULUI NATIONAL PARK, SOUTHERN CARPATHIANS, TRANSYLVANIA

In Romanian, *Piatra Craiului* means "King's Rock." The Piatra Craiului Mountains are 15 miles (24 kilometers) long and 7,350 feet (2,238 meters) high at their highest peak. Its chamois and other resident herbivores are preyed on by wolves, bears, and lynx.

Cornelia Dörr

Black stork
Ciconia nigra
GERMANY | ELBE RIVER LANDSCAPE BIOSPHERE RESERVE, LOWER SAXONY

In late summer adult black storks (*Ciconia nigra*) and their offspring often gather at shallow ponds or oxbows stacked with fish that have been cut off from the main watercourse like here in the Elbe River Landscape Biosphere Reserve in Germany. The storks enjoy a few days of feeding frenzy in the company of gray herons, great-white egrets, and gulls before they begin migrating south to their wintering grounds in Africa.

Dieter Damschen

↓

Beech
Fagus
GEORGIA | LAGODEKHI NATIONAL PARK, KUTAISI, CAUCASUS

Beech is the dominant species in most forests in Western and Central Europe. It is found at every altitude, but in correlation with its latitude: In southwest Scandinavia, it lives on the plains and down to sea level, while in the southern part of its range in Spain, Sicily, and Calabria, it is found on mountain slopes. The center of its range is the moist zones of Central Europe, and the largest beech forests are found in Romania, where the trees can reach 125 feet (38 meters) in height.

Popp-Hackner

Pontic rhododendron
Rhododendron ponticum
GEORGIA | BORJOMI-KHARAGAULI NATIONAL PARK, LESSER CAUCASUS

The forests of Georgia are highly unusual among the forest ecosystems of Europe generally, for the luxuriance of their understory and for the laurel-leaved relict species from the Tertiary (Tertiary laurisylva) that survive

there, such as *Rhododendron ponticum*. These forests are classed as temperate rainforests, although their canopies are dominated by deciduous oaks, hornbeams, and native chestnuts. During periods of glaciation the forests of the Black Sea, like other temperate rainforests throughout the world, sheltered species that were intolerant of cold and drought. From these refugia, plant species were able to repopulate Europe when the climate warmed again 10,000 years ago.

Popp-Hackner

Barranco del Cedro
SPAIN | GARAJONAY NATIONAL PARK, LA GOMERA, CANARY ISLANDS

Among the plants of the del Cedro ravine are relicts of the water-loving laurel forest that occupied the Mediterranean area during the last part of the Tertiary period. La Gomera Island's forests are at the center of the Garajonay National Park, covering 15 square miles (39 square kilometers) or 7 percent of the park's area. Since 1986, the park has been listed as a UNESCO World Heritage Site, because of the ecological value of the laurel forest, the largest in the Macaronesian Islands.

Iñaki Relanzón

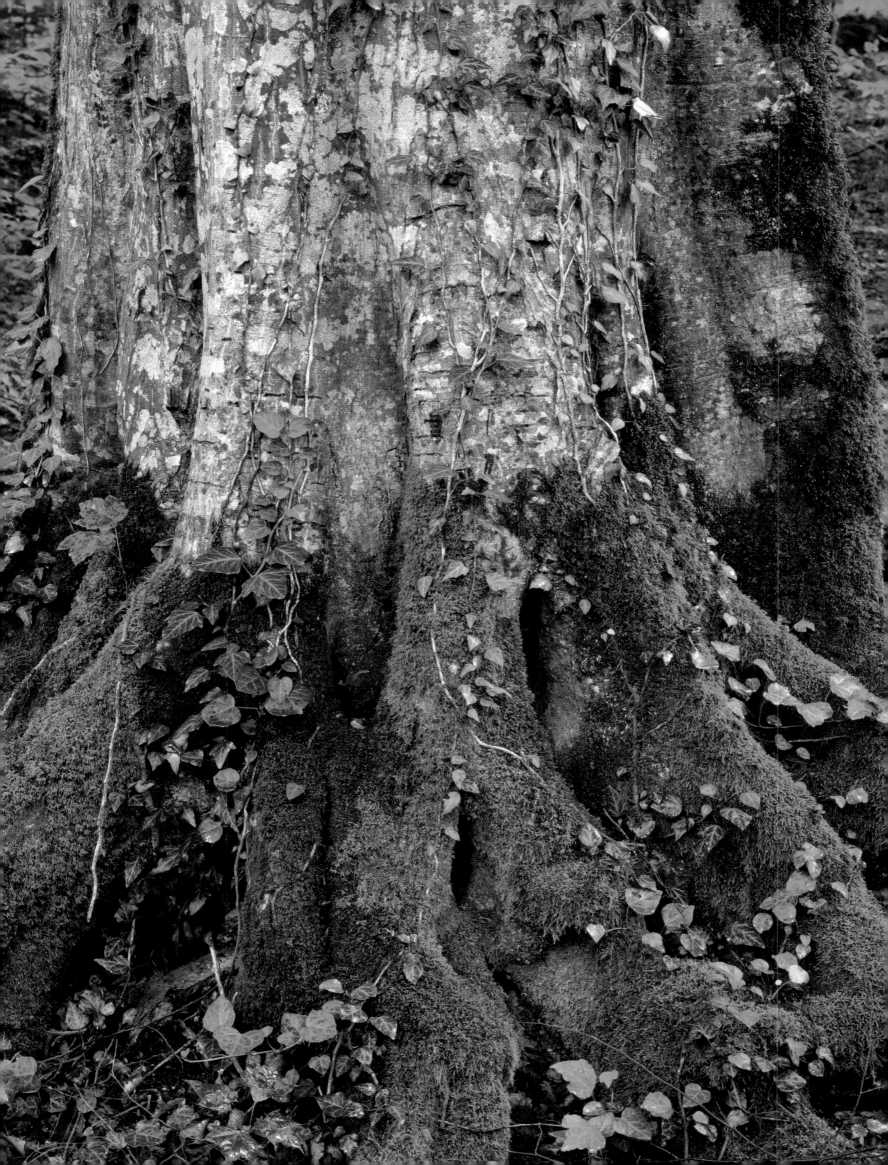

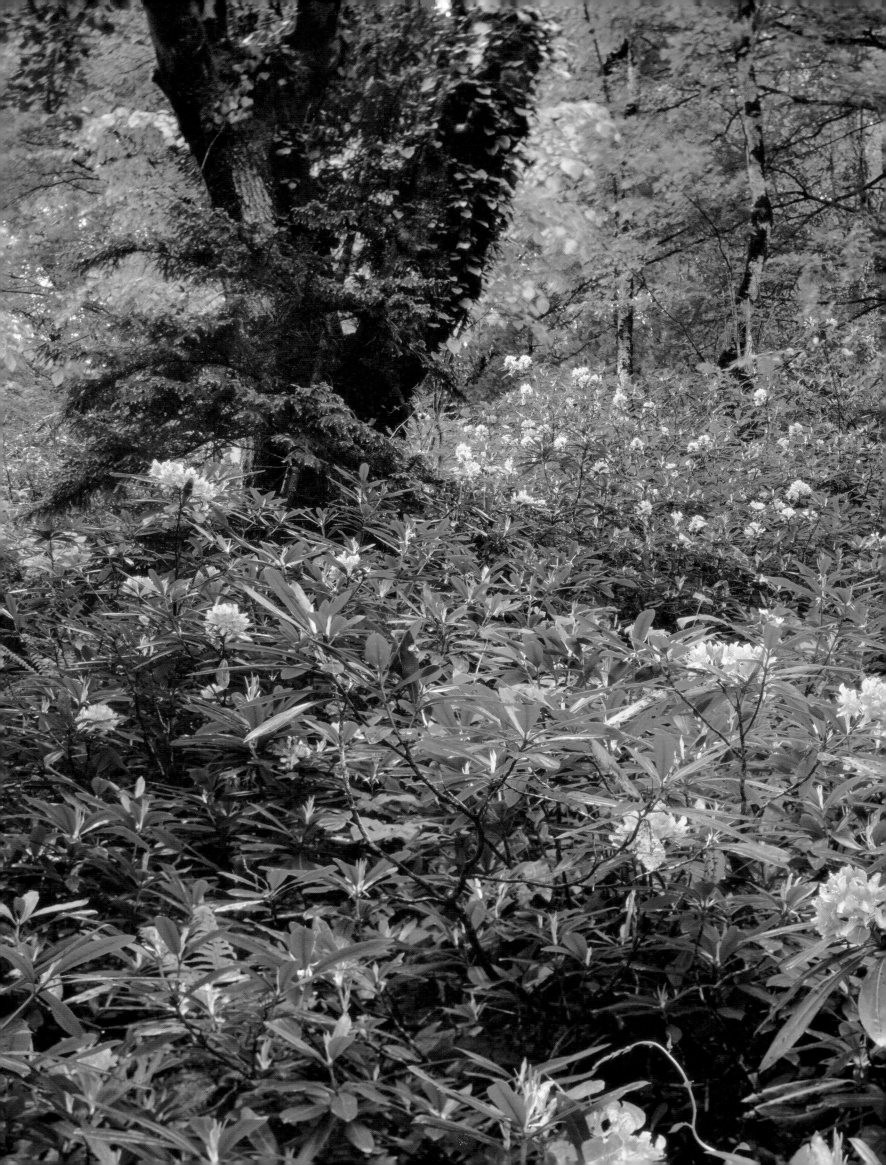

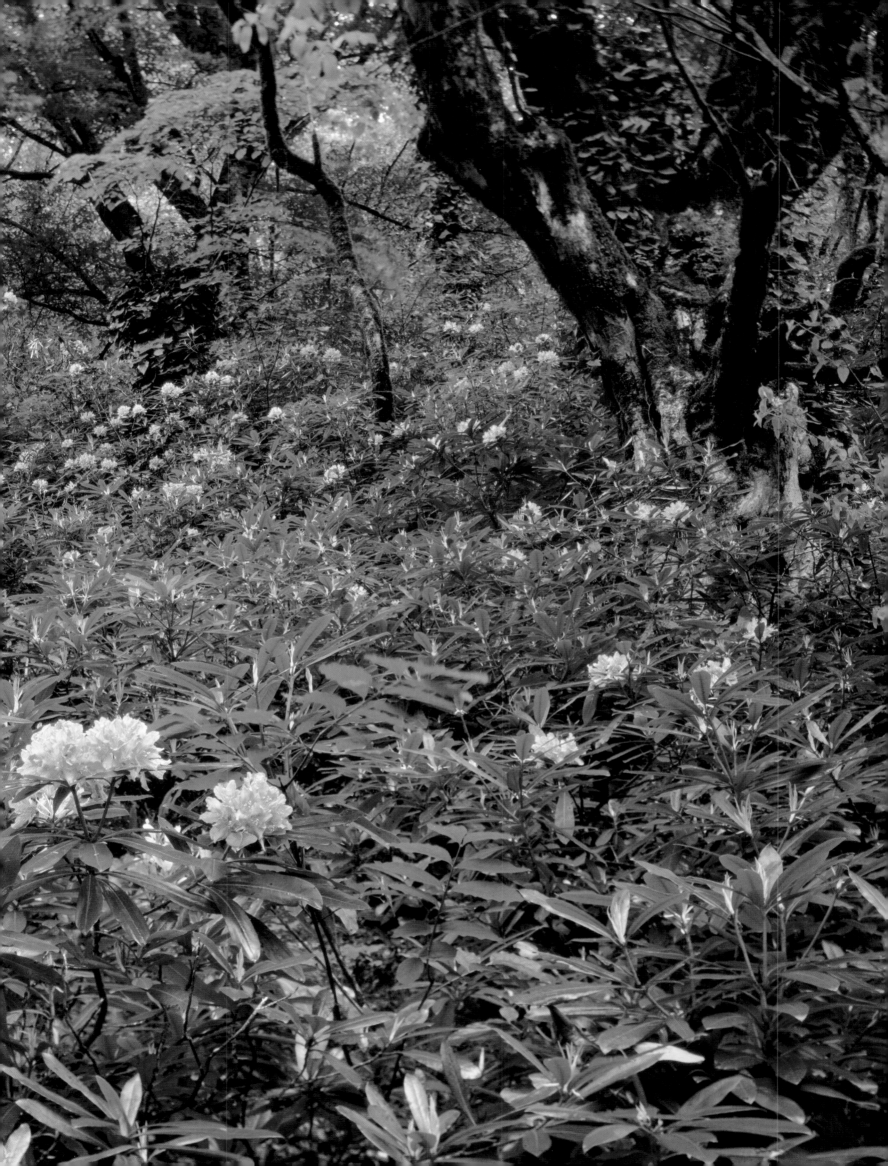

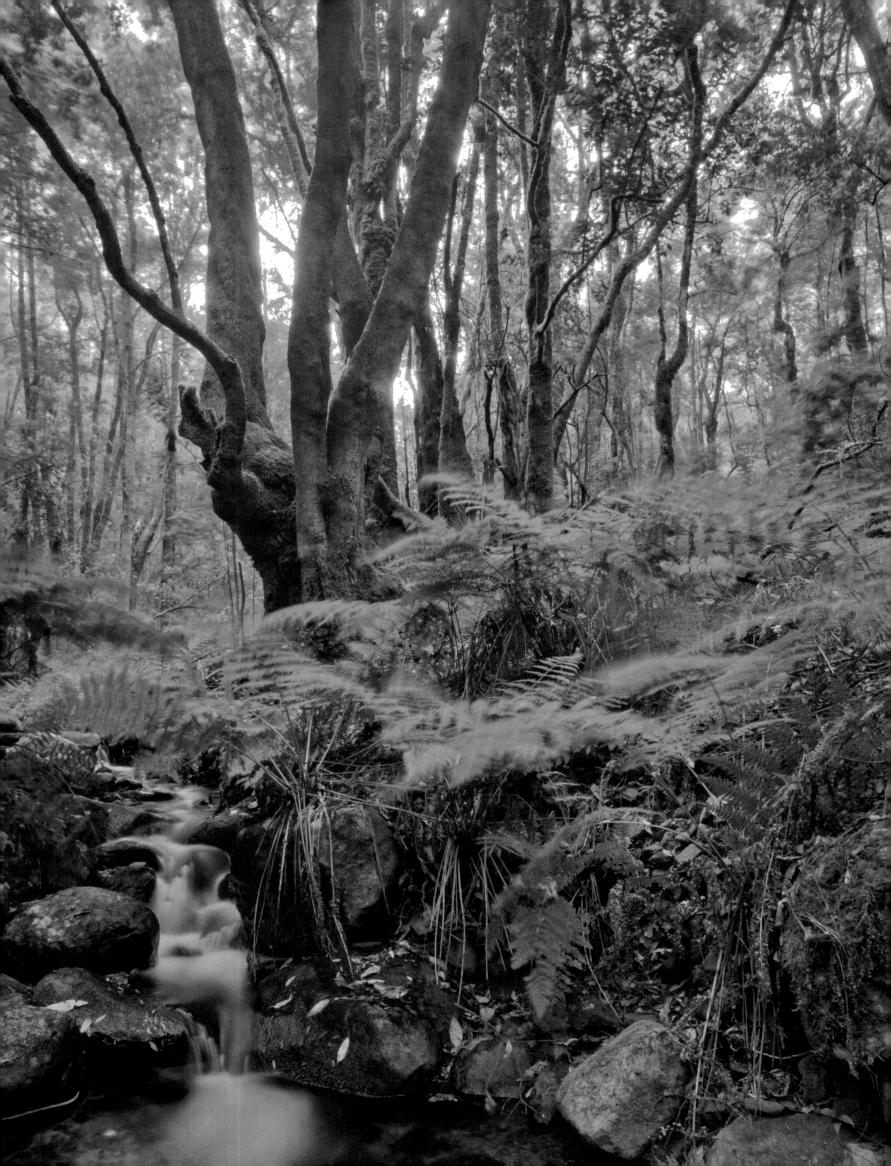

THE FORESTS OF COLCHIS

Situated on the eastern coast of the Black Sea in Georgia, the Colchian forests differ from other deciduous temperate forests of Europe. They belong to the family of evergreen temperate rain forests typical of hot, humid climates. The evergreen LAURIFOLIATE leaves are laurel-like, tolerating neither dry nor freezing conditions.

No other forest in Europe has the same abundance of epiphytes (mosses and ferns), which grow on trees without parasitizing them. The Colchian forests also have numerous large lianas and a highly luxuriant understory. While it is characteristic of temperate rain forests to be always green, riparian forests lose their leaves in winter at every height, and thus the laurifoliate, EVERGREEN species in the Colchian forest are concentrated in the understory. They include common box (*Buxus sempervirens*), rhododendron (*Rhododendron ponticum*), and holly (*Ilex aquifolium* and *Ilex colchica*). The upper stories consist of deciduous species close to those found in Europe's temperate forests (oak, hornbeam, etc.). The Colchian forests thus represent an intermediary between deciduous forests and true rain forests such as one finds in the Canaries and Madeira.

During past glacial eras, the eastern edges of the Black Sea kept their mild and moist temperate climate, providing areas of refuge (refugia) to a few species from the vanished laurel forests of the TERTIARY period. One such remnant species, flowering copiously in the Colchian understory, is the rhododendron.

Rain forests are sparsely scattered throughout the world. They are extremely rare in Europe, limited to its eastern boundary and to a few volcanic islands in the Atlantic—those that rise above 1,600 feet (500 meters) in altitude (Gran Canaria, Tenerife, La Gomera, La Palma, the Azores, and Madeira).

LAURIFOLIATE
Describes a forest having an abundance of woody species with leathery leaves that transpire heavily and are thus susceptible to drought, such as a laurel forest. This kind of forest exists only in climates that are free of frost and dry spells.

EVERGREEN
A plant that keeps its leaves all year, as opposed to a deciduous plant

TERTIARY LAURISYLVA
Forests that covered the Mediterranean Basin during the last part of the Tertiary period. These forests, which developed in a hot, humid climate, were composed of tropical flora whose main families included the Lauraceae (Laurel family), the Oleaceae (Olive family), and the Myricaceae.

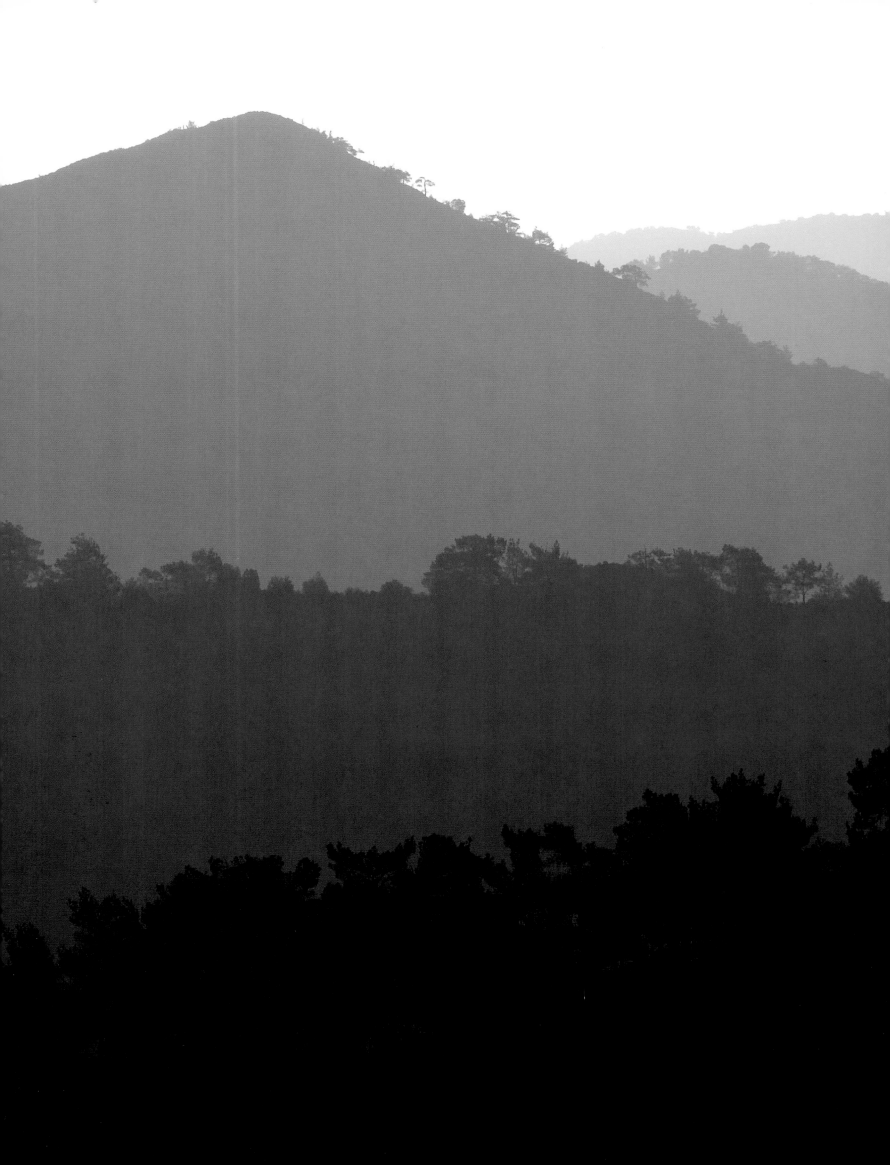

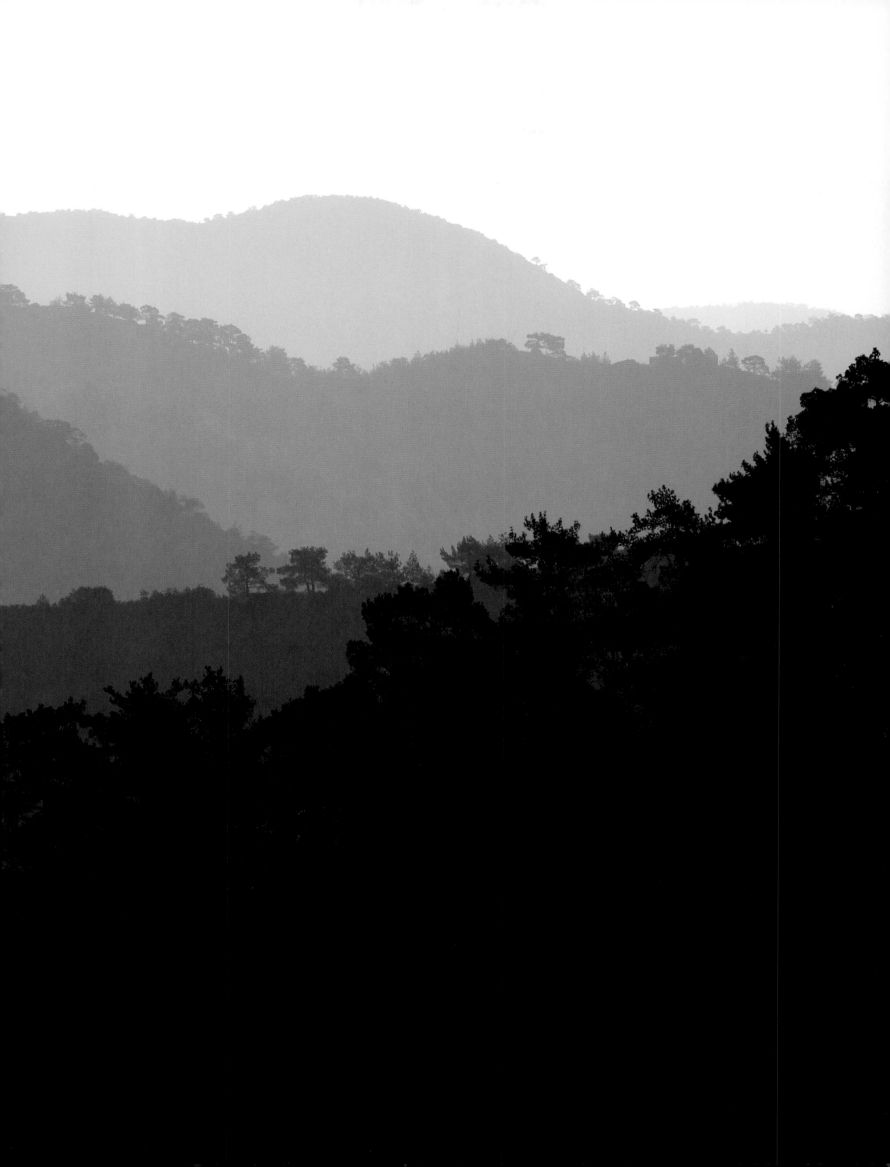

THE FORESTS OF THE MEDITERRANEAN

THESE FORESTS THRIVE IN THE MEDITERRANEAN CLIMATE, CHARACTERIZED BY A LONG PERIOD OF DROUGHT AND HEAT IN SUMMER, MILD winters, and rainy springs and falls. The summer dry period becomes shorter as altitude increases, and the temperatures become cooler. In consequence, Europe's Mediterranean biome (plant and animal community) has extremely diverse habitats (sea coast, mountainous regions, broad valleys, ravines, volcanoes) and varied geological substrates.

The Mediterranean forests can be divided into three main types: the broadleaf evergreen forest, the coniferous forest, and the deciduous forest. The first, which is found at low altitudes, consists primarily of live oaks, whose leaves tolerate the dry summers thanks to their thickness and waxiness. The trees, which use protective measures that limit water loss, are termed "sclerophyllous" and include the holm oak (*Quercus ilex*) and the cork oak (*Quercus suber*).

The coniferous forest grows at several altitudes. At low elevations, it consists largely of Aleppo pines, while in the mountains it consists of firs and cedars. The deciduous forest thrives in areas with more rainfall and at low to medium elevations. It consists of downy oak (*Quercus pubescens*) and other deciduous species also found in Europe's temperate zone—hornbeam, ash, alder, poplar, linden, and maple. The bay laurel (*Laurus nobilis*), which is typically Mediterranean, along with European holly (*Ilex aquifolium*) and common ivy (*Hedera helix*), two species common to temperate and Mediterranean zones, are all laurifoliate species (having laurel-like leaves) sensitive to dry conditions and abundant only on moist sites in mountain ravines and riparian forests.

Mediterranean forests have been profoundly changed by fire, steel, and livestock. Human activity over thousands of years has altered their species composition. It is thought that the forests of the Mediterranean plains and the mid-level mountains were not composed mainly of live oaks but of deciduous trees both in the canopy and the understory and of laurifoliate species that have now disappeared, such as yew, holly, and laurel. Small groupings of trees, relict stands of the original forests, still subsist in France at an altitude of 2,300 feet (700 meters) in the forest of Sainte-Baume. The dominant species there is a deciduous oak, the downy oak, while the understory carries a spectacular growth of yews, some of whose individual trees are several centuries old and 10 feet (3 meters) in circumference.

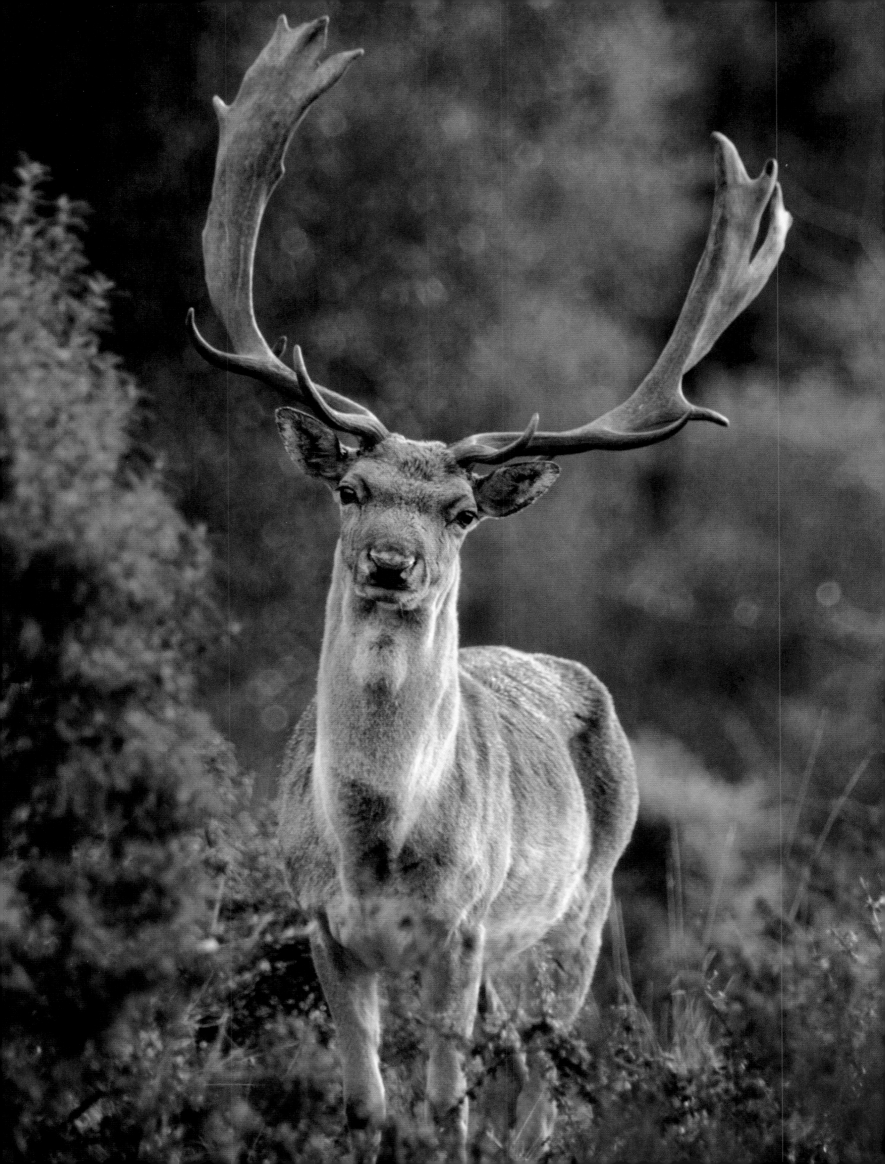

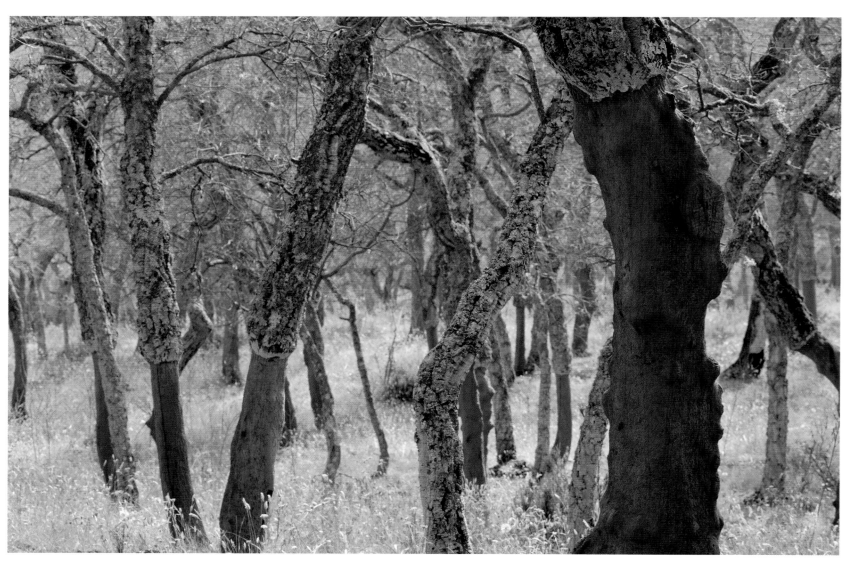

Of all European forests, those in the Mediterranean have suffered most at the hands of man, particularly in the period from classical antiquity to the mid-nineteenth century. Oaks were felled on a vast scale for shipbuilding, and goats destructively grazed the recovering woodlands. One exception, the sacred forest on the Athos peninsula in Greece was preserved, protected from felling and overgrazing by a neighboring monastery. In most other parts of the Mediterranean, the forests have not been able to regenerate until the last two centuries.

AN EXCEPTIONAL WEALTH OF FLORA

Rich in diversity, the Mediterranean forests gather a number of species from Asia Minor and the Middle East with others from temperate Europe. They are also home to species descended from forests that occupied the Mediterranean Basin before the glacial period more than 100,000 years ago! Of the 45 genera of **WOODY** plants that composed the Tertiary forests, only a few species, known as "Tertiary relicts," have survived in a few refugia, the large islands of the Mediterranean (Sicily, Crete, Cyprus), and a few small valleys and riparian forests in continental Spain, Greece, Italy, and France. Species can be found in these areas that otherwise disappeared from Europe entirely after the last glaciation,

and whose presence is not due to a modern reintroduction. In Crete, a species of zelkova (*Zelkova abelicea*) has survived, and in Cyprus a cedar (*Cedrus libani brevifolia*). On the continent, populations of horse chestnut (*Aesculus hippocastanum*) and sweet chestnut (*Castanea sativa*) survive in a few valleys in Greece. In western Turkey, there are two small survivor populations of species from the Juglandaceae family, Persian walnut (*Juglans regia*) and Caucasian wingnut (*Pterocarya fraxinifolia*). Unlike these native populations, the European walnut and chestnut trees growing today in Europe's other forests were imported by man in prehistoric or classical times, as they had disappeared in the wild state after the last glacial period.

Because several of these indigenous species grow in forests that are now open or semiopen, scientists believe that such habitats have existed continuously all across the Mediterranean since the last glaciation. Among these indigenous species are the orchids in all their great diversity, including the fascinating genus *Orphrys*, every species of which has ensured its reproduction by developing a symbiotic relationship with a single and highly local species of insect.

WOODY
All plants make lignin, a molecule that gives them structural strength. Woody plants are those that manufacture a greater amount of lignin, for instance, trees. Lignin and cellulose are the main components of wood. *See* Lignin, p. 52.

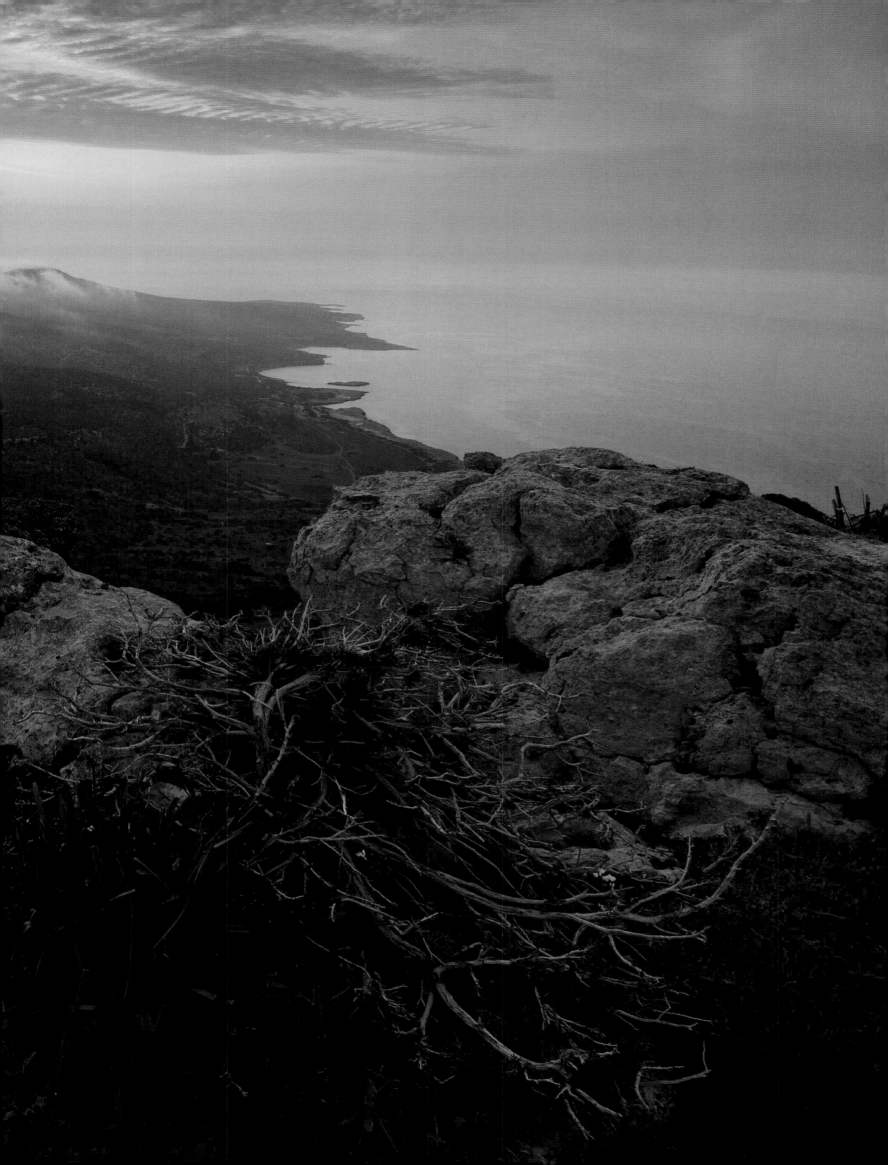

Troodos Massif
CYPRUS

Cyprus is the third-largest island in the Mediterranean Basin. It consists of two mountain ranges separated by a central plain; the Troodos Mountains are on the western and southern end of the island. Cyprus, like the other Mediterranean islands, served as a refuge for plant species intolerant of cold, such as the Cyprus cedar (*Cedrus libani* subspecies *brevifolia*), a species endemic to the island. This cedar, which in the past suffered severe depredations, survives only on the western slopes of the Troodos range, at an altitude between 3,000 and 4,000 feet (900 and 1,200 meters). It is considered threatened.

Peter Lilja

Fallow deer buck
Dama dama
ITALY | MAREMMA NATIONAL PARK, TUSCANY

During the colder periods and the until the end of the last ice age the distribution of fallow deer (*Dama dama*) was restricted to the Middle East and probably to the warmer regions of the Mediterranean and Turkey's Termessos National Park. A few thousand years later the Phoenicians and Romans introduced the species to Greece, Italy, and Spain; in medieval times it was brought to private game parks in Denmark, central Europe, and on the British Isles. Today it is one of the most widespread deer species in the world with populations from New Zealand to North America, from Sweden to North Africa.

Florian Möllers

Mediterranean vegetation in autumn
GREECE | ALONISSOS ISLAND

Called chaparral in North America, *fynbos* in South Africa, and *maquis* or *macchia* in the Mediterranean, this shrubland community of evergreen plants like buckthorn, spurge olive, sage, juniper, myrtle and tree heath replaces larger trees and forests, where they had been frequently burnt, overgrazed, or otherwise destroyed by man. Also, it grows in arid, rocky areas where only its drought-resistant species are able to survive, such as some places on the Greek island of Alonissos.

Stefano Unterthiner

Cork oak trees
Quercus suber
ITALY | AGGIUS, SARDINIA

The cork oak is a broadleaf evergreen that avoids calcareous soils and thrives on unconsolidated silicious substrates at low altitudes around the Mediterranean Basin, in Spain, Italy, and the western islands. It forms natural forests on moist sites with other evergreen oaks such as the holm oak (*Quercus ilex*), downy oak (*Quercus pubescens*), or Portuguese oak (*Quercus faginea*), and with pines. Buying wine bottles with cork stoppers, produced form the bark of the cork oak, will support the survival of these forests, which might otherwise be turned into farmland.

Staffan Widstrand

Spanish moon moth
Actias isabellae glalliaegloria
FRANCE

The Spanish moon moth, here in the subspecies *glalliaegloria*, spreads its beautifully patterned wings in a subalpine forest of Scotch pine, a host plant of the moon moth caterpillar. Restricted to a small area in the French Alps, the adult Spanish moon moth is a large, nocturnal flier, with a wingspan of 4 inches (10 centimeters). The species is strictly protected.

Niall Benvie

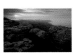

Mount Moutti tis Sotiras
CYPRUS | AKAMAS PENINSULA

The slanting evening sun caresses the bare rocks of Mount Moutti tis Sotiras, elevation 1,640 feet (500 meters), towering over the Akamas Peninsula. The site retains a few pockets of pine forest between the *maquis*, or scrubland, and the cultivated fields.

Peter Lilja

Orchid
Serapias lingua
ITALY | GARGANO PENINSULA, APULIA

The *Serapias lingua* orchid has all the charms it needs to attract bees, but it often self-fertilizes. The only function of the bees is to break up the pollinia (the cohesive masses of pollen grains formed within a pollen sac). Its flowers also provide insects a place to shelter in inclement weather or simply to spend the night, but when the insect leaves the flower in the morning, it takes some of the pollen with it. Most of the bees that use the flower as a shelter are males.

Claudia Müller

Griffon vulture
Gyps fulvus
SPAIN

The griffon vulture is an essential link in the food chain of the Mediterranean Basin, disposing of the carcasses of large animals, wild and domestic. This raptor, whose wingspan of 8.5 feet (2.6 meters) makes it one of the largest in Europe, nests in colonies on the steep cliff faces of mountain gorges. The number of griffon vultures has declined sharply because of deliberate poisoning with strychnine, indiscriminate use of pesticides, and changing patterns of land use (including the decline of pastoralism, which provided animal carcasses). The decline slowed in the 1970s and 1980s, thanks to a halt in the use of toxic pesticides and a general improvement in the attitude toward carrion eaters. A new threat came from a recent EU legislation that ordered the removal of all carcasses, the most important food source for these vultures and other scavengers. In 2011, this legislation was repealed by the EU, but country-specific legislation is still behind. The largest griffon vulture population lives in Spain and counts 8,000 nesting couples; from this population, the species was reintroduced to France, in the Cévennes National Park.

Markus Varesvuo

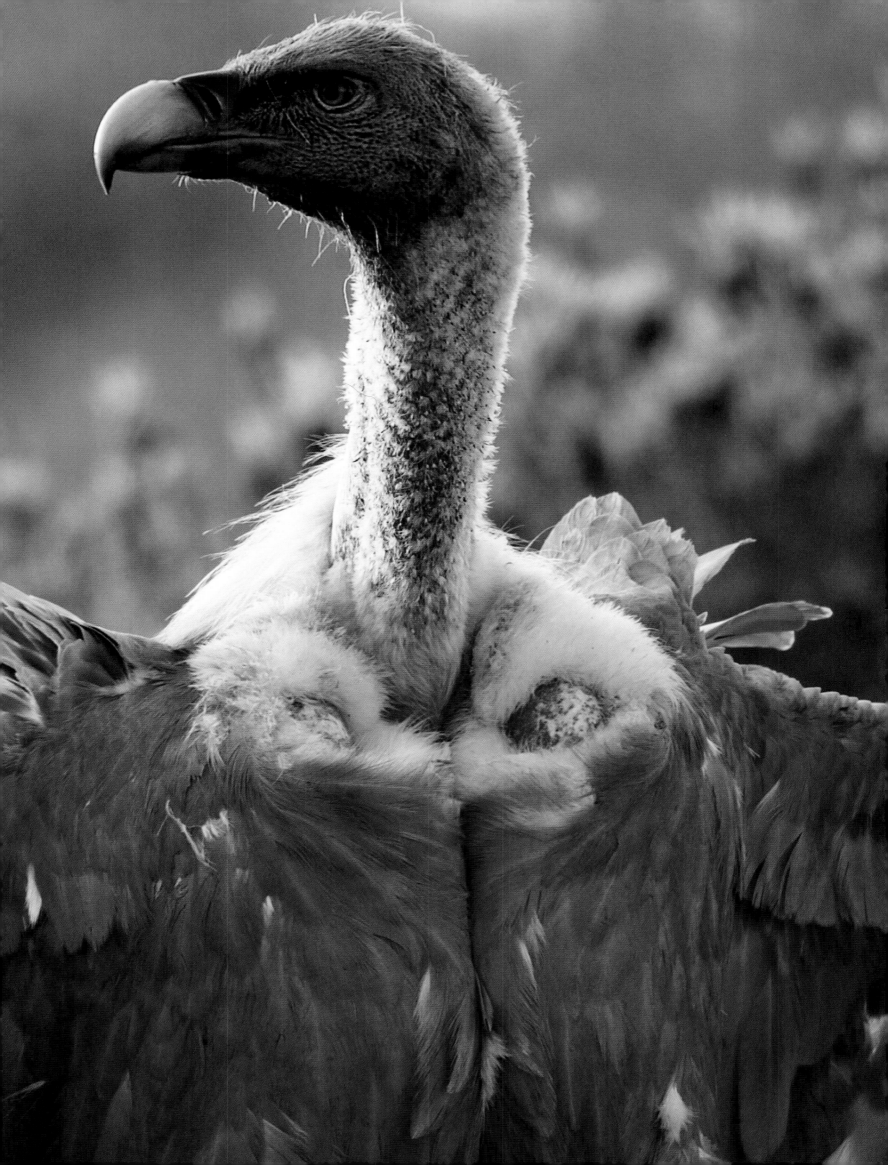

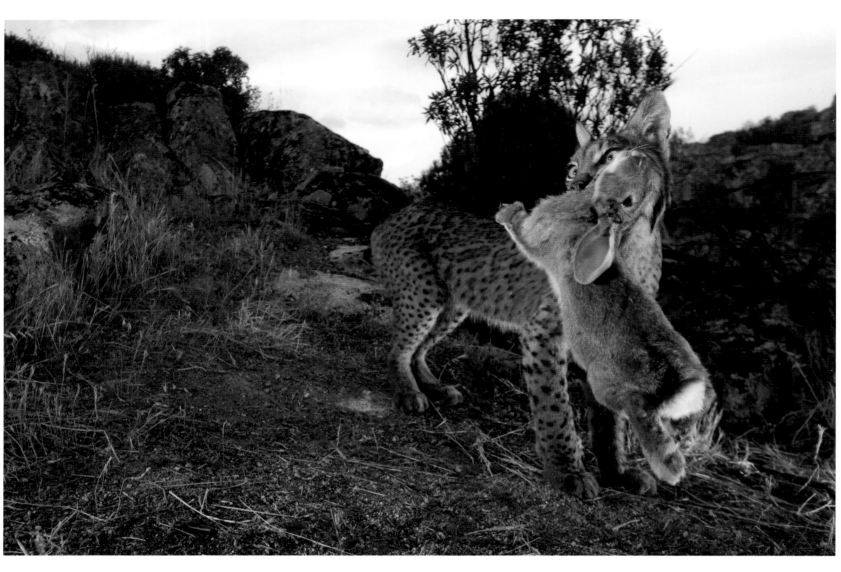

THE MEDITERRANEAN FAUNA

The fauna of the Mediterranean forests is for the most part found in the rest of temperate Europe, but a few species are particular to it. Among the mammals is the Iberian lynx (*Lynx pardinus*), considered the most critically endangered terrestrial mammal in Europe, with a total population estimated in 2010 at 200 to 210 individuals. Another species living wholly within Spain is the Spanish ibex (*Capra pyreneica*). Once threatened with extinction, it is today making a healthy comeback thanks to hunting restrictions and conservation efforts, with a population of some sixty thousand in 2010. The origin of the fallow deer (*Dama dama*), which ranges widely throughout the Mediterranean today, is not known with certainty. Some isolated populations, notably on the Greek island of Rhodes and in the Termessos region of southern Turkey, may have survived undisturbed through the last glaciation, so different is their genetic makeup from that of all other populations. In many regions, fallow deer were introduced at some point in the last several thousand years, perhaps by the Phoenicians, the Romans, or the Normans, or by more modern Europeans—*Dama dama* was introduced to Cyprus in the twentieth century. The red deer (*Cervus elaphus*) is indigenous to many countries in central Europe but was probably introduced to Sardinia in the late NEOLITHIC, then several thousand years later to Corsica, where it subsequently became extinct. Today, after several decades of vigorous conservation efforts, the Sardinian population is thriving.

In many cases, however, the original fauna of the Mediterranean islands, which was so rich in indigenous species at the end of the last glacial period, did not fare well after the irruption of man in the early Holocene, in the ninth millennium BC in Cyprus, 7000 BC in Sardinia, and 6500 BC in Corsica. In Cyprus, man drove two aboriginal species to extinction: a pygmy hippopotamus (*Phanourios minutus*), which disappeared toward 1700 BC, and a small elephant (*Elephas cypriotes*) around the same time. The other pygmy elephants of the Mediterranean islands (Malta, Sardinia, Crete), which evolved on site within a confined area, had probably disappeared naturally before man's appearance or were exterminated shortly after. In Corsica and Sardinia, man is probably responsible for the extinction of a dwarf deer (*Megaceros cazioti*).

Among the birds are several species that are specifically Mediterranean, though they overflow somewhat into southern temperate Europe. Several raptors nest in forests but hunt in more open habitat: the Spanish imperial eagle (*Aquila adalberti*), a dedicated predator of rabbits and other rodents; the black vulture (*Aegypius monachus*), which feeds voraciously on the carcasses of large herbivores; and the short-toed snake eagle (*Circaetus gallicus*), which feeds on snakes and other reptiles. The European roller (*Coracias garrulus*) and the scops owl (*Otus scops*) nest in the trunks of old trees, but both are dependent on the large insects they find in more open country. The Corsican nuthatch (*Sitta whiteheadi*), which is endemic to its home island, favors old forests of Corsican black pine with ample stores of dead wood.

NEOLITHIC
Period of prehistory marked by profound changes in technology and social organization, due to the adoption of a production economy based on agriculture and pastoralism. The neolithic shift did not occur all at once, however. In the Near East, the Neolithic period began around 9000 BC. It ended with the spread of metallurgy and the invention of writing in about 3300 BC.

The various species of typically Mediterranean turtles live in forests and in open places, where they incubate their eggs in holes in the ground warmed by the sun.

Finally we will mention a few forest insects specific to the Mediterranean, such as the forest caterpillar hunter (*Calosoma sycophanta*), which preys on the oak processionary caterpillar; the two-tailed pasha (*Charaxes jasius*); and the magnificent Spanish moon moth (*Graellsia isabellae*), which is the largest butterfly in Europe and is related to other species living mostly in the tropics. The Spanish moon moth reproduces at the very top of large pines in the Alpine forests of France.

FORESTS ON VOLCANOES AND IN THE MACARONESIAN ISLANDS

Volcanic forests are rare in Europe, restricted to a few islands in the western Mediterranean (Sicily, Lipari Islands), where they have almost disappeared as a result of human pressures. Some more developed ones exist in the Macaronesian Islands (Canaries, Madeira, Azores). Wherever they are, these forests share an important feature: all started from an entirely sterile environment, composed of material spewed from the bowels of the earth—ash, cinders, or lava. The recolonizing species must tolerate the toxicity of the rocks, as well as the shortage of water and minerals, and the effects of altitude. In a dry climate, the forests only grow back after several centuries, following a long period of low-growing vegetation. And at every moment the plant communities are in imminent danger of destruction from fresh flows of lava.

Mount Teide (12,000 feet or 3,600 meters), a still-active young volcano from the Quaternary on the island of Tenerife at the center of the Canary Archipelago, supports lovely pine forests (as does Mount Etna). The species is an indigenous one, the Canary Island pine (*Pinus canariensis*), which, at the elevation of 3,300 feet (1,000 meters), forms beautiful unbroken forests 160 feet (50 meters) tall. At higher elevations, the trees become sparser and shorter, seldom exceeding 40 feet (12 meters) in height. The pines, which become more and more deformed from the effects of wind, disappear entirely between 6,500 and 6,900 feet (2,000 and 2,100 meters).

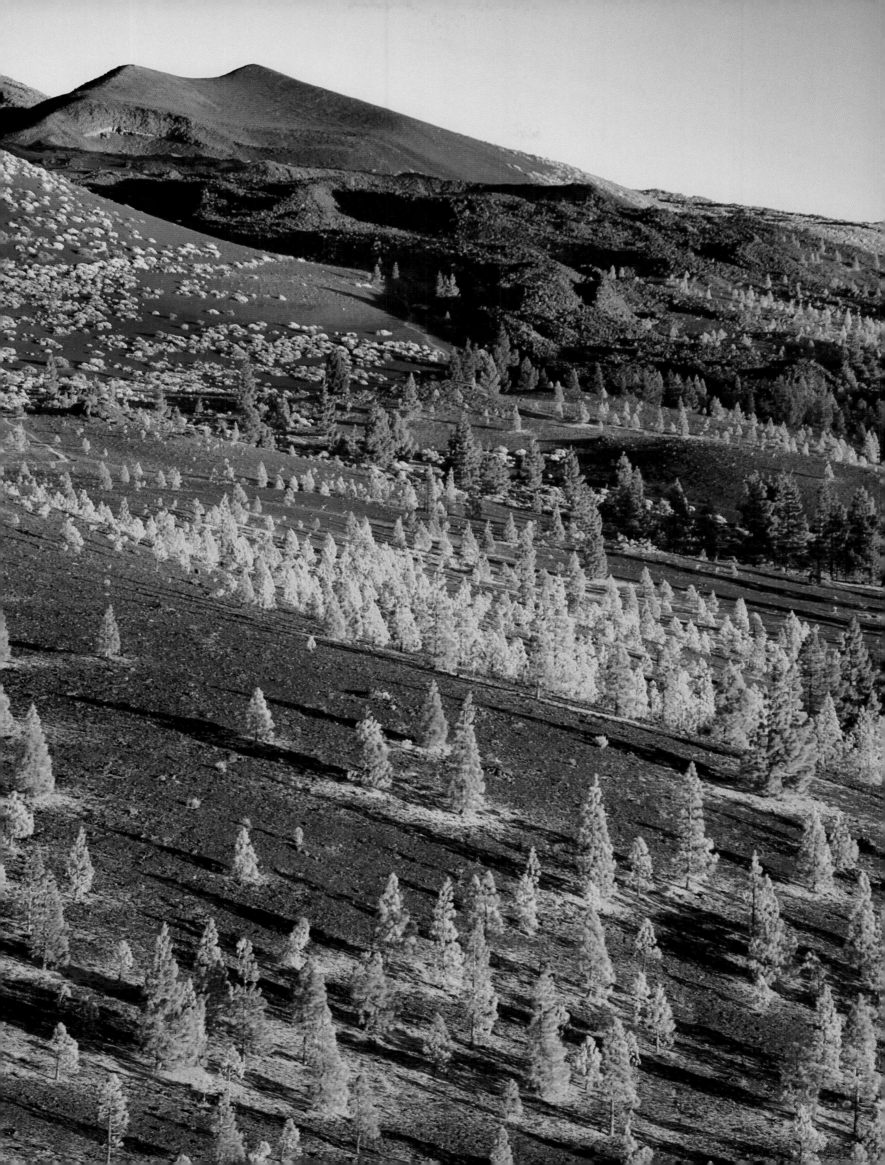

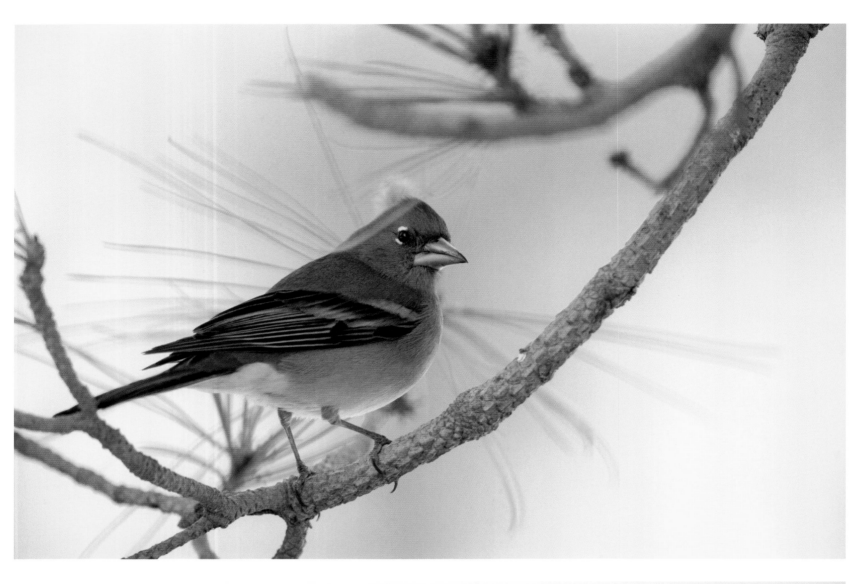

Besides the pine forests, one finds in the Macaronesian Islands true rain forests, which grow from an altitude of 1,600 feet (500 meters) on the slopes of volcanoes several million years old. They have managed to survive through periods of glaciation, which explains why these islands have plants representative of the forests that covered Europe at the end of the Tertiary period, from five to two million years ago. The Macaronesian forest is therefore rich in species from such tropical families as the Lauraceae and contains many epiphytes trailing from the branches, giving these dense stands a fantastical appearance. Their survival is due to their situation in the middle of the ocean, where the extremes of temperature and aridity that prevailed on the continents for hundreds of thousands of years were softened. In addition, these islands have enjoyed a relatively even temperate climate for the last ten thousand years. The average annual temperature of 60 degrees Fahrenheit (16 degrees Celsius) shows minimal variation throughout the year.

The ample precipitation necessary to maintain the laurisilva (a laurel forest, a subtropical or mild temperate one) comes not from rain but from the fogs brought by the trade winds sweeping up the eastern slopes of the mountains. The water droplets from the fog are deposited on the large laurel-like leaves of the trees, then run toward the leaf rib, and from there, fall to the ground. Forest-wide, considerable amounts of water are condensed from fog. In addition, the soil of these areas has a strong tendency to retain humidity. Hence, the ecosystem is able to maintain a moist atmosphere in the understory in spite of sparse rainfall, where the constant high levels of humidity account for the dense growth of plants and the great abundance of epiphytes. The Macaronesian forests have aptly been called "fog forests."

Most of the species living on these islands are specifically indigenous to them, due to their geographic isolation in the Atlantic Ocean. The indigenous species can vary from island to island. The trocaz pigeon (*Columba trocaz*) is indigenous to Madeira, for instance, while the laurel pigeon (*Columba junoniae*) and the blue chaffinch (*Fringilla teydea*) are specific to the Canary Islands. Striking examples of indigenous insects can be found in the family of the Carabidae, with 76 exclusive species.

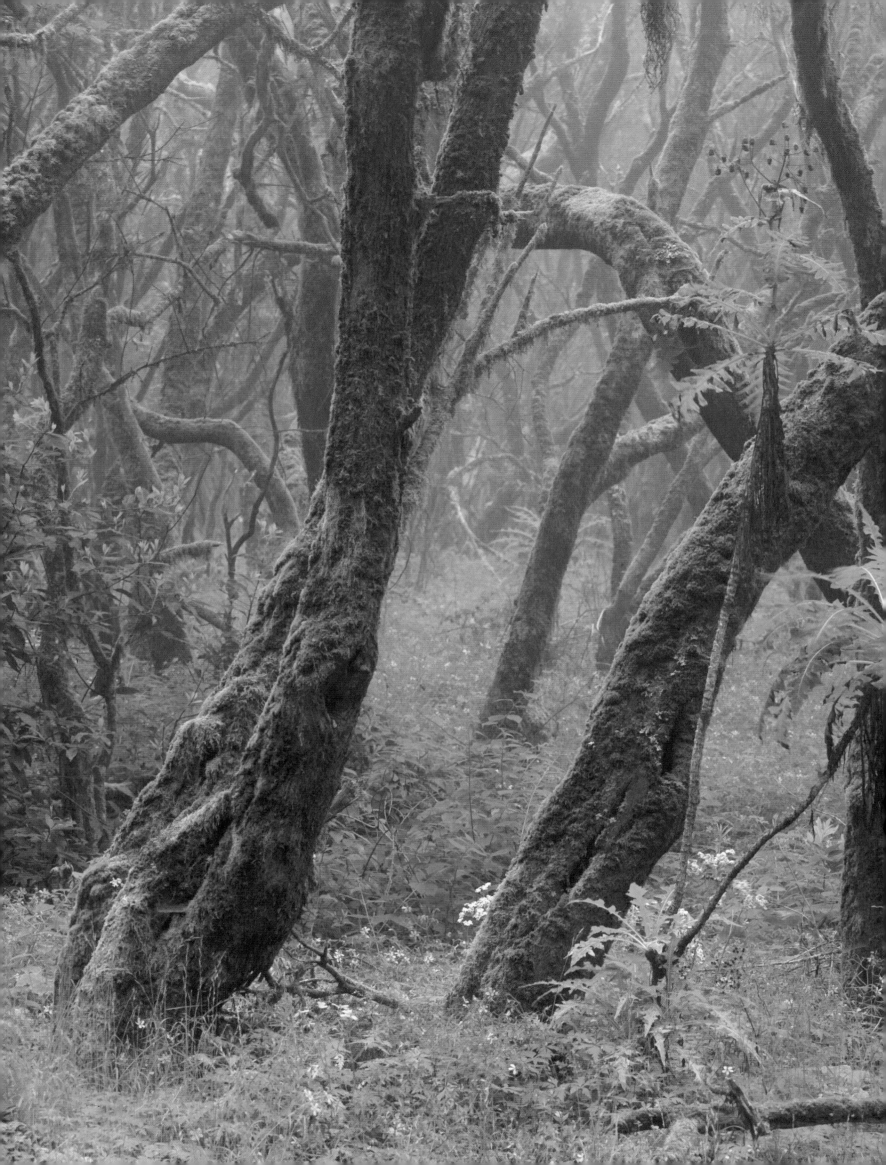

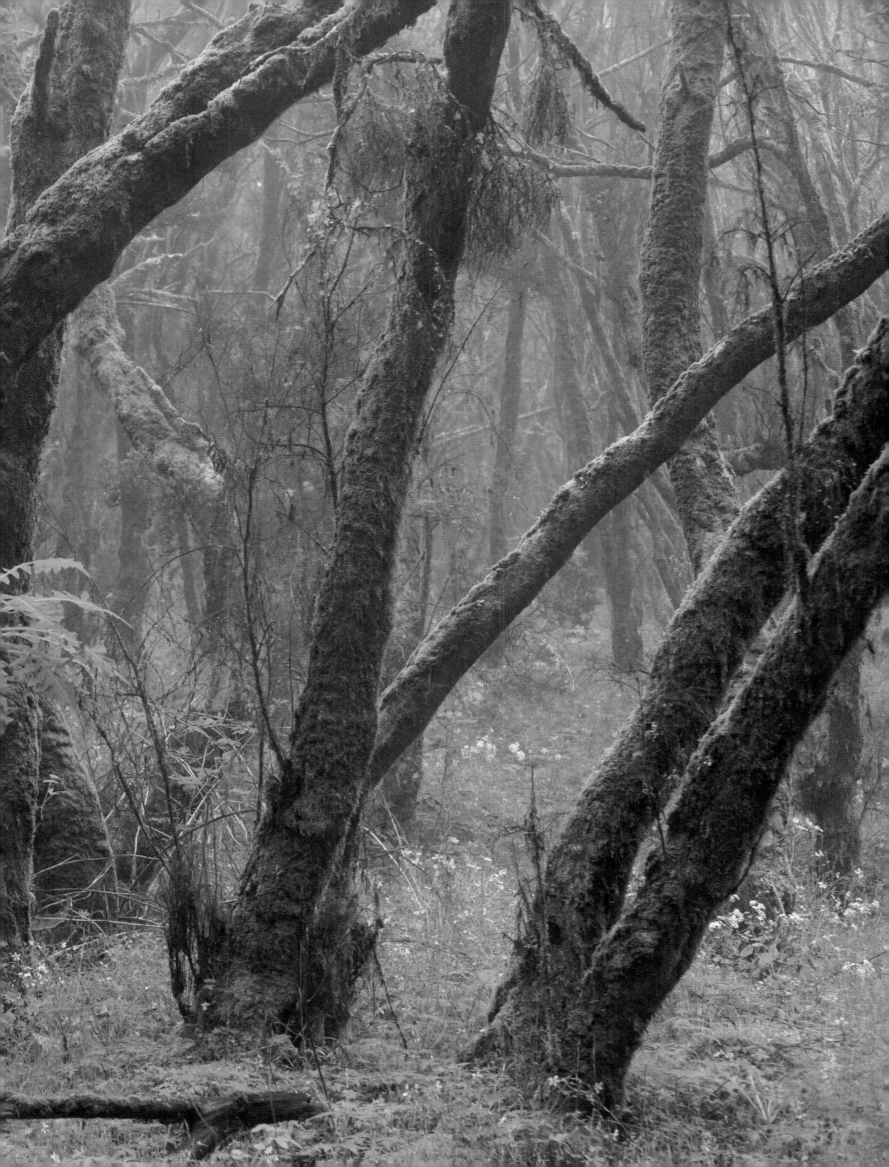

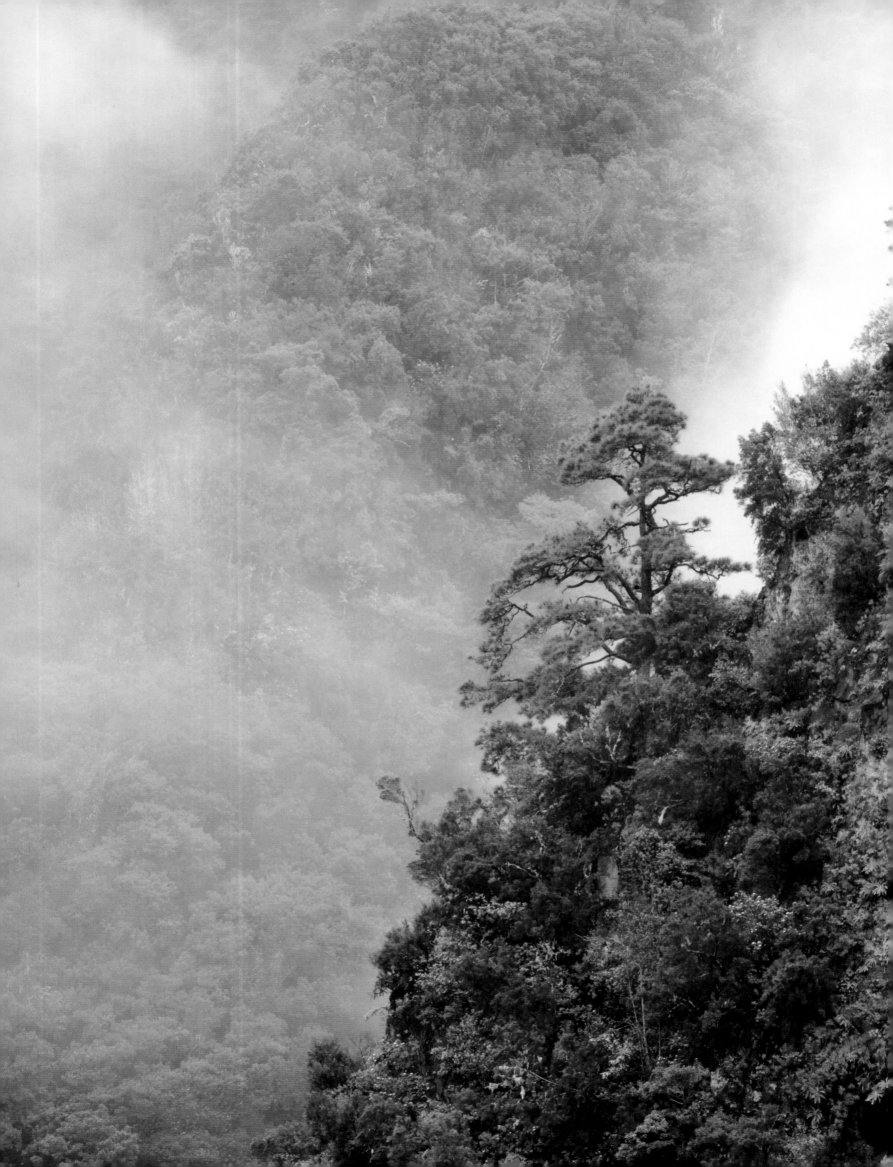

↑

Iberian lynx and its prey

Lynx pardinus
SPAIN | SIERRA DE ANDÚJAR
NATURAL PARK, SIERRA
MORENA, ANDALUCIA

The ordinary prey animal of the Iberian lynx is the European rabbit. The Iberian lynx is the most threatened species in Europe today, with a total estimated population in 2010 of 200 to 210 animals. The Spanish government and several conservation initiatives report slowly increasing success with the reintroduction of captive-bred animals to suitable habitats: a mosaic of scrubland and grassland with patches of forest and rocky areas—and enough rabbits, the populations of which have declined in many areas.

Pete Oxford

Hermann's tortoise

Testudo hermanni
GREECE | PINE FOREST IN THE PATRAS
REGION, NORTHERN PELOPONNESE

The endangered Hermann's tortoise (*Testudo hermannii*) lives in a wide variety of habitats in its Mediterranean range.

Christian Ziegler

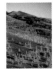

The Pico Viejo at sunset

SPAIN | TEIDE NATIONAL PARK,
TENERIFE, CANARY ISLANDS

On the slopes of the stratovolcano formed by Mount Teide and Pico Viejo, between 3,300 and 6,600 feet (1,000 and 2,000 meters), grows a forest of pines endemic to the island, the Canary Island pine (*Pinus canariensis*). In moist, favorable soil, the tree can grow to a height of almost 200 feet (60 meters) if left undisturbed. At altitudes above 8,200 feet (2,500 meters), the forests become sparser and the trees more compact.

Iñaki Relanzón

Blue chaffinch

Fringilla teydea
SPAIN | TEIDE NATIONAL PARK,
TENERIFE, CANARY ISLANDS

On the flanks of volcanic Mount Teide, the highest mountain in the Canaries—and, at 12,198 feet (3,718 meters), in all of Spain—the dominant tree species is the Canary Island pine (*Pinus canariensis*). The forests on Teide offer an interesting ecological comparison to the forests on Etna, which, at approximately 10,902 feet (3,323 meters) depending on its eruptions, is the tallest volcano in continental Europe.

Iñaki Relanzón

Mount Teide at sunrise

SPAIN | TEIDE NATIONAL PARK,
TENERIFE ISLAND, CANARY
ISLANDS ARCHIPELAGO

On the slopes of Mount Teide, the highest mountain (12,188 feet/3,718 meters) in the Canaries and in all of Spain, the Canary pine (*Pinus canariensis*) is the dominant species. The forests of Teide, an active volcano, have interesting ecological comparisons with those that grow on Etna, the largest volcano in Europe (10,922 feet/3,323 meters, varying during eruptions).

Iñaki Relanzón

Laurel forest on La Gomera

Laurus azorica
SPAIN, GARAJONAY NATIONAL PARK,
LA GOMERA, CANARY ISLANDS

Fog is an important source of water for the rainforests of the Macaronesian Islands, composed of tree species with soft leaves that transpire heavily. The laurel forest's ability to condense water out of fog was used by the aboriginal inhabitants of the Canaries, the Guanches. An engraving from the eighteenth century depicts men using jars to collect water flowing from the branches of a tree called a "fountain tree," probably a laurel-leaved tree. The inhabitants of El Hierro, the most remote of the Canary Islands, would dig pits under these fountain trees to collect water that then connected to shallow trenches that led to their fields.

Iñaki Relanzón

Laurel forest on La Palma

SPAIN, LOS TILOS NATIONAL PARK,
LA PALMA, CANARY ISLANDS

The cloud forests of the volcanic Macaronesian Islands, which emerged from the Atlantic Ocean toward the end of the Tertiary period, are famous for their biodiversity. Favored by a mild climate, which is both warm and humid thanks to frequent fog, and by very fertile volcanic soils, these islands have become conservatories for the flora of the Tertiary laurel forests that once covered Mediterranean Europe and Northwest Africa. The most representative plant species belong to the genuses *Laurus*, *Ocotea*, and *Ilex*, but in forms endemic to the islands.

Iñaki Relanzón

177

FORESTS HAVE ALWAYS INFLUENCED MAN PROFOUNDLY—AS A SPACE IN WHICH TO LIVE, AN INCUBATOR OF RESOURCES, A SOURCE OF RELIGIOUS INSPIRATION, AND A SAFE HAVEN IN TROUBLED TIMES. BUT IN THE PAST, EUROPE'S FORESTS HAVE ALSO BEEN DRASTICALLY CUT DOWN, PARTICULARLY IN THE MEDITERRANEAN AND ATLANTIC PORTIONS OF THE CONTINENT. THOSE THAT HAVE SURVIVED HAVE MOST OFTEN BEEN OVERHARVESTED. EVEN TODAY, TIMBER HARVESTING PRACTICES ARE GENERALLY FAR TOO INTENSIVE, DESPITE THE THOUGHT AND EFFORT THAT HAS GONE INTO IMPLEMENTING BEST PRACTICES FOR FOREST MANAGEMENT, AS FORMULATED IN CENTRAL EUROPE. WE URGENTLY NEED TO TAKE STOCK OF THE POTENTIAL THREATS TO THESE ECOSYSTEMS FROM CLIMATE CHANGE AND THE IMPACT OF POLLUTION, BOTH IN THE PAST AND STILL TO COME.

FORESTS AND MAN

CONSCIOUS OF HIS SINS, MAN HAS TRIED TO SAFEGUARD THE REMAINING FORESTS BY DRAFTING LAWS THAT PROTECT HABITATS AND SPECIES, AND BY PUTTING STRONG PROTECTIONS AROUND THE RELICTS OF OLD-GROWTH FORESTS. PROGRAMS TO REINTRODUCE SPECIES WHERE THEY HAVE BEEN ELIMINATED AND TO PROTECT THE MOST ENDANGERED BIRDS AND MAMMALS SHOULD HELP TO ENRICH THE BIODIVERSITY OF EUROPE'S FORESTS. LAND THAT HAS BEEN ABANDONED BY AGRICULTURE COULD BE ALLOWED TO REGENERATE SPONTANEOUSLY AS FOREST, WITH ITS FULL COMPLEMENT OF WILD FAUNA, HERBIVORES, AND CARNIVORES.

FORESTS ARE, FOR MANKIND, REFERENCE POINTS FOR MENTAL AND SOCIAL CONSTRUCTIONS. DURING THE AGE OF REASON, THEY WERE REDUCED TO A MORE NEUTRAL NATURAL SPACE, BUT for millennia forests were objects of sacred veneration in every part of the world. This supernatural universe lasted far into historical times in Europe and can be found, for instance, in the epics of knight-errantry.

SUPERNATURAL NATURE

Man's need to turn to the supernatural for a touchstone explains why he has long peopled sacred forests with creatures from the spirit world. Whatever name is given them, these fantastic beings often symbolized the four main elements of nature; they followed one another according to the rhythm of the seasons, becoming assimilated finally into the endless cycles of life and death. Elves and fairies, the most diaphanous creatures in the enchanted realm, are said to live in the air, clouds, and wind. They are the guardian spirits of trees, plants, and all flora, and often dwell in trees. Sirens, sprites, naiads, and water fairies supposedly take form in the wet world of rivers, streams, springs, and fountains, revealing themselves in spring to take part in nature's reawakening. In the depths of the earth and beneath the roots of trees purportedly live the small folk—dwarves and gnomes—whose scowling faces are imprinted on the bark of trees and whose bonnets can be mistaken for mushroom caps. They come out in the fall when fungi

are in season and fruits are ripening and are responsible for the sprouting of seeds in the soil, as well as guarding underground veins of precious stones. Finally, there are the alleged salamanders, basilisks, and dragons that live in flames and beds of coal. They come out at the beginning of winter, marked by the holidays in November. This style of thinking also imagines the forest as a place of darkness, inhabited by dangerous, cunning spirits. Trolls supposedly live there, eating men who pass by, and vampires are said to suck human blood.

WONDROUS PLANTS AND MYTHICAL ANIMALS

Plants, especially trees, have also assumed shadings of the supernatural. Ambiguous entities, in contact both with the sky and the realm of the dead, they flirt with eternity by living a very long time (the oldest are thousands of years old) and can reach a spectacular size. Old trees have been worshipped because they reveal the deepest structures in the world, expressing life, youth, immortality, and wisdom. Cosmic trees, the tree of life, and the tree of the knowledge of good and evil extend deep into the heavens, and their roots reach into another world. They are sources both of fecundity and regeneration.

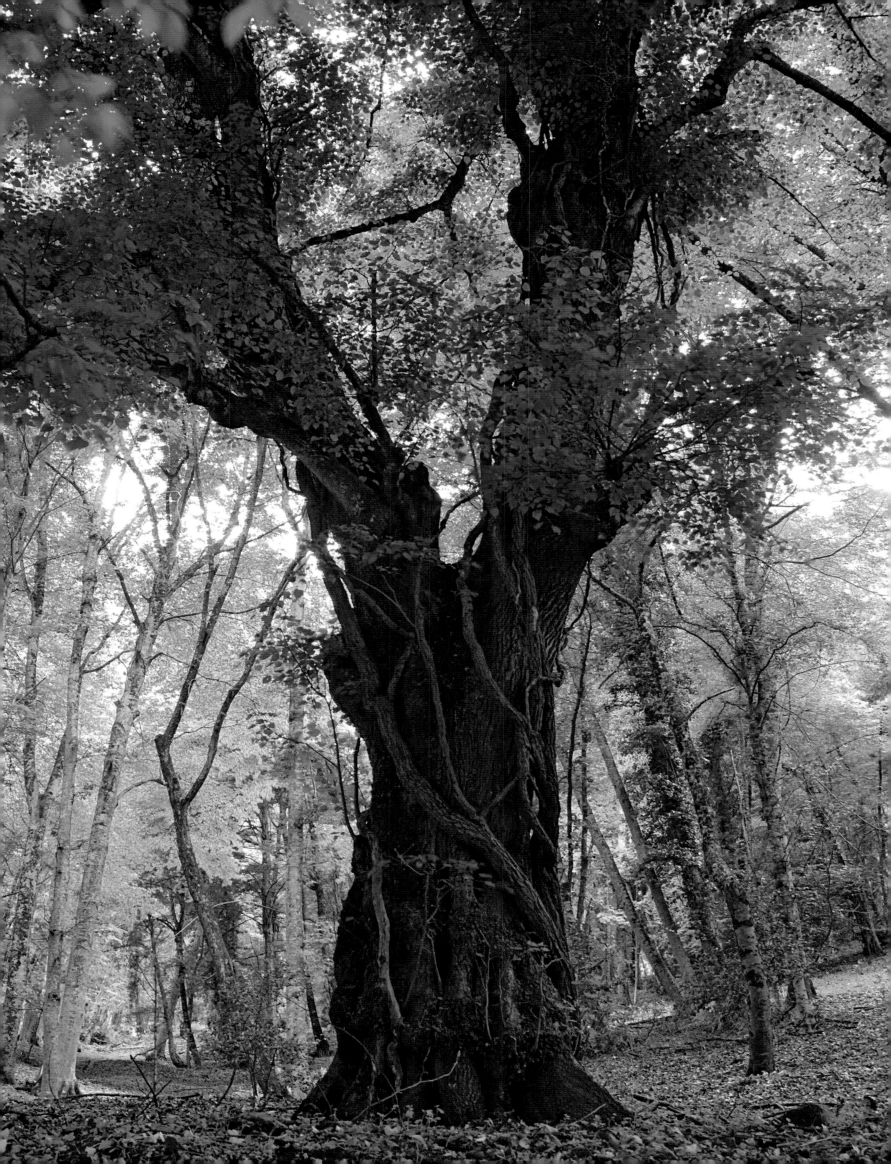

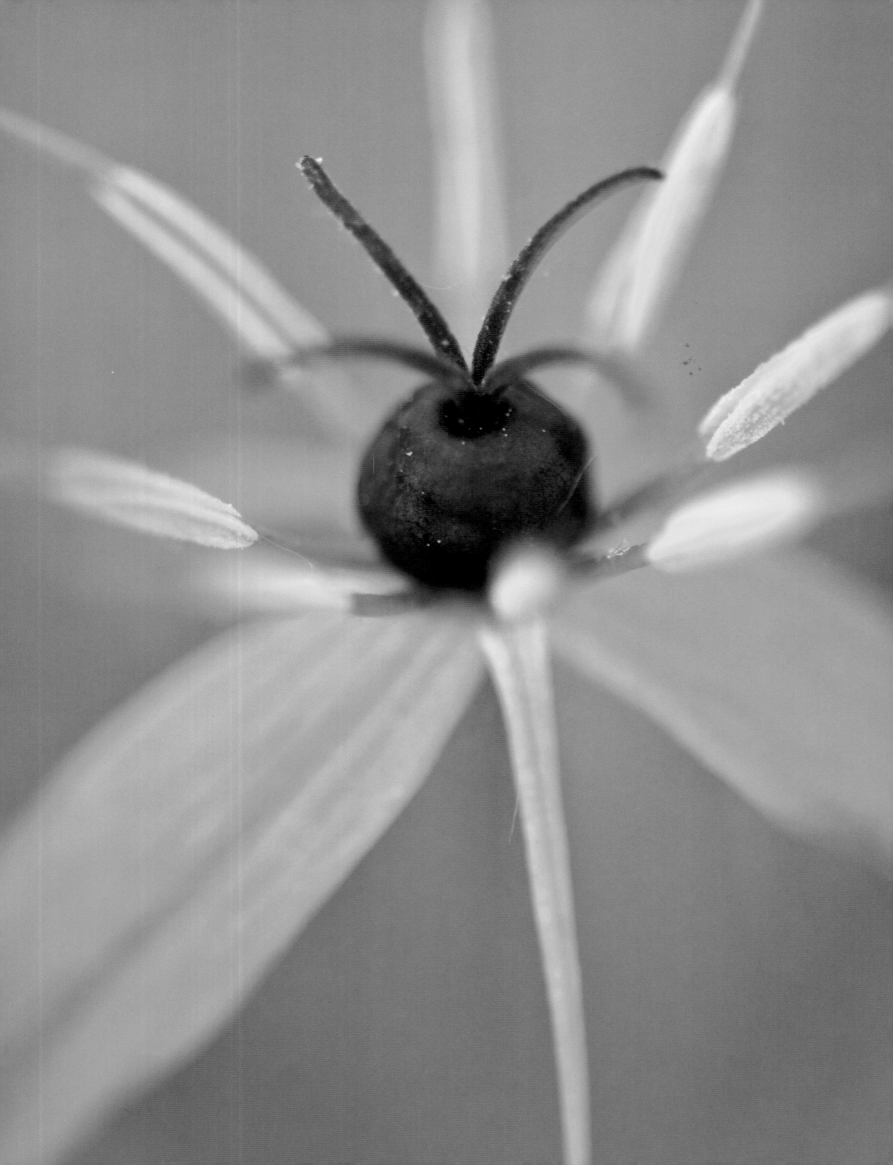

The most famous is the great ash Yggdrasil, the tree of the world revered in Norse mythology. It supported nine worlds—from the world of the gods to that of the dead—and was supported by three roots symbolizing past, present, and future. The yew and oak have been cosmic trees, or symbols of knowledge, in other European countries such as Ireland. Oaks, as spirits of the forest, have been associated with thunder and lightning by the Greeks and Romans, and also by the ancient Scandinavians, Germans, and Celts. Oaks were also emblematic of priests, druids, (whose very name means "man of oak"), and such figures from folklore as Robin Hood. Yews—which can live for more than 5,000 years, and perhaps as long as 9,000 years—are a symbol of eternal life. Winter solstice ended with a celebration of the yew, linked in Scandinavia to the god of archers (its wood was used to make bows).

In the Mediterranean, since time immemorial, yews have been planted beside burial sites, and they are still often seen in European cemeteries. The linden, whose flowers are used in traditional herbal medicine for their calming effect, has also been considered sacred and is often planted in villages. Lindens were also the alleged homes of elves and dragons, and were linked first to fertility, then to justice. The olive tree, ubiquitous in the Mediterranean and the Near East for thousands of years, has—thanks to the oil derived from its fruit—played a crucial role not only in culture and religion but also in cookery, medicine, and economy. The tree was a symbol of abundance, prosperity, and divine blessing among the ancient Hebrews, while the ancient Greeks assigned it to Athena, goddess of wisdom, who created the first olive tree on the rocky hillock of the Acropolis, and the Romans associated it with Minerva, goddess of health and wisdom.

There are many thousand-year-old trees in Europe. The most famous are in places that have long been under man's control—parks, gardens, cities, and forest preserves. Among them are the littleleaf linden (also called a small-leaved lime) at Tassillon in Bavaria; the Fortingall Yew in Scotland; the oak in the forest of Nordskoven in Denmark; the Bowthorpe Oak in Lincolnshire; and the lime coppice in Westonbirt, Gloucestershire. But there are also ancient trees in old-growth forests, growing unknown and unworshipped in their natural settings.

Aside from trees, many other forest species have been associated with magical and religious ceremonies. Hawthorn was once celebrated on May 1 throughout Europe, decorated with ribbons and flowers to welcome the return of sunny days and fertility. Ivy and holly, which are evergreens with an inverted fruiting cycle (autumn blossoms, late winter fruits), were symbols of everlasting life. Mistletoe was considered sacred when it grew on oaks and was harvested by the Celtic druids. A pale remnant of these beliefs is reflected in certain surviving European traditions: Ivy is still used to decorate headstones, and mistletoe is gathered at New Year to symbolize happiness for the year to come.

Forest animals have also played a role in the construction of values in primitive and traditional societies. Many myths feature animals, some of which have given their names to tribes, particularly when the founders are said to have been suckled, for instance, by a female ibex, bighorn sheep, or wolf. In these fables, the nursing animal provides not so much nourishment as true

mothering, and the child retains the traits of its foster parent. Traditional medicine incorporates animal products into its recipes for unguents, powders, filters, and talismans that protect or give strength and courage. Fox grease or the grease of a felid such as the lynx was used to treat gout and nervous conditions, for example.

Red meat, which gives men strength, is associated with the virility of the hunter. Imaginative thought, social prestige, and the act of eating are so intimately linked that the fruits of the hunt are surrounded by dietary restrictions, and most of the animals that provide meat are the objects of religious cults. The sacred universe of forests has inspired fantastic legends; one of the most universal across Eurasia is the tale of the "Wild Hunt." This story of mad pursuit has left numerous traces in European literature and has been given multiple supernatural meanings that have varied across different periods and civilizations. It often takes place deep in the forest and involves the horseback pursuit of a mythical animal (generally a stag). This animal (along with the bear) has been the object of religious worship all through prehistory and antiquity in temperate and Mediterranean Europe. The stag symbolizes the hunt or death, and the "black blood" of stags in rut is compared—as is the blood of solitary male boars—with the blood coursing in the veins of hunters in the fall, or in the veins of savage men of the woods possessed by demons. The Wild Hunt is sometimes assimilated with an act of founding, such as the conquest of a new territory, in which case the stag becomes the mythical ancestor of the clan. The Norse god Wotan took part in the Wild Hunt. Gathering his warriors and leading them in pursuit of demons, he watched over the unleashing of nature's forces and the maintenance of world order by drawing the forces of night on himself.

For Christians, the legend of the Wild Hunt was generally told as a morality tale with the hunters receiving punishment for serious crimes, such as giving in to blood lust and breaking the rules of honor.

Among the large mammals the aurochs, bear, bison, and Asiatic lion (the latter roamed Europe's forests in the Neolithic and was known in Greece in antiquity) were the most worshipped. Given their impressive size, courage, and beauty, they attracted multiple symbolic meanings over the millennia, both in their natural aspect and in chimerical, imaginary shapes. Thus the aurochs (such as Taurus the bull) and the lion—cosmic animals—are still represented today in the map of the sky and, after appearing in the pantheons of many Mediterranean and Near Eastern cultures, were integrated into Christian symbolism.

The bear, on the other hand, which was worshipped by the Scandinavians, Russians, Germans, Slavs, and Celts, was opposed as a symbol by the Christian church, in an effort to lessen its aura of power and arrogance. Its image is nonetheless highly visible in contemporary life. The bear is still an emblem used for many artisanal products in Croatia, for example, and for a number of food products (cheese from the French Pyrenees, the crowned bear of Ursus beer in Romania, and honey in Austria). The bear appears in many coats of arms (those of the Asturias, in Spain, for one) and other crests (the Abruzzi National Park in Italy and the Kocevje Preserve in Slovenia, among others). In Finland and Russia, the bear is the national animal and its meat is still eaten roasted, stewed, and in patés.

THE IMAGINARY FOREST

Determined to root out pagan beliefs from European societies, Christian thought has long linked forests and their inhabitants to wildness and barbarity. It is therefore not surprising that men of the forest, even such artisans as charcoal makers and glass makers, lived in closed communities isolated from villages. Deriving a living from the deep forest was almost a sentence of banishment. Also, forests served as hideouts for brigands and bands of marauders who preyed on the villages. In France during the Protestant persecutions, the Calvinist insurrectionists hid in the forests of the Cevennes, and in Corsica a number of bandits found refuge in the *maquis*.

But not all renegades who took to the woods inspired fear or rejection, as witnessed by the legend of Robin Hood, who championed the poor in a repressive time. Once again the symbolism attached to forests is enormously complex, for the outlaw who holed up in the forest did not consider it a simple hiding place: It was also a place on the fringes that challenged the credibility of the established order, a place of freedom that functioned as a stepping-stone to a better society. Petrarch spoke glowingly of the forest as a haven from the existing social order, but Dante casts the symbolic forest in his *Inferno* as a place of sin, error, wandering, and forgetfulness of God. In Boccaccio, the forest is a place of initiation—it represents the mysteries of sexuality. European painters, for their part, rarely showed forests in a natural state, giving them a more orderly, landscaped appearance. An exception is Rolandt Savery, a seventeenth-century Dutch landscapist, who masterfully painted the virgin forest with its deadfalls, canopy openings, and tangle of vegetation. The French landscape painters of the School of Barbizon (1840–1870) are another exception; they painted the Forest of Fontainebleau at a time when it was still full of standing snags, decaying wood, and large trees.

Modern western society looks at the forest largely from a utilitarian perspective as something that can exist only to the extent that it is useful to man. Other values are assigned to it as well, relating to esthetics, sports, healthy living, and the conservation of biodiversity. The collective imagination is satisfied with nature films and childish representations on the level of teddy bears and cartoon animations. A general fascination with ancient trees can nonetheless be noted in European cities, where old trees are protected, and where initiatives are put in place to protect the last remaining tracts of primordial forest.

To these multiple approaches to nature must be added the "nature spectacles" that form quiet pockets in the midst of cities: wooded parks and zoos. Meanwhile, the forest that regenerates on fields abandoned in times of war, epidemic, or economic disaster is often not well regarded at all. The forest still symbolizes exile and the gods' disfavor, loss of bearings, accumulation of living and dead plant matter, and eruption of creatures that are repulsive or harmful, from slithering snakes to swarming rodents.

In this long progression of ideas, what is left finally of the sacred world of the early forest dwellers? Some philosophers interpret man's confused attachment to the forest depths as a paltry trace of this very ancient heritage.

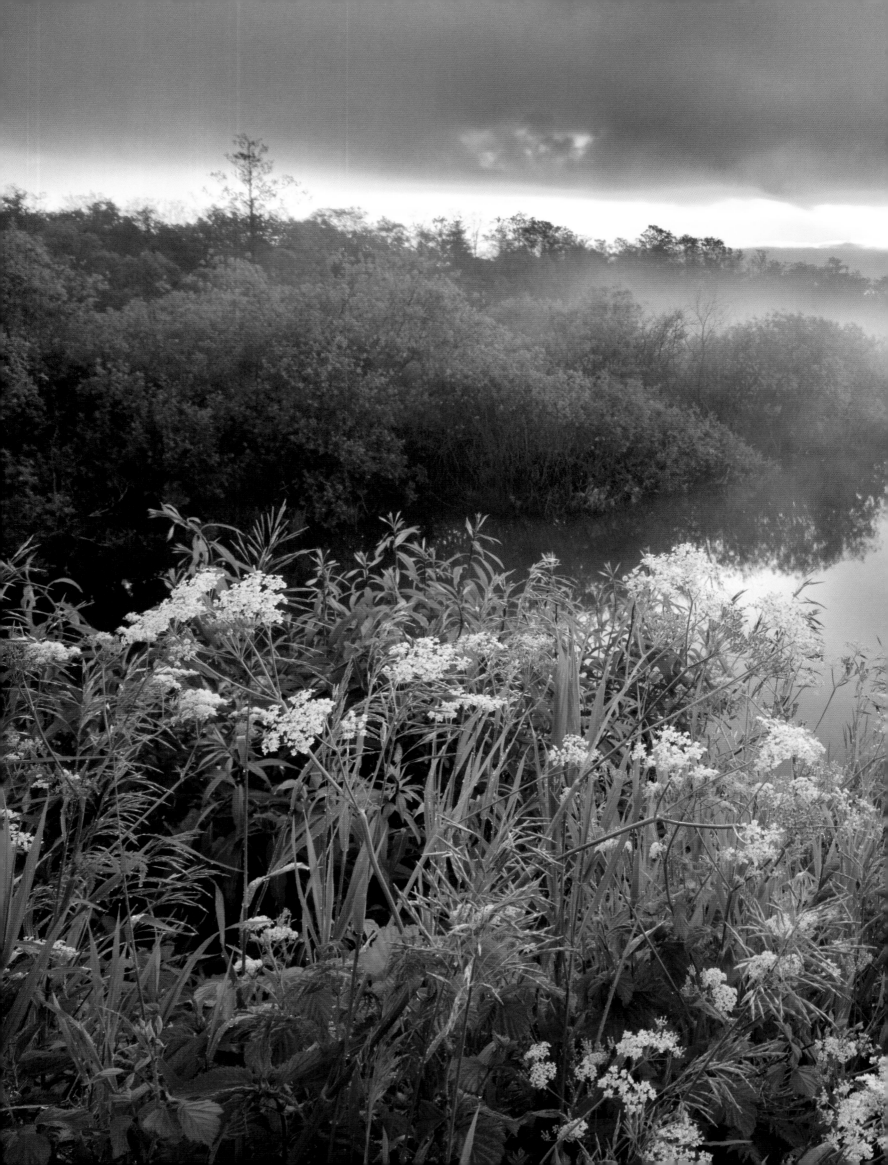

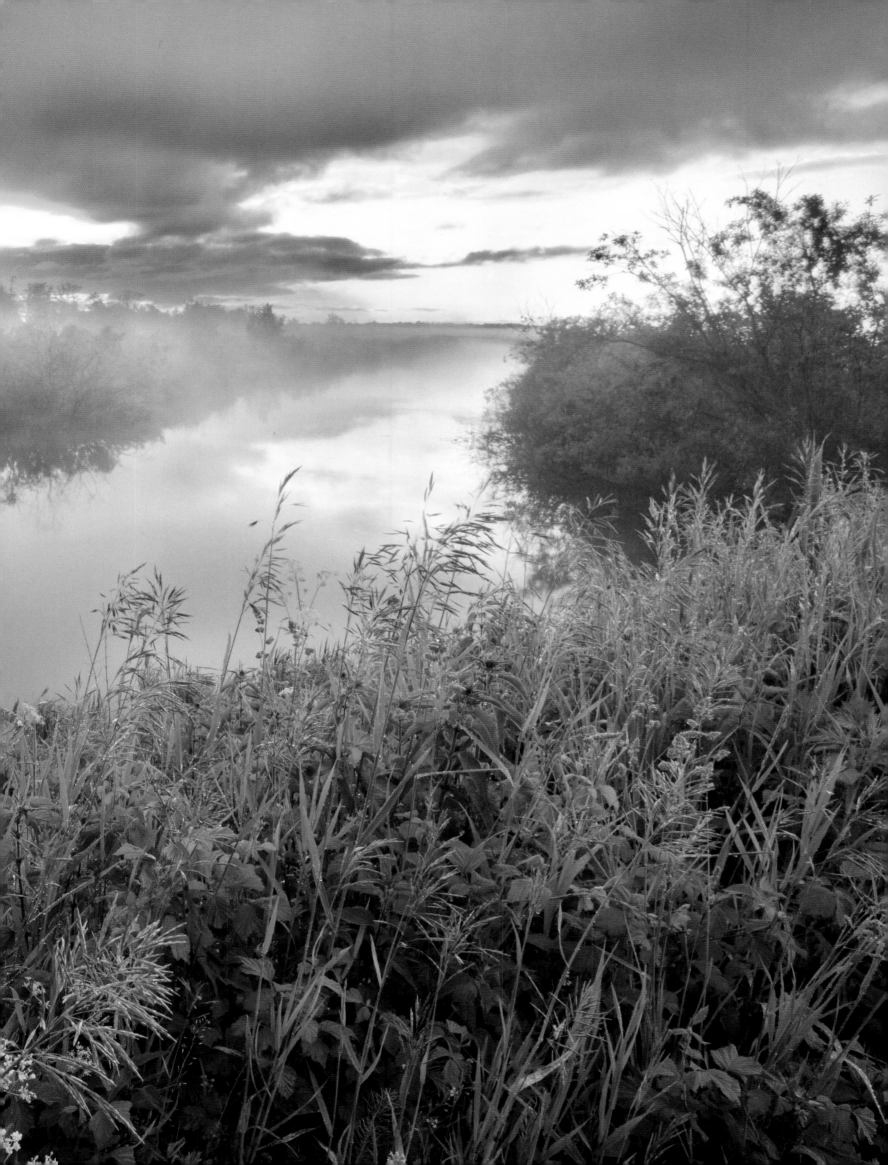

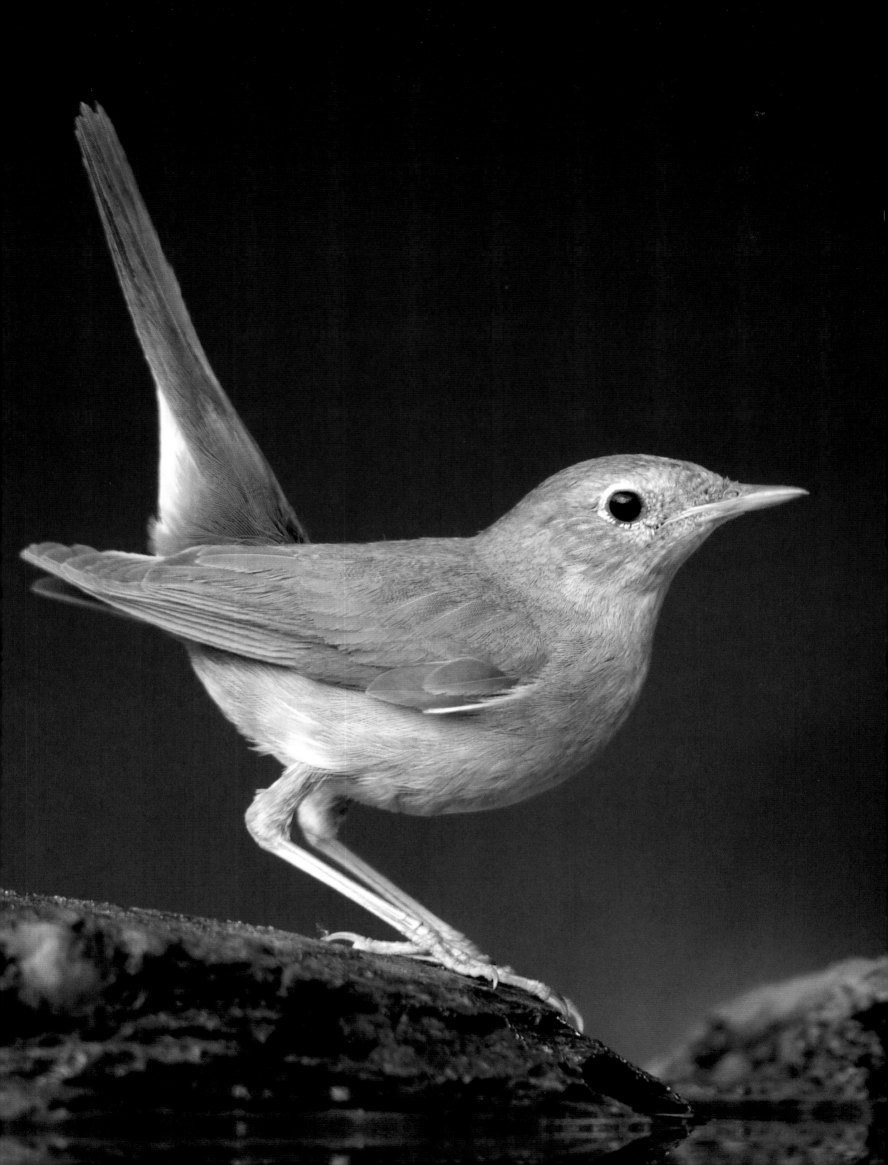

Common ivy

Hedera helix
ITALY | UMBRA FOREST, GARGANO
NATIONAL PARK, APULIA

Ivy is a vine that, like all vines, is unable to support its own weight. To gain access to sunlight, ivy climbs the trunk of canopy trees. Its method of climbing is complicated: Its creeping and climbing stems wind around the trunk and affix themselves using the small hooks of their aerial roots. The close contact of the ivy with its host tree gives the impression that ivy strangles it and robs it of sap. Nothing could be farther from the truth: Ivy is not a parasite, since it develops extensive roots in the soil from which it extracts mineral elements. Ivy therefore coexists peacefully with its host. Far from killing it, ivy supplies the host tree with minerals in the spring when it drops a portion of its leaves. The image of ivy in human society is not entirely negative, as one often finds ivy growing on old headstones or engraved there as a motif to symbolize eternity.

Sandra Bartocha

Herb paris

Paris quadrifolia
BELGIUM | HALLERBOS,
FLEMISH BRABANT

Herb paris, or true-lover's knot, is a perennial herbaceous plant of the understory of deciduous forests. It is easily recognized by its four large leaves in the shape of a cross and its single flower, which forms a dark-blue berry in the spring. The fruit is toxic, but the plant is used in homeopathic medicine for its chemical properties.

Maurizio Biancarelli

Morning mist over a swamp

LITHUANIA | NEMUNAS DELTA
REGIONAL PARK

Before the esthetic and ecological value of wetlands became recognized, Europeans perceived swamps as dangerous places. The teeming mass of living and dead vegetation in a swamp and the lurking presence of noxious and repulsive creatures alienated men's affections. Besides, draining wetlands seemed a way of ridding the world of a source of "pestilential exhalations," nefarious to man's moral and physical being.

Mark Hamblin

Nightingale

Luscinia megarhynchos
HUNGARY

The nightingale, a shy denizen of farm and hedgerow habitats, has among the most complex songs of all European songbirds. Its rich and melodious voice produces a wide range of sounds and a varied repertoire of more than 1,300 motifs (trills, whistles, gurgles, and long phrases).

Markus Varesvuo

Mushrooms

Mushrooms appear and disappear at a moment's notice. They are either edible or poisonous, fatal or hallucinogenic. Their colors can be spectacular, their smell quite strong. The subterranean world of fungi, so closed to man's observation, remains something of a mystery.

Staffan Widstrand

Logging in the taiga

FINLAND | OULANKA FOREST, NORTHERN
OSTROBOTHNIA

The taiga environment is in grave danger from being excessively logged. Repeated clear-cutting over large areas destroys the natural complexity of these forests, their plant biodiversity, and the habitats of their most fragile species (organisms that spread slowly or that rely on deadwood for food or shelter, including many species of fungi). In addition to consuming vast quantities of trees and space, humans also build large networks of roads, which greatly harm animal life.

Staffan Widstrand

Alpine ibex

Capra ibex
ITALY | GRAN PARADISO NATIONAL PARK,
AOSTA VALLEY

The ibex has been intensively hunted, both for sport and for its supposed magical or medicinal properties. The last remnants of the Alpine ibex population took refuge in the Gran Paradiso mountains in the nineteenth century. The ibex's return to the Alps was the result of a campaign in the early twentieth century to reintroduce captive-raised specimens to the wild. It spread spontaneously to France from the neighboring Gran Paradiso range, and can now be found in the Vosges mountains and other mountainous regions of lower altitude as well, where the ibex lives in high-altitude coniferous forest, just at or below the treeline. Despite periods of stagnancy and local setbacks, the overall results have been spectacular: In 1990, the total ibex population was more than 25,000.

Erlend Haarberg

189

IT SEEMS CLEAR THAT THE HUNTER-GATHERER CIVILIZATIONS THAT PEOPLED EUROPE AT THE START OF THE HOLOCENE ABOUT 10,000 YEARS AGO MADE A DEEP MARK ON FORESTS because of their practices of controlled burning and hunting, favoring certain plants, and harvesting wood. But it was only after the development of sedentary culture and the arrival of Neolithic civilizations, which happened about 7,000 years ago in Europe, that the forests of the Holocene were cut down permanently to make way for fields and pastures. The loss of forestland occurred even earlier in the Mediterranean Basin. In most of Europe's northern countries, by contrast, as well as in portions of central and eastern Europe, the forest remained a major element of the landscape. In western Europe and the Mediterranean Basin, the loss of woodlands accelerated sharply in the Bronze and Iron Ages.

Forests have fulfilled many functions for mankind. In the course of man's history, they have provided a home territory, raw materials, religious inspiration, and a peaceful haven in uncertain times. Recently, men have become interested in ways of better preserving them, on the one hand to maintain them as a sustainable resource over the long term, and on the other to put strong measures in place to save what is left of the old-growth forests, certain habitats, and key elements of the flora and fauna.

FORESTS AS A PROVIDER OF RESOURCES

Forests have supplied many resources to man, from the raw materials for his shelter and housing to the products necessary for his nutrition, health, and arts. The movement of populations allowed the spread of knowledge about plants and their potential uses and the spread of the plants themselves. For instance plants originally from parts of Eurasia, like the walnut, fig, chestnut, and later the apple and the almond became widespread in Europe.

Some plants were exclusively used as foods (for example: garlic, wild asparagus, rough bedstraw, hazel, dandelion, wild strawberry), while others were singled out for their medicinal properties (foxglove, Scotch broom, elm, black bryony). Yet many plants had multiple uses: Brambles were used as food (berries) and as medicine (to improve blood circulation); European elder was used in making beverages and as a dye. Some plants are used as ingredients in perfumes (rose), as aromatic spices in cooking (cumin, hops, juniper), are distilled for their essential oils (conifers), or are noted for their poisons (yew seeds, ivy berries).

Wood was used in prehistoric times to feed the fires that kept dangerous animals at bay, cook raw foods, and heat communities, thus improving opportunities for social interaction and cultural exchange. It was the basic raw material for building palisades and huts, fashioning traps and deadfalls, making tools (dogwood, white heath), weapons (yew), furniture (oak, fruitwood, and woods that were resistant to fungus such as cypress and cedar), and decorative objects.

Some timber is still highly valued. In the boreal zone, Siberian larch, whose wood is dense and flexible, is considered excellent for construction, but it has been overharvested as the Russians sell it to meet demands in central Europe. Other conifers are equally prized, including Siberian spruce and Scotch pine. The oak that grows in temperate forests is appreciated by builders and cabinetmakers for its hard, dense wood, as are certain fruitwoods. The wood of particular small trees (dogwood, spindle) is used for toolmaking. Some oaks provide valuable bark, such as the cork oak (*Quercus suber*) and the holm oak (*Quercus ilex*), harvested for their cork and tannins, respectively. Conifers also provide resins, for instance the maritime pine (*Pinus pinaster*).

Mushrooms are another significant resource. They are a food source or a complement to other foods (truffles, boletuses, chanterelles, and many other edible species). Other mushrooms are psychoactive (such as *Amanita muscaria*, used in shamanistic rituals).

Men have also hunted, eaten, or otherwise used numerous species of animals, both invertebrates (snails, honeybees) and vertebrates, from amphibians to mammals to birds. Mankind has domesticated a number of forest species such as aurochs, (ancestor of today's domestic cattle), tarpan (ancestor of the horse), reindeer, wild boar, and wolf (ancestor of all breeds of domestic dogs).

MAMMALS: MAN'S FIRST VICTIMS

Mammals hold a unique place in the history of man. They have been hunted since the dawn of time for their meat, fur, and supposed sacred powers, as well as for more specific attributes such as their antlers, horns, and musk glands. But the history of mammals also illustrates the brute force of mankind, which has visited cruelty, injustice, and suffering on animals for thousands of years.

Fortunately, there has been an opposite and very positive effort to protect mammals in the wild, breed them in captivity, and reintroduce them to places where they have been eliminated. This has been successful enough in recent decades to mitigate man's historically negative impact. It is also true that human societies, which have varied widely across Europe, have not all been equally successful at suppressing wildlife. The animals for their part have been quick to flee, to hide in overlooked corners, and to profit from any relaxation to recover lost ground. Fluctuations in their population therefore reflect human history, the pressures due to hunting or poaching, the effect of political decisions and royal edicts, of wars, and of conservation agreements. There is the fact, too, that many species are very opportunistic, which allows them to adapt well to highly man-modified environments, living close to human settlements where they are tolerated up to a point.

In early antiquity, the hunt was practiced by the powerful for diversion and sport; it entailed rounding up wild animals, sometimes on a massive scale, for removal to animal preserves, and this decimated wildlife populations in the Near East. The hunts continued through the Greco-Roman period, and the Roman circuses took a heavy toll on the large quadrupeds of North Africa, the Mediterranean Basin, and temperate Europe.

In historic times, the fur trade in the parts of Eurasia where winters are severe helped to empty the forests of their animals. Furs of many kinds (otter, lynx, beaver, wolverine, wolf, bear, squirrel, mink, sable) were symbols of high social standing throughout western Europe from the late Middle Ages and were the object of a lively and extensive trade between northern Europe and the Mediterranean. For example, more than a million furs per year—most of them squirrel—were produced in the Baltic and Slavic states during the fourteenth century.

Large animals were particularly affected by human activity, as witnessed by the histories of Europe's large herbivores: the bison, the moose (called "elk" in Europe), and the aurochs. These three species occupied vast, partially adjoining areas between central Europe and the Baltic forests during the millennia that preceded and followed the last glaciation. The range of the aurochs, a powerful wild bovid with large horns, probably extended from the Near East to Europe and into northern Scandinavia. Still abundant during the Neolithic (its bones are routinely found at archaeological sites), the aurochs declined rapidly during subsequent millennia. Its extinction followed the domestication of cattle, which led to intensified hunting and persecution of its wild competitors. The aurochs began to be exterminated across Europe well before the medieval period, though its disappearance from central Europe followed later. Eliminated from Russia in the sixteenth century, they subsisted only in the forest of Jaktorov, near Warsaw, Poland. When only 100 aurochs remained, the Polish royal family tried to save the species, but the last aurochs died in 1627 following an epidemic.

The second largest European bovid, the bison, occupied a vast territory after the last glaciation, extending over the entire continent from the Middle East to the Iberian Peninsula and also in northern and southern Scandinavia and the Baltic countries as far east as the Caucasus. The European bison, immortalized as it appeared in the Pleistocene (*Bison priscus*, most likely) in the splendid cave paintings of Lascaux in France and Altamira in Spain, disappeared early on from the Mediterranean area—much like the aurochs—but subsisted longer in Europe's temperate zones. There were still bison from eastern France to Switzerland and in Pomerania in the eleventh century, and in Lithuania in the sixteenth century. At the end of the nineteenth century, only one population still existed, in Bialowieza in Poland, on the frontier with Belarus. The mountain subspecies (*Bison bonasus caucasicus*), which had survived in the Caucasus, fell prey to hunting and poaching despite efforts to preserve it. The plains species (*Bison bonasus*), however, was saved from extinction by a concerted rescue that made use of zoo specimens. In 1929, six bison raised in captivity were sent to the forest of Bialowieza, where they were kept in a fenced area. They served as stock for the different herds that developed subsequently. After 1946, new breeding centers for bison appeared. In 2011, according to the Large Herbivore Foundation, there were 4,230 bison in Europe, of which more than half lived in the wild.

The European elk (*Alces alces*), originally lived in the moist and swampy forests of Europe. Once found in Gaul, it disappeared from the region between the ninth and tenth centuries. It remained abundant in Germany for a time but gradually disappeared from there as well. Today it is found only in the northern parts of Europe, from Scandinavia to the Baltic countries and Russia, as well as in certain Eastern European countries (Poland, for instance), where it was reintroduced from Russia.

193

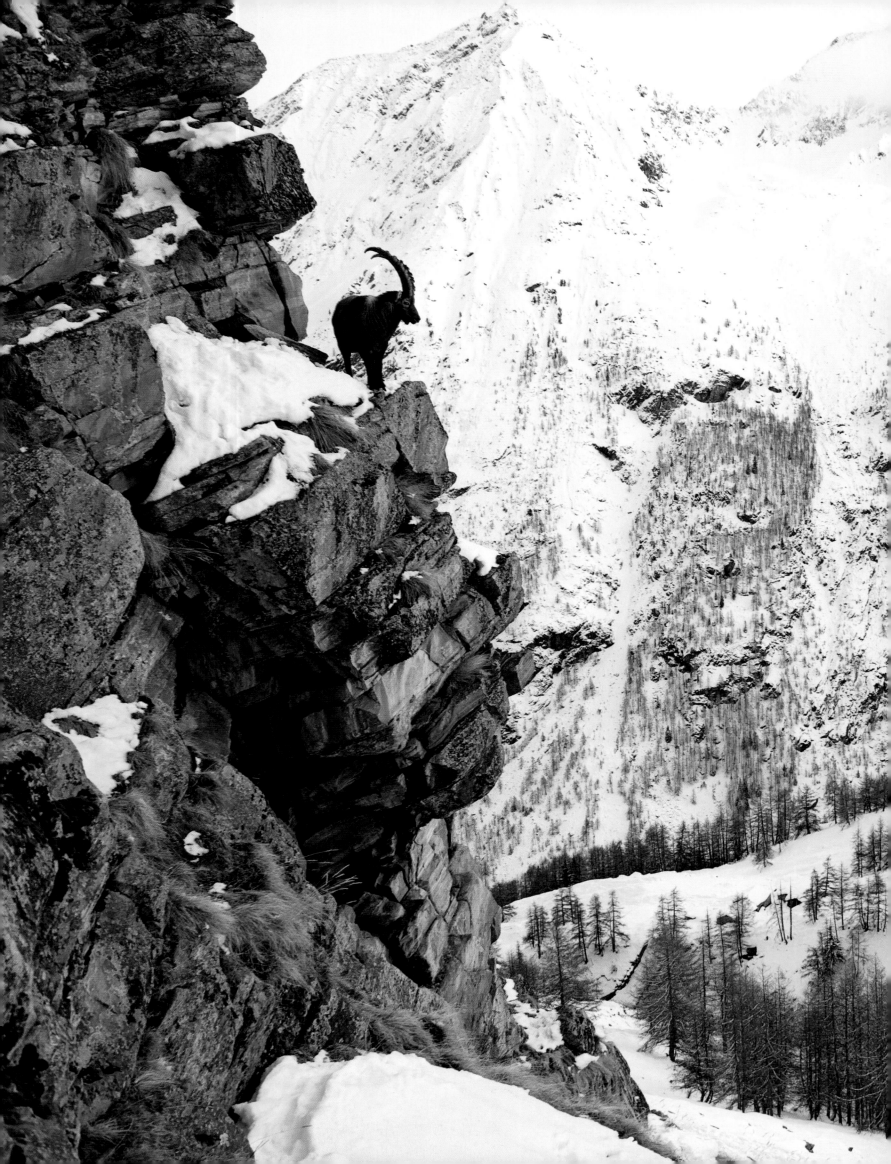

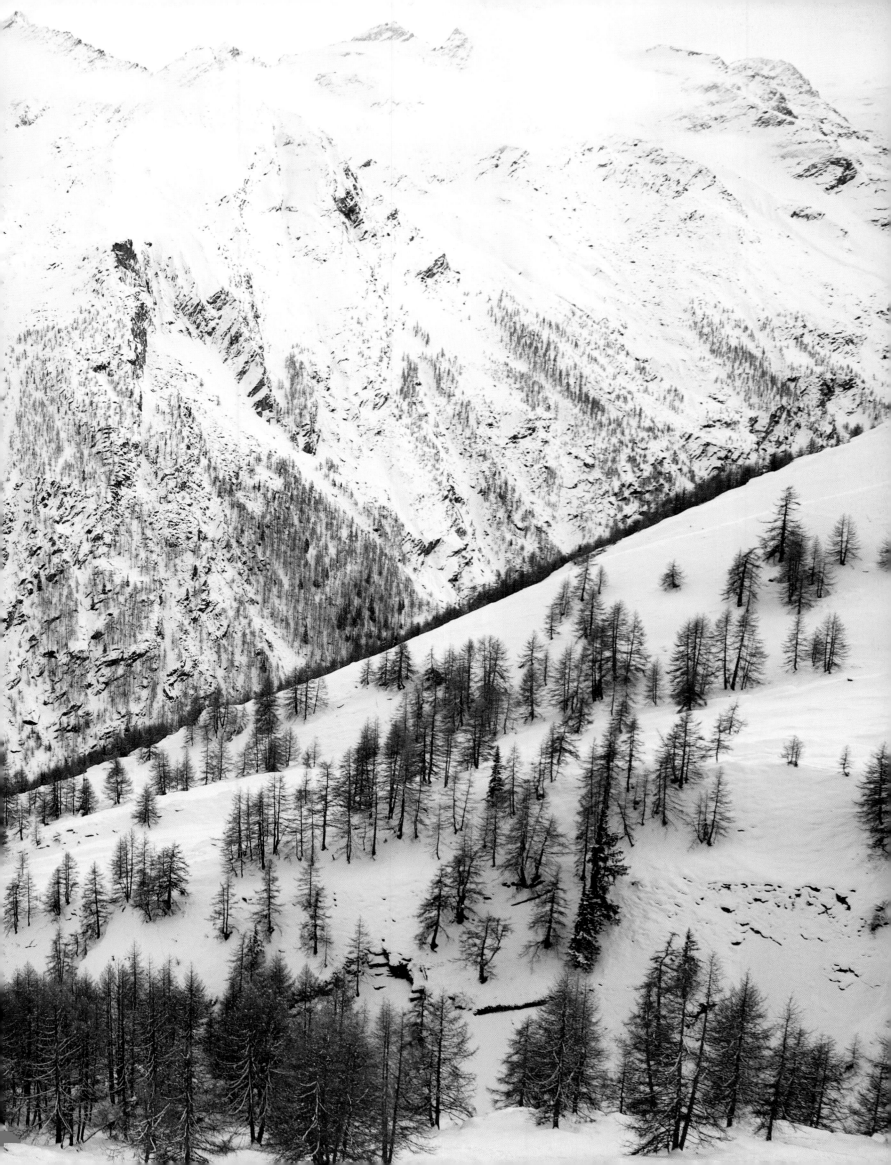

Other smaller herbivores were also hunted relentlessly. One example is the ibex (*Capra ibex*), which practically disappeared from Europe until, at the low point, only 63 animals remained in the Gran Paradiso national park in Italy. Fortunately, the reintroduction of the ibex was successful, particularly in the Alps, and their number today is estimated at nearly 40,000. The red deer (*Cervus elaphus*) and the chamois (*Rupicapra rupicapra*) share a similar story. Yet all these herbivore populations represent only a fraction of those in existence 10,000 years ago.

The carnivores were harassed just as unmercifully by human society, but almost all of them survived nonetheless. One exception is the Asiatic lion (*Panthera leo persica*), which, though originally from Africa (Ethiopia), extended its range into the Mediterranean Basin (Egypt, Turkey, Greece) and central Europe (Bulgaria, Hungary, and Ukraine). Its disappearance from temperate Europe occurred so early that it was probably due to natural circumstances. On the other hand, it was unquestionably human hunters who extirpated the Asiatic lion from the Mediterranean forests of Greece between the tenth and fifth centuries BC. The lion survived in the high mountains of western Turkey until the nineteenth century. Today, a relict population still struggles for survival in the eastern extremity of its range, in northern India. The Caucasian leopard (*Panthera pardus ciscaucasica*), for its part, survived in the wild into the 1980s and was reintroduced on the Russian slopes of the Caucasus only in 2009. The last Caucasian tiger was killed in the region of Tbilisi, Georgia, in 1922.

The bear, lynx, wolf, and wolverine were systematically slaughtered for centuries by a variety of means: stalking, poisoning, traps with jaws or pits with sharpened stakes, organized hunts, and any number of tortures, in the case of the bears. Eradication of the carnivores was encouraged by the practice of putting bounties on their heads. In Russia, for example, 1.5 million wolves were killed between 1925 and 1990. The situation is now reversed in many countries, as fines or prison sentences are levied for killing the larger species. Fortunately, the hunting of large animals did not lead to their total extinction. Since the flowering of the environmental movement, certain large predators have reclaimed parts of their territories, thanks to wildlife protection zones that can be quite vast in northern European countries (Finland and Scandinavia, the Baltic states, and Russia). These animals are not always immune to the effects of hunting, however, as they are hunted on a quota system in some places and are often poached. An idea of current population levels can be derived from a 2010 census: In the northern European countries, the aggregate bear population was estimated at 4,000, Eurasian lynx at 2,500, wolverine at 700, and wolf at 220. Though the latter figure might seem low, wolves are actually on the upswing in Scandinavia, where they had entirely disappeared 20 years ago. There are also populations of large carnivores in Rumania (3,000 wolves, 6,000 to 7,000 bears), Belarus (1,500 to 2,500 bears, approximately 2,000 wolves, and 250 lynx), and in the Balkans (3,000 to 3,500 bears). Russia has the largest populations of large predators (30,000 bears, 40,000 wolves), while Germany counts some 80 wolves at present and a growing population of lynx.

Conditions have, in spite of everything, been better for large predators in Europe's north and east than in its western or central parts. The lynx, for instance, was eradicated from the Alps at the end of the nineteenth century. In the 1970s, lynx were reintroduced to the northwestern Alps between Switzerland, France, and Italy; to an area further east, between Slovenia and Austria; and to the Vosges Mountains in France.

The bears that inhabited western Europe until the Middle Ages are now reduced to three localities: the Pyrenees (between 16 and 20 bears), the Cantabrian Mountains in Spain (approximately 140 bears), and the Abruzzi region in Italy (45 bears). Switzerland and Bavaria, being nearby, regularly receive isolated individuals from Italy. Additionally, there are 400 bears living in the Carpathian Mountains of Ukraine.

Wolves, which were so abundant in central and western Europe until the eighteenth century, are at present restricted, in the temperate zone, to the mountains of eastern Europe. In the western regions, the wolf is starting to make a comeback, thanks to protections recently put in place. Wolves that came originally from the Italian Alps have spread to the eastern end of the French Pyrenees since 1999. The census for the winter of 2010–2011 records 27 zones where the permanent presence of wolves has been confirmed, 20 of which feature fully functioning wolf packs. It is estimated that there are approximately 200 wolves in France, whose territory has recently extended into the northeast. Wolves from Italy have also made their way to Spain and are expected to join up soon with elements of the Spanish population, which is estimated at 2,000.

Europe has, in addition, seen the introduction of a certain number of alien species—largely brought in by hunters—that compete with native animals. One such is the fallow deer (*Dama dama*) and another the mouflon or mountain sheep (*Ovis amon musimon*)—though the latter is native to Sardinia. A number of domestic species have also turned feral, such as cats and certain breeds of horse, as well as pigs. Feral horses today roam the large islands in the Danube Delta in Romania. The domestic cat is found in every forest in Europe that has a village on its borders.

THREATENED BIRD SPECIES

Birds have also been harmed by human activities. Overhunting in the regions where they nest or spend winters has deeply diminished bird populations, and many species have seen a drastic reduction in their range. The grouses (capercaillie, ruffed grouse) of the mountains of Europe, herons (storks, ibises) in the riverine zones and deltas, pigeons, and migrating songbirds have all been affected by man's activity. Yet the protections instituted in certain countries have allowed their numbers to rebound.

Birds have faced other threats as well, such as the fashion for wearing feathers in hats during the nineteenth century, which threatened the population of egrets. Today the greatest dangers come as by-products of human activity: the habitat destruction due to intensified forest management and agricultural reclamation, the loss of wetlands to drainage, the accumulation of industrial poisons in predators such as hawks and vultures, and the persistence of superstitions (relating to birds of prey). There is evidence, however, that all these species once so gravely threatened are reclaiming their former territories, thanks to strong protective measures. The black stork and the great egret are two species that have increased significantly in recent years.

Male western capercaillie with females

Tetrao urogallus
SWEDEN | BERGSLAGEN

The western capercaillie, a large woodland grouse, lives in coniferous forests and is particularly suited—as are other members of the grouse family—to the Eurasian taiga. These birds share a strict dependence on indeciduous needle-leaved trees that provide both shelter and food during the long winter months. The mating dance of the male is spectacular. He fans out his large tail, lifts his neck and head, and emits a series of guttural cries, ending with the sound of a popping cork. His colors during the mating season are rich and contrasting: On his breast is a magnificent bib that, depending on the incidence of light, shines a metallic green or violet. His eye is round with a brown iris, and above it is a bright red rosette, a sort of erectile fleshy excrescence. This tuber, known as a "caruncle," dilates during the cock's sexual displays toward the hen.

Erlend Haarberg

Red fox

Vulpes vulpes
GERMANY |
CHARLOTTENBURG, BERLIN

A spectacular animal remarkably capable of adapting to the human landscape, the fox is not always appreciated by man. Though some admire the fox's intelligence, others consider the animal sly, cowardly, crooked, and thieving. The fox is often characterized as a pest since it competes with man as a predator of barnyard fowl and a hunter of small game. Foxes are also accused of transmitting rabies. These negative perceptions, based on traditional beliefs, explain the various forms of persecution visited on the fox. While many of their original forest habitats have been destroyed, foxes have long used urban areas as havens from human persecution. In fact, their densities are much, much higher in places like Bristol, Munich, and Berlin than they are in what men relentlessly call "the wild."

Florian Möllers

Great egret

Egretta alba
HUNGARY

The great egret has, with other similar species, paid heavily for the fashion of decorating women's hats with feathers. The fashion went out of favor in the second half of the twentieth century, but by then Europe had left only a small population of great egrets in the Danube region. An organized conservation effort allowed the surviving colonies in Austria and Hungary to increase their numbers, and today populations of this large heron are growing in western Europe and the Mediterranean. The expansion of the great egret in western Europe begins with the overwintering of a small number of birds, then a gradual increase in their numbers, followed by a summer residency without nesting. Finally, in certain countries, as the egret's numbers climb further, the bird appears in its mating plumage and begins to reproduce. The species has established new colonies in the past twenty years in Hungary, France, Austria, Germany, and The Netherlands, and can frequently be observed in winter in central Europe as far north as the coast of Denmark.

Markus Varesvuo

Terrace cultivation

PORTUGAL | MADEIRA ISLAND

Lost in the middle of the Atlantic, Madeira was not inhabited until the fifteenth century, unlike the Canary Islands, which were settled earlier. Entirely forested with laurel-leaved species, the island was quickly denuded to supply the wood trade and meet the high demand for shipbuilding materials. The forest was also cleared to make way for sugarcane plantations, as sugar was scarce and expensive in Europe at the time. By the eighteenth century, when sugar production began its slow decline, the original forests had practically disappeared.

Terrace farming is still practiced on Madeira today: Buttressed by dry stone walls, the island's slopes support an extraordinary variety of plants, which grow luxuriantly thanks the fertile volcanic soils and mild climate.

Milán Radisics

Mariina skála and Rudolfuv kámen

CZECH REPUBLIC | JETRICHOVICE,
CESKÉ SVYCARSKO
NATIONAL PARK, BOHEMIA

European landscapes also owe a great deal of their beauty to spectacular geological formations. Bohemian Switzerland has an abundance of sheer cliffs bordered by forests of scraggy pines, as here at the site of Mariina skála, or "Mary's Rock," also known by the German name Marienfels, and Rudolfuv kámen, or "Rudolph's Rock."

José B. Ruiz

Stag beetle

Lucanus cervus
MOLDAVIA | CODRII FOREST RESERVE

The clearing of dead trees, as is common in many European forests, will sentence any population of the fascinating stag beetle (*Lucanus cervus*)—and most other wood-loving insects—to death. Females of this seemingly prehistoric species lay their eggs in rotting log piles and in the roots of rotting trees of various species, preferring oak, especially those growing along rivers. The beetles remain grubs for four years before pupating and emerging as adults, which might then live for only a few months.

Laurent Geslin

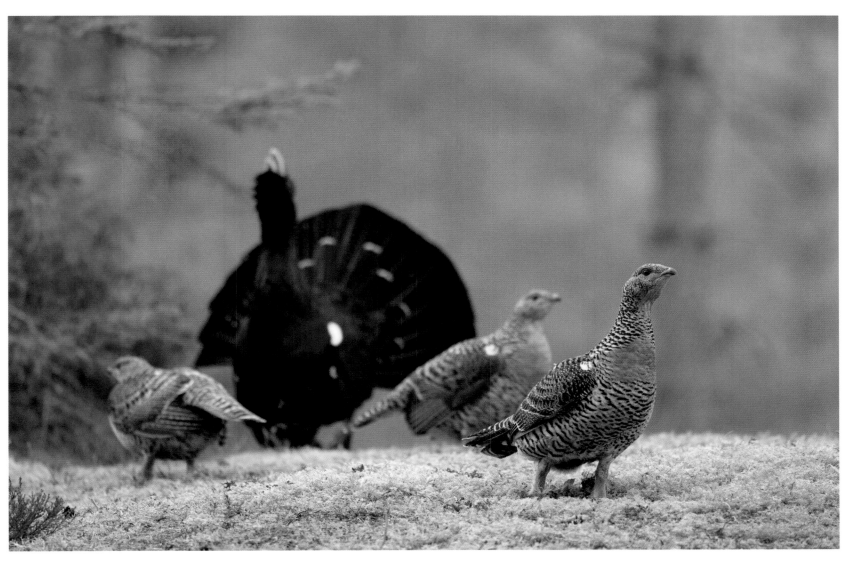

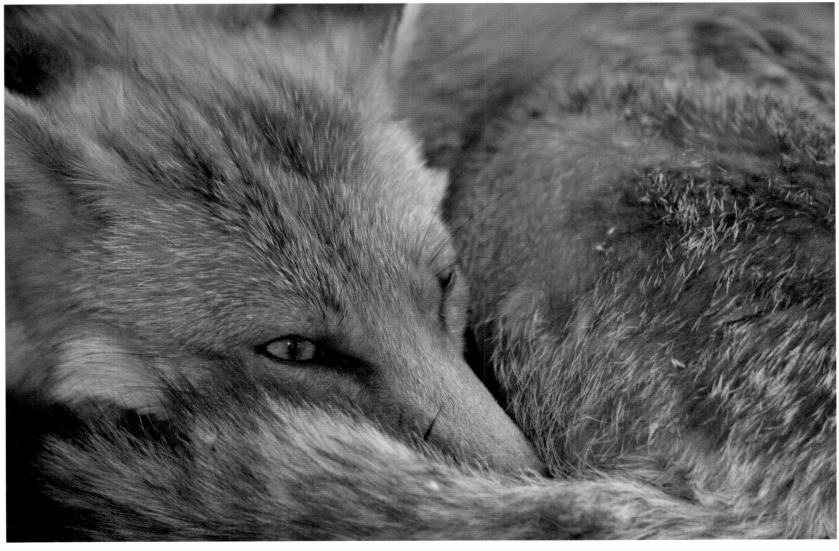

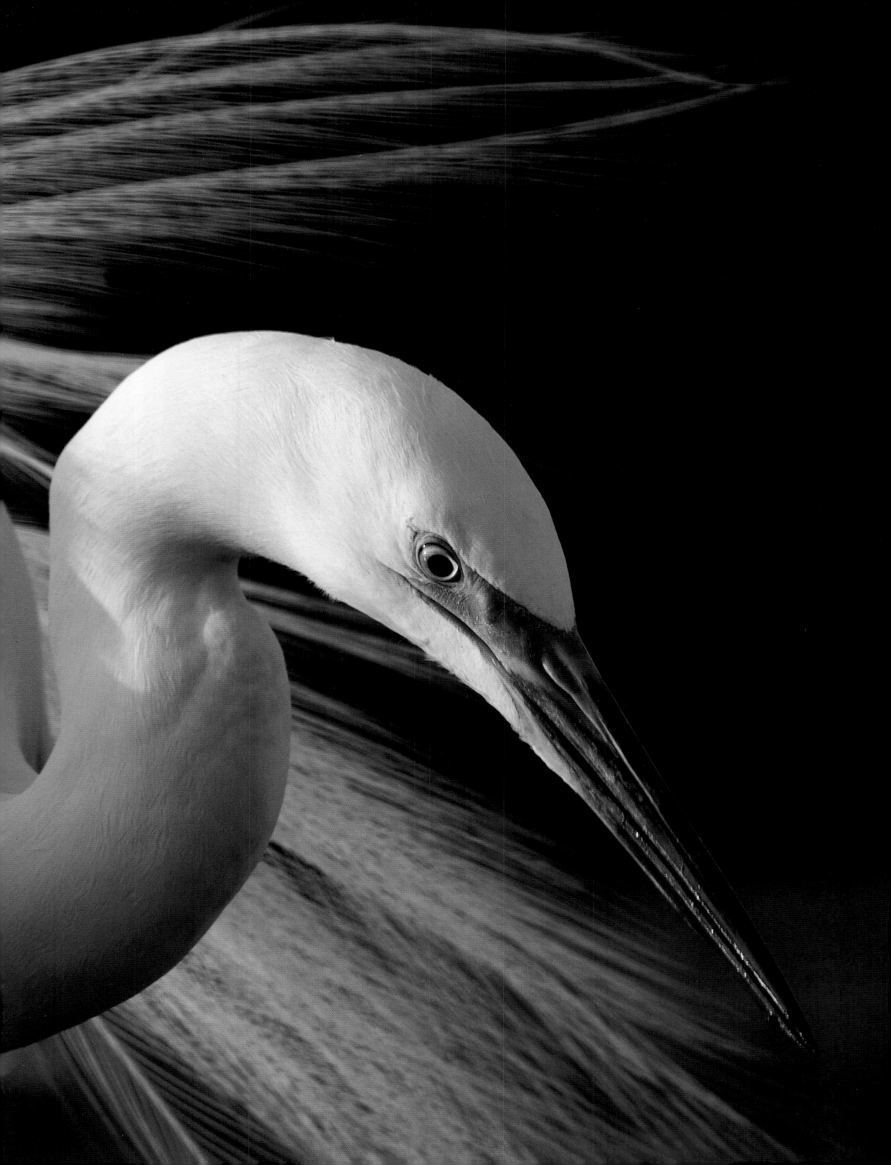

FORESTS IN DANGER

FOREST LANDS STILL COVERED 80 PERCENT OF CENTRAL AND WESTERN EUROPE IN 500 AD, BUT WITHIN 800 YEARS HAD BEEN REDUCED BY HALF. IN THE MEDITERRANEAN ZONE, the clearing of forests happened much earlier. In temperate Europe, it was the monks in particular who promoted forest clearing, believing that ploughing the soil was an act of faith that affirmed man's supremacy over nature. The Benedictine monks of the seventh and eighth centuries held that putting wild land under cultivation was a way of expiating original sin. Aided by pious monarchs, these early religious orders sought to establish themselves in isolated corners to worship God, bring Christianity to the inhabitants, and clear land. Deforestation gathered momentum from the eleventh to the fourteenth centuries as the European population increased, passing from 18 million in 600 AD to 39 million in 1000 AD and reaching 75 million at the beginning of the thirteenth century, before leveling off in the fourteenth century during the plague. Deforestation was a response to the strong demand for pasture and arable land during those centuries, but also to the Christian ideal that man must conquer nature and rule over it.

Human pressure on European forests again grew more intense during the sixteenth century, this time to feed the enormous growth of the trading economy. Ships had to be built and weapons manufactured, forges had to be supplied with wood and wood charcoal for iron. The decline of forests was seen as necessary for meeting a nation's needs and maintaining its competitive edge. In the more industrialized western portions of Europe, deforestation was always more extreme. One consequence of the clearing of these forests was that the northern forests also came to be used more intensively.

This long-term and extensive deforestation has had a profound effect on soils, landscape, and fauna. Water retention and absorption decreased, mountain slopes eroded at an accelerated rate, and the most sensitive forest species were deprived of their habitat. In the Mediterranean, deforestation caused the natural aridity to become more pronounced, ruined the topsoil layer, and dried up springs. In the Atlantic zone, the soils over acidic rock became so degraded that forest recovery was difficult.

The fragmentation of Europe's forests has also brought about the extinction of all the populations that require forest continuity in order to reproduce, such as some lichens and certain insects that colonize slowly. The excessive clearing has made many habitats disappear and altered predator-prey relations. In very small and isolated forests, for instance, the number of bird species is greatly reduced. At the same time, their populations are proportionately much larger, because their natural predators in the forest are fewer. The number of blue tit couples (*Cyanistes caeruleus*) in the small isolated forests of Belgium is almost ten times higher than in the large old-growth forest of Bialowieza in Poland.

THE MOST FRAGILE FORESTS

The forest clearing that most heavily impacted Europe's forests was in the riparian zones of its large rivers, on the islands of the Atlantic and Mediterranean, and in the Mediterranean plains.

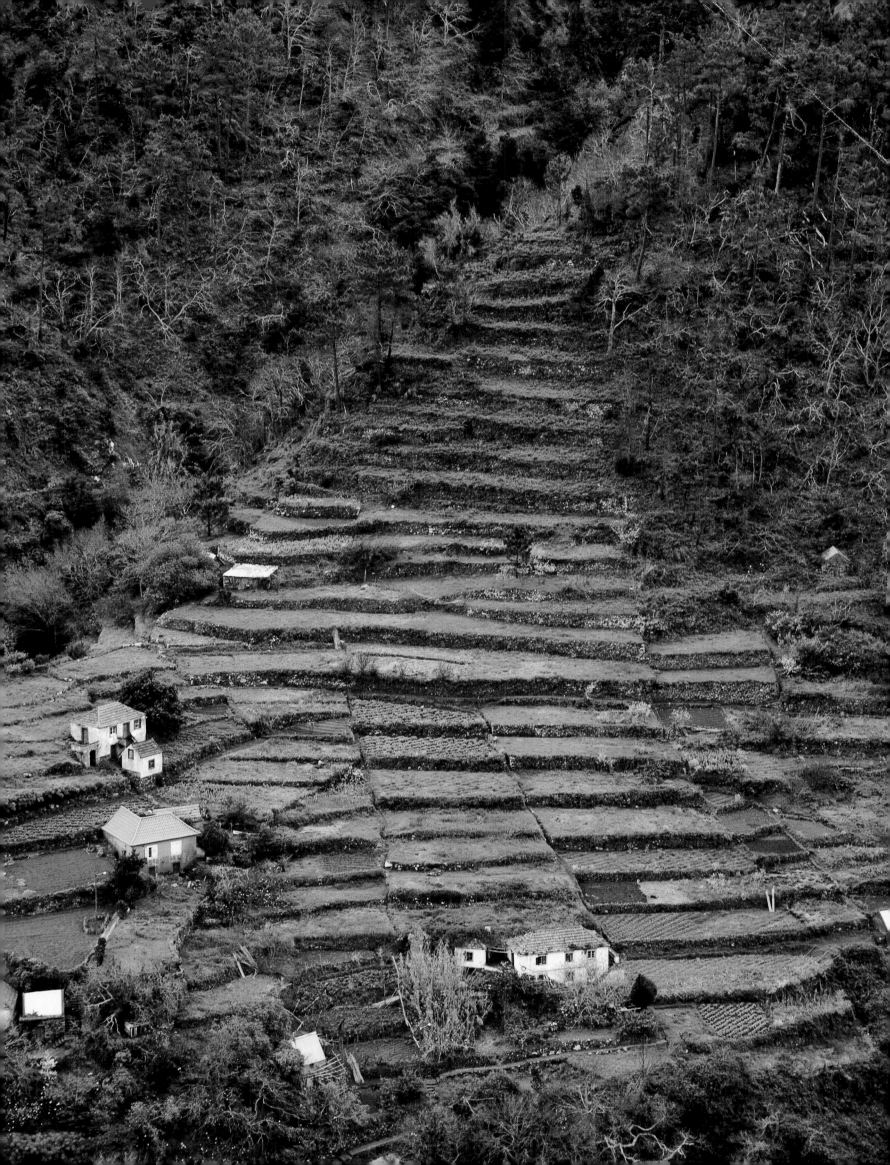

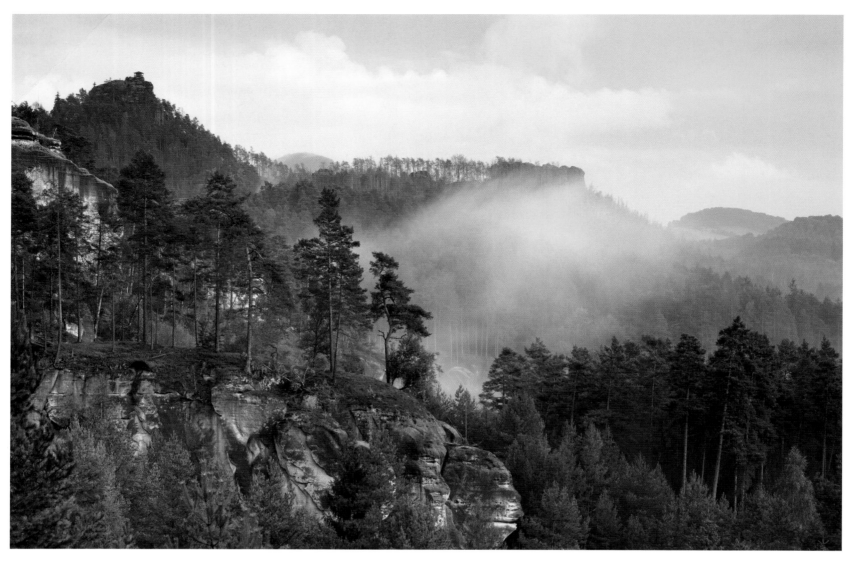
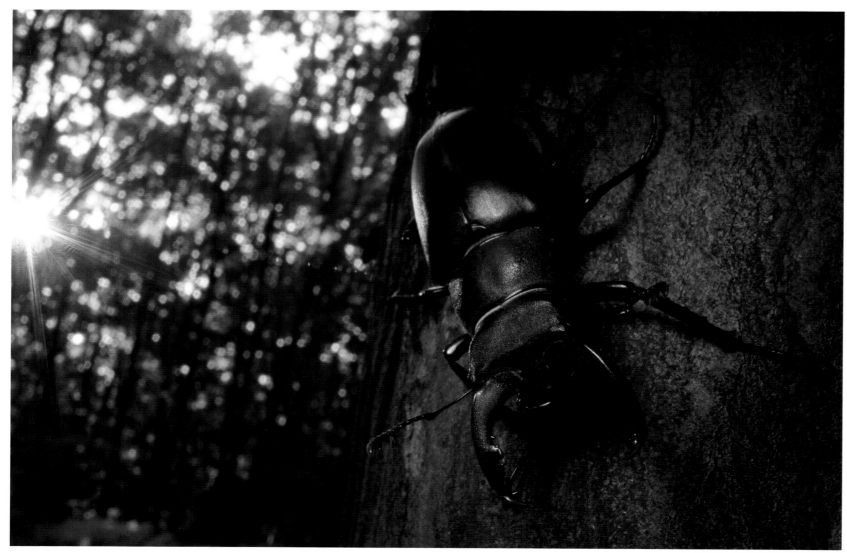

The riparian forests were cleared to make way for plowed fields, pastures, towpaths, and many other useful features. The earliest clearing occurred in the river deltas (Po, Ebro, and Rhone) of the Mediterranean, proceeded by the clearing of their catchment basins, which accelerated slope erosion and increased the sediment load of the rivers below them. Staying with the example of the large river plains, it is estimated that Europe's riparian forests retain only 5 to 20 percent of the area they occupied at the start of the historic era.

The dam building of the nineteenth and twentieth centuries caused the clearing of the alluvial forests, particularly those bordering the upper Rhine. Of greater consequence, these hydraulic works profoundly affected the functioning of the floodplains and their surviving forests by eliminating the heart of the whole ecosystem: the rhythmic seasonal expansions and contractions of the river. The saddest examples of this in western Europe are the Rhine and the Rhone. Now that flooding has ceased and groundwater levels have been stabilized, the remaining riparian forests have lost their defining attribute: strong primary productivity. They have also been subjected to intensive logging and systematic replanting, from which they have only slowly and partially recovered. At present, the naturally luxuriant architecture of riparian forests, both softwood and hardwood, on the edges of the continent's large rivers survives only in a few rare protected areas. Many species that rely on specific habitats formerly present in these forests, such as the vernal pools so important in the life cycle of amphibians, are missing now that they have been deprived of sudden, violent flooding.

In Europe's river deltas, from the Volga to the Guadalquivir, forests have become scarce or entirely nonexistent, due to clearing, over-exploitation, and rising salt levels. Damming and the artificial control of water flow have disrupted the most basic functioning of deltas, which rely on the fluctuating and random distribution of land according to the deposition of sediments from the river and the sea.

The harmful effects on habitats and individual species of intensive agriculture, hunting, and mass tourism must be added to the challenges facing Europe's riparian forests. The economic stakes today are such that it would be unreasonable to hope for the restoration of riparian forests to their full splendor, even in the floodplain valleys bearing the most prestigious titles of environmental protection—national parks, biosphere preservation areas (Ramsar Convention), nature preserves—in the deltas of the Danube, Ebro, Rhone, and Po.

Yet the riparian forests of the large river plains are known to render many services to man. They ensure the good quality of groundwater by filtering and purifying floodwaters. Riparian forests reduce riverbank erosion thanks to tree roots, and lessen the height of floods by dissipating the kinetic energy of the water. These forests introduce organic matter into rivers, thus increasing their carrying capacity for fish, a fundamental resource for humans living in the river floodplains, along with wood from the forests.

Considerable efforts have been made in certain riverine areas to recover some of these lost benefits and protect those that remain. The new thinking in environmental

management is to protect a "space of freedom and mobility" for watercourses. The "space of mobility" is defined as the area holding the major bed of the river and within which the river channels conduct the river's lateral movements. Policies are established that remove water pollutants, limit or forbid the extraction of gravel, and prevent the building of new dams (and in some cases result in the destruction of old ones). Integrated pest management is applied to floodplain agriculture, thus limiting the use of pollutants in riverine areas, and attempts are made to bring the water to the point where swimming is once again safe. These initiatives reflect a growing environmental awareness in our societies, without which the protection and rehabilitation of nature would not be possible.

Dense human populations have damaged the forests covering the islands and archipelagos of Europe. This holds true as much for the Mediterranean as for the Atlantic, North Sea, and Baltic Sea. Island forests are generally overused, except where strongly protected (certain islands in the Baltic Sea and the Gulf of Bothnia, for instance) or where they are left undisturbed to reclaim areas abandoned by human settlement (notably in Corsica). The frailty of island ecosystems also comes from their isolation and small size, which expose their populations to greater danger from extreme events (human encroachment, storms, erosion) and from the invasion of alien species.

The forests of the Mediterranean islands, which were cut down very early in human history, have been drastically reduced in extent. The vast majority of Mediterranean islands were shorn of their forests, except at the highest points of a few mountains in Cyprus, Corsica, and Sicily, or in the Macaronesian Islands. Yet because agriculture is now practiced less extensively on these islands, their forests are in the process of recovering their former expanse.

THE FOREST AREA

Forests cover 45 percent of the total land area of Europe. Theirs is a substantial presence, but it takes the form mainly of managed forests, tree plantations, and second-growth forests on abandoned lands, with only a minuscule fraction of old-growth forests. Russia has the largest area of forestlands, some 3 million square miles (8 million square kilometers), or more than 80 percent of the total forest area of Europe!

The northern European countries contain several large areas of boreal forest associated with swamplands. In Finland, the forests of Närängänvaara, Virmajoki, and Romevaara (43 square miles, or 111 square kilometers), full of trees more than 400 years old, make up one of the largest old-growth forests in the country, along the border with Russia. Another is the forest of Elimyssalo (32 square miles, or 83 square kilometers). In Sweden, the Sjaunja Nature Reserve has 170 square miles (440 square kilometers) of old-growth spruce and pine forests. In Norway, the largest boreal forest is the Ovre Pasvik National Park (77 square miles, or 199 square kilometers), near Finland and Russia. In the temperate zone, the forests in the middle latitudes and those in central Europe are the least fragmented, sometimes tens of square miles (more than 26 square kilometers) in

area. In Latvia there are vast expanses of riparian and swamp forests, as well as lovely mossy forests on its islands. In Belarus, the Berezinsky Reserve and Belovezhskaya Pushcha National Park (connecting across the border with the Bialowieza Forest in Poland) are well populated with swamp forests—the forest neighboring Bialowieza has 15 square miles (39 square kilometers) of protected woodlands, out of a total forested area of 214 square miles (554 square kilometers). Romania, for its part, has the oldest beech-fir forest in Europe, the Slatioara Natural Reserve, 1.5 square miles (4 square kilometers) in extent, as well as the largest old-growth beech forest in Europe, the Nera Forest in the Carpathians, covering some 19 square miles (49 square kilometers). Other beautiful temperate forests are preserved in the Slovak Republic, Slovenia, Montenegro, and Macedonia.

In the western and Mediterranean portions of Europe, forests that are still in good condition are much scarcer and generally only found in a few inaccessible mountain regions. Others have been spared from total destruction because they are situated near a monastery, such as the forest on the mountain ridge of Sainte-Baume in southern France.

Old-growth forests, which are natural forests by definition, are rare and widely separated. But there exist other types of natural forests as well, which have resulted from the abandonment of agriculture. Abandoned fields and pastures, a phenomenon seen in certain European nations over the last 150 years, are generally found where soils are poorest and result from global socioeconomic conditions. When small landholdings are no longer economically viable, farmers are forced to move away or at least concentrate their efforts on the most fertile lands. Studies indicate that farm abandonment in Europe will continue in the coming decades, for an aggregate area of 50,000 to 65,000 square miles (130,000 to 168,000 square kilometers) by 2030. The regions most likely to be affected in the near future are obviously those with the poorest soils in the most inaccessible areas, and this reversion to forests can already be observed in Europe's mountains and northern zones, from Finland and Sweden to the Pyrenees. Forests are also growing back in the Massif Central in France, many parts of the Alps, certain mountainous areas in Germany, the border between Germany and the Czech Republic, the Italian Apennines, and the Carpathian Mountains.

RECENT THREATS TO FORESTS

Forests have recently been subjected to many forms of atmospheric pollution due to human industrial activity. Acid rain has deeply altered forest soils and impacted forests, particularly conifer forests. On the other hand, the rise in carbon dioxide levels over the past century has stimulated growth wherever water and soil nutrients have been in sufficient supply. This increase in productivity has modified the biology of leaf-eating insects, increasing their rate of growth and the quantity of foliage that they eat. The rise in carbon dioxide levels causes a parallel rise in ozone, a product of photochemical reactions related to man-made nitrogen oxides. Ozone levels have doubled in the northern hemisphere during the twentieth century. Ozone gas is harmful to plants, as it disturbs the photosynthetic process. In the short term, it causes discolored stains on the leaves of trees, and in the medium term it accelerates

207

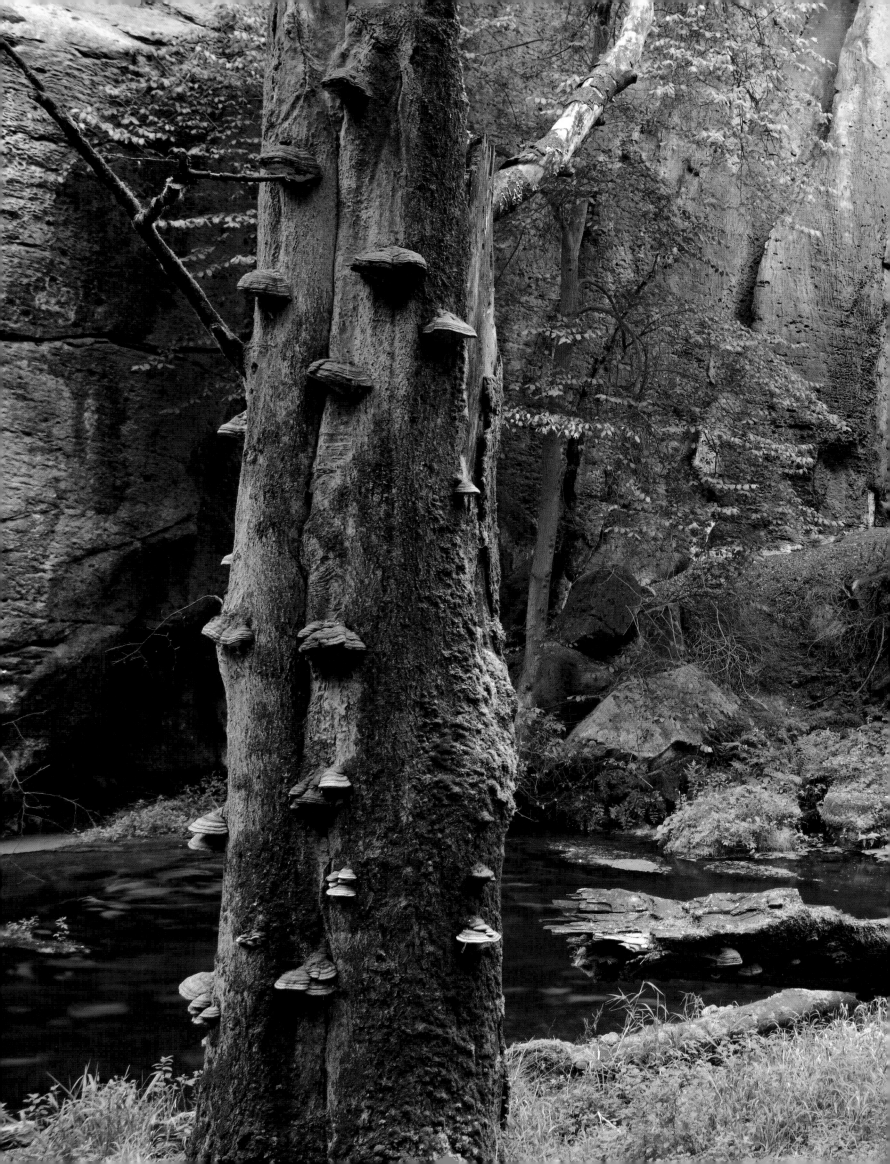

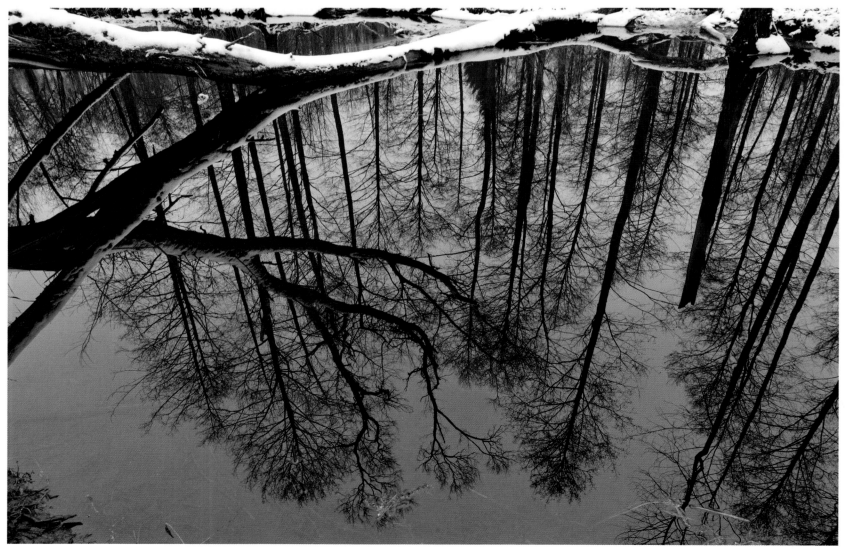

the aging of leaves, shortening the time available to a tree for photosynthesis.

Climatic changes alter the geographic range of all forest species, whether animal, vegetable, or microbial, and favor some species at the expense of others. For example, holly (*Ilex aquifolium*) is currently extending its range into northern France, and the same is true of the holm oak (*Quercus ilex*). Also, many specialists predict that the warming trend will favor leaf-eating insects and increase their destructive effect on forests, particularly where trees are stressed by heat waves comparable to those of 1976 and 2003.

Additionally, forests must contend with the onslaught of alien species imported by man, which in some ecosystems have been responsible for vast amounts of damage. The diseases that affect cultivated grapes, for instance, have practically eradicated wild grapes from European forests, and a fungus imported from Asia in timber shipments in the early 1900s and introduced to Europe's forests by insects has killed most of the elms in Europe and North America. Other exotic pathogens include *Erysiphe aphitoides*, a powdery mildew that attacks oak trees; *Chalara fraxinea*, or ash dieback, which is killing ash trees; and *Phytophtora alni*, which causes lethal root and collar rot in alders.

The global trade in timber, grain, living plants, and wooden packing material has also introduced alien wood-boring beetles to Europe. Some 400 alien insect species have been identified in trees growing in nurseries, parks, and gardens, and these insects could spread to Europe's forests. A population spike of the kind seen in the pine sawyer (*Monochamus galloprovincialis*), spurred by climate change, is possible for some of these species, which may then become invasive.

The planting of non-native trees from America, Asia, or other parts of Europe represents another danger for European forests. Altering conditions in the natural environment, including the introduction of new parasites, these planted species often become naturalized. The list of such trees is long and includes Atlas cedar, black pine, black cherry, Douglas fir, red oak, eucalyptus, and black locust. Invasive plants can also arrive through activities other than forestry, such as horticulture, a notorious source of alien introductions.

The impact of all these non-native species on Europe's forest ecology is difficult to predict, and the fate of the exotic species themselves is uncertain. Will they disappear, mutate, or become hybridized? What pathogens will eventually attack *them*?

The invasion of alien species does not affect only the plant world. Several animals originally limited to breeding farms have escaped and become naturalized: the gray squirrel (*Sciurus carolinensis*), the American mink (*Mustela vison*), and the raccoon dog (*Nyctereutes procyonoides*). These new species threaten to alter the geographic ranges of genetically similar local species or displace native species entirely. The American mink, for instance, seems to be displacing the European mink (*Mustela lutreola*), a threatened species, in the competition for limited wetland habitat.

211

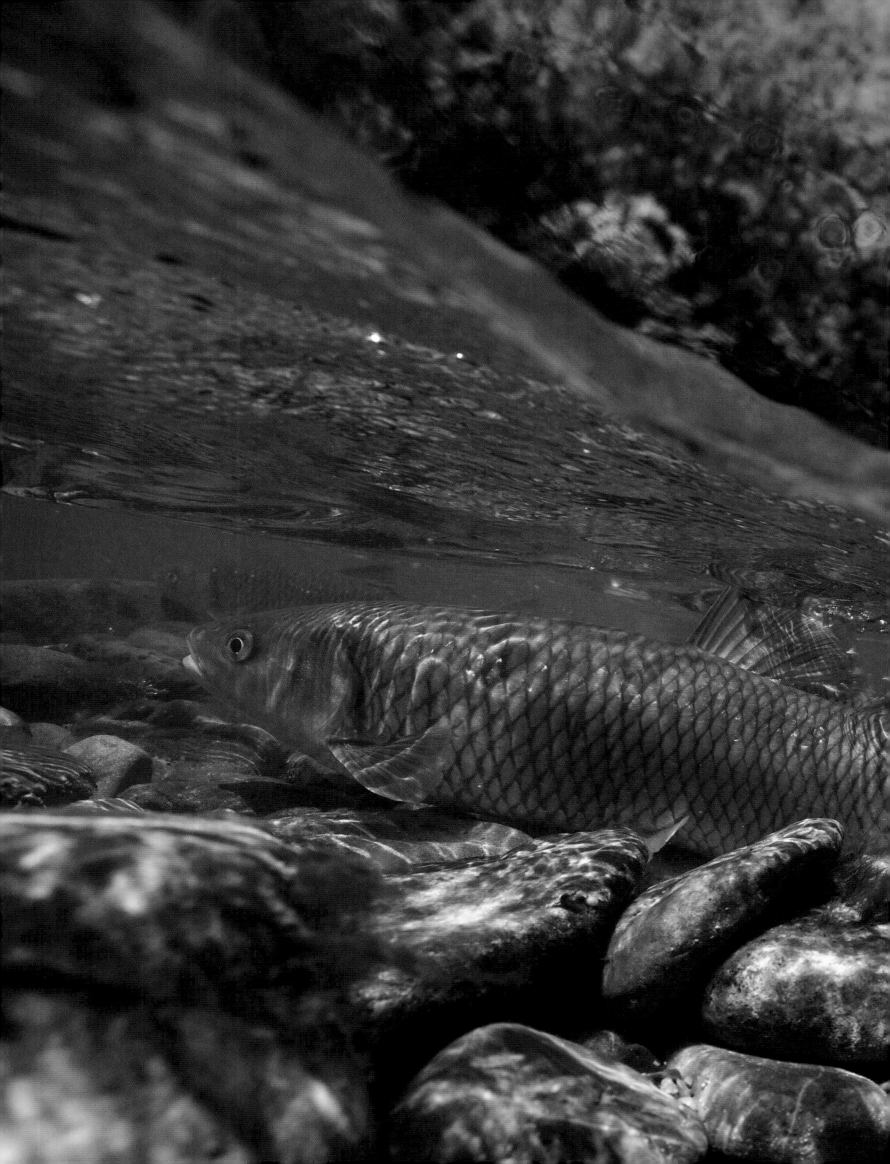

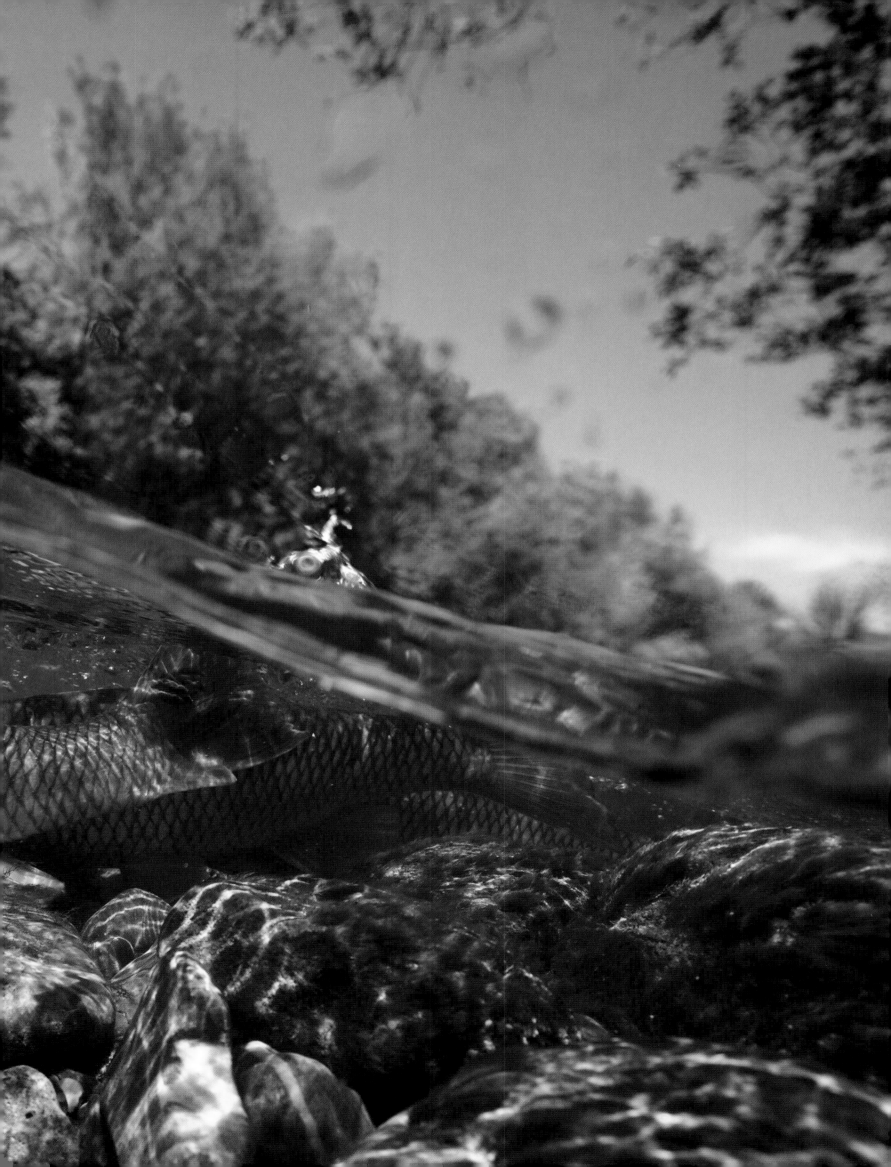

↑

Krinice Gorges

CZECH REPUBLIC | DLOUHY DUL,
CESKE SVYCARSKO NATIONAL
PARK, BOHEMIA

Forests growing in
gorges, which are little
frequented by man and
difficult to access for
logging, serve as havens
for Europe's animal and
plant life. The gorges of
the Krinice River host a
magnificent beech-pine
forest with an abundance
of deadwood, reminiscent
in its architecture of the
untouched forests of the
first millennia after the
last ice age.

José B. Ruiz

Golden eagle
Aquila chrysaetos
NORWAY |
FLATANGER, NAMDALEN

The world population of
golden eagles is estimated
at fewer than 10,000 pairs,
of which 15 to 20 percent
have their home range in
Europe. This majestic bird,
a symbol of power often
featured on heraldic crests,
inhabits mountainous
areas, where it nests mainly
on cliff faces. The golden
eagle can live at lower
altitudes in bog forests in
northeastern Europe, where
they build their nests in
trees. This raptor preys on
rabbits and hares, grouse,
and a variety of small
mammals. The golden eagle
has been hunted, trapped,
and poisoned, its nests have
been raided for their eggs,
and its bog forest habitats
have been disturbed and
reduced by human activity.
Conservation efforts and
a ban on spraying poisons
have allowed the eagle's
population to rise again in
some European countries.

Staffan Widstrand

Bialowieza
Forest in winter

POLAND | BIALOWIEZA
BATIONAL PARK

An old-growth forest, poetically
reflected in still waters.

Stefano Unterthiner

European chub

Squalius cephalus
SWITZERLAND |
LA TOUR-DE TRÊME,
ROMANSCH SWITZERLAND

The chub is a freshwater
fish found in European
rivers, but is also common
in forest lakes that are
connected to a river
system. The species is
omnivorous, feeding
largely on invertebrates
but also on small fish and
fruit that falls into the
water. Where the species
is still numerous, the
eggs, young, and adult
fish serve as an important
food source for larger fish
like taimen and pike, as
well as for otters, mink,
herons, storks, and many
other predators.

Michel Roggo

Rrapi i Taksimit

ALBANIA | SHEBENIK-JABLLANICE
NATIONAL PARK

The Shebenik-Jabllanice
park, which extends over an
area of 130 square miles (337
square kilometers), contains
a rich variety of mammals,
including chamois, wild boar,
wolf, bear, and Balkan lynx
(*Lynx lynx martinoi*), as well
as the spectacular golden
eagle. Albania's forests are
threatened by illegal logging
and the use of forestlands
as pastures, which results
in drastic erosion and
irreversible soil loss.

Anders Geidemark

Japanese knotweed

Fallopia japonica
FRANCE | ALLIER RIVER,
PONT-DU-CHÂTEAU, AUVERGNE

Japanese knotweed (*Fallopia
japonica*) was introduced to
Europe in the nineteenth
century through female
plants collected in the
wild in Honshu, Japan.
The plant naturalized
rapidly. Its dispersal across
Europe in less than 90
years was spectacular, all
of it occurring through
vegetative reproduction
from rhizome fragments.
Knotweed is also hybridized
with another Japanese
species, the Giant knotweed
(*Falliopa sachalinensis*).
These hybrids continue
to spread throughout the
world, and have become
such aggressive invaders
that it is difficult to stop
their progress. Apart from
"out-shading" native species,
the plant's rhizomes may
damage riverbanks and lead
to their erosion, causing
considerable changes in
the water regime. Many
European countries spend
millions of euro each year
to rectify these damages.
The case history of Japanese
knotweed should be
remembered each time an
alien species is proposed
for introduction on a large
scale; at present, plants
are generally introduced
without much thought to
the risks they pose.

Florian Möllers

↓

Great spotted woodpecker

Dendrocopos major
FINLAND, KOROUMA, POSIO, LAPLAND

The great spotted woodpecker
is the most common variegated
woodpecker in Europe's forests,
from the boreal forests in the
north to the Mediterranean in
the south. Relatively shy, it is
generally not noticed until it
utters its sharp cries or pecks
at dead trunks in search of
larvae. Its loud and rapid-fire
rat-a-tat rings through the
woods in spring.

Sven Začek

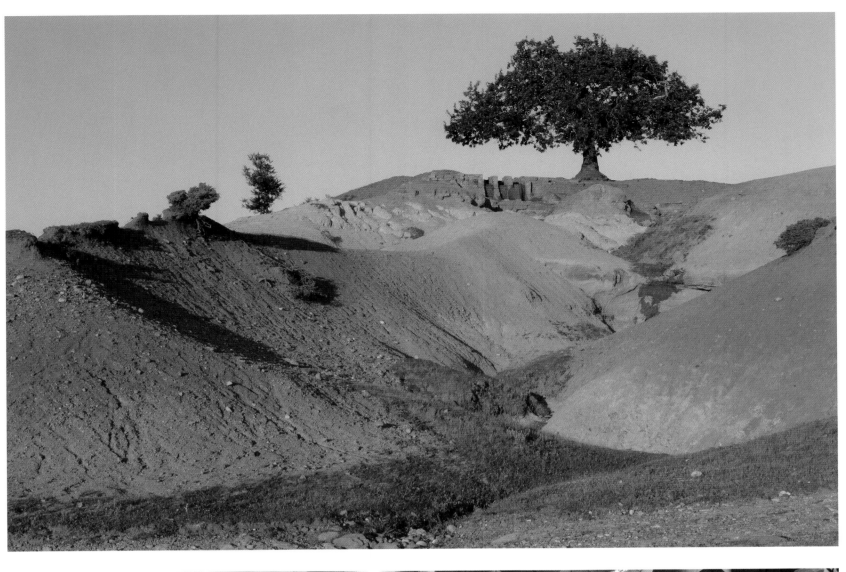

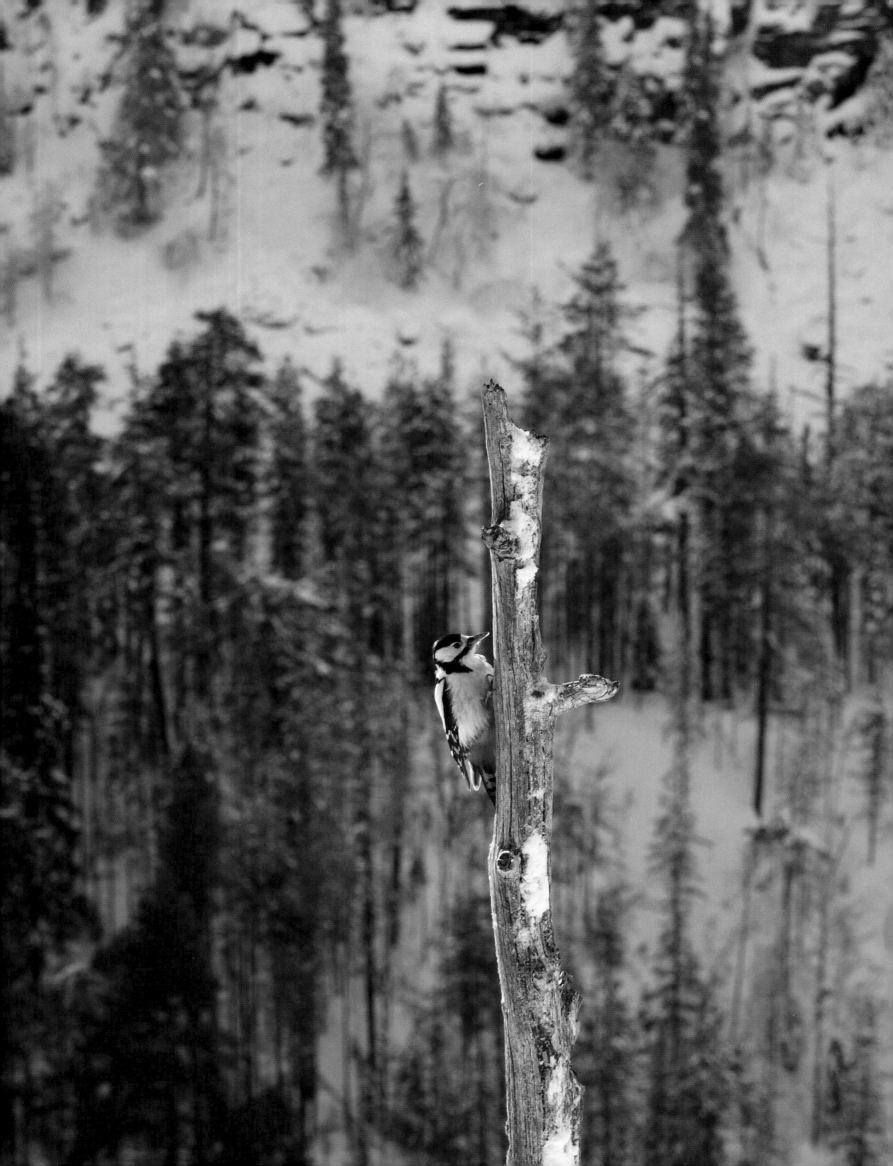

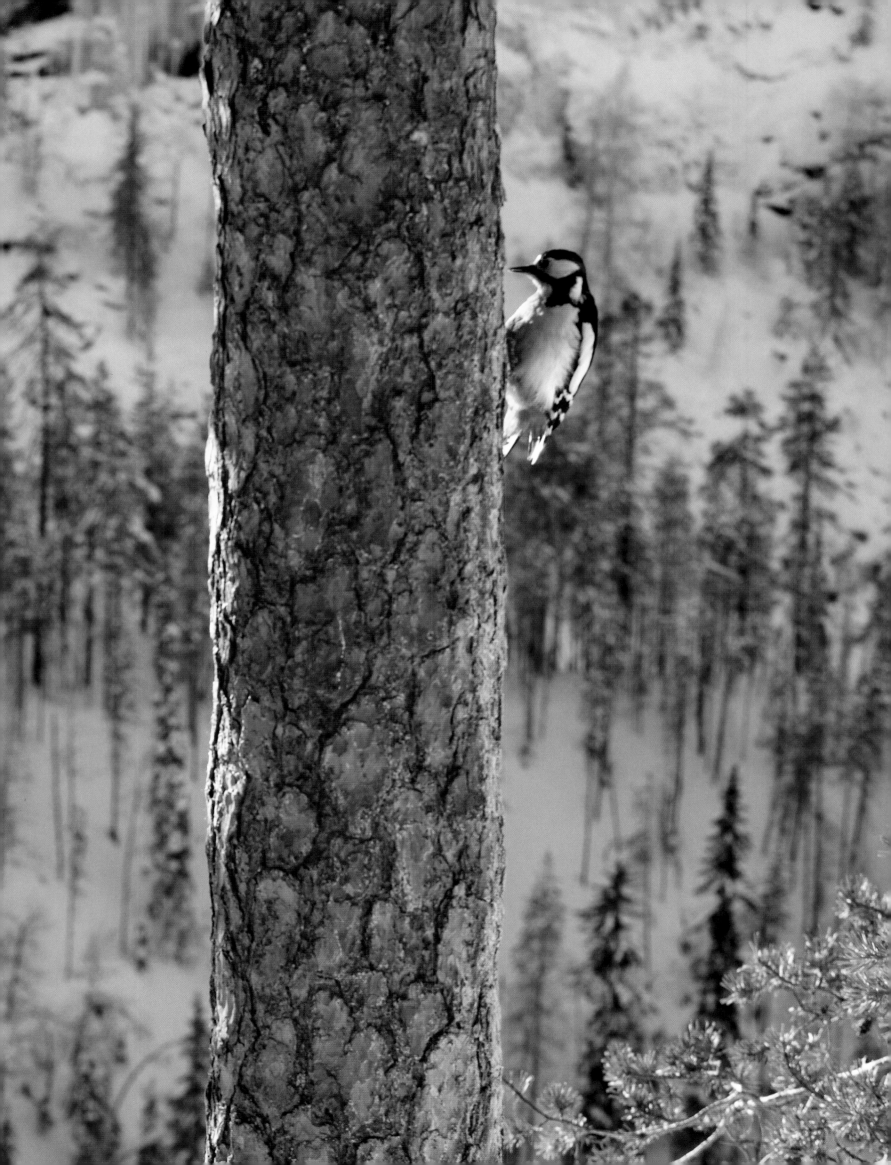

FORESTS ARE, FOR HUMAN BEINGS, LANDMARKS OF SOCIAL AND MENTAL CONSTRUCTION. THE ENLIGHTENMENT REDUCED THEM TO MERELY NATURAL, EVEN NEUTERED, SPACES, BUT FOR millennia forests everywhere had been considered sacred. In Europe, this supernatural universe survived for a long time, through much of recorded history, and mention is made of it in, for example, chivalric epics.

MANAGING FORESTS

In every age, man has tried to address the excessive and disorganized clearing of forests, but silvicultural rules for the management of timber cuts were only clearly formulated in the sixteenth century. The demand for wood shot up at that time, largely in response to the increase in manufacturing, and was used to feed the hot fires of forges and glass-making workshops. France displayed its superiority in the seventeenth century by implementing the forest reforms of Colbert; his edict regulating the management of French forests, promulgated in 1669, was acknowledged as a model throughout Europe.

Forestry would only develop as a science, however, in the eighteenth century. Several schools appeared in Europe at that time to devise forest management practices. The most common practice, still in wide use today, is the "regular high forest," which supplies large quantities of wood. The forest is divided into parcels destined to be clear-cut at intervals of 50 to 150 years. After the harvest, the forest regenerates either naturally or from seeds sown after preparing the ground. During the growth cycle, the best trees are selected and the remainder culled. This creates an unnatural ecosystem, however, for a number of reasons. It results in a weak structure of same-age trees belonging to only a few species. Plantings of a single species,

producing forests where the trees are all the same age in every parcel, exhaust the soil more than forests consisting of a variety of tree species of diverse ages, which allows the trees to tap the soil's resources at different levels. Also, in monocultural same-age plantings there are few very large trees and even fewer old or dying trees. It is these, when 25 to 50 percent of their wood is dead, that provide the material needed for shelter by cavity-dwelling species. Clear-cutting large tracts of forest is also harmful to the soil as it exposes it periodically to full sunlight, rain, and erosion. Large openings have always been a feature of forests, but in the case of dead-falls and windthrows the soil is protected by the fallen trees, which take decades to decay fully, and by the layers of plants and shrubs that rapidly cover the ground.

These forms of forest management, far removed from the natural functioning of a forest, are practiced all throughout Europe, particularly in its temperate and boreal zones. They do not take into account the fragility of a forest when its canopy is brutally opened, nor the waste in wood resources, since these trees are very often felled before their full maturity. Oaks, for instance, can be allowed to live 300 or 400 years in excellent condition without losing any of their value and will furthermore shelter a wide array of fauna for several centuries—a biodiversity that simply disappears where trees are systematically cut down before they are 200 years old. The same holds for pure stands of many market-grown species. The felling of trees before maturity

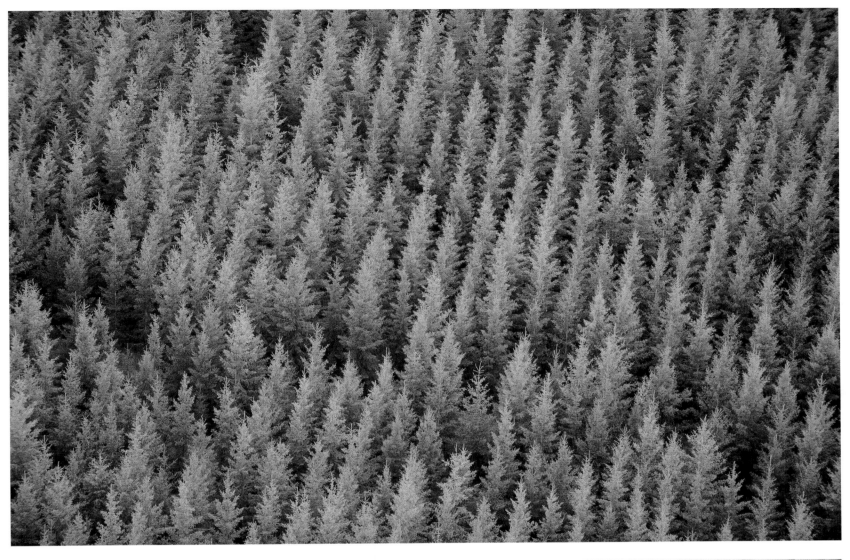

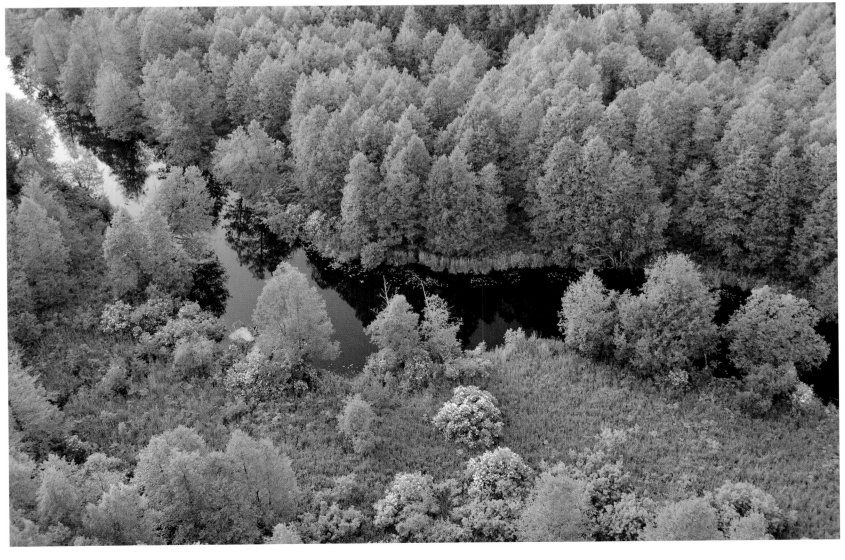

has caused insects that feed on rotting wood, the saproxylophages, to become rare in European forests, and leads to too-frequent changes in the ground fauna. But the absence of deadwood is also due in part to ideology, to a notion that forests must be made "clean." According to a widespread belief, deadwood is "dirty" and forests "need to be cleaned up." This kind of forest management, in any event wasteful, reduces forests to their economic aspect, while ignoring their ecological and esthetic dimensions.

Other methods of forest management come much closer to the natural functioning of the forest ecosystem. One such is the "mixed all-aged forest," which respects the stratification of the understory, the forest microclimate with its filtered light, the natural regeneration of seedlings, and the mixture of species. Trees are not cut down at a predetermined age, but logging is surgical, precise, and predicated on the local environment and ecological constraints. Large tracts of the forest are never cleared, ensuring that the soil is kept from degradation. The concept of the mixed all-aged forest was developed in Switzerland and Germany after World War II. The shift toward forestry practices that preserved greater biodiversity came, in Germany, from Lower Saxony, as a result of the Löwe federal program. This form of silviculture also makes it a priority to set off a minimum area of untouched forest, so that the species dependent on the presence of deadwood can either reestablish or maintain their populations. Early recognition of the mixed all-aged forest by a ministerial decree led to its adoption in other parts of Germany as well.

In France, as in Germany, forests in a good state of preservation have been put on protected reserves. This creates, in forests damaged by logging, small sites that are called islands of senescence (which are untouched) or "rotation patches" (in which logging is managed). This also preserves dead trees in every part of managed stands, not only to provide corridors for species with long periods of establishment but to supply all the habitats necessary for species that feed on rotting wood. A further recommendation is to protect a few vigorous trees with cavities, as well as trees with very large crowns, suitable as nest sites for large raptors and corvids. Yet the practice of dividing forests into same-age parcels of a few species, the so-called "regular high forest" system, is in force in most of the country. Intensively implemented, it limits the richness of France's forests.

The basic principles of forestry could be improved to make forests more resistant to extreme conditions and the effects of climate change. It seems quite essential, for instance, to better protect the most fragile forests, such as riparian forests, and to leave deadwood in rivers that have not been dammed, at least when it poses no danger to navigation. Where forests are managed for timber, it should be a practice not to cart away or otherwise remove the branches of felled trees, so as not to deprive the organisms that feed on them of their source of food.

Whatever forestry practices are used, certain forests are almost invariably overstocked with large herbivores, maintained for the sake of sports hunters. Of course, game animals should be allowed to find their natural ranges, but bringing game animals back to a proper equilibrium is crucial: by not providing feeding stations for them in winter, by allowing large predators to reach densities where they can have a dampening effect, and in the meantime by regulating game populations more actively. Another crucial issue is to determine appropriate hunting quotas, which balance the respective revenues from leasing hunting rights and selling wood.

"NATURAL" FORESTS?

The forests that are in good condition and relatively untouched by man—primary forests and those left alone for several centuries—should be inventoried very accurately in every country in Europe. Available records indicate that well-preserved forests account at most for 26 percent of Europe's total forested area, and that they are mostly in the boreal zone and in Russia. In the remainder of Europe, less than 3 percent of the forests are considered to be in a good state of preservation, and efforts should be undertaken to improve their size, functioning, and biodiversity.

VOLUNTARY POLICIES

After the Rio de Janeiro Earth Summit in 1992, a pan-European strategy to protect biodiversity and habitats was set in motion. Sponsored by the United Nations and the European Council, it supported practical research programs and the introduction of "conservationist" forest management practices that paid attention to the most fragile elements of the forest's diverse flora and fauna.

Protecting forests also requires protecting threatened species of animals. While certain emblematic mammals have already been saved from extinction, as previously discussed, more protective measures are required. Contemporary trends point toward strong protective legislation, active campaigns against poaching and trafficking, reintroduction programs, and the conservation of habitats. Several kinds of agreements stand behind these initiatives. The Convention on the International Trade in Endangered Species (CITES) protects the predators, while the Convention on the Conservation of European Wildlife and Natural Habitats, passed in 1979

by the Council of Europe, keeps a close eye on endangered species. The Habitats of the European Union directive attempts to maintain biodiversity by protecting and restoring habitats and promoting conservation. That directive, along with the Birds Directive, is the basis for the Natura 2000 network, the largest network of nature-protection areas in the world. The tallies of endangered species maintained particularly by the International Union for the Conservation of Nature (IUCN) have made it possible to mount rescues of many species and their habitats. In certain countries, the World Wildlife Fund also provides assistance in developing conservation plans and policies. The results have on occasion been spectacular—for the black stork, large raptors like the white-tailed eagle, bear, bison, and wolf.

Victory is not yet in sight—far from it. New life may have been breathed into the forest conservation movement, but it has not stopped trees from being cut down intensively. In many European countries, there is a tendency to overharvest forests, often by clear-cutting extensive areas, and to zero in on forests that have been spared from recent human activity and therefore have the largest trees. The social and environmental function of forests is no longer respected, to the fury of forestry officers. In Romania and Poland, there is great pressure to overharvest forest resources because of the pressing market demand for wood from Asian nations such as China. In Kosovo, Macedonia, Albania, and Serbia, wood is being harvested illegally and a number of spectacular forests are being cut down despite well-meaning efforts to protect them. The Caucasus has been cleared of trees continuously since 1945. In Eastern European countries, many forests are threatened with overharvesting as a result of economic pressures.

The large predators, for their part, are still being hunted or poached, both in the

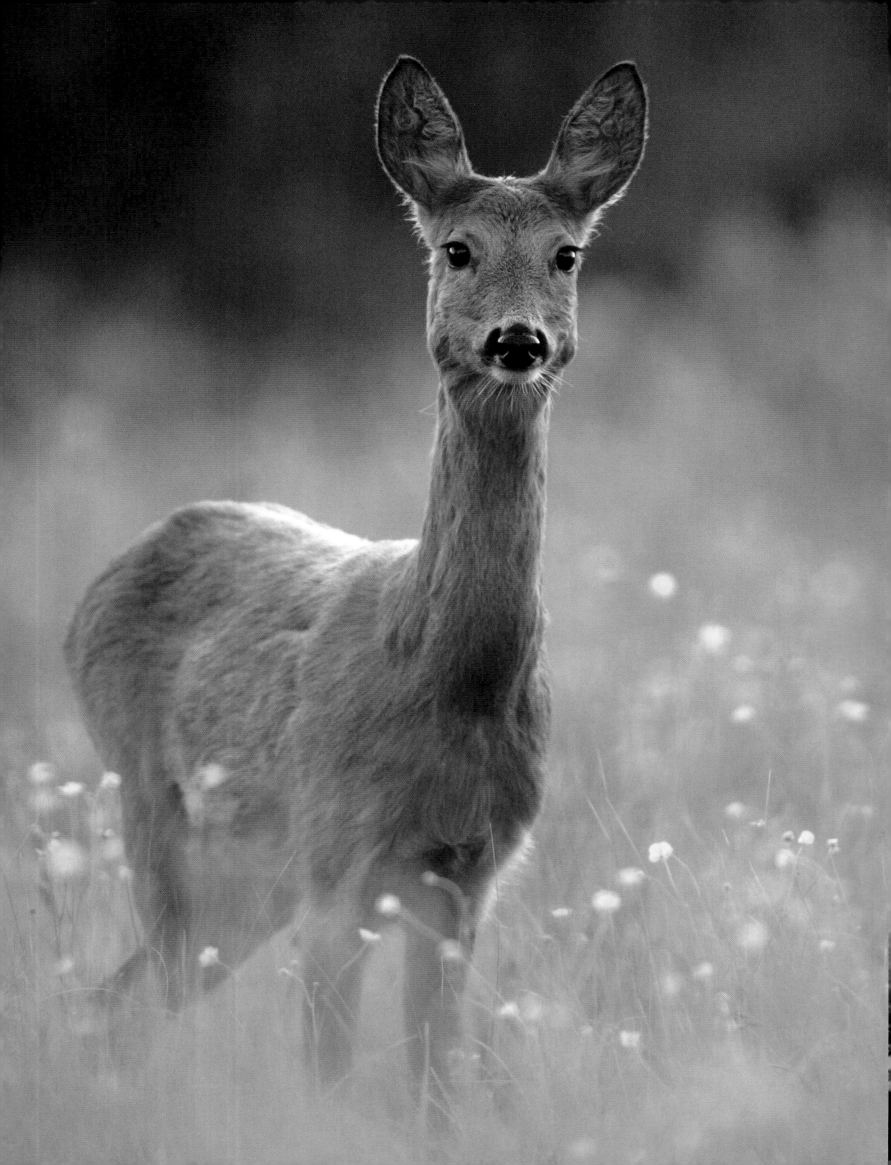

countries where they have not yet been eliminated and in those where they are trying to reestablish themselves. The hunting-rights lobby is still very strong in the countries that have bears (Caucasus, Russia, Finland, Greece, and Bulgaria, among others), and poaching takes its toll. The requisite conditions for certain species—bears, for instance, need extensive areas of conifer forests in the north and of beech-fir forests in the south—are not necessarily available in countries where intensive forestry is practiced or deforestation has occurred on a large scale. Also, their return is not yet considered a benefit for European forests, despite the poor management of game animals in industrial countries, which results in excessive numbers of large herbivores. With more predators, populations of deer, roe deer, and boar could be controlled naturally and brought back to equilibrium. Ideas have changed in the past several decades, and public opinion has moved in a favorable direction, but in very few countries. Though the situation is improving overall, there is still a great deal to be done before large predators resume the function of controlling Europe's forest populations.

CAN WE DO BETTER?

The European Union wanted to stop biodiversity loss by 2010, but noting that the goal had not been achieved, the concerned European nations decided to push the date back to 2020. A first step toward reaching this goal would be to actually apply the rules of best forestry management as enunciated by European scientists and foresters. Active implementation of efforts to preserve biodiversity could then be conducted in the showcase of Europe's national parks and natural reserves. To do this, we must start to think of the forest as an ecosystem, not a factory for producing wood, and hunting must be curtailed or even prohibited in certain areas. Where hunting plays a part in regulating prey populations, the assessment of population levels should be made by foresters, not hunting lobbyists.

Most species of large wild animals in Europe are a long way from reaching natural levels of population density. Effective management strategies for biodiversity will have to make more use of ecotourism and create jobs in those countries lucky enough to still have "symbol" species and large old-growth forests. There will also need to be an effort to make large carnivores better accepted in societies that have not had contact with them in several centuries but may now see their populations increase. Various avenues have been suggested, from using images to enhance their profile or associating them with local products, to finding effective ways to protect farmers from (and compensate them for) the damages large carnivores might cause.

Natural forests are sorely lacking in Europe, and an excellent way to restore them would be to remove certain forested areas from the arena of for-profit activity. These could be forests that are basically in good condition but that have been repeatedly harvested for timber or else second-growth forests on abandoned farmland. Such forests would rapidly develop richer, more complex food chains, assuming that all hunting, both of large predators and their prey, was forbidden. Several instances of rapid regeneration can be found in France's Mediterranean region, where rich and varied forests have sprung up on pastures abandoned only a few decades ago. In the Ardèche, forests resulting from farm abandonment are already hosts to genets, foxes, squirrels, badgers, and a number of herbivorous mammals. Tallies of the beetles living in the decaying wood of these young forests show that 298 distinct

223

species live there—a very large number for Europe. In the gorges of the Ardèche, one can now find the Bonelli's eagle (*Hieraaetus fasciatus*), the Egyptian vulture (*Neophron percnopterus*), the peregrine falcon (*Falco peregrinus*), and the Eurasian eagle-owl (*Bubo bubo*), as well as several pairs of short-toed snake eagle (*Circaetus gallicus*).

The large number of deer in these forests, which offer shelter in an otherwise inhospitable landscape, is highly favorable to the return of the wolf. The lynx is also benefiting from the increase in forested area, as is the wild cat. Woodland birds are making parallel advances. The western capercaillie (*Tetrao urogallus*) is particularly emblematic: Coming within a hair of extinction between 1850 and 1900, the capercaillie rebounded in the Pyrenees as farmland gradually reverted to woods. Industrialization and World War I literally emptied the mountains of thousands of small landholders, and the forests that recolonized the once intensively farmed land in the western and central Pyrenees are now a paradise for this handsome grouse.

The program known as Rewilding Europe proposes another way to use the opportunities offered by the abandonment of agricultural lands. The term "rewilding" implies that natural processes will be allowed to reassert themselves, preferably over large central areas connected by corridors or buffer areas. The original wild species of the region or their surviving relatives (the Konik horse and the Hecht aurochs, for example) would be partially reintroduced or would reappear on their own, and human interference would be kept to a minimum. The wilderness would develop into forests, open prairies, or some intermediate form of landscape. Either way, the areas would see the recurrence of a broad biodiversity, with a high density of wild species. Ideally, the central areas would

be managed independently of the consumer economy, meaning mainly that they would be off-limits to all hunting, logging, agriculture, and major construction. At present, there are virtually no areas in Europe with a full complement of wildlife that are not managed by man. The organizers of Rewilding Europe hope to create ten natural zones, each with a minimum surface area of 400 square miles (1,000 square kilometers), before 2020.

Another promising approach along parallel lines is to preserve more wilderness in areas that are heavily used by man. It is known, for instance, that small stands of old trees in rural hedgerows and on the outskirts of cities are quite quickly recolonized by insects that have become rare in Europe, such as the rosalia longicorn (*Rosalia alpina*), the stag beetle (*Lucanus cervus*), the great capricorn beetle (*Cerambyx cerdo*), and the hermit beetle (*Osmoderma eremita*). Hedgerows are a reservoir for a wide variety of fauna that find shelter and food there, and they are particular havens for woodland invertebrates. Hedges function as connecting links between stands of forest, their effectiveness as ecological corridors being all the greater when the forest areas are near each other, at least for species that are weak colonizers. The insects are better protected when the hedgerows are planted with native species. Also, the wider the hedge and the more layered its vegetation—shrubs, small trees, large trees, and deadwood—the greater the diversity of species to be found there, as each of these elements provides a range of habitats for animals and their predators.

The restoration of certain sections of Europe's rivers and streams should be undertaken on a very large scale. The removal of dams and roads, the restoration of stream banks by allowing natural forests to regrow there, and an acceptance of deadwood that falls into the water would give an entirely new aspect to the watercourses in the mountains, steep valleys, and plains of Europe.

Nature in its wild state can be preserved, using even more modest means, in cities themselves. The biodiversity of the fauna in urban areas has increased over the past 150 years because of the gradual adaptation of animals to the spread of cities and because new kinds of habitat are being created. Certain animals have adapted very well to the urban environment: 24 species of birds were recently identified in the streets of Madrid, Spain; 12 mammals in Marseille, France (including squirrels, foxes, and especially bats); more than 50 species of mammals in Berlin, Germany, where 125 species of birds are known to nest, with higher populations of nightingales than anywhere in Bavaria. Other bird populations, notably the blackbird (*Turdus merula*) and the European magpie (*Pica pica*), are on the increase.

Regulations governing species that are deemed to be harmful in urban environments should be opened to public scrutiny and debate. Do they address real damage incurred by city dwellers, or is it simply a question of public intolerance? Are dense populations of urban species due to overly favorable conditions, since cities often lack predators, or are they simply the result of a lack of hunting pressure? A similar line of inquiry should be extended to plant life. It is possible to imagine avoiding the systematic destruction of natural vegetation that is spontaneously trying to reclaim streets, the banks of streams and canals, and cemeteries. Such initiatives have been implemented for some time in a number of large cities, including Dresden, Amsterdam, Fribourg, and Strasbourg. Why not go further and allow more volunteer plants (plants that don't have to be planted, that grow naturally) to take hold in public and private gardens, and give priority to old trees in public parks (as is practiced in Stockholm, Sweden), in hedgerows, and on fallow land? Could we not replace city lawns with extensive mown prairies, and plant corridors of native trees and shrubs along streets, instead of rows and rows of horticultural species? And why not incorporate nature reserves in the middle of cities instead of public parks, as is done in Berlin? These nature corridors, if they were implemented on a nationwide scale, would become true instruments for the conservation of so-called "ordinary" nature, in a world that is becoming more and more artificial: an "interstitial" nature, so to speak, inserting itself wherever it finds space.

In several European cities, the biodiversity of the urban and suburban areas is already greater than in the settled country around them or in forest ecosystems damaged by excessive logging. Furthermore, the population levels of a number of species, particularly birds, is higher in cities than in habitats that we consider more "natural."

225

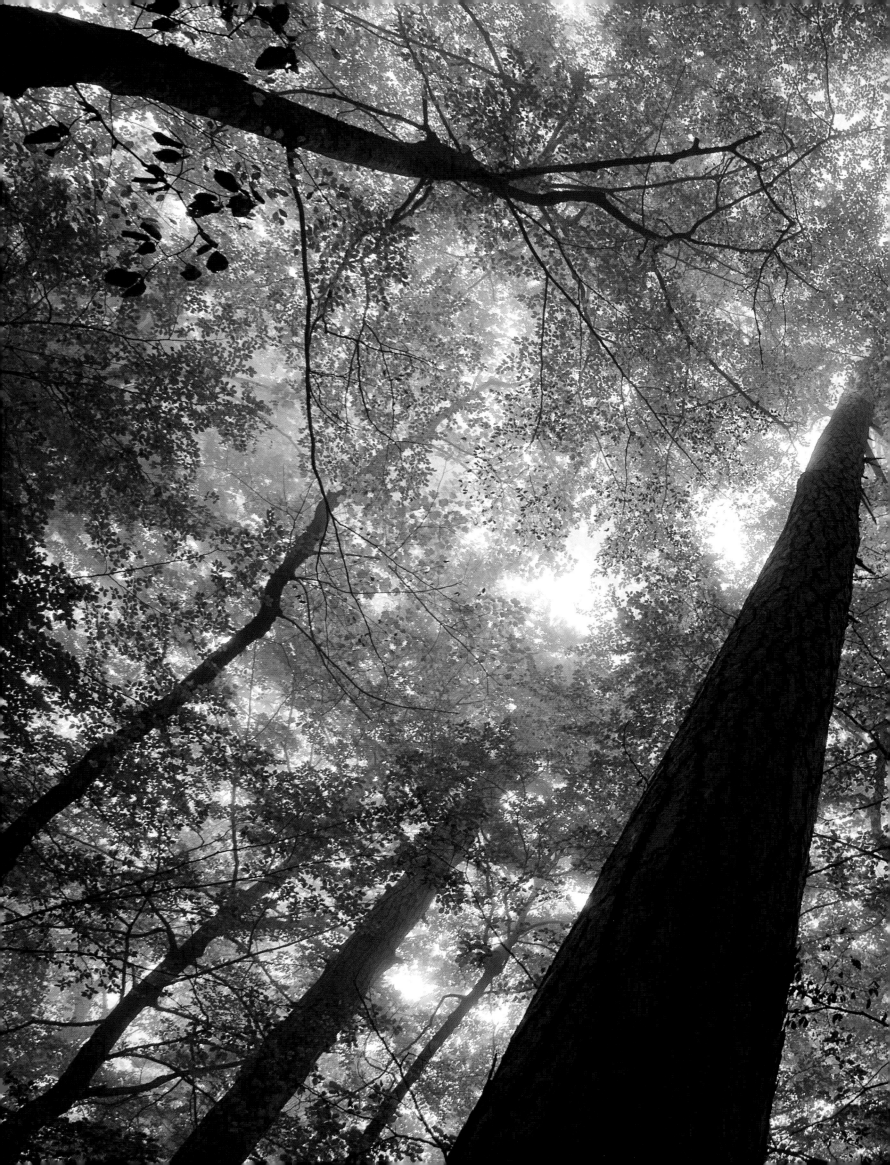

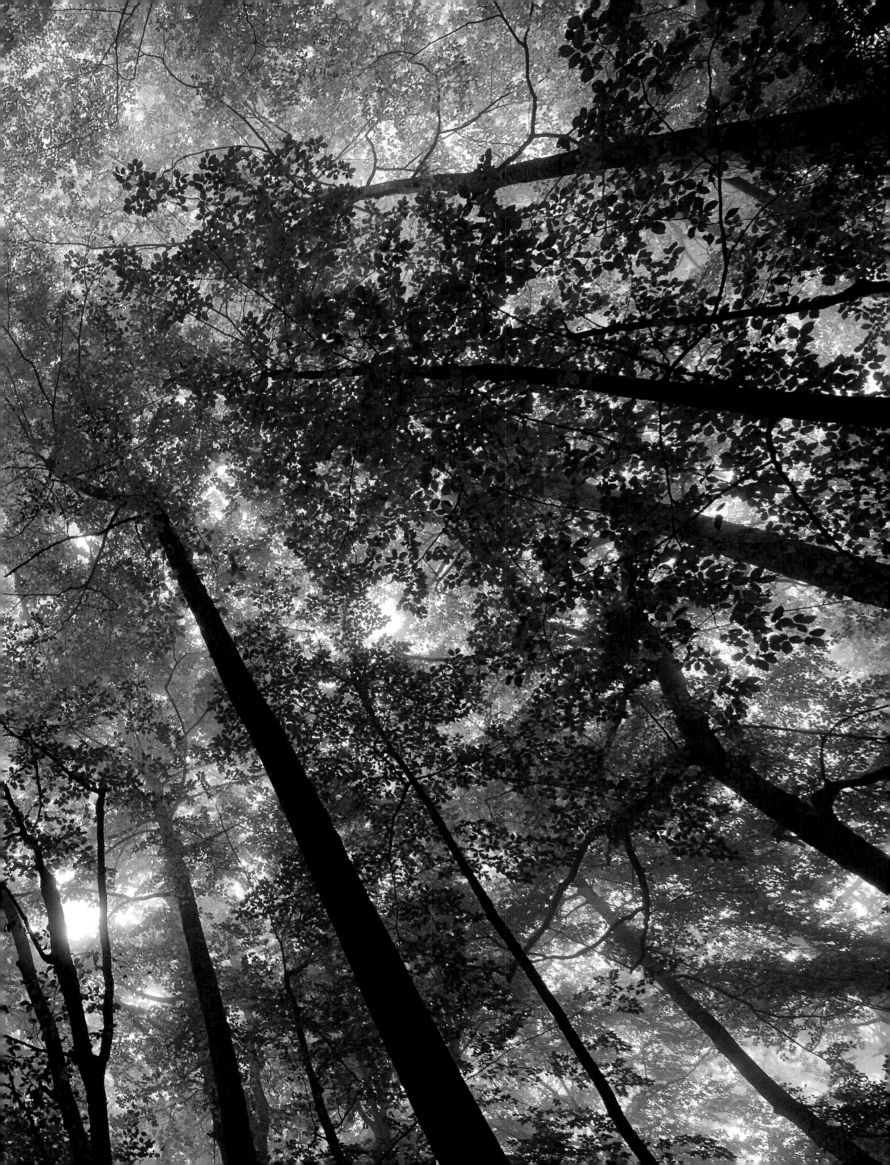

EPILOGUE

"ON A WINTER'S NIGHT, PREFERABLY A DARK AND MOONLESS NIGHT, YOU HEAR HIM! OR IS IT REALLY HIM? LEANING OUT OVER THE SILL, PUSHING BACK THE SHUTTERS, YOU HEAR HIS distant call again. A clandestine signal or a long, wild, sorrowful yowl.... A call that comes from the past, an eternal cry of suffering.... You had forgotten that long-gone time, lost forever.... But he has not forgotten! The fear that you instill in him, the panicked moments he has felt, the burning lead of bullets, the steel traps that have broken his bones and mangled his wild flesh. The nets, the poisons, the long slow death.... The wolf trap and the sharpened stakes that pierce the skin and then the very soul of the beast.... The destroyers are always there,... waiting in ambush for the canid, ready to do anything so as not to have to make room for it. The animal's detractors are as numerous as they were a thousand years ago, ready to cry wolf. And yet he comes, sure of his rights, his natural rights, which he will have to set in opposition to the rights of man. Let us welcome him as the natural regulator that he is, an indispensable regulator if we prepare for his return correctly. It is time to act, to offer him a territory.... Today, prey animals are plentiful, sometimes to the point of being pests. Roe deer, red deer, boar, chamois, and other more modest species are only waiting for a natural predator to bring balance and moderation to the excesses brought on by man."

—Jean-Luc Valérie
*The Return of the Wolf
in Lorraine, 2010*

The natural environment has always been interpreted by men through the lens of their cultures and systems of meaning. Forests, a source of life since the beginning of the Holocene, are no exception. Considered purely on the basis of their ecological role, their functioning seems altered, their components reduced in number, and their future more and more uncertain in the face of western culture's new technologies and rampant appetites.

Man's excesses have provoked a wave of reaction, which has had the welcome effect of slowing down the process to some degree. But the European view, even that of its most generous advocates, is still largely anthropocentric. A species is saved for the sake of "biodiversity" because it represents part of "man's heritage," implying that it belongs to men, that it exists only for them: for the hunt, esthetics, science, pleasure, and, in more distant times, for its sacred character.

Would it not be possible to accept the forest on its own terms, simply because the organisms in it have the right to exist? Protecting the forest and all its species, from the most modest to the most spectacular, without asking for anything in return, could be seen as a gift made to vast landscapes, accepted just for being an ecological reality.

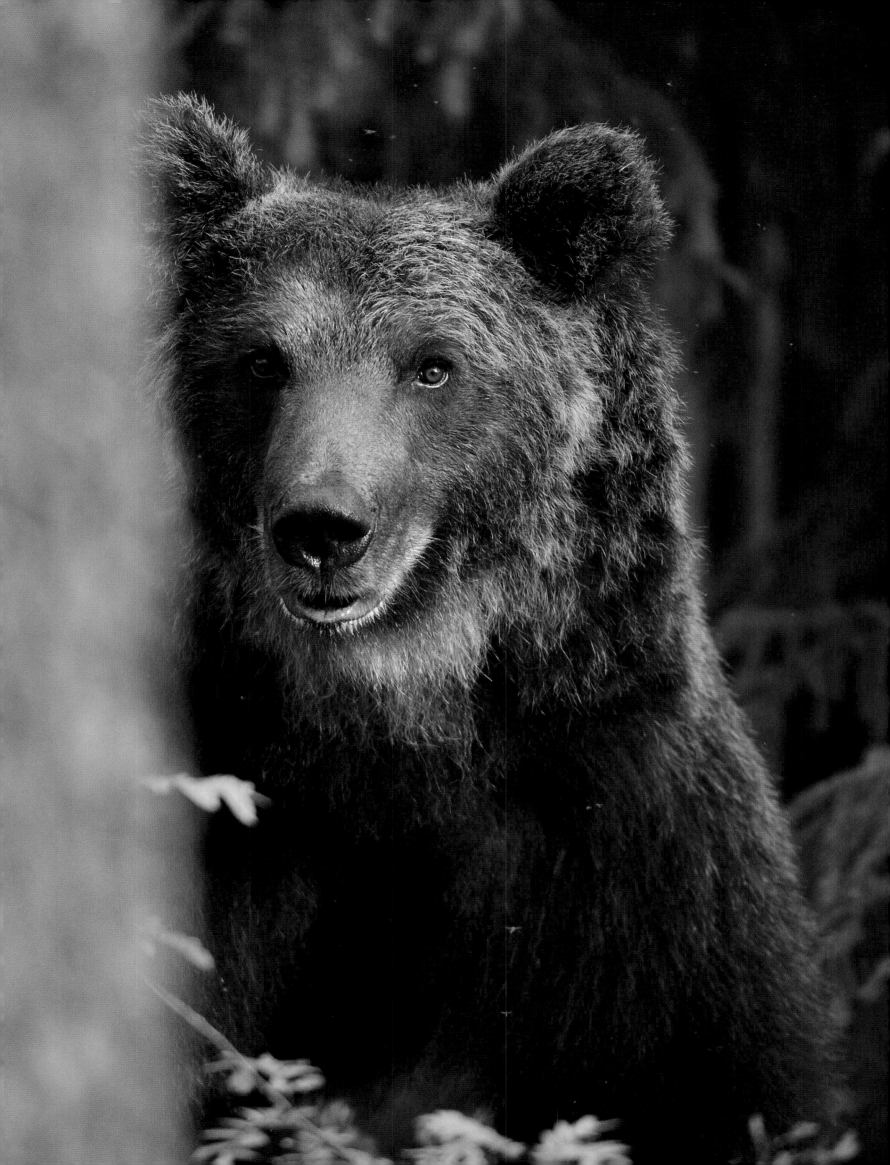

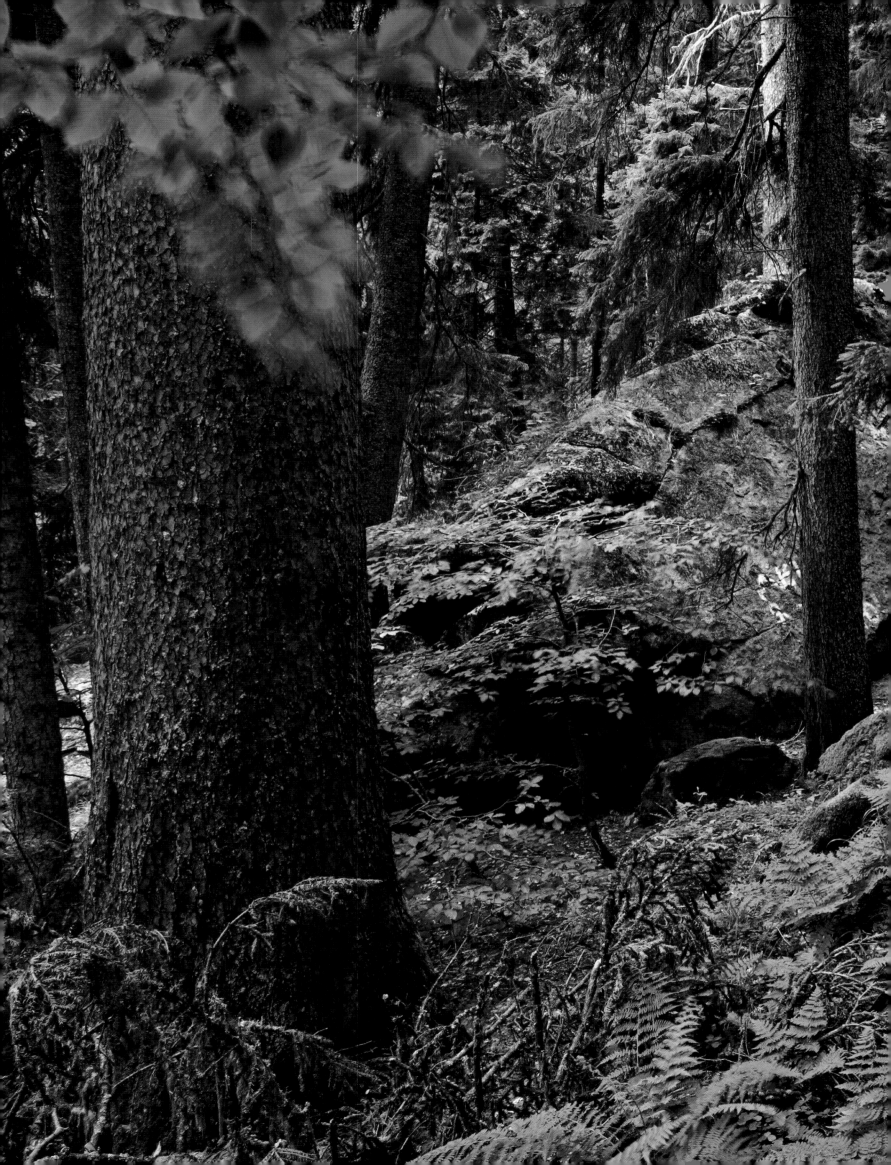

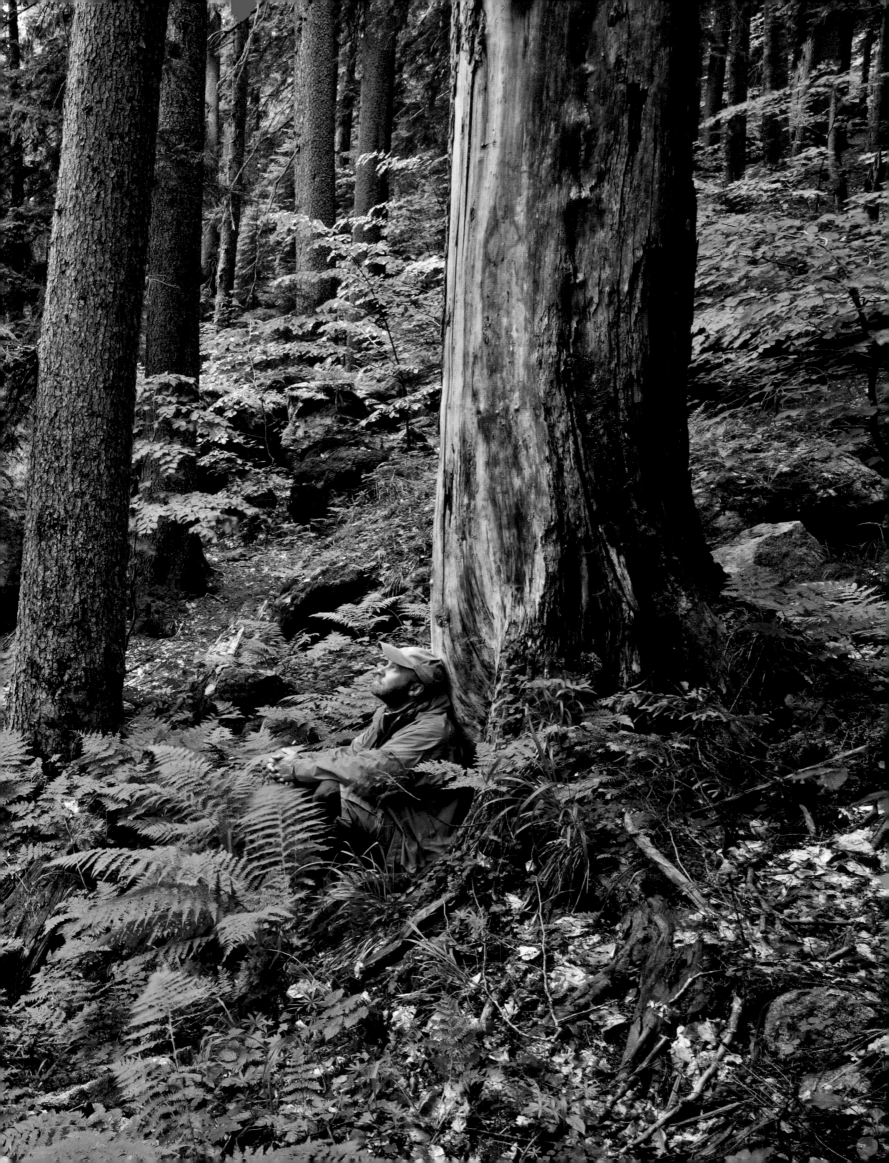

Intensive spruce plantation
Picea abies
SWEDEN | UPPLAND

Worldwide forestry practices can be divided into two camps: The first takes pains to protect the forest's biodiversity and respects natural laws, while the second plunders the ecosystem by clear-cutting large areas, planting same-age monocultures, and using chemicals to destroy pests. These intensive management practices, which pollute both the soil and waterways, remain profitable only in the short term, yet they are found in all of the world's forests, at every latitude.

Staffan Widstrand

Natural black alder forest
Alnus glutinosa
LATVIA | KEMERI NATIONAL PARK, GULF OF RIGA

This riparian forest along a watercourse in northern Europe illustrates all the complexity of a natural forest, even when it consists of only one species (here, black alder). The trees are of varying heights and varying ages, interspersed with glades where the forest is regenerating after a deadfall or a windthrow. Riparian forests throughout Europe are endangered by river control projects and logging. The loveliest of the remaining forests are in protection areas in northern and eastern Europe.

Diego López

Roe deer
Capreolus capreolus

The roe deer is probably the mammal most frequently encountered in the broadleaf forests of Europe. It feeds on shoots and leaves, brambles, ivy, and hazel, as well as on cultivated fruits and plants. It browses discriminately, choosing its food carefully and selecting only the most nutritious parts. In many countries in Europe, the roe deer population has increased a hundredfold, or even several thousandfold, in the past 30 years.

Grzegorz Lesniewski

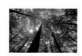

Forest growth of European black pine
Pinus nigra subsp. *nigra*
MONTENEGRO | CRNA PODA NATURE RESERVE, TARA RIVER CANYON, DURMITOR NATIONAL PARK

Located in 150-square-mile (390-square-kilometer) Durmitor National Park, a UNESCO World Heritage Site since 1980, the Tara River Canyon is the deepest in the world after the Grand Canyon. Its slopes shelter the largest extant forest of European black pine (*Pinus nigra* subsp. *nigra*), with individual trees fully 400 years old and 165 feet (50 meters) tall. The pines shown here are growing in the Crna Poda Nature Reserve, one of seven special protection areas within the park.

Milán Radisics

Ursus arctos
FINLAND | SUOMUSSALMI, KAINUU

The bear has been a symbol in the imagination of European societies since the Paleolithic Era, no doubt because of man's fascination with its extraordinary muscular strength, resistance to fatigue and inclement weather, and undaunted courage. Historically, most of northern and northwestern European peoples considered the bear to be the king of wild animals and made it a totem of warriors. This magical dimension can still be found in certain place names handed down from historical times, when bears still roamed Europe. Today, the fascination persists, as reflected in our movements to protect wild animals, our nature documentaries, our fictional films, and even the books and toys we give to children. The bear, largest of the carnivores and former king of Europe's forests, is certainly an animal like no other.

Staffan Widstrand

Forest of Nordmann fir
Abies nordmanniana
RUSSIA | DOMBAY REGION, CAUCASUS

Respect, admiration, and curiosity toward the great universe of this untouched forest in the Caucasus can all be read in the demeanor of this man sitting at the foot of a decaying fir tree. Will we ever truly know what we have lost by so profoundly altering the old-growth forests of Europe?

Tom Schandy

Eurasian jay
Garrulus glandarius
HUNGARY

The Eurasian jay, its highly visible blue shoulder patch and black tail contrasting with its white rump, is a fine example of a forest bird. On the ground, the jay's raised crest is an identifying characteristic. Usually solitary, the jay seeks out oak trees in the fall to build up his winter store of acorns. Jays are an important factor in the regeneration of oak forests on abandoned agricultural land. A single bird collects up to 5,000 acorns during a three-week period and will use only a small percentage of these. By caching acorns in open areas deep enough underground to germinate without competition from herbaceous plants, jays help new generations of oaks to grow.

Markus Varesvuo

List of places photographed in this book

Greenland
Kalaallit Nunaat
(Denmark)

Polar Region

Tundra
Boreal forest—coniferous or taiga
Boreal forest—mountainous

Temperate forest—oceanic
Temperate forest—mountainous
Temperate forest—continental

Rain forest

Mediterranean forest
Mediterranean forest—mountainous

Temperate steppe
Temperate semi-desert
Semi-arid steppe

Atlantic Ocean

Azores
(Portugal)

PORTUGAL

14

48 Madère
(Portugal)

16

13 **15** Canary Islands
(Spain)

MAP OF EUROPE'S FORESTS

Arctic Ocean

Franz Josef Land

Svalbard
(Norway)

Novaya Zemlya

Greenland Sea

Barents Sea

ICELAND

Norwegian Sea

64

21 19 18

22 17
20

FINLAND

45

44

SWEDEN

23

RUSSIA

Faroe Islands
(Denmark)

NORWAY

62 61 63

ESTONIA

North Sea

60
59

Baltic
Sea

38 37

LATVIA

Caspian
Sea

11

39

LITHUANIA

IRELAND

DENMARK

Kaliningrad
(Russia)

BELARUS

UNITED
KINGDOM

5

47

POLAND

UKRAINE

3

4 2

NETHERLANDS

BELGIUM

6

49

GERMANY

CZECH
REPUBLIC

46
57
55

MOLDOVA

25

LUXEMBURG

56

SLOVENIA

41

GEORGIA

52

26

FRANCE

24

LIECHTENSTEIN

65 SWITZERLAND

AUSTRIA

29

HUNGARY

30

ROMANIA

50
51

Black Sea

36

58

SLOVENIA

CROATIA

53

54

10

BOSNIA-
HERZEGOVINA

SERBIA

8

SAN MARINO

BULGARIA

MONACO

7 42

TURKEY

ANDORRA

33

43

Kosovo

SPAIN

12

Corsica

ITALY

MONTENEGRO

MACEDONIA

VATICAN

35

1 40

34

ALBANIA

Sardinia

32

GREECE

27

9

28

CYPRESS

Mediterranean Sea

Sicily

Peloponnese

Crete

MALTA

CARTOGRAPHY: CYRILLE SUSS

Arpin, P., "Les invertébrés dans l'écosystème forestier. Expression, fonction, gestion de la diversité," *Les Dossiers forestiers*, no. 9, Paris, Office national des forêts, 2001.

Auguste, P., *Cadres biostratigraphique et paléoécologique du peuplement humain dans la France septentrionale durant le Pléistocène. Apports de l'étude paléontologique des grands mammifères de Biache-Saint-Vaast*, doctoral thesis, Muséum national d'Histoire naturelle, Paris, 1995, 5 vol., 1,924 p.

Bailey, J.P., "Japanese Knotweed s.l. at home and abroad," in Child L. E. et al., eds., *Ecology and Management of Alien Plant Invasion*, Leiden (Netherlands), Backhuys Publishers, 2003, pp. 1–14.

Beaman, M. and Madge S., *Guide encyclopédique des oiseaux du Paléarctique occidental*, Paris, Nathan, 2003.

Berglund, B. E., Persson, T., and Björkman, L., "Late Quaternary landscape and vegetation diversity in a North European perspective," *Quaternary International*, Dublin (Ireland) International Union for Quaternary Research (INQUA), 2007, pp. 184, 187–194.

Birds in the European Union 2010: a status assessment, Cambridge (United Kingdom), BirdLife International, 2010.

Bobiec, A., Gutowski, J. M., Laudenslayer, W. F., Pawlaczyk, P., Zub, K., *The Afterlife of a Tree*, Warsaw-Hajnówka (Poland), WWF Poland, 2005.

Boisson B., *La Forêt primordiale*, Lagny-sur-Marne (France), Instant Présent, 1996; Rennes (France), Apogée, 2008.

Bonifay, E., *Les Premiers Peuplements de l'Europe*, Paris, La maison des Roches, series "Histoire de la France préhistorique: des origines à–500000 ans," 2002.

Bradshaw, R., Mitchell, F. J. G., "The palaeoecological approach to reconstructing former grazing-vegetation interactions," *Forest Ecology and Management*, volume 120, no. 1–3, Kidlington (United Kingdom), Elsevier, 1999, pp. 3–12.

Brasey, E., *Démons et merveilles*, Paris, éditions du Chêne, 2002.

Callot, G., *La Truffe, la terre, la vie*, Paris, éditions INRA, 1999.

Carbiener, D., *Les Arbres qui cachent la forêt. La gestion forestière à l'épreuve de l'écologie*, Aix-en-Provence (France), Édisud, 1995.

Dajoz, R., *Les Insectes et la forêt. Rôle et diversité des insectes dans le milieu forestier*, Paris, London (United Kingdom), New York (United States), Tec & Doc-Lavoisier, 1998, 2007.

Desprez-Lousteau, M.-L., Courtecuisse, R., Robin, C., Husson, C., Moreau, P.-A., Blancard, D., Selosse, M.-A., Lung-Escarmant, B., Piou, D., Sache, I., "Species diversity and drivers of spread of alien fungi (sensu lato) in Europe with a particular focus on France," *Biological Invasions*, no. 12, Heidelberg (Germany), Springer, 2010, pp. 157–172.

Dodelin, B., "Les coléoptères saproxyliques, derniers maillons de la forêt," *Bulletin de la Société linnéenne de Lyon*, special publication no. 2, Lyon, 2010, pp. 159–166.

Dolata, P., Posse, B., "Migration et baguage en couleur de cigognes noires *Ciconia nigra*," *Nos oiseaux*, no. 484, volume 53/2, Switzerland, 2006, pp. 85–93.

Duchiron, M. S., Schnitzler, A., "La forêt face aux changements climatiques: de la gestion productivistes à une sylviculture de l'écosystème," *Le Courrier de l'environnement*, no. 57, Paris, INRA, 2009, pp. 36–52.

Eliade, Mircea, *The Sacred and the Profane*, (Trans. Willard R. Trask), New York, Harper Torchbooks, 1961.

Folch, R., Camarasa, J. L., *Encyclopedia of the Biosphere. Humans in the World's Ecosystems*; volume 5: *Mediterranean Woodlands*; volume 6: *Temperate Rainforests*; volume 7: *Deciduous Forests*; volume 8: *Prairies and Boreal Forests*, UNESCO-MAB, Farmington Hills (United States), Gale Group Publisher, 2000.

Génot, J.-C., *Instinct nature*, Paris, Sang de la Terre, series "Grandeur nature," 2010.

Gobat, J.-M., Aragno, M., Matthey, W., *Le Sol vivant. Bases de pédologie, biologie des sols*, Lausanne (Switzerland), Presses polytechniques et universitaires romandes, series "Gérer l'environnement," 2003.

Gosselin, M., Paillet, Y., *Mieux intégrer la biodiversité dans la gestion forestière*, Versailles, éditions Quae, 2010.

Gstalter, A., Lazier, P., *Le Bison d'Europe. Mythe et renaissance d'une espèce sauvage*, Le Vigan (France), Bez et Esparon, series "Traces," 1996.

Hallé, F., Lieutaghi, P., *Aux origines des plantes*, volume 2: *Des plantes et des hommes*, Paris, Fayard, 2008.

Harrison, R., *Forêts. Essai sur l'imaginaire occidental*, Paris, Flammarion, 1992.

Heath, M. F., Evans, M. I., *Important bird areas in Europe. Priority sites for conservation*, volume 1: *Northern Europe*; volume 2: *Southern Europe*, series "BirdLife Conservation Series," no. 8, Cambridge (United Kingdom), BirdLife International, 2001.

Hell, B., *Le Sang noir. Chasse et mythe du sauvage en Europe*, Paris, Flammarion, 1994.

Hobbs, R. J., Arico, S., Aronson, J., Baron, J. S., Bridgewater, P., Cramer, V. A., Epstein, P. R., Ewel, J., Klink, C. A., Lugo, A. E., Norton, D., Ojima, D., Richardson, D. M., Sanderson, E. W., Valladares, F., Vila, M., Zamora, R., Zobel, M., "Novel ecosystems: theoretical and management aspects of the new ecological world order. Ecological sounding," *Global Ecology and Biogeography*, no. 15, Hoboken (United States), Wiley-Backwell, 2006, pp. 1–7.

Höchtl, F., Lehringer, S., Konold, W., "Wilderness: what it means when it becomes a reality. A case study from the southwestern Alps," *Landscape and urban planning*, no. 70, Amsterdam (Netherlands), Elsevier Science, 2005, pp. 85–95.

Jackson, P., Farrell Jackson, A., Dallet, R., De Crem, J., *Les Félins. Toutes les espèces du monde*, Lausanne, Paris, Delachaux et Niestlé, 1996.

Keenleyside, C., Tucker, G. M., *Farmland Abandonment in the EU: an Assessment of Trends and Prospects*, WWF Netherlands, London (United Kingdom), Institute for European Environmental Policy, 2010, 93 p.

Klimo, E., *Floodplain forests of the temperate zone of Europe*, Kostelec nad Cernymi lesy (Czech Republic), Lesnická Práce, 2008.

Korpel, S., *Die Urwälder der Westkarpaten*, Stuttgart (Germany), Gustav Fischer Verlag, 1995.

Kowarik, I., "Urban ornamentals escaped from cultivation," in Gressel, J., ed., *Crop Ferality and volunteerism*, Boca Raton (United States), London (United Kingdom), New York (United States), Singapore, OCDE, CRC Press, Taylor & Francis Group, 2005.

Lafranchis, T., *Le Taureau*, Puiseaux (France), Pardès, series "Bibliothèque des symboles," 1993.

Lewington, A., Parker, E., *Arbres millénaires. Ces arbres qui nous fascinent*, Paris, Le Courrier du livre, 2000.

Luniak, M., "Synurbization—adaptation of animal wildlife to urban development," in Shaw W. W. et al. (eds.), *Proceedings of the Fourth International Symposium on Urban Wildlife Conservation (1999)*, Tucson (United States), University of Arizona, 2004.

Marris, E., "Ragamuffin earth," *Nature*, no. 460, London (United Kingdom), New York (United States), Tokyo (Japan), Nature Publishing Group, 2009, pp. 450–451.

Maury, A., *Les Forêts de la Gaule et de l'ancienne France*, Paris, Jean de Bonnot, 1994.

Mercier, J.-P., *L'Europe des ours*, Saint-Claude-de-Diray (France), éditions Hesse, 2010.

Mourreau, J.-J., "La Chasse sauvage," *Nouvelle École*, no. 16, Paris, éditions Copernic, 1972.

Oldeman, R. A. A., *Forests: elements of silvology*, Berlin (Germany), New York (United States), Springer Verlag, 1990.

Pastoureau, M., *L'ours. Histoire d'un roi déchu*, Paris, Seuil, 2007.

Patou-Mathis, M., *Neanderthal. Une autre humanité*, Paris, Perrin, 2006; series "Tempus," 2010.

Pearce, F., *Quand meurent les grands fleuves. Enquête sur la crise mondiale de l'eau*, Paris, Calmann-Lévy, 2006.

Peterken, G. F., *Natural woodland. Ecology and conservation in northern temperate regions*, Cambridge (United Kingdom), Cambridge University Press, 1996.

Planhol, X. de, *Le Paysage animal. L'homme et la grande faune: une zoogéographie historique*, Paris, Fayard, 2004.

Quézel, P., Médail, F., *Écologie et biogéographie des forêts du bassin méditerranéen*, Paris, Elsevier, series "Environnement," 2003.

Ramade, F., *Conservation des écosystèmes méditerranéens. Enjeux et prospective*, Paris, Economica, Sophia-Antipolis, Plan bleu pour la Méditerranée, series "Les Fascicules du Plan Bleu," no. 3, 1997.

Roguenant, A., Raynal-Roques A., Sell Y., *Un amour d'orchidée. Le mariage de la fleur et de l'insecte*, Paris, Belin, 2005.

Rutz, C., "The establishment of an urban bird population," *Journal of Animal Ecology*, volume 77, London (United Kingdom), British Ecological Society, 2008, pp. 1008–1019.

Schnitzler, A., *Écologie des forêts naturelles d'Europe. Biodiversité, sylvigénèse, valeur patrimoniale des forêts primaires*, Paris, London (United Kingdom), New York (United States), éditions Tec & Doc, 2002.

Schnitzler, A., *Forêts alluviales d'Europe. Écologie, biogéographie, valeur intrinsèque*, Paris, éditions Tec & Doc-Lavoisier, 2007.

Schnitzler, A., "Past and present distribution of the North African-Asian lion subgroup: a review," *Mammal Review*, Southampton (United Kingdom), The Mammal Society, 2011.

Valérie, J.-L., *Le Retour du loup en Lorraine*, Haroué (France), éditions Gérard Louis, 2010.

Van Vuure, C., *Retracing the Aurochs: History, Morphology & Ecology of an Extinct Wild Ox*, Sofia (Bulgaria), Pensoft Publishers, 2005.

Vera, F. W. M., *Grazing ecology and forest history*, Wallingford (United Kingdom), CAB International Publishing, Oxford, 2000.

Vera, F., Buissink F., *Wilderness in Europe*, Baarn (Netherlands), Tirion Publishers, 2007.

Vrska, T., Adam D., Hort L., Odehnalová D., Horal D., Kral K., *Developmental dynamics of virgin forest reserves in the Czech Republic*, Prague, Academia, 2006.

Williams, M., *Deforesting the Earth. From Prehistory to Global Crisis. An Abridgment*, Chicago (United States), London (United Kingdom), The University of Chicago Press, 2006.

Whitehouse, N. J., Smith, D. N., "'Islands' in Holocene forests: Implications for forest openness, landscape clearance and 'culture steppe' species," *Environmental Archaeology*, volume 9, no. 2, London (United Kingdom), Association for Environmental Archaeology, 2004, pp. 203–212.

In the editing of this work on the forests of Europe, I found in Florian Möllers, photographer and passionate biologist of wildlife, a precious collaborator in the creation of these texts.

I would also like to express my deep gratitude to Stéphanie Zweifel, editor with éditions de La Martinière, for her great competence, patience, and unfailing kindness, and all my admiration for the talent and sensibility of Anne-Marie Bourgeois, responsible for the graphic design of this beautiful book.

A big thank you, finally, to colleagues and friends: Marie-Stella Duchiron, Benoit Dodelin, Jean-Claude Génot, Farid Benhammou, Christophe Brua, who all gave me precious help, by their literary contributions, discussion, and suggestions in their respective areas of expertise.

WILD WONDERS OF EUROPE IS THE LARGEST PHOTOGRAPHY-BASED CONSERVATION COMMUNICATION INITIATIVE IN THE WORLD.

Directed by Magnus Lundgren, Florian Möllers, Staffan Widstrand, and Bridget Wijnberg, the project assigned 69 of the continent's most talented and committed nature photographers to a great quest: to conduct 135 photographic missions across 48 European countries.

The result is an image archive consisting of more than 200,000 beautiful and unexpected images from all corners of Europe, revealing the shared natural heritage of the entire continent.

More information can be found on the project's website: www.wild-wonders.com. Usage rights for all images from this book can be obtained through our partner: Nature Picture Library (www.naturepl.com).

PHOTOGRAPHERS

THEO ALLOFS
BRUNO D'AMICIS
INGO ARNDT
NILS AUKAN
FRANCO BANFI
SANDRA BARTOCHA
NIALL BENVIE
DANIEL BERGMANN
MAURIZIO BIANCARELLI
PETER CAIRNS
LAURIE CAMPBELL
MARK CARWARDINE
DIETER DAMSCHEN
CORNELIA DÖRR
MAGNUS ELANDER
MARTIN FALKLIND
ELIO DELLA FERRERA
ANDERS GEIDEMARK
LAURENT GESLIN
EDWIN GIESBERS
DANNY GREEN
OLIVIER GRUNEWALD
ERLEND HAARBERG
ORSOLYA HAARBERG
MARK HAMBLIN
PÅL HERMANSEN
ARNE HODALIČ
KAI JENSEN
FRANK KRAHMER
GRZEGORZ LEŚNIEWSKI
MIREILLE DE LA LEZ
PETER LILJA
OLE JØRGEN LIODDEN
DIEGO LÓPEZ
MAGNUS LUNDGREN
BENCE MÁTÉ
DAVID MAITLAND
FLORIAN MÖLLERS

CLAUDIA MÜLLER
VINCENT MUNIER
JUAN CARLOS MUÑOZ
DIETMAR NILL
LÁSZLÓ NOVÁK
PETE OXFORD
JARI PELTOMÄKI
LINDA PITKIN
GEORG POPP
VERENA POPP-HACKNER
LOUIS-MARIE PRÉAU
MANUEL PRESTI
LUIS QUINTA
MILÁN RADISICS
LASSI RAUTIAINEN
IÑAKI RELANZÓN
MICHEL ROGGO
JOSÉ B. RUIZ
NUNO SÁ
TOM SCHANDY
IGOR SHPILENOK
RUBEN SMIT
JESPER TØNNING
STEFANO UNTERTHINER
MARKUS VARESVUO
STAFFAN WIDSTRAND
KONRAD WOTHE
SVEN ZAČEK
SOLVIN ZANKL
CHRISTIAN ZIEGLER
DANIEL ZUPANC

ART DIRECTION
VALÉRIE
GAUTIER

DESIGNER
M87 DESIGN /
ANNE-MARIE
BOURGEOIS

ASSISTANT
ADRIEN
LABBE

PROOFREADING
CLAIRE
LEMOINE

CARTOGRAPHY
CYRILLE SUSS

TRANSLATED FROM THE
FRENCH BY
WILLARD WOOD

ENGLISH-LANGUAGE
EDITION:

EDITOR
LAURA DOZIER

DESIGNER
SHAWN DAHL,
DAHLIMAMA INC

PRODUCTION MANAGER
JULES THOMSON

CATALOGING-IN-
PUBLICATION DATA HAS
BEEN APPLIED FOR
AND MAY BE OBTAINED
FROM THE LIBRARY OF
CONGRESS.

ISBN: 978-1-4197-0079-8

COPYRIGHT © 2011
ÉDITIONS DE LA
MARTINIÈRE

ORIGINALLY PUBLISHED
IN FRENCH IN 2011
UNDER THE TITLE *FORÊTS
D'EUROPE* BY ÉDITIONS
DE LA MARTINIÈRE,
A DIVISION OF LA
MARTINIÈRE GROUPE,
PARIS

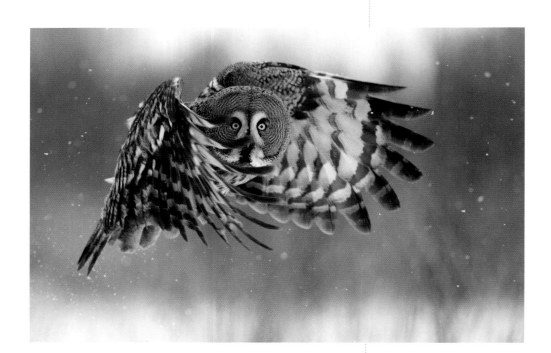

↑
Bluebell
Hyacinthoides non-scripta
BELGIUM | WOOD HAL, BRABANT

Maurizio Biancarelli

Brown bear
Ursus arctos
FINLAND | KUHMO, KAINUU

Staffan Widstrand

Great gray owl
Strix nebulosa
FINLANDE | OULU

Sven Začek

ABRAMS
THE ART OF BOOKS SINCE 1949

115 West 18th Street
New York, NY 10011
www.abramsbooks.com